THE ANCIENT MIDDLE CLASSES

THE ANCIENT
MIDDLE CLASSES

Urban Life and Aesthetics
in the Roman Empire,
100 BCE–250 CE

————————

Emanuel Mayer

HARVARD UNIVERSITY PRESS
Cambridge, Massachusetts
London, England
2012

Copyright © 2012 by the President and Fellows of Harvard College
Printed in the United States of America

Library of Congress Cataloging-in-Publication Data
Mayer, Emanuel.
The ancient middle classes : urban life and aesthetics
in the Roman Empire, 100 BCE–250 CE / Emanuel Mayer.
p. cm.
Includes bibliographical references and index.
ISBN 978-0-674-05033-4 (alk. paper)
1. Middle class–Rome. 2. Middle class—Rome—Social life and customs.
3. Social classes—Rome. 4. Rome—Civilization. I. Title.
DG78.M42 2012
305.5′50937–dc23 2011051597

Contents

Figures

Preface and Acknowledgments

This book was inspired by my colleagues and students at the University of Chicago who, to my surprise, sparked my interest in economic history. The book is rooted in two basic observations. First, over the last two centuries B.C.E., most Greco-Roman cities rapidly transformed from agrotowns into vibrant commercial centers with hundreds if not thousands of permanent shops and a surprisingly large rental housing market. Second, what we nowadays consider art, such as wall painting or sarcophagi, was bought by and marketed to a broad social spectrum, which, for the most part, clearly did not constitute a social, political, or economic elite.

By itself, neither observation is particularly new or revolutionary, at least not to a traditionally trained classical archaeologist like myself. But these two observations have, if systematically studied together, implications for our understanding of ancient economic and social history. In my mind, the most important implication is that we can discuss the lifeworlds of well-to-do businesspeople and professionals in terms of modern class analysis and speak of them as "ancient middle classes."

Of course, there are other implications too, as for ancient trade, labor organization, and monetization. But even though I touch on these and

other economic issues where they fit into my overall argument, this book is not an attempt to write a revisionist socioeconomic history of the Roman Empire. As a result, this book has little to say about slaves and the poor, demography and economic growth, the socioeconomic makeup of rural communities, or other topics that have been at the forefront of current debates on Roman economic and social history. That said, I hope that this book will be of interest to those studying these issues in detail, as the archaeology of the urban economy and of subelite lifeworlds has not yet played a major role in the debate. In addition, I hope that my colleagues in classical archaeology will find the middle-class framework useful for discussing evidence that did not make it into this book, for instance eastern sarcophagi or mummy portraits from Egypt.

Despite the focus of this book on a much-neglected segment of Roman society, the literature on the issues, sites, and even objects discussed here is immense. Keeping the notes to a third of the overall text required restricting myself to scholarship that was mostly published in this millennium. Of course, there is a great deal of older literature that is still essential reading, and I have acknowledged my debts where they are due. But in an age of very comprehensive encyclopedias on almost every aspect of the ancient world and even more comprehensive bibliographic databases, I felt that there was more to be gained in being selective than in displaying redundant erudition. As an archaeologist, I have favored publications that are heavy on evidence, preferably on archaeological and epigraphic material that, as I believe, has in many cases not received the attention it deserves. On the other hand, I have made it a priority to engage with more theoretical work that, in my view, has had the greatest impact on current debates on ancient socioeconomic history and art.

In terms of terminology, I refer to all inhabitants of the Roman Empire as Romans for simplicity's sake, no matter whether they were citizens, called themselves Romans in one of the empire's many languages, or willingly or unwillingly contributed to its economic, social, and cultural life. Throughout the book, I have avoided archaeological jargon. But it is worth pointing out that the Latin and Greek terms I do use reflect their current meaning among modern scholars and not necessarily their ancient usage. The only bow to archaeological convention is the numbering of Pompeian houses by *regio, insula,* and house entrance(s). This system complements

their mostly fictive nicknames and allows the reader to find them quickly in reference works such as *Pompei: Pitture e Mosaici*.

Many people helped make this book possible. My colleagues at the University of Chicago have provided much encouragement and support and I can only mention a few. Michael Allen and Cameron Hawkins carefully looked over an early draft of Chapters 1 and 2. Alain Bresson, Jonathan Hall, and Peter White read not only early versions of various chapters but also complete drafts of the manuscript. Their astute criticism has helped to considerably improve the book and I am deeply in their debt for the time and effort they have devoted to this. Chris Faraone and the Center for Ancient Religions made it possible to organize a meeting, "Myth in Private Lives," which provided an opportunity to workshop some of my ideas to a distinguished audience. I am grateful for the input I received from them, most notably from Francesco de Angelis, Björn Ewald, and Paul Zanker. Of my colleagues outside Chicago, Ed Harris and Walter Scheidel have read drafts of early chapters and contributed important insights, and Geoff Kron and I have had many fruitful and stimulating discussions. I am also grateful for the comments and criticism that I have received from the two anonymous readers for Harvard University Press.

The Radcliffe Institute of Advanced Studies at Harvard University provided a luxurious and stimulating environment for the academic year 2008–2009, during which the first half of the book was written. I wish to thank all my fellow fellows for making this the most intellectually exciting year of my career so far. My editor, Sharmila Sen of Harvard University Press, has been one of my most careful and incisive readers over the last three years, and I have greatly enjoyed our many conversations. Heather Hughes has shepherded this book through the production process and I am grateful for her commitment and attention to detail. I am also indebted to Reinhard Foertsch of the *Forschungsarchiv für römische Plastik* for his help with procuring images. Cornelia Schweiss turned the plans to which the book refers into axonometric drawings, which will hopefully improve and clarify aspects of the text. Anthony Shannon undertook the arduous task of transforming the social science–style quotations, which I had used while writing the manuscript, into Harvard-style references.

It is more than academic convention to thank my family. This book was written over three difficult years during which they showed great

support. My parents and my sister sent warmth and encouragement from abroad as best they could, as did my Canadian in-laws. My sister-in-law Rebecca Lazar and my parents-in-law, Frum and Alex Himelfarb, also provided editorial help. The Himelfarbs also taught me a great deal about the real-life practice of politics and economics. But the greatest debt of all is to my wife, Nomi Claire Lazar, who supported me and this project to the point of neglecting her own work. This book is dedicated to her, to the memory of our sons, Isaac and Samuel, and to our daughter, Talia.

THE ANCIENT MIDDLE CLASSES

I

Class, Stratification, and Culture

The Roman Middle Classes and
Their Place in History

The term "ancient middle classes" requires justification. It has been shunned over the last thirty years, and given its previous uses, understandably so.[1] But "middle class" as a concept is essential to understand the great social transformations that led to the mass culture of the Roman Empire, which, in terms of houses and tombs, is the subject of this book. Without a thriving class of artisans, merchants, and professionals, Roman urban life as we know it would not have come into existence. And it is thanks to these middle classes that we are left with the thousands of marble sarcophagi and hundreds of elegantly decorated houses in places like Pompeii that occupy archaeologists today. Hence, without the concept of ancient middle classes we are bound to profoundly misunderstand art and city life in the Roman Empire. But which social groups can be labeled ancient middle classes and how do we define them? This introduction is devoted to this question.

Middle Classes Modern and Ancient:
Anachronism and Evidence

Class is a modern concept. The ancients thought and wrote about their own societies in terms of social rank and legal status. But because political, social, and historical discourses in the nineteenth and twentieth centuries revolved in large part around class and class struggle, class analysis was used in the study of ancient societies. Sir Moses Finley and his intellectual heirs have criticized this as anachronistic. Finley was primarily concerned about Marxist notions of class, which define class by access to the means of production. In his view, this formalistic approach ignored the role that the intricate status order of ancient societies played in shaping the ancient economy. In response to Marxist analysis, Finley used Max Weber's concept of "status society" to explain how ancient ideologies shaped economic behavior.[2] But here Finley's use of Weber is one-sided in a crucial respect: at least in Weber, class is not absent from status societies, even if it is not the primary mode of social stratification. Class is still significant in measuring the level of economic opportunity for social groups, in particular for "commercial classes," who are made up of artisans, merchants, and professionals. And here documentary and archaeological evidence from the ancient world shows patterns of remarkable economic opportunity and social mobility for a very large number of artisans and merchants from the second century B.C.E. onward.

Yet commercial classes are not identical with "middle classes," neither in a Weberian nor in a colloquial sense. Today, "middle class" stands for a social group that is defined not simply by economics but also by a shared ethos and a common culture. This is why successful working people from economically diverse backgrounds can self-identify as middle class. For instance, the Labour politician John Prescott, who was born to a Welsh railway signalman, and the blue-blooded, Eton- and Oxford-educated Tory prime minister David Cameron have both famously identified themselves as middle class. To account for similar cultural and political phenomena, Weber introduced the category of "social class," which he defined as a group made up of individuals who share similar economic opportunities and, at the same time, social and cultural conditions.

So was there a social class in antiquity that we may call a "middle class"? Clearly, there were a large number of artisans and merchants in the Roman Empire who lived and worked under very similar conditions. As they stood between the rich and the poor, we may call them a middle class, by analogy to later historical middle classes. This is possible because, despite radically different historical circumstances, ancient, more recent, and even modern middle classes share important and salient features: first, the importance of work in their public self-definition; second, the celebration of love and affection within the nuclear family; and, third, a desire for a comfortable and joyful life.

Of course, all of these concepts resonate with contemporary perceptions of the middle class, and, indeed, using "middle class" as an analytical frame is a strategic anachronism. Yet, this anachronism is both useful and appropriate. We cannot gain traction on the social and cultural history of the Roman Empire if we restrict ourselves to the categories of ancient social thought. And, as an analytical tool, this particular anachronism makes sense. Looking at Roman commercial classes through the lens of modern middle classes reveals some remarkable aspects of ancient social life and culture that would otherwise remain hidden. Using this lens requires a brief look at contemporary notions of middle-classness.

Being middle class means and has always meant more than living comfortably, somewhere between the rich and the poor. Middle-class comfort is earned through hard work and reflects individual achievement, first at school and later in professional life. This work-based notion of middle-classness is widely accepted in the developed world. The British may (still) be more discriminating than their American counterparts when it comes to drawing the boundaries between the working and the middle classes. And the various shades of the French bourgeoisie and the German *Bürgertum* may not fully overlap with what counts as middle class elsewhere.[3] But there are family resemblances between these different ideas of what it is to be middle class. Members of the middle class are well-trained and self-described hard workers, who believe that they own their economic success. This is why the strength of the middle class is often taken to reflect the health of society at large. Only a fair and ultimately democratic society, the argument goes, can reward people for their hard work and

allow for upward social mobility, a concept that is implicit in the idea of the middle class. The growth of Western middle classes, or, as some economists would now say, a newly won appreciation of and dignity for the middle classes, is widely believed to be the root cause for the creation of the modern world.[4]

In addition to these socioeconomic and ultimately political features, "middle class" is also a cultural category. Here, various regional and national traditions have created a great variety of what are perceived as middle-class ways of life. European middle classes tend to construct their identity around a cultural and often national tradition. This is less so across the Atlantic, where middle-classness is primarily defined by patterns of work and consumption. But there are similarities. Whether growing up middle class involves Little League or piano lessons, it generally implies some form of bourgeois family idyll or another. It is a commonplace that conjugal love was "invented" by the middle classes in the late seventeenth century, in opposition to the arranged marriages of the aristocracy and its libertine sexual mores. In sum, the strength of the middle classes and the dominant work-based paradigm of middle-classness seem to be a, if not the, defining feature of modernity.

At first glance, this may make a category like "Roman middle classes" look hopelessly anachronistic. Yet most current research on modern-era middle classes acknowledges that there were commercial middle classes long before the early modern period. These middle classes did not bloom like the Dutch burghers in the seventeenth century, it is claimed, because they were stifled by politically dominant, landholding aristocrats, who looked down on commerce and trade.[5] On this view, the premodern world was primarily one of landed lords and gentries, just as the modern world is supposedly one of hard-working middle classes.

This narrative, both in its early to mid-twentieth-century versions and its more recent incarnations, has had a profound influence on the interpretation of Roman society and culture. Ancient literature, or at least a superficial reading of it, supports the idea of a society run and dominated by gentlemen farmers, who may have occasionally engaged in rent-seeking entrepreneurial activities, but only on the side. This reduces the commercial middle classes of the Roman Empire to a footnote of ancient social history. And indeed, many of the most prominent and influential scholars

of Roman culture, like Andrew Wallace-Hadrill, insist that there were no ancient middle classes, properly speaking. The "middling classes" that existed, he claims, had no noticeable identity of their own. Instead, their cultural expression was bent on imitating the aristocracy, or, alternatively in a later version of this argument, the more affluent part of the *plebs* partook in an almost universal culture of luxury that emphasized social distinction.[6]

This book is an attempt to set this misconception straight. From the late first century B.C.E. onward, commercial middle classes came to shape urban life, not only economically but, even more importantly, socially and culturally. From their archaeological footprint, it is clear that they had their own values and forms of cultural expression, and contributed, in terms of material culture and art, just as much to Roman civilization as Greek and Latin writers did. That said, the cultural and geographic variety within the ancient world must lead us to reject the idea of a single, unified ancient middle class. Caravan traders from Palmyra, Mediterranean entrepreneurs beyond the Roman frontier, and craftsmen working in small Italian towns had a lot in common. But to stress their great diversity and the importance of local responses to the broad forces of economic and cultural change that transformed the ancient world in the last two centuries B.C.E., this book is devoted to a plurality of ancient middle classes. These differences are discussed in detail. But before we can attempt a theoretically rigorous socioeconomic definition of ancient middle classes, it is important to briefly emphasize their cultural similarities, which allow us to conceptualize the commercial middle classes of the Roman Empire as a social class.

Middle classes all over the Roman world did not see themselves as outsiders, as a superficial reading of classical literature might suggest. Instead, they proudly advertised their achievements, wealth, and ingenuity. Nor did they buy into the agrarian ideology of Rome's senatorial aristocracy. For instance, in Carian Hierapolis a Titus Flavius Zeuxis, who self-identified as a working man *(ergástes),* built one of the city's largest tombs right next to the city gate. Its inscription proudly stated that he had sailed on business to Italy seventy-two times.[7] Two or three generations later, another working citizen of Hierapolis, Marcus Aurelius Ammianus, commissioned a highly evocative sarcophagus, which faced the main road leading into town. Its lid was decorated with a water-powered sawmill. It transmitted waterpower

through a gear train that included a crank and a connecting rod, just like an eighteenth-century sawmill (or, for that matter, a steam engine) would have.[8] But just as exciting as the stunning technological sophistication of the sawmill is the inscription of the tomb: "Marcus Aurelius Aurelianus Ammianus, citizen of Hierapolis, skillful as Daedalus in wheel-working made this [mechanism] with the skill of Daedalus."[9] This may be a far cry from James Watt's monument in St. Paul's Cathedral, whose engine bears an uncanny resemblance to Ammianus's mechanism. But Ammianus's sarcophagus clearly expressed a sentiment that was at odds with the agrarian ideology of senators like Cicero.[10]

Ammianus was not alone in applauding his own ingenuity and skill. Hundreds of, often expensive, marble reliefs from all over the empire praised wealthy businesspeople as merchants and artisans. Even the identification with the mythical master mechanic and inventor Daedalus was common. For instance, a painted shop sign in Pompeii showed the town's carpenters carrying a bier in a procession. On the bier, two boys are sawing wooden planks, right next to a statue of Daedalus.[11] Such processions show that craftsmen saw themselves as part of a community of coworkers, which is all the more remarkable since the Roman Empire knew no guilds but only voluntary associations (collegia).

Even those successful artisans and businesspeople who managed to win public office in their communities were proud to announce their roots in trade. Clearly, they felt that their commercial success was perfectly compatible with political status. For instance, the sculptor Quintus Lollius Alcamenes, who was elected councilor (decurio) and later mayor (duumvir) in his town, is shown on his tomb practicing his craft while sitting on the mayoral chair of a duumvir (figure 8).[12] There is little reason to believe that urban businesspeople in general cared all that much about the highly rhetorical literature of the senatorial aristocracy, which denounced their endeavors as sordid and unworthy of great men.

But Roman middle classes not only differed from imperial elites in their public self-fashioning. The interior of their houses and their family tombs show that they had also found their own forms of cultural expression, which were rooted in a class-specific set of values. These were remarkably similar to bourgeois hopes and family ideals as they emerged in early modern Europe from the seventeenth century onward. Not only public

self-fashioning but also Roman aristocrats' semiprivate family commemo-ration was, primarily, concerned with their political achievements and the glory of the distinguished clan they belonged to. By contrast, middle-class Romans typically emphasized familial love and affection when it came to decorating their houses and tombs. Funerary epigrams captured, some-times heartbreakingly, the pain caused by a loved one's death, while im-ages of myth were used to evoke feelings of loss and love.

Similarly, the standardized motifs of mythological wall painting, which had initially been created for Rome's philhellene upper classes, were often altered in middle-class houses to express the, in the modern English sense of the word, bourgeois values of the businessmen whose homes they adorned: while educated members of the Roman *nobilitas* had playfully used mythological wall painting in their villas to reference their cultural interests, members of the Roman middle classes often reinterpreted these images to suit more idiosyncratic representational interests. In some cases, generic images were made to express the particular values of those who had chosen them. For instance, in the so-called House of Lucretius Fronto in Pompeii (V 4a), the common erotic motif of Mars and Venus as adulter-ous lovers was transformed into the image of a respectable couple in the house's main reception room. And a circular vignette with the portrait of a young boy was used to express his family's aspirations for him. He was given Mercury's winged hat and herald's staff.[13] Clearly, this boy's family had no qualms about advertising their hope that he would make money, a hope that Rome's literary aristocracy found crass. For instance, in the *Satyrica,* the wool merchant Echion (who may have been a freedman) is ridiculed for confusing higher education with professional training. He wants his son to become a *causidicus,* or low-level barrister, because "there is bread in this." But this is not the type of education his interlocutor Agamemnon provides. Agamemnon is a professor of rhetoric, who trains young well-bred men to become orators, who do not take on a case as a job but as a favor *(beneficium)* for a friend or dependent.[14]

This is not to say that Rome's middle and upper classes lived in strictly separate worlds. As the fictional conversation between Agamemnon and Echion suggests, there was room for interaction, and it is plain that Ro-man middle-class and aristocratic lifeworlds overlapped considerably. The cultural differences that existed between them were gradual and

sometimes subtle, because Romans of all classes were subject to many of the same forces of broad cultural change. For instance, the commemoration of nuptial love became a feature of aristocratic self-fashioning around the same time that the middle classes picked up the theme, yet in slightly different form. And Roman aristocrats also hoped for great careers for their sons, but in public service, not in business. That said, it is important to stress that almost no forms of cultural expression were exclusive to one particular class. For instance, a very small number of senators commemorated lost loved ones through mythological sarcophagi while some middle-class artisans had their sarcophagi decorated with scenes from their work life, even within the intimacy of a private crypt. But on the whole, the patterns sketched out above hold overwhelmingly true, which is all one can hope for in social and cultural history.

Theorizing Middle Classes

The distinctive archaeological footprint of commercial middle classes all over the empire has led preeminent scholars like the historian Paul Veyne and the archaeologist Paul Zanker to argue that they were indeed a *plebs media* (Veyne) or middle class (Zanker) in a social and cultural sense.[15] While Zanker's use of the term "middle class" *(Mittelschicht)* has been criticized as anachronistic, Veyne's articles on the *plebs media* have been more favorably received, even though Veyne uses Zanker's work and comes to very similar conclusions.[16] The main reason for this difference in reception may be that an ancient term like *plebs media* is compatible with ancient ideologies (the *plebs* may come in gradations like *plebs media* and *plebs sordida,* but it still does not matter much), while the term "class" seems to inject modern ideology into the study of antiquity.

This issue is at the heart of the debate about whether we can use anachronistic conceptual tools in studying the past. As argued above, modern terms are necessary to get analytical traction on Roman social and cultural history, but this requires a clear definition of the ideas in question, especially if a concept like "middle classes" is at odds with ancient social thought.

Ancient literature does not explain society in terms of socioeconomic class. Greek and Roman writers thought of society primarily in terms of

legal status and social rank. Society was run by great men, and great men were defined by the reputation of their families and the public offices that they held. How they made their money was not much talked about, as long as they still owned land and their (often substantial) commercial activities were not too scandalous. When this aristocratic system of personal dignity and public honor clashed with the new social realities of the Roman Empire, for instance, when imperial freedmen outclassed senators in terms of political influence or when rich businessmen outclassed senatorial landowners in terms of wealth, ancient literature explained this as a symptom of moral failure or corruption.

Conceptualizing such developments as a mismatch between social rank and economic class, as we modern social historians might, would have required an equally modern understanding of society that categorizes people by their living conditions and what they do for a living, as opposed to a premodern view that stresses where people fit within a more or less clearly defined social hierarchy of status groups, for instance, the *ordo senatorius* or the *ordo equester*. And indeed, terms like *plebs media* in imperial Rome (or *mésoi* in fifth- and fourth-century-B.C.E. Athens) do not, or at least do not primarily, refer to the economic condition of a particular group of ordinary people but instead to their political and ultimately moral stature. As a result, ancient definitions of social groups, like slaves, freed, and freeborn, or *decuriones,* knights, and senators, do not overlap well with modern definitions of class. This is why Sir Moses Finley and his followers suggested that class is not a useful category in Roman history. And since class is, after all, a murky concept with a complicated and deeply ideological history, why not write about the lives, culture, and public role of the more affluent segments of the *plebs* rather than about Roman middle classes?

The key reason is that the orders and ranks of Roman society do not make good categories for social and cultural history. First, social terms were used very loosely in both Greek and Latin. For instance, the Latin *ordo* could refer to professional groups like clerical workers *(ordo scribarum)* and, at the same time, census-based classes like the equestrian order *(ordo equester),* which, since the early Empire, included all freeborn Romans whose net worth exceeded 400,000 sesterces.[17] Second, the census-based classes of Roman society, which linked social and legal standing to a minimum wealth requirement, were culturally and economically far too diverse

to make their classification within the Roman system of public honors and legal privileges a meaningful category of social or cultural inquiry.

For instance, knights were not just gentlemen farmers but included many wealthy businesspeople and rich financiers from a whole variety of social backgrounds: knights could be the sons of freed slaves like Horace, retired centurions-turned-bankers like Vespasian's father and grandfather, or large landowners of all stripes and vastly diverging wealth, members of old—and relatively poor—Roman families, recently enfranchised bouleutic elites in the Greek-speaking East, or pro-Roman chieftains in the recently conquered West. Of course, the equestrian order overlapped in large part with what we could label the Roman upper classes, but it is important to remember that the requirement of Roman citizenship excluded a significant number of foreigners and freedmen, who could outstrip Roman knights in terms of wealth and political influence. For instance, imperial freedmen with close personal ties to the emperor were often richer and more powerful than many senators, and had reason to hope that their sons would be knights.

Indeed, ancient categories and modern notions of social stratification only correspond well in the case of the (upper) political classes, that is, the senatorial order and the knights in the emperor's service, who had been granted the honor of a public horse *(equites equo publico)*. Though culturally distinct in a meaningful way, these two classes were far from socially monolithic and, in addition, very small: in an empire of somewhere between fifty and seventy million people, only a few hundred were senators and only a few thousand knights of the public horse.[18] Still, these groups have been at the heart of Roman social history, because almost all Latin literature was written by them. This is, of course, perfectly legitimate: functional elites almost always form a distinct cultural group and are an important object of study.[19] Yet it is important to stress that office holding lower down the social scale was not equally meaningful and does not allow us to define social groups below the level of the imperial aristocracy.

For instance, it makes little sense to see the order of town councillors *(ordo decurionum)*, the priests in the imperial cult *(Augustales)*, or members of *collegia* as social groups in their own right.[20] First, membership in these groups was not mutually exclusive: one could be a *decurio*, an *Augustalis*, and, for that matter, president of a *collegium* all at the same time. Second,

these groups were socially and culturally even more diverse than members of the wider equestrian order. It was a very different matter to be a *decurio* in a place like Padua or Cadiz, which boasted a population of 500 equestrian families, than in Pompeii or in the unknown town where a sculptor like Quintus Lollius Alcamenes became mayor. In such smaller towns, it is likely that a significant portion of the decurions were well-to-do artisans and businesspeople. Similarly, being an *Augustalis* differed from town to town, and also membership in *collegia* differed socially and culturally: belonging to a club of doctors or contractors meant something different than membership in a *collegium* of weigh masters or caulkers—a fact clearly reflected in the varying size and décor of their clubhouses *(scholae)*.[21]

This is not to say that these groups do not make good subjects of research. Studying the *decuriones* opens a window into the management of local affairs, just like research on the *Augustales* and *collegia* has uncovered important aspects of the imperial cult and patterns of self-organization and patronage among Roman businesspeople. But while membership in one or more of these groups was surely important in people's lives, it was not the sole, or maybe even primary, social or cultural feature. This also applies to two other groups that have been given special attention: freedmen and soldiers. Again, slavery and military service undoubtedly left deep personal marks, which translated in specific modes of—mostly funerary—commemoration. But, again, these groups are heterogeneous: imperial freedmen—at least those who acted as personal agents of the emperor—were arguably a class of their own, while less well-connected ex-slaves mingled freely with freeborn coworkers and neighbors in their cities and *collegia*. And soldiers, once retired, went on to live very different lives.

Of course, Roman law treated decurions, ex-slaves, and soldiers as distinct categories, but here Veyne rightly emphasized that "taking a society at its own word and understanding it as it sees itself [in terms of the status order] leads to ignoring certain economic, political and intellectual realities."[22] And because legal status is a poor indicator of living conditions and lifestyle, class is a highly useful tool to analyze social stratification and its cultural and political implications, as long as class is used as a concept that combines an analysis of economic conditions with an analysis of social status and cultural conditions.

The problem with the concept of class is that it has other uses too, which have scared off some classicists. Most prominently in Marxism, class can be rigidly defined by access to the means of production, like land and machines. Marx used this highly abstract model of class to explain the exploitation of workers within his labor theory of value. This theory operates with only two basic classes: workers and capitalists. The working classes have no access to the means of production. As a result, they cannot produce goods and services of their own. This forces them to sell their labor power to capitalists. In a fair world, capitalists would pay workers according to the value that they add in the production process, for instance, by turning yarn into garments on a mechanical loom. But the capitalists' control over the means of production, such as yarn and mechanical looms, allows them to exploit the workers: in Marx's model, most capitalists will pay workers just enough so that they have the means to regenerate their labor power. The remaining value that they have added in the production process (surplus value) goes to fill the capitalists' coffers.[23]

This system is not suited, never mind designed, as a tool for a detailed analysis of social stratification. But Finley, both unfairly and inaccurately, evoked exactly this model to discredit the use of class in ancient socio-economic history. He pointed out that, according to Marx, not only a slave and a free wage laborer but also a senator and the nonworking owner of a small pottery shop would belong to the same class.[24] But even if this interpretation were actually in line with the Marxist model, it would not be a reason to abandon class in ancient social history. Mainly in response to Marx's dichotomous class system, modern sociology has developed several nuanced class theories, which were known to Finley when he launched his attack on the use of class. Arguably, the most influential post-Marxist class theory is that of Max Weber, whom Finley, ironically, considered his main intellectual influence. Over the course of the last century, Weber's model of society has been refined and developed further. But Weber's own class concept is suitable and perfectly adequate for the study of antiquity.[25]

Weber explains society in terms of both class and "status group" *(Stand)*. Class is determined by economic opportunity while membership in a status group is defined by the social order. Class and status group are distinct categories, but the "status order" is strongly influenced by the "economic order" and in turn reacts upon it. This is why status group and class often overlap

empirically. For instance, a feudal aristocracy often constitutes much of the upper classes, as was the case in most of premodern Europe. Weber's main innovation over Marx is that class, or rather an individual's "class situation," is not defined by access to the means of production. Instead, it is defined by an individual's "market situation." This is the "typical probability of 1) procuring goods 2) gaining a position in life [and] 3) finding inner satisfaction." This probability "derives from the relative control over goods and skills and from their income-producing uses within a given economic order."[26] In a nutshell, Marx was interested in class to explain the exploitation of the poor, while Weber was interested in class to explain how chances of economic success influence social stratification under specific cultural conditions.

In Weber's model, people belong to the same class if their chances of economic success are roughly the same. These chances are in purely economic (and not in social) terms based either on property or on skills. Typologically, Weber distinguishes between "property classes" *(Besitzklassen)* and "commercial classes" *(Erwerbsklassen)*. These are again subdivided into upper, middle, and lower classes.[27] At the top of the social scale, property classes are rentiers who live off land, real estate, and trade monopolies. At the bottom of the scale, property classes are debtors and (free and unfree) peasants, whose economic chances are defined by their lack of property. Commercial classes range from entrepreneurs and sought-after professionals at the top to more or less skilled laborers at the bottom of the social scale. A synopsis of property and commercial classes allows for a taxonomy of "social classes," which are defined by shared living conditions within a horizontally stratified society.[28]

While Weber acknowledges that property and commercial classes always coexist, their relative significance changes over time, as does the significance of class vis-à-vis a status group. In societies that are dominated by commercial classes, economic class is the prevailing mode of social stratification. Conversely, in societies that are mostly made up of property classes, status group is the principle of social organization. "Depending on the prevailing mode of stratification," Weber then distinguishes between "status societies" and "class societies."[29]

So why is Weber's model useful for describing Roman society and Roman middle classes? Chiefly, it provides a scale for gauging the role of class within society. It does not force us to analyze Roman society in terms of

either class or status group, as Finley and his followers suggest. Instead, it opens up the possibility of discussing the importance of economic opportunity and living conditions vis-à-vis the role of social orders or, in Weber's terms, status groups.

Weber himself, who started out as a classicist, saw ancient Greece and Rome as status societies. This is easily explained by his reliance on ancient literature. But when we look at the archaeological evidence from the Roman world, a radically different picture emerges: the cities of the empire were increasingly shaped by commercial classes, whose economic and social prospects depended on specialized production and trade and not primarily on their position within a status group such as a medieval guild. Their living conditions across a vast geographic area came to resemble each other so closely that they have all the attributes of social middle or, in Weber's own terms, bourgeois classes. This model of class as a combination of economic, social, and cultural features informs the methodological approach of this book.

Historical Method and Archaeological Hermeneutics

In its Weberian use of class, the argument presented here deviates from the current scholarly focus with respect to Roman economic and cultural history. First, it looks at the Roman economy not in terms of overall economic development or growth, but in terms of economic opportunities for Romans of all classes. Second, it does not take Roman material culture and art primarily as a means of social distinction, nor does it attempt to reconstruct ancient viewing experiences in any detail.[30] Instead, the book uses the visual culture of the Roman middle classes as a historical source to reconstruct class-specific social values and lifestyles, which transcended the individual.

Due to the fragmentation of the field of classics, some readers may wonder how the economic underpinnings of ancient cities can be meaningfully connected to the archaeology of tombs and domestic décor. But, as the book argues, the archaeology of urban business and urban art complement each other in telling the story of how the ancient world as a whole transformed into a remarkably cosmopolitan and urban place, which provided not only political elites but also commercial middle classes a lifestyle

that was better than that of most Europeans until the nineteenth century. This argument draws on Weber's use of class as a gauge of economic opportunity.

From the early second century B.C.E. onward, urban commercial classes began to flourish all over the ancient world, and cities transformed from "agrotowns" with limited markets into vibrant commercial centers. By the time of Nero, a shoemaker like Vatinius could hold office in Beneventum and give games that caught the emperor's attention. And a man like Vespasian, who was the son and grandson of centurions-turned-bankers, could have a successful senatorial career and be entrusted with the command of a large army, which, ultimately, allowed him to claim the purple for himself.

Such life stories are not easily reconciled with the idea of a status society, as Weber himself experienced it in his own lifetime. In pre–World War I Germany and elsewhere in Europe, the highest levels of government and the military were still the domain of hereditary aristocrats, whose families were centuries old and who kept a social distance from commoners. Lower down the social scale, the institutional barriers of Europe's status societies, for instance guild monopolies and serfdom, were still in living memory. By contrast, in the time of Nero, most senators did not come from old families. As a matter of fact, a surprisingly large number of them were descendants of former slaves.[31] And, as we shall see, there were no institutional barriers to changing professions, even in the specialized urban labor market. This would have been unthinkable in most of Europe before the 1800s.

Of course, social status and status groups did play a role in Roman society, influencing economic opportunities. For instance, freedmen were banned from holding public office, and those who belonged to the "aristocracy" of office holders not only enjoyed very real legal privileges but were also banned from practicing certain professions. Yet, remarkably, so many successful freedmen financially qualified for and were eager to hold public office that there was the need for a new system of purely honorific positions to accommodate them. And some senators showed entrepreneurial initiative when their agricultural and urban rents did not produce enough income. For instance, Vespasian started a mule-breeding business after he fell on hard times.

All this evidence is, of course, anecdotal. And it is perfectly legitimate to ask whether, for instance, Suetonius's life of Vespasian is an accurate guide to Roman social and economic history when there is other literary evidence to contradict it. Indeed, ancient literature alone is not of much help in understanding the role of class in Roman society, simply because most ancient writers cared little about the lives of ordinary Romans and were not interested in what we might call sociology. But 200 years of archaeological research have provided us with good data on the socioeconomic conditions and lifeworlds of ordinary Romans, which is why this book is, primarily, an archaeological reconstruction of the Roman middle classes.

This requires using archaeological evidence in a way that Finley and other like-minded classicists did not envision. To them, archaeology was ill suited to uncover social structures or broad cultural trends.[32] But I hope to show that the reverse is true. Archaeology is primarily useful in detecting large-scale patterns that change over time. And it is changing patterns of urban commerce and nonelite lifestyles that allow us to reconstruct the rise of the Roman middle class as a social class. These patterns are discussed in the four following chapters of this book.

Chapter 2 charts the socioeconomic transformation of Mediterranean cities in the last three centuries B.C.E. These changing Roman cityscapes provide us with good evidence for the existence of middle classes, in an economic sense. By the time of Alexander the Great, most cities in Greece and Italy were akin to medieval and early modern agrotowns: most households owned a house in the city and at least some land. This allowed them to produce food and many basic goods in-house. By the time of Augustus, most urban households no longer owned land. Indeed, the proportion of households living in rented accommodations ranged between 50 and 90 percent, depending on city size. These households depended on urban markets and a specialized urban industry for food and other basic goods and services.

Rental apartments were not shabby tenements. They came in varying sizes and can be mapped along a continuous spectrum of domestic comfort. In country towns like Pompeii, there were also smaller houses, which were owned by businesspeople with a mixed economic portfolio. They combined income from urban (and maybe agricultural) rents with that from their main business. These apartments and smaller houses coexisted

with the—often palatial—dwellings of local landowning elites. This reflects a remarkable socioeconomic stratification among households that defies the common notion of Roman society as a bipartite system, which only knew the rich, their dependents, and the poor.

As an intermediary result, Roman cityscapes provide us with good evidence for the existence of middle classes, at least in an economic sense. But this is not necessarily evidence for middle classes more generally speaking. As discussed above, economic middle classes can only be considered middle classes, properly speaking, if they share economic opportunities and cultural traits. And here it becomes important to know whether the tenants of medium-sized houses and apartments were rent-seeking property owners or were actively involved in the urban economy as a clearly identifiable social group. If they were rentiers, they would not fill the bill of a commercial class, but if they had active business interests, they could qualify as an urban middle class.

While the economic life of individual houses and apartments is almost impossible to reconstruct, changing patterns in the commercial infrastructure of Roman cities show the dramatically increased role of urban production and interregional commerce. Nowadays, most economic historians studying the ancient world are happy to concede that towns served as a center of production, which catered to the aggregate demand of peasants and small farmers who lived in the surrounding countryside, and not just to the demands of wealthy landholding citizens, who lived in the cities themselves. This model fits the world of Mediterranean cities around the time of Alexander the Great. Even at this time, though, there is ample evidence for at least some long-distance trade in manufactured goods. Still, the *agorai* of most Greek cities were, primarily, temporary markets. These mattered most to peasants and small farmers who came to town on market days. And indeed, permanent shops, which require abundant walk-in customers to make good economic sense, seem to have been a rarity outside Athens and perhaps a few other big cities. This lack in urban demand is probably why the workshops of most craftsmen before the third century B.C.E. were embedded in relatively large households, which still baked their own bread, cooked their own meals, and wove their own cloth.

It is striking that these patterns of production and retail almost completely disappeared in the last three centuries B.C.E. Throughout the

ancient world, streets came to be lined by hundreds if not thousands of shops. These were rented, or more rarely sold, to artisans and retail merchants. In a small city like Pompeii there were 600 shops and only 400 houses. Those who rented these shops lived in either a back room or on a mezzanine floor above their business. Successful artisans presumably rented apartments elsewhere or owned small houses. From an economic perspective, we have what could be a middle class. But I have argued that, economically, middle classes can only be considered middle classes, properly speaking, if they share cultural traits as well as economic opportunities.

Were these urban businessmen middle class in the sense that they constituted clearly identifiable social groups? In Chapter 3, I begin to argue that they were, using the evidence provided by the way they shaped the character of cities. These middle classes began to play an important role in city life.

By the time of Augustus, almost all cities in the Roman Empire were commercial in character. All major urban streets were now lined by permanent shops. And voluntary associations of businesspeople began to assert themselves as a group by constructing conspicuous clubhouses and temples, just like local elites in previous centuries. This presence of shopkeepers and the strength of their associations attest to a profound change in the urban economy all across the empire. And this change helps explain the conditions under which middle classes could come into existence.

Strikingly, not only large cities were shaped by a shopkeeper economy. Even at the periphery of the Roman Empire, for instance, in Roman Britain, streets in rather small cities were lined by shops. Yet the shopkeeper economy of Roman cities was far from uniform. Instead, it followed local patterns. In the newly founded cities of the northwestern provinces, elongated shop-houses were common. Conversely, in the formerly agrarian cities of the Mediterranean basin, commercial space was created by walling off shops from already existing houses. In the wealthy cities of the Greek East, such shops were given a façade of columns facing the street. This resulted in colonnaded streets, which were called *plateiai*. Eventually, the term *plateia* replaced *agora* as the word for the heart of town. In the Arab world, *plateiai* became the *suq* or bazaar, and in some cities like Damascus the Roman *plateia* still functions as the city's main marketplace.

So how could these urban bazaars be economically sustainable and how did they come to supersede the *fora* and *agorai* of the Greco-Roman

world in terms of public significance? The answer cannot have been a rise in local demand alone, at least not outside ancient megacities like Rome and Carthage in the West or Antioch and Alexandria in the East, which had several hundred thousand, and in the case of Rome almost certainly over a million, inhabitants. Sure enough, the landless artisan-tenants now had to buy food and cloth from others, just as they had to pay for visits to the bath, the barber, and the brothel. But such goods and services were not the engine of the shopkeeper economy. It rather seems that a significant proportion of urban artisans mass-produced highly specialized items, which were, in part, intended to be sold to walk-in customers, but which were primarily made for wholesale merchants. Under the model proposed here, wholesale merchants would have distributed such specialized goods across a large geographic area. Whether or not we see the Roman Empire as one integrated market, it is quite evident that the size of the Roman market (or markets) allowed for a far greater degree of craft specialization than before, and for a very long time after.

From an archaeological perspective, a model based on specialized production that was facilitated by interregional trade networks would explain why so many goods made in one workshop traveled so far afield. And it would also explain how even small cities all over the Roman world could support as many shops and workshops as they did.

The sheer number of workshops and associated businesses shows that there was economic opportunity for artisans and traders who shared the same market situation in Weberian terms: they depended on their skill and their sales and not on working their own land or that of others. But did they form a culturally distinct group? In this context, the voluntary associations of the ancient world *(collegia)* are important. As Finley pointed out, there were no trade guilds in antiquity, which he believed to be a symptom of economic underdevelopment.[33] But the reverse is true. Guilds were an impediment to economic development, because they strictly controlled market access. By contrast, there were almost no legal barriers to changing professions in the Roman world, as Egyptian papyri and Pompeian graffiti demonstrate.

This means that whatever voluntary business associations did to improve the economic prospects of their members was not legally enforceable. Instead, *collegia* could enforce their charters through strict social control. This social control was possible because *collegiati* celebrated common

religious festivals and their members' important family milestones to-
gether. Many *collegia* even arranged burials. The desire of artisans and
traders to form voluntary associations shows that they saw themselves as
members of a social group, which is one good argument for calling them
middle classes. But there is also good evidence for a distinct middle-class
culture, which is the subject of Chapters 4 and 5.

Roman artisans and merchants broadcast their achievements on their
tombs. This is important because it demonstrates that businesspeople felt
that their commercial success was just as praiseworthy as the achievements
of political elites. While *collegia* shaped the public image of middle-class
artisans and merchants as a social group, the decoration of their private
tombs provides an insight into the norms and values shared by individual
members of the middle classes. These norms and values are the subject of
Chapter 4, which deals with middle-class tombs.

The images and inscriptions on the façades of middle-class tombs praised
hard work, commercial success, and, occasionally, technical ingenuity. But
far more interesting than this public image is the decor of middle-class
crypts, which were only accessible to a very limited audience. Here, com-
mercial success was only rarely a subject, at least on sarcophagi, which
form the bulk of our visual evidence. Instead, images of Greek myth were
used to express the grief and horror caused by a loved one's death and the
enduring love of those left behind. This highly emotional tone reflects a
new ideal of love and affection within the core family, both between hus-
bands and wives and between parents and children.

So far, this cultural shift has been primarily explained in terms of elite
lifestyles. In particular, the use of Greek myth is often explained as the
display of cultural capital, along the lines of Pierre Bourdieu's theory of
social distinction. But I hope to show that this is wrong. Mythological
sarcophagi were (almost) exclusively produced for middle-class buyers
who used Greek myth in a specific way. Myth provided a common reper-
toire of stories that, according to a famous epitaph, could be used loosely as
"mighty comparisons in little matters." This high-pitched way of remem-
bering the dead did not square well with aristocratic sensibilities. Roman
senators preferred to commemorate their deceased family members for
traditional virtues like chastity and diligence, which points to a real cul-
tural difference between Roman upper and middle classes.

Similar differences can be detected in the houses of the living, which are the subject of Chapter 5. As mentioned above, educated Roman elites used images of myth to reference their cultural interests, while Roman middle classes—who were perfectly aware of the underlying myths and occasionally even some of its literary representations—used them in more playful and idiosyncratic ways. In the face of the evidence, the claim that Romans lower down the social scale just copied fashions that they had seen in the houses of the rich is hard to sustain. Again it seems that elite and middle-class lifestyles were, for all their apparent similarities, qualitatively and saliently different. And it is with these qualitative differences overall that this book is concerned.

As any classicist knows, it is very difficult, or perhaps impossible, to quantify anything with certainty when it comes to studying the ancient world. This is why I make no attempt to quantify the Roman middle classes. The most recent—and very conservative—estimate of "middling classes" puts them between 6 and 12 percent of the Roman Empire's over-all population.[34] While we cannot know with any certainty how accurate this might be, it is of little concern for the argument presented here. The main claim is that the Roman Empire did generate a sizeable middle class and a middle-class culture, and it is this middle class that generated the bulk of the archaeological evidence from Roman cities.

2

In Search of Ancient Middle Classes

An Archaeology of Middle Classes in Urban Life, 100 B.C.E.–250 C.E.

Ancient economic and social history suffers from a lack of hard statistical data. We know that ancient governments kept detailed census and tax records. But these documents were almost exclusively written on perishable materials and are, with a few exceptions, now lost to us. Unless we want to write Greco-Roman economic and social history exclusively in terms of ancient political thought, we must turn to nontextual data. Here, the organization of ancient cityscapes provides us with a macroscopic picture of social stratification and economic life. In particular, the economic transformation of households and the evolution of commercial infrastructure in the last three centuries B.C.E. clearly point to changing patterns of urban life. And these changing patterns can be translated into class analysis.

As this chapter argues, the size of commercial classes increased in the last three centuries B.C.E. Not only were there more artisans and merchants; the new structure of ancient cities also points to high social mobility among these commercial classes. This translated into a broad spectrum of domestic wealth. In the last century B.C.E., house sizes can be mapped on an almost continuous scale, and the same applies to domestic comfort:

elegant wall painting, well-made furniture, and high-quality household items were a feature of almost all houses. How the commercial classes who owned these properties can be conceptualized as a social class is discussed in Chapter 3. But this chapter is concerned with how the rise of a multilayered society that stood economically between the rich and the poor can be detected in the archaeological record.

The concept of a multilayered urban society differs from most current accounts of ancient city life. As those are mostly rooted in ancient literature, they reflect the concerns of literary elites. Before we turn to the archaeological visibility of middle commercial classes, these views must be reviewed briefly to explain why ancient middle classes could remain hidden in plain sight for so long and why categories of ancient social thought are inadequate to explain ancient urban life.

Why Ancient Categories Cannot Explain
Ancient Urban Life

Greco-Roman writers in the first century B.C.E. and the imperial period liked to complain about the spread of luxury (*tryphé* and *luxuria*). In their view, the display of wealth by those lower down the social scale subverted the status order. This reflected the widespread assumption that social stratification and wealth distribution were not a matter of economics but of morality.[1] In this vein, Andrew Wallace-Hadrill has argued that the ancient debates on luxury provide the key to a Greco-Roman understanding of urban life in the last two centuries B.C.E.[2] Because the elites on top of the rank-based pyramid abhorred the use of their status symbols by those lower down the social scale, Wallace-Hadrill gives a political explanation for the new economic realities. On his view, we are not primarily dealing with a display of newly won prosperity but, instead, with the aspirational use of aristocratic culture, along the lines of Pierre Bourdieu's concept of social distinction:[3] "subelites" supposedly imitated elite lifestyles in order to set themselves apart from the even less fortunate.

Wallace-Hadrill argues that it was mainly political upheaval that brought about this seismic social change. He identifies Rome's imperial expansion and the Social War of 91–88 B.C.E. as important forces of social development.[4] But he does not explain how subelites could afford their

new "status symbols." This is why economics is essential here. Political change undoubtedly affected the identity politics of Rome's literary elites. But it was not only the lives of the elites that were transformed in the last two centuries B.C.E.

In the first century B.C.E., commercial classes came to enjoy remarkable prosperity, which allowed for new forms of cultural expression. There are only a few hints in ancient literature that these were perceived as a middle segment of society. Conceptually, fifth- and fourth-century Greek writers like Euripides and Aristotle already thought that there were *mésoi* in the middle of society.[5] And Latin writers occasionally referred to a *plebs media*. But ancient literature, and with it much of modern scholarship, only draws a line between rich and poor, not least because the *mésoi* and the *plebs media* are notoriously hard to define.[6]

This disinterest in middle classes, or even worse a dichotomous system of rich and poor, is at odds with the archaeological record. At least in the period under discussion, the archaeological footprint of "ordinary Romans" is far greater than that of their betters. Also from an archaeological viewpoint, many *pauperes* were not poor in relation to most of their fellow citizens or even the local aristocracy of councilmen. Social boundaries, as defined by status and rank, were permeable, and social mobility pervasive.[7] As ancient categories of social stratification are clearly inadequate to explain the socioeconomic realities of ancient city life, class emerges as the analytical tool of choice, and not just in a descriptive sense. If we use Weber's definition of class as a gauge of economic opportunity, we can explain how ancient cities became socially and economically diverse and why social mobility was a fact of life.

Archaeological evidence suggests that this social mobility was made possible not only through inheritances and dowries, as is well attested in Roman literature, but also through economic success in the urban economy.[8] A broad class of city dwellers prospered but was, at the same time, in an economically insecure position. They faced the possibility of downward as well as upward social mobility. This, in purely economic terms, is the primary definition of a middle class.

In what follows, I argue that the rise of commercial cityscapes from 300 B.C.E. onward allowed for a decent living outside agriculture. This is so despite the fact that, in terms of gross domestic product (GDP), agricul-

ture may have remained the main area of economic activity.[9] My argument rests on evidence from a series of recent and detailed studies on ancient housing, which address questions of household economy and urban ecology. Luuk de Ligt has already pointed out that the rural houses in the *villes morts* of the Syrian limestone massif can be mapped on a broad continuum between lavish villas and ramshackle farms.[10] In this study, I focus on new work in urban housing.[11]

Most of these studies are concerned with Greek cities of the fourth century B.C.E. and the Campanian cities around Mount Vesuvius, which were destroyed in 79 C.E. So far, the differences between these two sets of cities have been explained mostly in terms of culture and politics. But I argue that their differences are primarily due to dramatic socioeconomic change in the period between 300 B.C.E. and 100 C.E. This is not to ignore real cultural differences, but it seems that Greek and Italian cities came to look very much alike from around 200 B.C.E. onward, and this is striking.

A look at emerging commercial cities of this period shows the rise of commercial classes, who eventually came to shape a new urban life. The enormous shift in ancient urbanism in the last three centuries B.C.E. is best illustrated by contrasting a fourth-century-B.C.E. Greek town with a fully matured commercial city of the first century C.E. Ideally, this would be the same place, but at the current state of research, Olynthus and Pompeii are the best candidates for such a comparison. From there, I chart the rise of commercial cityscapes and then return to Pompeii for a socioeconomic survey of a commercial town, which allows for an archaeological definition of middle and ultimately social middle classes.

A Tale of Two Cities: Olynthus and Pompeii

The comparison between Olynthus and Pompeii is a common one, but scholars tend to focus on differences between the Greek and Roman worlds. This is legitimate as long as there is an explicit acknowledgment that these cities also belong to two different periods in economic development. Like fourth-century-B.C.E. Pompeii, fourth-century-B.C.E. Olynthus was an agrotown with limited markets, little craft specialization, and few service industries. By contrast, first-century-C.E. Pompeii was a town with a fully

monetized and highly diversified urban economy. This change allowed for the rise of middle commercial classes, who could profit from the new economic opportunities provided by the new commercial cityscape.

Olynthus and Pompeii, the cities in question, stand for us as archetypes of Greek and Roman urbanism. Both cities provide good evidence for studying domestic architecture because they were not gradually abandoned, but suddenly destroyed. Olynthus was sacked and razed in 348 B.C.E. by Philip II of Macedon. Pompeii was destroyed when Mount Vesuvius violently erupted in 79 C.E. On the whole, the houses and their inventories were left intact—the Macedonians and the refugees from the eruption removed only a few valuable items and ignored the rest. While Pompeii is uniquely well preserved, Olynthus was initially excavated to higher standards and presents our best evidence for ancient urban life in either Greece or Italy. A comparison between Olynthus and Pompeii shows how far urban life developed between the end of the classical period and the rise of the Roman Empire. To date, scholars have primarily focused on political and cultural shifts.[12] And indeed, Olynthus and Pompeii illustrate well-known divides between fourth-century-B.C.E. Greek and first-century-B.C.E. and C.E. Roman culture.[13] But fundamental economic differences between these two cities are at least as interesting. These were not a matter of different sociopolitical choices but a reflection of a fundamental change across time in the makeup of households and household production.

These changes reflect the transformation of the ancient economy at large.[14] Economic and social diversification led to a greater flow of goods, services, and money between economic units.[15] Households in Pompeii, but not in Olynthus, had markedly different shapes and sizes. Houses and households in Olynthus conformed to a set pattern and did not dramatically differ from one another in size, comfort, decor, social distinction, or economic sophistication. This also seems to have been the case in fourth-century-B.C.E. Pompeii, to the extent that we can reconstruct urban life in this period.[16]

In Greece, this uniformity has been cast as an issue of town planning. The lower city of Olynthus follows a regular grid. In many such Greek cities of its time, the houses in each block are of similar size and design. Wolfram Hoepfner and Ernst-Ludwig Schwandner have tried to concep-

tualize these similarities by arguing that architects developed a *Typenhaus* (standard-house) as the basic building block in planning cities for an egalitarian and democratic citizenry. They linked this philosophy of town planning to Hippodamus of Miletus, whom Aristotle mentions as an architectural and political theoretician.[17]

This narrative has drawn much criticism. Historians have criticized Hoepfner and Schwandner for unduly idealizing Greek democratic society.[18] Archaeologists have pointed out that the evidence is more complex: houses in Olynthus, and elsewhere, do vary in size and décor to a degree, and the wealthy seem to have quickly enlarged their own properties by buying up sections of neighboring houses.[19] Still, in comparison with postclassical cities, the homogeneity of domestic architecture in cities like Olynthus, Kassope, and Priene remains striking.[20] And while civic ideology probably played some role, the key distinction between these and later cities turned on socioeconomic underpinnings that, as I argue later, provide evidence for commercial middle classes.

In his *Household and City Organization at Olynthus,* Nick Cahill has suggested that the domestic outfitting found in nearly every house reflects an individual household, and that each of these was highly self-sufficient in that it could produce many essentials of life. Looms, found almost everywhere, could supply the household with cloth.[21] Small stone mills were common and could supply flour for bread.[22] Such household-based production persisted on a significant scale even when more specialized workshops and shops were integrated into the houses.[23] There is no doubt that in comparison with earlier Greek cities, Olynthus shows a high degree of economic sophistication and market-oriented production.[24] There is even evidence for the letting of individual rooms as shops if they faced a major road, especially near the *agora*.[25] But Olynthus remained an agrarian town. Most households show no traces of commercially oriented industry or trade. They almost certainly relied for supplies and income on the produce from a piece of land in the thickly settled countryside around the city.[26]

Pompeii offers a striking contrast. It lay amid rich agricultural land, but its cityscape reflects different economic ties and imperatives. When Pompeii was destroyed in 79 C.E., it was not a city of picturesque single-family homes like Olynthus. Nearly all houses were of irregular shape

and differed considerably in size and comfort. But most importantly, multiple households lived on almost every property. Pompeian landlords frequently blocked off doors and closed off walls to create autonomous shops and apartments. The apartments were mostly located on the second floors and had their own entrances from the street (figure 1).[27] We know from wall-painted rental notices and other literary and legal texts that most shops and all upper-story apartments *(cenacula)* were rentals. Felix Pirson, who surveyed the houses of Pompeii and Herculaneum, concluded that up to 42 percent of all households in

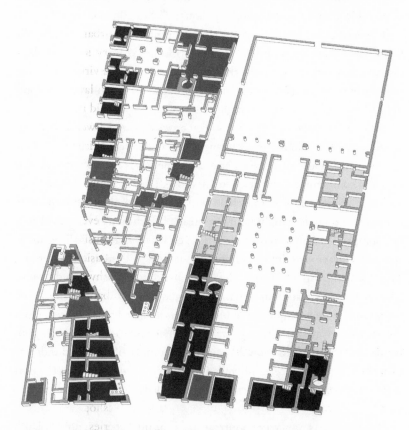

FIGURE 1. Insula Arriana Polliana (VI 6) and adjacent *insulae* (VI 3 and 4). Independent commercial units for rent are shaded in dark gray. Residential rental units (including external staircases) are shaded in light gray, commercial units belonging to larger houses in medium gray.

Pompeii, and 53 percent in neighboring Herculaneum, lived in rented accommodation.[28]

These accommodations showed great variety. The smallest and most common rentals were *tabernae,* one- or two-room commercial outlets with a single-fronted façade and a mezzanine floor *(pergula)* that served as living or storage space; the largest were elegant multiroom apartments on the second floors *(cenacula equestria).* It seems that about half of all Pompeian households lived by renting space in or over someone else's property. This is remarkable, for neither Pompeii nor Herculaneum were major cities. In Rome's cosmopolitan port city of Ostia, rentals made up over 90 percent of available housing units.[29]

It is significant for our understanding of ancient urbanism that so many Pompeians had to pay rent. By the second century B.C.E., literary references to rent dramatically increase, whereas they are virtually absent from earlier authors. There is also a large body of Roman law regulating rent. From these sources, we know that rents had to be paid in cash, typically for six months in advance.[30] In Rome, these rents were high and could earn a landlord several million sesterces a year.[31] This implies that city dwellers must have had access to considerable amounts of cash, and in turn that they must have had an income in coin. Also, many necessities of life had to be bought in coin. Noncommercial and self-supporting household production as in Olynthus seems absent from rentals and even most large houses in Pompeii.[32] Instead, we see highly specialized businesses in the commercial landscape of the city, which catered to the basic needs of all its inhabitants, and not just to the demands of the wealthy landed elites, who are typically identified as the main consumers of urban production.[33] Bakeries, taverns, and fulleries primarily catered to the needs of less wealthy Pompeians, whose households could no longer provide them with bread, regular cooked meals, and clothing.[34] This new urban economy had major social ramifications.

Whereas in Olynthus most households seem to have baked their own bread, Pompeii boasts no less than seven small bakeshops—probably patisseries—and twenty-two large bakeries. These bakeries required major capital investment and attest to a high degree of division of labor. There was usually a kneading, a baking, and a milling room. The milling rooms were equipped with large, mostly donkey-powered stone mills.[35]

Bakers' bills on Egyptian papyri show that the maintenance and opera-
tion costs of large bakeries were high.[36] Still, the bakers and their depen-
dents made a good living. This could be partly attributed to the heavy
regulation of the grain market,[37] but there is more evidence for the out-
sourcing of baking and cooking, especially among the lower social strata
of Pompeii.

There were at least a hundred small bars (so-called *tabernae, popinae,
thermopolia*) on the streets of Pompeii, which also sold food and provided
less wealthy Pompeians with a space to socialize.[38] This is an aspect of
both economic and social diversification. Respectable Pompeians enter-
tained their friends at home in large and well-decorated reception rooms,
just as the Chalkidians of Olynthus had done in their *androanes* 400 years
earlier. Unlike Olynthus, where almost every house had a purpose-built
andron, certainly none of the Pompeian *tabernae,* and not all multiroom
apartments, included a room suitable for entertaining guests. A person who
lived in cramped conditions had to turn to a tavern to dine, drink, and
meet with friends. Such bars were profitable, despite the low social status
and modest means of their clientele. The ill repute of these taverns did not
stop the owners of some of the largest and richest houses in Pompeii from
opening a *popina* right next to the main entrance of their houses, or from
making the locale accessible from their *atria.*

This spatial, economic, and social diversification within an individual
house could be taken one step further by transforming an entire *domus*
into an industrial complex. In these cases, the owner of the house and the
workers went to live elsewhere. In preindustrial societies, spatial separa-
tion between working and living is unusual. Before the third century
B.C.E., it is almost completely absent from Greco-Roman urbanism. In
Pompeii, the archaeologically most visible industrial complexes are fuller-
ies. Entire *atrium* houses were transformed into fulleries by the installa-
tion of vats, treading stalls, and cloth presses. The size (and sometimes the
decor) of these establishments is remarkable and attests to a lucrative com-
mercial industry and service.[39] Fullers both processed raw wool and cleaned
dirty clothes. A key detergent was urine, which made fulleries unpleasant
both to work in and to live near. Nevertheless, there was no attempt to
concentrate fulleries in one part of Pompeii. The decision to transform a
house into a fullery seems to have been left to the owner.

Because of their high archaeological visibility, fulleries once played an important part in the debate on the nature of the ancient economy.[40] From the broad perspective of urban ecology, questions of ownership, labor organization, and investment strategies are not essential. What matters here is that, as in the case of taverns and bars, many households outsourced basic services. There is little evidence for such businesses staying in one location over an extended period of time in an essentially ever-changing commercial cityscape. Perhaps service businesses were particularly susceptible to fluctuating demand.[41] In any case, the economy of Pompeii had highly specialized elements in a transient urban framework, which played host, at one and the same time, to extreme social inequality and notable social mobility. Against this backdrop, Petronius's *Satyrica* is instructive. As an aristocratic social satire, it mocks well-bred but penniless intellectuals, and wealthy but boorish nouveaux riches. Naturally, it does not purport to present an accurate picture of Roman society. But its trenchant ridicule of would-be aristocratic life does overlap surprisingly well with the archaeological record sketched above.

Changing commercial fortunes are an important conversation topic among the bumbling freedmen attending *Trimalchio's Dinner*, the best-known part of the *Satyrica*. Interestingly, Trimalchio and his nouveaux riches guests measure their commercial success against a gamut of housing options. This puts flesh on the rich archaeological evidence for socially diverse city living, and also for the ever-changing spatial reorganization of Roman houses. For the most part, according to Trimalchio, anyone born to the mezzanine over a shop *(natus in pergula)* could scarcely dream of owning a house *(aedes)*.[42] This makes the achievement of the former slaves at his dinner party all the more remarkable. Apartments on the second floor *(cenacula)* are a step up from *tabernae*, but the ultimate mark of success is to become a landlord oneself. One freedman guest has proudly put up an "advertisement next to his hovel *(casa)*: 'C. Pompeius Diogenes lets a *cenaculum* from the first of July, having himself bought a *domus*.'"[43] The greatest *domus* of the narrative is, of course, Trimalchio's own exuberant townhouse, which comically apes the dwellings of the sociopolitical elite. Interestingly, it grows piecemeal, absorbing neighboring houses and businesses: originally not more than a shack *(casula)*, it transforms into a mansion with two marble-colonnaded courtyards, four *triclinia*, twenty *cubicula*, an

upstairs dining hall *(cenatio)*, a boudoir *(sessorium)* for his wife, an excellent porter's lodge, and many guest rooms.[44] It has a private bath in what used to be a bakery.[45] Of course, Trimalchio is a caricature and his house is a literary fiction. But the description is consistent with early imperial domestic architecture. Large houses in Campania and elsewhere often grew like a honeycomb, as Trimalchio would say.[46] Even the transformation of a bakery into a private bath is attested archaeologically in Pompeii. This made sense because the furnace could be reused for heating the bath, a feature Trimalchio naturally boasts about: "It gets as hot as an oven."[47]

Trimalchio's house is as unusual as are his career and his wealth. As the *puer dilectus* of his former master (and a sometime consort of the master's mistress), he inherits a fortune, which allows him to invest millions into high-risk shipping. After accumulating enormous wealth, he buys land and aspires to the elegant lifestyle of the landed aristocracy.[48] The other guests are not quite as well off, but this makes them all the more interesting. Trimalchio's best friend, Habinnas, is a mason *(lapidarius)* "who has a reputation for making excellent monuments."[49] His business earns him enough to buy his wife fine gold jewelry and allows him to serve as a priest in the imperial cult. This circumstance allows him to keep lictors in his large entourage, and he initially comes across as a *praetor* to the narrator of the *Satyrica*. The freedman C. Iulius Proculus, an ex-millionaire, has fallen upon hard times, but when his business as a mortician *(libitinarius)* still flourished, he used to "eat like a king."[50]

It is important for our understanding of Roman urbanism that Trimalchio's guests are identified by their (mostly demeaning) urban occupations, even though their low-status businesses allow at least one of them to own property in the countryside. The wool worker *(centonarius)*, Echion, invites the rhetoric professor, Agamemnon, to his small villa in a friendly but interested gesture.[51] Echion is concerned about his sons' education and wants to be on good terms with the city's most celebrated educator. Tellingly, he values education only economically, as a hedge against changing business fortunes. In Petronius, Echion is, of course, a boor who confuses professional training with higher education. But his utilitarian—and for cultured ears outrageous—understanding of education is characteristic of the concerns of urban middle classes: his older son is to practice law, but

not like an aristocratic orator who offers his services as a *beneficium* or strives for political or literary fame. To Echion, law is about making money *(habet haec res panem),* which, as a profession, is at least not categorically different from other trades the boy might take up if he were to abandon jurisprudence: "I mean to learn him a trade, as a barber, or an auctioneer, or at least a barrister *(causidicus).* None but Orcus can take that away from him."[52] Obviously, a villa and a well-off father are no guarantee of financial security. Echion's concerns suggest that the children of well-heeled urban businessmen had to work for a living and could not live off their estate.

Naturally, there can be no proof that all Pompeian businessmen thought like the fictional Echion, or that its monumental masons and morticians were budding millionaires. From their archaeological footprint, it is impossible to say how closely the businessmen who worked and lived in the shops, apartments, and houses of Pompeii mirrored the freedmen of the *Satyrica.* Petronius provides anecdotal evidence, but this remains a precious source and engages contemporary social realities. Archaeology alone cannot recover the social, legal, and political status of the individuals who lived in the houses of Pompeii. What archaeology can do is to reconstruct large-scale socioeconomic patterns, which in turn suggest the emergence of a socially mobile society, below the level of the socioeconomic elite. The comparison between Olynthus and Pompeii shows that the cityscape of first-century-C.E. Pompeii was socially more diverse and economically more specialized than that of fourth-century-B.C.E. Olynthus.

It is important that both towns were by no means exceptional in their own time. Many cities of the fifth and fourth centuries B.C.E. had a distinct agrarian character while later cities across the Mediterranean were characterized by a highly specialized and transient commercial cityscape. Landlords frequently squeezed as much revenue out of their properties as possible. They created apartments and shops for rent, which provided merchants and artisans with business and living space. We may not be able to identify these tenants as we would like, but we have now enough evidence to establish the existence of well-heeled propertied classes beneath the local aristocracy. With the evolution of commercial cityscapes, economic diversification allowed for acquiring fortunes in addition to, and possibly in combination with, agriculture. The evolution of such

commercial cityscapes attests to a new type of urban life from the Hellenistic period onward.

The Evolution of Commercial Cityscapes

In 79 C.E., the streets of Pompeii were lined with almost 600 *tabernae*. This is an impressive number, because the city contained only about 400 houses with an *atrium* or other small circulation area *(medianum)*. Pirson identified 416 autonomous *tabernae* that could have been leased or privately owned.[53] To date, well over 800 *tabernae* have been excavated in second-century-C.E. Ostia. They provided commercial and often also living space, and complemented the numerous auction halls and back-alley markets, which closely resembled bazaars.[54] Indeed, the architecture of covered markets in the Near East evolved from just such Roman shopping streets. The prominent place of workshops, shops, and modest housing in the urban landscape points to a permanent and highly specialized commercial life that existed in parallel to seasonal markets. This permanent market provided artisans and merchants with a consistent income and made them independent of the limited official market days.[55] Only this kind of commercial cityscape could enable an urban mode of life economically independent from agriculture. But how and when did it emerge?

There is, as yet, no consensus on how to weigh the importance of social versus economic factors in the making of ancient cityscapes. In his pioneering book, *Houses and Society in Pompeii and Herculaneum,* Andrew Wallace-Hadrill suggested that commercial diversification in the cities of Campania was generated by the Roman patronage system.[56] He assumed that wealthy *patroni* allocated space to their *familia* and their clients within their *domus.* This allegedly resulted in the "big houses" that Wallace-Hadrill compared to the Parisian *hôtels* of eighteenth-century French nobles.[57] There is ample evidence for the economic relationships between patrons, clients, masters, and freedmen. It is, thus, entirely possible that the apartments and shops in an aristocratic *domus* were given (or rented) to clients and freedmen. But this accounts for only one aspect of urban living. As we have seen, landlords like the fictional Pompeius Diogenes also rented to strangers, and Roman law suggests that renting was a common practice, and not just in big houses: the owners of remarkably small properties also

walled off shops and built external staircases to their upper stories so that they could rent out one or more *cenacula.*

While the Roman patronage system may have fueled economic diversification, it cannot have caused it. Rental accommodation and shop rentals became common all across the Mediterranean over the course of the third and early second centuries B.C.E., not just in Italy but also in the East, where the Roman patronage system was not practiced. There were *tabernae* already in fourth-century-B.C.E. Greco-Roman cities, but actual shopping streets did not become a prominent feature of urban life until the third century B.C.E. In this respect, middle republican *coloniae* and contemporary Greek cities looked economically very much alike, despite considerable cultural and political differences. This suggests that larger economic forces were at work in the emergence of commercial cityscapes all around the Mediterranean, which is discussed later. First, I trace these transformations in Roman colonies and Italian and Greek cities in the third and early second centuries B.C.E.

Most Roman colonies were initially laid out on a grid. This urban grid corresponded to sectioning that was imposed on the adjacent countryside. The rural grid created identical plots that served as the basic module for allocating land to the colonists according to their military ranks.[58] This system is most widely known in its Roman manifestation as *centuriatio,* but it was already used by the western Greeks in the seventh century B.C.E. Colonists were supposed to live in the city and to own and cultivate the surrounding land. Of course, both urban and rural properties quickly changed hands and created a socially diverse landscape. As at Olynthus, there were shops, possibly for rent, but vibrant commercial cityscapes did not emerge until later.

A good example of this urban development in central Italy is Fregellae on the Via Latina, which was first established as a Latin colony in 328 B.C.E. and was destroyed in 125 B.C.E. Fregellae was a very successful city. In 177 B.C.E., 4,000 Samnite families moved there at a time when many other Latin colonies were failing because of mass migration back to Rome.[59] Fregellae produced prominent military leaders, orators, and even a playwright.[60] In Strabo's time, the site was still used for religious ceremonies and as a seasonal market for towns in the area that had been Fregellae's satellites before its destruction.[61] As a major town, Fregellae boasted a

monumental city center, complete with a forum, a *comitium*-senate complex, several sanctuaries, and the earliest known public bath in Italy.[62] But the site is best known for its domestic architecture.

The houses of Fregellae still await final publication, but the preliminary results point to a pattern of commercialization in the early second century B.C.E. In its final phase, the houses were canonical *atrium* houses. They were restructured over time. Domus 7 was even rebuilt on a slightly adjusted plot.[63] Each element of the stretch Domus 1–7 on the *decumanus primus* included at least one autonomous *taberna* in the street façade. But most importantly, some of the richest *domus* were transformed into fulleries around the middle of the second century B.C.E.[64] It is noteworthy that these houses had been owned by families with a strong sense of public display. Before its transformation into a fullery, what was probably the *atrium* or *tablinum* of Domus 2 had been decorated with a terra-cotta frieze of victories flanking trophies. Domus L on the *cardo maximus*—likewise transformed into a fullery—had been adorned by a frieze including soldiers in Italian and Macedonian armor, elephants, and other military paraphernalia such as *rostra*. In a domestic context, military iconography of this kind is only attested in the houses of Fregellae.[65] It may confirm the literary tradition that Roman aristocrats decorated their houses with references to the campaigns in which they had fought.[66]

Filippo Coarelli linked the destruction of these friezes—which probably went hand in hand with the remodeling of the houses as fulleries— to the arrival of 4,000 Samnite families in 177 B.C.E., and he assumed that their arrival forced the Latins out.[67] This is not compelling. Centuries later, the transformation of large Pompeian houses into fulleries was not the result of demographic change, but instead of a business decision. It is entirely possible that the owners themselves decided to turn prime real estate on the *cardo maximus* and *decumanus primus* into business venues, and went on to live elsewhere, perhaps in adjoining space but almost certainly still in Fregellae. The arrival of 4,000 Samnite families was not necessarily disruptive and may very well have been welcomed as economically beneficial. It provided the leading men of Fregellae with workers and tenants. A similar phenomenon occurred in second-century-B.C.E. Pompeii, which the Samnites had controlled since the fifth century: rich citizens

invested in commerce and, at the same time, enjoyed a refined urban culture. The commercialization of large properties was a widespread phenomenon that cannot be linked to any single historical event.

Unlike Fregellae, Pompeii survived the troubles of the second century B.C.E. Its Hellenistic urban fabric is, therefore, less well known. Only a few of the richest and best-built houses of the second century B.C.E. survived in one form or another until 79 C.E. Our sample may be skewed as a result, but it is nonetheless interesting, because it attests to a commercially minded urban elite.

The so-called Samnite houses of Hellenistic Pompeii and Herculaneum are mostly large *atrium*-peristyle houses from the early second century B.C.E. They are easily identified by their accurately built and skillfully decorated tuff façades, which probably survived because they were stable and looked pretty. The construction technique allows us to reconstruct the original appearance. Most Samnite houses included *tabernae* in their main street façade. Strikingly, two of the very largest and richest houses of Pompeii, the Casa del Fauno (VI 12) and the Casa di Pansa (VI 6), included four and six *tabernae*, respectively.[68] Presumably, their original owners were very rich: both houses dwarfed the royal palaces in the citadel of Pergamum. The interior design of the Casa del Fauno was so extravagant that its successive owners found it worth preserving for almost 300 years. Still, *tabernae,* which were used for commerce and trade, dominated its public front. This is remarkable because recent scholarship has often assumed that Greco-Roman elites found any public connection with commerce distasteful.[69] The distaste professed in literature stands at odds with the archaeological record of the early second century B.C.E.

At Cosa, an unsuccessful Latin colony in Tuscany, the most elaborate houses in the political heart of the *colonia* likewise had autonomous *tabernae* facing the forum, and this also occurs near the heart of the Roman world: even the presumably senatorial second-century-B.C.E. *domus* on the Palatine Hill were lined by *tabernae.*[70] Whatever the political and literary elites wrote about the proper place of a Roman aristocrat in the economy, as individual landlords they chose to create permanent commercial spaces on their property, and these private choices recur in the public building projects of Roman censors in the early second century B.C.E.

It would be far fetched to claim that there was such a thing as a Roman economic policy, but facilitating commerce and trade was a matter of interest to leading Roman aristocrats, certainly around the turn of the second century B.C.E. The introduction of the *denarius* in 211 B.C.E. probably had more far-reaching economic consequences than any public building project of the censors, although the motives behind this monetary reform remain unclear. Nevertheless, the construction of *tabernae* by the censors attests to some economic consideration: Livy mentions them along with general improvements of infrastructure, such as road paving and the construction of basilicas, harbors, and dams. In 179 B.C.E., M. Fulvius Nobilior constructed in Rome "a *forum piscatorium* surrounded by *tabernae* which he sold for private use."[71]

Such building projects were not limited to Rome. They also occurred in small *coloniae* like Calatia and Auximum. In 174 B.C.E., the censors Q. Fulvius Flaccus and A. Postumius Albinus "spent the money which they received from the sale of portions of the public domain in both of these places on building *tabernae* around their *fora*."[72] Q. Fulvius Flaccus also built *tabernae* in Sinuessa out of his private funds.[73] Interestingly, Livy notes *tabernae* as fixtures independent of the censors' public building projects: he writes about various groups of *tabernae* in second-century-B.C.E. Rome as if they were well-known reference points, and mentions *tabernae* in other Italian cities.[74]

The archaeological evidence in Fregellae, Pompeii, and Cosa suggests that Livy is not simply projecting the conditions of his own time back into the distant past, but instead offers a glimpse into the urban life of the middle republic. *Tabernae* were obviously seen as profitable building projects for both private individuals and high-ranking Roman aristocrats. They could be sold or let, which in the latter case provided a steady flow of income to their owners. This strategy is also visible in the eastern Mediterranean, where a commercial landscape seems to have emerged just a little earlier.

As in the West, permanent shops in the Greek world were constructed by communities and Hellenistic kings, and also by private individuals. The building activities of Hellenistic kings are of particular interest because they attest to the commercialization of monumental public architecture. Kings did not build independent shops, but instead added them to

stoai that they built in the *agorai* of friendly cities. So far, these *stoai* have been mainly discussed as a form of royal euergetism. Recent scholarship has focused on their aesthetic qualities and political connotations.[75] But in addition to their impressive appearance, most *basilikai stoai* in Greek *agorai* provided business and storage space that could be locked overnight while, during the day, allowing for elegant and pleasant shopping in the shade.

One of the earliest *basilikai stoai* was built by Antiochus I in Miletus. The second Seleucid king gave a "*stoa* of a stadion's length (189.2 m)" to the city in 299 B.C.E.[76] Thirty-nine shops with a back room opened onto the city's main *agora;* a second row of thirty-nine shops was accessible from a street running behind the hall. Two inscriptions specify that the revenue from these seventy-eight shops was to be used for funding the reconstruction of the city's largest sanctuary, the temple of Apollo at Didyma.[77] This strategy is consistent with other donations by Hellenistic kings, who were concerned about the sustainability of their gifts and preferred perpetual endowments over one-time handouts. By building a *basilike stoa* instead of making a financial endowment, Antiochus I secured a permanent presence in the city: first through the *stoa* itself, and then through the honorary statues that the Milesians erected for him and his mother Apame, but most importantly through his institutionalized role as a major benefactor of the Didymaion.

Unfortunately, no other inscriptions like the ones from Didyma survive, yet in the light of royal concerns for sustainability, it is fair to assume that royal market *stoai* elsewhere came with shops for similar reasons. But what matters most in the context of evolving commercial cityscapes is that there was demand for such shops by merchants and artisans who were willing to pay rent for a location in a prominent *stoa.* Tellingly, most of these buildings were erected in the early second century B.C.E., when shops also became common in the West. Greek *poleis* also added them to their market halls.[78] Especially prominent second-century-B.C.E. examples are the multistoried *stoai* around the *agorai* of Assos and Herakleia Latmos. The basic trend occurs across the eastern Mediterranean.[79]

As in Roman Italy, the autonomous shops of the Greek world did not originate in public architecture but were first built by private landlords. There were already a few in Olynthus around the middle of the fourth

century B.C.E. In early third-century Priene, there were at least sixty shops. A single row of eleven shops lined the western section of Priene's high street, the so-called Westtorstraße.[80] But as in the Latin West, veritable shopping streets did not become common before the later third or even early second centuries B.C.E. The best evidence comes from the port of Delos, where around 500 shops have been excavated so far. Monika Trümper has argued that these shops indicate economic and social diversity on Hellenistic Delos.[81] They are found in public buildings, clubhouses, and luxuriant mansions, and also in modest houses. Like the *tabernae* of the Latin West, they served as simple living quarters. Occasionally, the room above such a Delian *taberna* was accessible through a separate entrance from the street. This suggests that the upper story of such a shop or workshop could be let separately. Pavlos Karvonis's more recent and detailed work on Delos's commercial architecture has uncovered further parallels with Republican Italy. Commercial outlets in public buildings were let by the sanctuary of Apollo and used for a whole variety of business activities. Karvonis argues for some turnover among tenants, which he also sees reflected in the private shops and workshops that were walled off from private houses. They were frequently remodeled, which indeed suggests that they were used for different businesses.[82] Strikingly, these private shops resemble *tabernae* in the West. They not only had mezzanine floors but also large doors, which, when opened, could attract walk-in customers. This is all the more important as there is ample evidence for more ephemeral shops in Delos's various *agorai* and also for large commercial buildings.[83] Clearly, the business community of Delos required many permanent shops and not just market stalls, as would have been standard before the Hellenistic age.

Of course, Delos was one of the most important ports of the Hellenistic world and economically not representative. But *tabernae* and shopping streets have emerged wherever Hellenistic architecture has been studied in any detail, even in small and relatively unimportant cities in Sicily like Soluntum, Morgantina, and Tyndaris.[84]

The randomness of this architectural sample points to a widespread pattern of urban commercialization. Its randomness also suggests that the rise of commercial cityscapes all across the Mediterranean was primarily an economic phenomenon, because it occurred in many places around the same time, despite social, cultural, and political differences.

In this context, it is important that while shops and *tabernae* had similar locations and uses all around the Mediterranean, they did not always look alike. In the Greek world, shops usually lacked the large open front of Roman *tabernae* but instead had to be entered through a large door.[85] This made Greek shops less attractive to the casual shopper passing by, but this difference does not substantially alter our understanding of Hellenistic commercial cityscapes.

Even small places like Priene featured dozens of small commercial outlets. They existed in parallel to the large *agorai* and *fora,* which continued to be used as the main urban marketplaces. Further, many of these shops also served as housing, possibly for the merchants and artisans owning or renting them. The bulk of our textual evidence on such urban merchants and artisans comes from the first century B.C.E. or later, and may therefore not accurately reflect the social conditions of the early and middle Hellenistic periods. But from an archaeological perspective, it is likely that in most Hellenistic cities, hundreds of merchants and artisans earned most of their income from the businesses based in small shops. In doing so, they generated income not only for themselves but also for their landlords. To date, these landlords have been chiefly identified with the local landed gentry, but the archaeological evidence points to a more complex social pattern.[86]

There seems to have been economic opportunity for an urban population that was neither poor nor rich, independent of income from agricultural production. These propertied classes had a potential for social mobility through making money in the urban, nonagrarian economy. Of course, there is little literary or epigraphic evidence for this phenomenon. But there is plenty of evidence for the meteoric rise of local dignitaries into the senatorial aristocracy. As we shall see, the economic strategies of these *homines novi* mirrored, at least initially, those of their less wealthy compatriots. The involvement of the upper classes in the urban economy can thus help in the development of a model for nonaristocratic business strategies. Despite the hostility of ancient literature toward all nonagricultural businesses, the involvement of the local upper classes in commerce and trade was not a marginal phenomenon. On the contrary, it was at the heart of elite economic activity in the late Republic and early Empire.[87]

Upward Mobility and Economic Strategies
of the Urban Upper Classes

The increased archaeological visibility of artisans and merchants corresponds chronologically with the distaste professed for commerce and trade in literary sources. Finley and his school have conclusively shown that the anticommercial rhetoric of much of ancient literature was rooted in the agrarian ideology of Rome's senatorial aristocracy. But it is far from clear to what degree this rhetoric and its underlying ideology actually influenced or even reflected economic behavior.

Finley famously quoted a passage from Cicero's *De officis* as the "foundation" for his hypothesis that the low status of artisans and small merchants did, in fact, shape economic behavior.[88] Cicero made a categorical distinction between sordid and liberal trades (*quaestus sordidi* vs. *quaestus liberales*). Artisans and small merchants fell into the first category.[89] But this one statement is not proof of their social or economic marginalization. As Henri Pleket points out, agrarian ideology and commercial interests are not necessarily mutually exclusive.[90] In the early modern period, aristocrats looked down on commerce and trade, and even the richest merchants of the period, for instance the Fugger family, invested in landed estates. But despite this primacy of agriculture, commerce and trade still bloomed in the cities of the period.

A similar conclusion could be drawn for the Roman Empire from the first century B.C.E. onward. After his rise to the Senate, Cicero himself did not part with the apartment buildings that his wife owned in Rome, and he continued to keep a row of shops that he had inherited in Puteoli.[91] In this light, Cicero's harsh elitist judgment may just as well reflect what Marxist theory has called the "aristocratization of the bourgeoisie," or the desire of the moneyed classes to partake in the leisured lifestyle of the landed aristocracy. Such social ambition often leads to the public denial of a family's roots in commerce and trade.[92] This attests not to the social marginalization of the propertied classes but, quite to the contrary, to their economic prowess and potential for upward mobility. A literary classic on this phenomenon is Molière's *Bourgeois gentilhomme*. Petronius's fictional freedman-merchant-turned-gentleman-farmer, Trimalchio, qualifies as an ancient example of the type.[93] And to a lesser degree, the same could be said of Cicero himself.

Like almost all Roman aristocratic writers, Cicero was a *homo novus* who had risen from the commercial classes of small-town Italy. His father was of equestrian rank but still a man of no consequence, and had, "according to some," owned a fullery in Arpinum.[94] Cicero was ridiculed for having been born and raised in a shop.[95] Because slurs about relatively modest origins were a common rhetorical device in the politics of the late Republic, Cicero's family roots in commerce and trade have never been given much attention. The same applies even for Augustus, whom Marc Anthony taunted for being the grandson of a banker *(argentarius, mensarius)* and a baker.[96] But these taunts are interesting because they may have been true, and would attest to remarkable social mobility into the highest echelons of Roman society.

Both Cicero and Augustus kept uncharacteristically quiet about their fathers and grandfathers.[97] Augustus's early self-fashioning famously focused on his adoptive father, Caesar, while some of his more zealous supporters proclaimed him the son of Apollo. Plutarch and Suetonius later canonized hyperbolic genealogies that linked Cicero's family, the Tullii, to the Roman king Servius Tullius, and Augustus's birth family, the Octavii, to a patrician *gens* of the early Republic.[98] Of course, these genealogies were fictional. A sealing pin *(tessera nummularia)* from the Ides of June 53 B.C.E. was notarized by an *argentarius,* C. Octavius.[99] This was the birth name of Augustus and also that of his biological father and grandfather. His grandfather was probably still alive in 53 B.C.E.—according to Suetonius, he lived peacefully to an old age.[100] If the *argentarius* of the sealing pin was indeed Augustus's grandfather rather than one of his freedmen, then it would seem that he kept running his own banking business even after his son, Augustus's father C. Octavius, had risen to the rank of *praetor* in 61 B.C.E.

Such multistatus families of obscure and sometimes servile origins were not uncommon in the upper classes of the late Republic and the early Empire, even among the senatorial aristocracy. According to Tacitus it was argued in a Senate debate on freedmen's rights that "very many knights, and numerous senators" were of freedmen origin.[101] Early Roman emperors occasionally indulged conservative aristocrats by "purging" the Senate of all its members who were of servile ancestry. In light of freedmen families rising to the imperial aristocracy, it is hardly surprising that a

considerable part of the local aristocracy (perhaps up to 20 percent) of the Roman Empire was of freedmen descent.[102] When our documents list these councilmen by occupation, they often turn out to have been merchants and artisans and not just landowners.[103] Of course, local councilmen did not live in a *taberna,* and probably combined income from several sources, even though they were still identified by their primary business. In this context, it is instructive to revisit the passage in Q. Fufius Calenus's invective against Cicero in which he taunts the orator for his modest background:

> [Cicero] is a cheat and an impostor and grows rich and powerful from the ills of others, slandering, mauling, and rending the innocent after the manner of dogs, whereas in the midst of public harmony he is embarrassed and withers away, since love and good will on our part towards one another cannot support this kind of orator. How else, indeed, do you imagine, has he become rich, and how else has he become great? Certainly neither family nor wealth was bequeathed him by his father, the fuller, who was always trading in grapes and olives, a fellow who was glad enough to support himself by this and by his wash-tubs, who every day and every night defiled himself with the foulest filth. The son, reared in these surroundings, not unnaturally tramples and souses his superiors, using a species of abuse practiced in the workshops and on the street corners.[104]

According to Calenus, Cicero's father drew his income from many sources. The grapes and olives he traded may even have grown on the small family farm, which Cicero euphemistically described as an example of republican austerity.[105] But his father also owned a fullery, which allowed Calenus to insult Cicero as a sleazy small-town lawyer who had built his wealth on the misfortunes of others. It is very unlikely that Cicero's father personally ran the fullery, but it probably figured so prominently among his possessions that he became associated with it.[106] The later emperor Vespasian, the son and grandson of centurions-turned-bankers, resorted to trading mules after he had fallen on hard times, and was subsequently known as *mulius* (the muleteer).[107] This makes perfect sense in light of the archaeological evidence from the late Republic and the early Empire, as we will see shortly.

In a small city like Pompeii, Wallace-Hadrill's big houses were at the same time mansions and sources of considerable revenue. Still, under the

influence of Finley's *Ancient Economy*, even recent archaeologists have claimed that large *domus* lost their aristocratic status when workshops, shops, and orchards were associated with them. This harks back to Amedeo Maiuri's proposal in 1941 that such commercialization could only have occurred at Pompeii after the earthquake of 62 C.E., when many local aristocrats supposedly left their houses in town for villas in the countryside. But there is no evidence for such views, as the following three examples will demonstrate. These examples are Casa di Sallustio, the Casa di Pansa, and Casa di Postumii.[108]

Three Houses: Rent Seeking and Economic Opportunity for Commercial Classes

The example of the Casa di Sallustio shows how an old and large house was subsequently upgraded to provide the landlord with urban rents, and how this created business space. The example of the Casa di Pansa demonstrates that even Pompeii's mayor engaged in this rent-seeking strategy, while the Casa di Postumii stands for a slightly smaller house, whose owner created rental shops, workshops, and apartments on his property but still ran a butchery in his own house.

The Casa di Sallustio (VI 2, 3–5.30.31), the textbook example of the Roman *atrium* house and of the first Pompeian style of wall painting, shows that the living quarters of large houses were often embellished after workshops and shops were added (figure 2).[109] In its Hellenistic phase, the Casa di Sallustio was laid out as a symmetrical *atrium* house, built on a slightly larger, irregular plot. The house was originally surrounded by a narrow, roughly C-shaped garden on its north, east, and south sides while an impressive tuff façade to the west greeted visitors strolling on the Via di Consolare. As with other Samnite houses, its façade was a continuous row of large *tabernae*. Two *tabernae* (VI 2, 3.5) flanking the main entrance were accessible from the *atrium,* but the four others were not. They might have already been let by the house's first-century-B.C.E. owner.

Around the reign of Augustus, the landlord invested further in the commercial potential of the Casa di Sallustio. Two more *tabernae* were built at the expense of much of the south garden and linked to the *taberna* on the southeast corner of the property, which then housed a *thermopolium* (VI 2, 1). These two rooms and their *pergulae* were possibly a tavern

and probably also the barkeeper's apartment, because he had a cult niche and a latrine installed. The *taberna* to the north of the *thermopolium* could also have been let, because there was a *pergula*.[110] A second *thermopolium* was set up in a *taberna* just to the north of the main entrance. It must have been run by a dependent (possibly a slave) of the landlord, because it remained accessible from the *atrium* (VI 2, 5). The last two *tabernae* to the north of this *thermopolium* were joined by opening a door between them. They belonged to a large bakery built at the expense of most of the north garden (VI 2, 6). The profitability of the Casa di Sallustio was increased

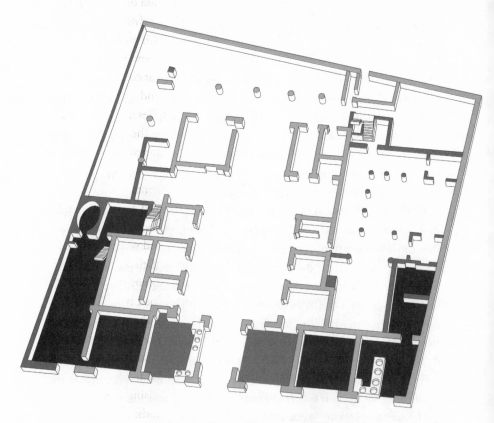

FIGURE 2. So-called Casa di Sallustio (VI 2, 3–5.30.31). The *tabernae* next to the main entrance (in gray) are connected to the *atrium* and must have been run by dependents of the landlord. The commercial rental units are shaded in dark gray. The tavern and the bakery were constructed at expense of the C-shaped garden of the house. The walls belonging to this second construction phase are shown in dark gray.

by these adjustments. Significantly, its living quarters still underwent remodeling in accordance with Neronian and Flavian fashions of domestic decor, which Paul Zanker has explained as an aspiration toward "villa-luxury." A peristyle garden with gaudy wall paintings was added to what had been the eastern half of the south garden. The east garden received a columned veranda and a garden *triclinium*.[111]

It has been repeatedly claimed that the Casa di Sallustio was transformed into an inn *(caupona)*, because of the tavern right next to its entrance, but there were many such bars in exactly this position. Given the luxuriant redecoration of the residential areas of the Casa di Sallustio, one could just as well assume that building two additional *tabernae* and a bakery paid off, and allowed the landlord to transform his townhouse into what Zanker has called a "miniature villa."[112] More recently, much better excavated houses also show that domestic embellishment could go hand in hand with building workshops, shops, apartments, and orchards at the expense of the dwelling area of a mansion. This applies to houses both larger and smaller than the Casa di Sallustio, including the so-called Casa di Pansa, the *domus* of Cn. Alleius Nigidius Maius, one of Pompeii's late mayors.

One of the two surviving painted rent advertisements from Pompeii comes from a corner of the Casa di Pansa.[113] It covered an entire *insula* and belonged to Cn. Alleius Nigidius Maius. This local aristocrat had been born into the local Oscan family of the Nigidii and was, as an adult, adopted into the wealthy Campanian family of the Alleii, or rather their freedmen heirs.[114] He served as a quinquennial *duumvir,* the *flamen* of Vespasian, and sponsored gladiatorial games. This earned him the title of a *princeps coloniae.* Nigidius Maius clearly belonged to the milieu of local leading men who fathered first-generation senators like Seneca, the two Plinies, and Tacitus. Ironically, it was the offspring of such *homines novi* who espoused a reactionary agrarian ideology, while local dignitaries like Nigidius Maius were not at all squeamish about advertising their involvement in the urban economy. His rent advertisement reads:

> Insula Arriana Polliana of Cn. Alleius Nigidius Maius. *Tabernae* with their *pergulae, cenacula equestria,* and *domus* are for rent from the first of July (79 C.E.). A [prospective] lessee should contact Primus, slave of Cn. Alleius Nigidius Maius.[115]

Pirson conclusively linked this *dipinto* to the archaeological remains of the Insula Arriana Polliana (VI 6) (figure 1).[116] Its core, the so-called Casa di Pansa (VI 6, 1.8.12.13), is well known as the textbook example of the so-called *atrium*-peristyle house because of its perfectly symmetrical layout. Like other Samnite houses of the second century B.C.E., the tuff façade here sheltered a row of large *tabernae* with *pergulae*. The main entrance of the house was flanked by three *tabernae* on each side. Over the centuries, several independent housing and commercial units were blocked off at the expense of the main house. In 79 C.E., there were two large bakeries with sales rooms and *pergulae,* six autonomous *tabernae cum pergulis,* five *cenacula* on the second floor, and three multiroom units on the ground floor, which compared in size to smaller Pompeian houses (1,000 square feet and more). The upper stories of two of these *domus* were turned into *cenacula.* In the third *domus,* there was still access to rooms on the second floor. All these units were created over the course of 100 years and seem to have been let out. We know this, first, because the rent advertisement mentions *tabernae, cenacula,* and almost certainly *domus* in the plural, and second, because all units originally belonged to the main house before the doors between them and the Casa di Pansa were walled off.[117] Also, separate units shared their water supply with the Casa di Pansa. The main house seems to have been in the process of redecoration when Vesuvius erupted, suggesting the continued interest of the mayor in his palatial townhouse.

At least in Pompeii, the *princeps coloniae* was obviously not shy about his role as a major landlord and having two large bakeries on his main property. This is all the more important since a man of his stature almost certainly owned land in the country. Still, Nigidius Maius squeezed as much revenue as possible from his urban residence. The large *hortus* (8,700 square feet) at the rear of the *insula* could be enjoyed from a columned veranda, but it was not formally planted: it was a vegetable garden.[118] Nigidius Maius even let the second floor above his elegant peristyle court, which may have allowed the tenant of this *cenaculum equestrium* to peep down into the most secluded section of his landlord's house.

This commercialization of the Insula Arriana Polliana can only be explained by economic concerns. Of all Pompeians, Nigidius Maius had probably more than enough slaves, clients, and freedmen to put up in his

tabernae, cenacula, and *domus.* But as the rent advertisement suggests, he did not care very much who lived in his *domus,* because he advertised his apartments publicly and left the selection of his tenants to a servile manager. Aristocratic decorum and focus on the *familia,* as conjured in the writings of Cicero, are absent from one of the largest and oldest upper-class *domus* of Pompeii. Moreover, the revenue strategies of a key local notable were no different from those of less wealthy but still prosperous landlords.

From 1997 to 2002, Jens-Arne Dickmann and Felix Pirson reexcavated the so-called Casa di Postumii (VIII 4, 2–6.49.50) (figure 3). The project aimed at understanding how living and working conditions in a single *insula* evolved over time.[119] This reevaluation demonstrated that in the case of the Casa di Postumii, economic considerations had a profound influence on the layout of a relatively large and elegantly decorated *atrium*-peristyle house. The Casa di Postumii was located at a busy intersection right across from the Stabian Baths. This allowed the owner to build *tabernae* on the north and west sides of his property, which took up over a third of the available ground area. Five autonomous *tabernae* opened up along the Via dei Teatri and were possibly let to the artisans and merchants who lived there. Three more *tabernae* facing the Via dell'Abbondanza were accessible from the *atrium* and were used for the business of the landlord.

The most remarkable commercial feature of the Casa di Postumii was a narrow, twenty-meter room on the east side of the house. It had been built over a large public drain. At first glance it appears to be an oversized kitchen with an oven and a latrine, but there were unusual additions like a marble work desk and two water basins. The northern part of the room was left unpaved and unroofed, which may indicate that animals up to the size of a pig were temporarily kept there. Pirson, therefore, suggested with due caution that it might have been a butchery.[120] This would be consistent with a graffito on the western wall of the peristyle listing 140 pounds (200 *pondera*) of lard and 250 bunches of garlic for July 7. Such a remarkable quantity of lard was more likely to be sold than purchased in a single day.[121]

Tellingly, the construction of the elongated room meant that the peristyle, constructed at the same time, could not be rectangular. The

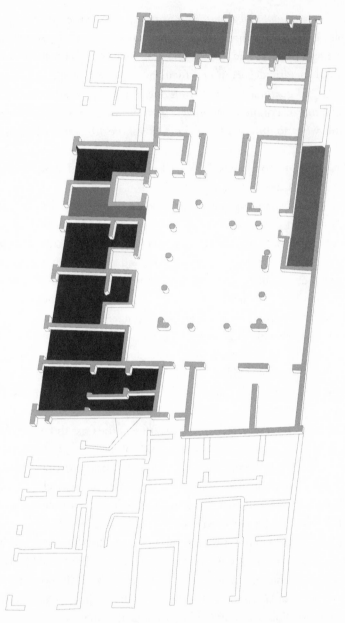

FIGURE 3. So-called Casa di Postumii (VIII 4, 2–6.49.50). The *tabernae* flanking the main entrance (in gray) were run by dependents of the owner. The *tabernae* facing the so-called Via dei Teatri (in dark gray) were rented to artisans and merchants. The elongated room opening up to the peristyle (in gray) probably served as a butchery and commercial kitchen. Its position was determined by a large public drain.

northeastern corner of this large and elegantly colonnaded garden had to be restricted. Obviously, the peristyle was considered as separate from the kitchen. A door was installed in the eastern hallway of the peristyle to restrict access, and the intervals between the columns in the northeastern corner of the courtyard were closed by puteals to set apart the corridor leading up to the kitchen. Just the same, commerce took precedence over aesthetics. The position of a large public drain determined the location of a particularly dirty business, even though the owner of the Casa di Postumii tried hard to maintain a sense of dignity when he lavishly rebuilt his house after the earthquake of 62 C.E.

Similar patterns of commercial use have also emerged in other large houses wherever recent archaeological research has looked beyond wall paintings and mosaics. In their work on the urban economy of Pompeii, Miko Flohr and Damian Robinson have cataloged bakeries and textile workshops (mostly fulleries and dye workshops) and put them into their domestic context.[122] This is a very small sample from the trades attested in Pompeii, but bakeries and textile workshops lend themselves to quantitative analysis because they can be securely identified. It is noteworthy that 40 percent (or twelve) of all thirty textile workshops were attached to the city's largest *atrium*-peristyle houses.[123] The same percentage applies to bakeries.[124] These numbers are highly revealing because there were only about forty such mansions in Pompeii.

Clearly, the owners of the largest and most luxurious houses in the city were well represented among men with an interest in industry. The results of both Flohr and Robinson reflect a growing consensus among archaeologists and some historians on the connection between elegant living, commerce, and trade: at least in Pompeii, there was no spatial separation between the mansions of the landed gentry and the "sordid" workshops of artisans, shopkeepers, and small merchants.[125] But there remains an ongoing discussion over the social implications of this connection. Cicero's famous verdict on commerce and trade inevitably plays an important role in the debate. Instead of taking his word as the genuine sentiment of the Roman upper classes or, alternatively, dismissing it as moralistic grandstanding, we need to try to understand its sociocultural background and reach.

When Cicero denounced all economic involvement in anything but large-scale agriculture and trade, he not only kept quiet about his own connections

in urban trade and commerce but also denounced Roman city life *tout court* as we know it from archaeology. In doing so, he set himself apart from all but his peers in the senatorial aristocracy. As a senator, his avenue to wealth was through his association with the richest and most powerful men of his time. His political connections gave him access to otherwise unattainable multimillion-sesterces loans and brought him additional income, for instance, through inheritances and political gifts. Only very few upper-class Romans were in his position. Consequently, his verdict against *quaestus sordidi* cannot be taken as an upper-class economic ethic per se, especially since commerce and trade played an important part in the self-representation of both local elites and urban propertied classes, as we shall see later.

Cicero's anticommercial ramblings are best understood as his contribution to a debate about rank and status at a time when the primacy of agriculture also needed to be defended by contemporary writers like Varro. Praise of agriculture, a topos in its own right, was arguably an attempt to define proper economic behavior rather than to represent the status quo. Setting standards for senatorial decorum would have made sense in an upwardly mobile society.

In Cicero's view, the decurional order must have hovered uncomfortably close to the urban middle classes. Indeed, the economic strategies of a Nigidius Maius were virtually identical to those of fellow citizens who lived in much smaller houses and were probably not nearly so wealthy as he, and also to those of the owners of the Casa di Sallustio or the Casa di Postumii. Robinson's survey of Pompeii shows that 60 percent of all bakeries and textile workshops were attached to houses of lesser size. They were owned by a social stratum between the landholding political elites and persons who worked and lived in the *tabernae* that they rented from the well-off. In a straightforward economic sense, these people were a middle class.

Toward an Archaeological Definition of Commercial Middle Classes

Even though there was clearly a correlation between the size of a house and the wealth of its owner, square footage does not directly translate into

financial net worth or social status. And house size also does not reflect on the social status of its owner, or whether his economic behavior conformed to aristocratic norms. For instance, the Casa di Pansa was only marginally bigger than the house of the *argentarius* L. Caecilius Iucundus (V 1, 23.26.10), who, by Cicero's reckoning, practiced a "sordid trade." Indeed, an archaeological analysis of houses can only uncover economic strategies and by extension, class. This chapter surveys Pompeian houses in terms of the economic opportunities of their tenants and owners. This in turn will provide us with a key tool for class analysis as it reflects market and, by extension, class situation.

To analyze Campanian urban society, Wallace-Hadrill has proposed an elegant method for sampling the houses of Pompeii and Herculaneum by dividing them into four groups. These "quartiles" correlate ground area with architectural design and possible use.[126] Wallace-Hadrill's sample of 234 housing units is representative because it is not based on a selection of individual houses, but instead on surveying entire *insulae* in two *regiones* of Pompeii (I and VI) and four *insulae* in Herculaneum (III–VI). Housing units in the lowest quartile (fifty-eight units with an average ground area of 269 square feet) are independent *tabernae* (10–45 square meters) with no clear connection to a larger house. Units in the second quartile (sixty-one units with an average ground area of 1,162 square feet) are either large *tabernae* or small houses (50–170 square meters). The third and fourth quartiles (fifty-seven and fifty-eight houses with an average ground area of 2,647 and 7,685 square feet, respectively) comprise large houses, often with at least one courtyard or, in the very largest houses, a peristyle. Wallace-Hadrill convincingly argued against populating each of his four groups with a different class. The truly poor must have lived in the *domus* of their masters and patrons, which Wallace-Hadrill conceptualized as big houses (after Philippe Ariès). But this does not imply that the "pursuit of 'lower-class' and 'middle-class' housing is misleading."[127] On the contrary, Wallace-Hadrill's urban sample provides an important data set for doing exactly that.

As mentioned above, in surveying the archaeology of Roman cityscapes for social stratification, class is a necessary analytical tool. Legal status and social rank are, for the most part, invisible in the archaeological record, as are cultural identity and education levels. As we shall see in Chapter 5,

Pompeians shared in the same visual culture and appreciated the same type of domestic decor across obvious social boundaries. The same standardized mythological wall paintings are found in the back rooms of large *tabernae* and large reception rooms of the very rich. But what is visible in the archaeological record is economic behavior, which allows for analyzing socioeconomic class. At the current stage of research, it is only (relatively) safe to make a distinction between those Pompeians who had to work for a living and those who probably did not. Any further differentiation quickly becomes speculative, but not wholly uninteresting, as we shall see.

In using Wallace-Hadrill's quartiles, the *tabernae* of the first group clearly do not necessarily represent the living conditions of Pompeii's poor. Renting a *taberna* required income. But even when *tabernae* were owned by their inhabitants, income was still needed for purchasing basic necessities, like food and clothing, which could not possibly be produced in such a small household. We know from Gassner's survey of Pompeian shops that such income was widely generated through artisanal production or retail trade.[128] Merchants and artisans renting or even owning *tabernae* were certainly better off than the slaves laboring in the bakeries and textile workshops of the large *domus,* or who, alternatively, ran a *taberna* for their master or patron.

It is also likely that the owners of the large *tabernae* and small houses in the second quartile worked for a living if their properties included a single large shop connected to the rest of the house. But here the scarcity of available documentation defeats any detailed analysis, except for large bakeries and textile workshops that required fixed and easily identifiable installations. This is unfortunate for a social analysis of domestic decor, because quite a few of Pompeii's most lavishly decorated houses fall into the second quartile. But after their republication in the *Häuser in Pompeji* series, it is at least clear that the owners of the Casa dell'Ara Massima (VI 16, 15–17) or the Casa del Granduca (VII 4, 56) took their income from the single large *taberna* attached to their houses, even though the exact nature of their business remains uncertain.[129]

Yet, even where there was no such shop, it is possible that houses in the second group were inhabited by merchants and artisans. For instance, a cache of twenty-eight finished and eighty-six unfinished cameos in the

small but elegant house of Pinarius Cerialis (III 4, b) strongly suggests that he was a gem cutter.[130] The house did not include a *taberna* but was arranged around a small colonnaded garden, a highly unusual feature for its size. By Pompeian standards, the quality of its fourth-style wall paintings was also unusual. They were as exquisite in execution as their subject matter of vignettes from classical Greek plays was uncharacteristically highbrow. Since he had no shop, Pinarius Cerialis must either have expected his customers to visit his elegantly decorated home or else made house calls to them.

Only very rarely is the evidence (and documentation) for business activities in houses of group 2 as conclusive as in the case of Cerialis's next-door neighbor, the pottery dealer, Zosimus (III 4, 1a). Not only does his painted shop sign *(VASA FAECARIA VEN[duntur])* survive, there was also a large stockpile of pots for sale and a graffito identifying him as a Jew. Such detailed information is unavailable for most houses in the second quartile. Consequently, we cannot know for sure how many of them were owned by artisans and merchants. But we can make an informed guess: 60 percent of the houses in the second quartile were each linked to a single *taberna* that occupied much of the overall ground area. It is, therefore, not too much of a stretch to assume that the owners of such houses worked for a living. The same cannot be established for the owners of group 3 and group 4 houses.

Still, it is possible that the owners of group 3 and 4 houses practiced a trade. In the *protyron* of the sprawling Casa di Sirico (VII 1, 25.47), a mosaic inscription *salve lucru* (welcome profit) famously greeted visitors.[131] By virtue of his uniquely preserved business archive, the *argentarius* L. Caecilius Iucundus stands as the classic example of the "working rich," living in a large group 4 *atrium*-peristyle house. But Iucundus's financial interests were not his only source of income: his house also included three autonomous *tabernae cum pergulis* (VI 1, 20; 22; 24), which were probably let out.[132] According to the famous wax tablets found in his house, Iucundus himself rented two properties from the city. One was a fullery, which cost him 1,652 sesterces per year, the other a villa, which he rented for 6,000 sesterces per year.[133] Strikingly, Iucundus's portfolio closely resembled that of Cicero's father, if we believe the invective of Q. Fufius Calenus (see above). The presence of multiple rentals (both commercial and residential)

and labor-intensive workshops, like bakeries and fulleries, among group 3 and 4 houses shows that their owners had diverse business interests.

In the case of large bakeries and fulleries in group 3 houses, it is reasonable to assume that they were personally overseen by the owner.[134] But on a property like the Casa di Pansa, they were only one item in a large urban portfolio that included many different commercial assets. We know from ancient literature that the rich were aided by trusted slaves or freedmen in the management of large estates. Cn. Alleius Nigidius Maius's slave Primus was a servile manager of that sort. Special commercial interests notwithstanding, large landlords were rentiers in a Marxist sense, especially if they also owned land. The very richest among them had opportunities to run for local office, live a life of letters (like Atticus), or even seek a career in Rome (like Cicero).

So far, Wallace-Hadrill's survey allows for a preponderance of big houses. Houses in groups 3 and 4 make up half of all 234 units in his sample and certainly account for more than half of the population who lived in the *insulae* surveyed.[135] In Helen Parkins's words, the Pompeii and Herculaneum of Wallace-Hadrill are "domesticated consumer cities," in which a rich landowning elite supplements its income from rural estates with urban commerce and trade.[136] But Pirson's more recent work on rentals challenges this picture. In addition to 164 *tabernae* in group 1, and 392 houses in the three other quartiles, there were 252 lettable *tabernae* and 156 identifiable *cenacula* in Pompeii.[137]

The lack of archaeological information on second-floor apartments makes it hard to assess them socially. Literature provides some vivid examples but is, on the whole, of little help. Seneca, famously, took lodging over a *balneum* in Baiae to test his concentration in a noisy environment.[138] Also, the Christian martyr Flavius Justinus lived over a *balaneion* in Rome. Archaeologically, such apartments are attested in the Forum Baths of Pompeii.[139] In Rome, the financially troubled future emperor Vitellius moved his family into a *cenaculum* after he was forced to let his *domus* for rent.[140] Poets of equestrian rank like Martial and Juvenal bitterly complained about having to live in *cenacula* instead of a proper *domus*.

Still, the situation conjured up by literary sources was specific to the capital and perhaps a few other large cities. Most tenants in Pompeii's 156 *cenacula* were surely not philosophers on vacation, Christian saints, cash-

strapped senators, or world-class poets. It is also unlikely that these dwell-
ings were rented by Pompeii's transient and temporary population:
roughly three dozen *hospitia* and *cauponae* catered to this group. So what
class of people lived in these rentals?

We may know the background of one Pompeian tenant. A lewd graffito
(*CIL* 4, 10150) was scratched into an entrance corridor of the Praedia Iulia
Felicis (room *a* of II 4, 10). The Praedia Iulia Felicis was, as we know,
rented out by an absentee landlady. The corridor in which the graffito was
found led directly up to a *cenaculum* on the second floor.[141] It is unusual
that the addressee of the insult is not mentioned by name. Writing the
graffito into the entrance corridor of a *cenaculum* could suggest that he
lived there. The graffito reads:

> Since you have held eight [jobs] all that is left for you is to have sixteen
> [more]: you have worked as an inn-keeper. You have worked as a clay
> man. You have worked as a pickler. You have worked as a baker. You
> have been a farmer. You have made bronze trinkets. You have been a
> huckster and now you are a jug-dealer. If you lick cunt you will have
> done everything.[142]

Whether or not this epigram refers to a tenant of the Praedia Iulia Felicis,
renters were probably mostly men of, at least initially, moderate commer-
cial success. Renting a *cenaculum* required income, but unlike large *taber-
nae,* such an apartment lacked a sales room. Economically, owning a small
house of a similar size made more sense, not least because most Pompeian
houses doubled as productive assets. Petronius's fictional freedman,
C. Pompeius Diogenes, and the poets Martial and Juvenal aspired to
home ownership. If their negative attitude toward *cenacula* was at all rep-
resentative, up to 16 percent of all housing units in Pompeii would have
been occupied by tenants who had the means to rent an apartment but
lacked the funds for buying a house. They were obviously neither rich nor
very poor. In a colloquial sense, they were middle class.

However crudely, archaeology can establish which Pompeian houses
were productive assets and which were not. Houses including rentals and
labor-intensive workshops generated revenue for their owners. In all other
houses, owners and tenants had to take up a gainful occupation unless
they had an income from agricultural rents. Those inhabiting a *taberna*

almost exclusively practiced a trade. And it is reasonable to assume that the same is true of at least half of the owners and tenants in the next higher quartile.

Tellingly, only 2 percent of all lettable *tabernae* and 12 percent of all *cenacula* in Pompeii belonged to houses in the second quartile, even though they made up a quarter of all houses. The profitability of houses steeply rose in the next two quartiles. Eleven percent of Pompeii's lettable *tabernae* and 45 percent of its *cenacula* belonged to group 3 houses. The lion's share of rentals was attached to the largest houses in the fourth quartile: 56 percent of all lettable *tabernae* and 34 percent of all *cenacula* belonged to houses in this group.[143] What do these numbers mean for class analysis?

If we define class economically as a gauge of economic opportunity, the lower classes in Pompeian society can be safely associated with dependent labor, like free and unfree farmhands and craft apprentices. In the Roman world, as in most other preindustrial societies, highly qualified and well-remunerated wageworkers were rare.[144]

Dependent workers were either slaves or so-called *institores,* agents who ran a business or a shop in someone else's name. Of course, such lower classes are almost invisible in domestic architecture and can at best be associated with the *tabernae* directly attached to large houses. But as soon as we leave this category, difficulties arise: was an artisan or merchant economically lower class, even when he ran a shop on his own account? If we assume, for simplicity's sake, that all those living in Pompeii's 252 lettable and 164 architecturally independent *tabernae* (the houses in Wallace-Hadrill's first quartile) owed services and money to a master or patron, they would still have enjoyed some degree of economic opportunity: as we shall see in Chapter 4, in Rome several freedmen *tabernarii* commemorated the location of their shops on expensive marble tombs. And some shopkeepers in Pompeii had the backroom of their business decorated with high-quality mythological wall painting. But even if we do not associate these shops with (lower) middle classes, as I would, we would still be left with 156 *cenacula* and 392 traditional houses, all of which clearly did not belong to elites or upper classes by any stretch of the imagination.

At the other end of the spectrum, the line for upper-class houses has to be drawn even more arbitrarily. Compared to the first three groups, house

sizes in Wallace-Hadrill's fourth quartile vary greatly (350–1,000 square meters). Fewer than forty units in this category were full-fledged *atrium*-peristyle houses, and fewer than a dozen could compare in size to the Casa di Pansa or the Casa di Fauno. But subdividing group 4 would not help our understanding of economic class in Pompeii. Wallace-Hadrill's classification system shows, first and foremost, that there was no categorical difference between houses but rather a fairly continuous gradation in size. From the upper-second quartile onward, landlords turned houses into productive assets by walling off rentals and adding labor-intensive workshops that had to be operated by slaves, freedmen, or hired labor. The larger the house, the more productive assets could be accommodated. Only very few house owners did not engage in this archaeologically visible kind of enterprise. These must have lived off agricultural incomes or cultivated business interests other than collecting rent from urban real estate and industry.

The overwhelming majority of Pompeian landlords actively worked to turn their houses into profitable enterprises. This economic strategy manifested itself as soon as there was space enough to block off a *taberna* or let a second floor. Because it was so extremely common, this behavior could not be exclusively "upper class." Instead, it rather impressively demonstrates that there was considerable demand for lettable *tabernae* and that, as a result, the middle segments of Pompeii could also supplement their income through urban rents.

The fictional businessmen at Trimalchio's dinner illustrate this. They made investments of this kind and were able to upgrade from a *cenaculum* to a house or even to buy a villa like Echion. The continuous scale of house sizes in Pompeii demonstrates that there was no categorical gap between the rich and the poor. Widespread opportunities in the urban economy allowed for social mobility, which is reflected not only in the broad spectrum of shop and house sizes among Pompeii's working population but also among the houses of the town's elite.

If we accept for Pompeii the traditional number of 100 *decuriones* and assume that these councilmen were house owners, then most fourth-quartile houses probably belonged to this group. But even this group exhibits substantial economic differences, perhaps analogous to the widely diverging means of Roman senators.[145] But these differences in lifestyle

and economic strategies were differences of degree, not of kind. The economically mixed portfolios of the propertied classes of Pompeii point to a considerable overlap between middle and upper classes. It is perhaps for this reason that an upstart senator like Cicero aimed to distinguish between sordid and liberal trades. As much as his readers, Cicero must have been aware that the categorical difference between rent-seeking gentlemen farmers and rich decurional families with active interests in urban commerce and trade was purely ideological and, therefore, needed to be stressed and enforced all the more vigorously.

This brings us back to the initial point of this chapter: ancient discourses on urban life and nonelite prosperity provide little illumination when it comes to the socioeconomic structure of ancient cities, at least in the period under discussion. The rent seeking of Pompeian landlords shows that there must have been considerable demand for rental shops and apartments among the town's commercial classes. Owners of relatively large houses also engaged in business activities and thus complemented their income from urban and possibly agricultural rents. In terms of Weberian class analysis, this points to remarkable economic opportunity outside traditional agriculture.

But so far, we have seen only a little of the extent and the quality of such opportunity. In the next chapter, I discuss how economic opportunity for commercial classes translated into the commercialization of cityscapes and the formation of a social class that we can call a "middle class."

3

From Commercial to
Middle Classes

Urban Life and Economy in the Roman Empire

The transformation from agrotowns into economically and socially diverse cities created economic opportunities outside agriculture. As many items of daily use could no longer be procured through household production, artisans, peddlers, and shopkeepers made it their business to produce and sell them. This also applied to services. A series of recently discovered graffiti from a medium-sized house in Ephesus list a number of items and services that had to be accounted for.[1] These are foodstuffs like bread, olive oil, and sausages but also items of daily use like laundry detergent and soap. Services are listed too. They include entry fees to the bath, tips for the bath attendant, a haircut, and a laundry bill. The biggest item on the list is four *denarii* in legal fees. Obviously, Echion was correct: there was bread in practicing law. But interestingly, all other items are only valued with a few *assaria*, local small change in bronze.

This has important implications for understanding the economic condition of commercial classes: it attests to microtransactions, which are only conceivable in a fully monetized economy where artisans and shopkeepers cater to a large customer base. This brings us back to Weber's concept of "market situation." As there was a living to be made in commerce

and trade, we are dealing with commercial classes, who marketed their skills as grocers, bakers, sausage makers, soap producers, hairdressers, and, higher up the value chain, as advocates. Conversely, the prominence of entry fees to the *thermae* shows that were was money to be made by investing in urban real estate beyond rental shops in apartments. And this, in turn, provided contractors and skilled craftsmen with economic opportunity. Bath buildings, for instance, had to be not only constructed but also maintained by specialists like window makers and plumbers.

But how substantial were these commercial classes within ancient cities, and did they form a social class or classes with a shared lifestyle and similar chances of social mobility? This chapter is devoted to this question.

The first question of size and economic prominence is directly related to the issue of trade. As market size drives specialization, only a relatively large market can support a significant number of specialized artisans, who thrive on high-value skills. This is precisely what obtained in the Roman Imperial Period. Hence, the first part of this chapter is devoted to how Roman trade enabled the kind of *taberna* economy that came to characterize cities all over the empire. The resulting ubiquity of artisans and shopkeepers in ancient cities is important. Despite considerable regional differences in design, shopping streets became a fixture all over the empire and not just in big trading hubs like Ephesus.

This ubiquity of artisans and shopkeepers leads to the second issue discussed in this chapter: can the commercial classes of the ancient world be understood in terms of social class? In other words, did urban businesspeople live under similar social and cultural conditions? Here, communal actions of craftsmen in the Roman East and the organization of voluntary associations all over the ancient world show that the commercial classes of the ancient world acted and lived together as social groups. In this respect also, they constituted a middle class. But first we turn to the role of businesspeople within the Roman economy at large.

Artisans and Trade in the Roman Economy

The prominence of rental properties, small commerce, and artisanal production in the urban landscape of Hellenistic and early Imperial Pompeii

squares well with Keith Hopkins's theory about the role of taxes, rents, and trade in the Roman economy.[2] Hopkins argued that the unification of the Mediterranean under Roman rule and the subsequent conquest of northwestern Europe changed the economic dynamic of the ancient world. Rome levied taxes in gold and to a lesser extent in silver. Gold coinage was only minted in the capital and, for a short period, also at Lugdunum. According to Hopkins, this centralized monetary system forced the tax-paying population of the empire to recuperate their tax money through trade with Rome, where most of the taxes were consumed and redistributed to the army.

Exporting agricultural produce was insufficient to meet fiscal demand, because the capital and the frontier armies consumed less grain than the grain equivalent owed in taxes. As a result, taxpayers had to raise cash. Hopkins assumed that this was achieved through producing "marketable and exportable goods, which were sold to recoup the money taxes, which had been sent off to Rome or the frontier armies."[3] On a mostly local scale, taxes competed with the rents that farmers had to pay to their landlords. Hopkins suggested that the rental income of Rome's aristocracy of 600 senators alone amounted to almost as much as the taxes levied by the state.[4] Absentee landlords collected their rents also mostly in coin. This forced tenant farmers to cash in their harvests.[5] Buyers were urban merchants, shopkeepers, and artisans without (sufficient) farmland, who, in turn, earned their income through trade, commerce, and artisanal production. Hopkins's system is built on rough estimates of the empire's population, minimum GDP, and a few archaeological observations, most importantly on the number and size of Mediterranean shipwrecks, which peaked between 200 B.C.E. and 200 C.E., and the dissemination of Hellenistic technology across the Mediterranean.[6]

Recent archaeological studies on merchant ships, trade, and technology, not yet known when Hopkins wrote, confirm his theoretical considerations about dramatic changes in the period between 200 B.C.E. and 200 C.E. Roman ships were not only larger than their classical predecessors but also equipped with stocked anchors, sophisticated rigging, and bilge pumps, which were not reinvented until the seventeenth and eighteenth centuries.[7] Dozens of shipwrecks and large quantities of cheap, mass-produced goods like *terra sigillata* have now been found as far as the west

coast of India.[8] The spread of Roman culinary culture beyond the Mediterranean created additional demand for olive oil and *garum* in regions where olive trees did not grow and *garum* could not be locally produced.[9] Metal was mined at an unprecedented scale. This is attested by the sheer number of large and technologically sophisticated Roman mines, millions of cubic meters of slag, and, most impressively, by air pollution with copper and lead, which remains conserved in Greenland's ice shelf. This pollution reached levels comparable to those of the early Industrial Revolution.[10]

These new data have provoked debate about the size and nature of the Roman economy. This research currently focuses on the question of economic growth.[11] In essence, it is a new round of the debate between "modernists," primarily represented by materially minded scholars, and "primitivists," mostly text-based historians.[12] Quantifying economic growth would certainly improve our understanding of the ancient economy and the Roman Empire as a whole. But at the current state of research, we first need to try to understand the immediate sociocultural implications of these new economic insights before we move on to questions of growth and scale.

To date, the most eloquent account of Rome's socioeconomic sophistication is found in Bryan Ward-Perkins's *The Fall of Rome and the End of Civilization*.[13] Ward-Perkins compares living conditions under the Roman Empire to those of late antiquity. In the first two centuries after the fall of the Roman state in the West, populations declined, livestock shrank in size, basic comforts like cheap, mass-produced roof tiles and quality tableware became unavailable, and key technological expertise was lost for almost a millennium. Ward-Perkins explained this catastrophic collapse, in part, as a result of Rome's economic specialization, which made the mass production of cheap, high-quality goods possible. When "specialized production failed, it was not possible to fall back immediately on self-help," and when it did, "the post-Roman world reverted to levels of economic simplicity, lower even than those of immediately pre-Roman times, with little movement of goods, poor housing, and only the most basic manufactured items."[14] If we combine this forceful narrative of collapse with the rise of a more articulated urban life as sketched above, the 400 years between 200 B.C.E. and 200 C.E. stand out as a period of general prosperity.

The current focus on economic growth has resulted in framing Roman prosperity as a macroeconomic issue. Archaeologists of the Roman economy are, therefore, mostly interested in providing data sets that may be statistically relevant for measuring growth like atmospheric pollution, the number of shipwrecks, the size of livestock, and how much marginal land was used for growing cash crops like olives.

Local economic patterns are mostly studied on a regional scale.[15] The relatively few studies addressing the archaeology of the urban economy tend to take aim at Finley's concept of the consumer city by arguing that there were export-oriented workshops with an output exceeding local demand.[16] These results matter to Roman economic history, but the samples collected are not necessarily relevant indicators for what modern economists consider economic growth.[17] Still, the archaeology of the Roman economy has uncovered dramatic changes in economic behavior. This is relevant for studying urban life under the Roman Empire, even though cities themselves do not play a prominent role in the current debate.

Remarkably, the Roman imperial system created a consistent pattern of urban life all over the Roman world, despite significant geographical, social, and cultural differences. This aspect of Roman social and economic history is rarely studied. Instead, the current narrative on change in Roman urbanism is dominated by a discussion of the impact of Roman culture and political ideology.[18] Of course, culture and ideology played a decisive role in the development of Roman urbanism. To Latin writers like Tacitus, building Roman-style cities meant spreading urban amenities like theatres and bath buildings, which were to transform the conquered barbarians culturally.[19] Even today, the Roman *fora, thermae,* amphitheaters, and other public architecture in the northwestern provinces are the most visible sign of Roman political and cultural influence. But the construction of big Roman buildings does not explain why Italian urbanism in a broader sense spread to the provinces, and why the Mediterranean world under Roman rule came to look so much alike economically. This economic homogeneity of Roman cities is, in my mind, the most significant indicator for a profound change in the socioeconomic makeup of the ancient world. It was largely due to a lively trade in finished goods, as envisaged by Hopkins. In the light of recent urban archaeology, the production and export of marketable goods appears to have unfolded in a *taberna*

economy. This *taberna* economy may have only modestly contributed to Rome's overall GDP, but it changed the socioeconomic underpinnings of urban life all across the Roman world and, by extension, allowed for the rise of urban middle classes.

Artisanal Production, Trade, and Urban *Taberna* Economy

Big public buildings have long been at the heart of scholarly interest in ancient urbanism. The size, embellishment, and continued maintenance of amphitheaters, theatres, and bath buildings have been used as a yardstick for measuring economic strength.[20] While this is surely one indicator of urban prosperity, the economy of public architecture says little about the internal conditions of urban economic life. Constructing and maintaining large public buildings like temples, *thermae,* and amphitheaters required a well-developed economic infrastructure, but monumental building projects alone do not explain the rise of commercial cityscapes. Large buildings can go up in societies lacking a monetized economy. Investment in public architecture does not necessarily create a business environment in which hundreds of small shopkeepers and artisans thrive.

Small-scale commerce became a hallmark of Roman cities, despite and not because of the anticommercial rhetoric and ideology of the imperial elites in the capital. Urban landlords found it more profitable to rent individual *tabernae* to shopkeepers and artisans than to manage several businesses themselves. The array of businesses found in the *tabernae* of a given property in Pompeii and Herculaneum demonstrates that Roman landlords were not interested in what their tenants did for a living as long as they paid their rent.[21] Landlords' predominantly financial interests forced comprehensive monetization on rent-paying artisans and shopkeepers.

In addition to rent, *tabernarii* had to pay in cash for raw materials and necessities of daily life.[22] As a result, artisans and merchants were a main conduit for cash flow in the market economy of their cities. In contrast to the long-held belief that they almost exclusively produced and sold goods for local consumption, the internal logic of the *taberna*-based economy tied into local and interregional trade, both in raw materials and finished

goods. It was this pan-Mediterranean commercial culture that allowed for the rise of middle classes and their cultural consumption.

The general availability of imported commodities in small towns all across the empire is one of the most remarkable features of the Roman economy. The most vivid literary picture of Roman trade is painted in occasional references to the *horrea* of Rome. Cicero and Seneca stressed the dazzling variety of goods that were auctioned off there. Of course, as the capital, Rome was unique. But an impressive variety of both imported and locally produced goods were available even in small towns all across the empire. Diocletian's edict on maximum prices famously included over a thousand items. Exotic commodities like lions were surely not for sale in every Roman town, but the edict assumed that most of the thousand items listed were.[23] The archaeology of *tabernae* throws light on the extensive and anonymous trade networks, which made well-stocked local markets and widespread consumption possible. Raw materials such as metal ingots, purple dye, or even color pigments were traded over thousands of miles and then sold, often in small quantities, to individual artisans.[24]

A *taberna* in Herculaneum (VI 12) attests to the availability of raw materials. It belonged to a metalworker. Behind a marble counter, the tenant of the *taberna* had a smelting pot installed. Finds included various finished metal objects, most notably three bronze candelabras and a fine statue of Bacchus. The smelting pot was used to smelt lead and indeed two lead ingots were found in what had been the wooden shelves of the *taberna*.[25] These ingots went through five different hands before they ended up in Herculaneum. Nicolas Monteix suggested that the ingots originally came from Spain and that they had been stamped by a mine official, by a customs officer in the port of departure, by the merchant shipping them to Italy, by a customs official in the port of arrival, and finally by the merchant who probably bought ingots wholesale and then sold them in small quantities to individual artisans.[26]

This array of middlemen attests to an anonymous system of economic exchange. Wealthy landowners sold the produce of their estates to wholesale *mercatores,* often before it was even harvested.[27] We are less well informed about the trade in nonagricultural goods, but artisans and shopkeepers could obviously rely on wholesale merchants to provide them with raw materials and goods for retail sale. On the other end, the *procurator*

running the mine did not have to worry about marketing his ingots to their final users. Only this anonymous trade in raw materials made the local production of many goods in small, individually run *tabernae* possible.

Local production was, however, not the only source of finished goods. Roman merchants took advantage of cheap local production and traded finished goods over long distances. As much as it was profitable to import lead ingots from Spain to Campania, merchants from the north of Italy made it their business to import metal objects from the alpine client kingdom of Noricum. This trade is well attested through archaeological and epigraphic evidence from the Magdalensberg in Carinthia, Austria, where steel and bronze objects were produced in quantity and sold wholesale.

The ancient name of the Stadt auf dem Magdalensberg is still a matter of some controversy.[28] The settlement flourished for about ninety years before its inhabitants moved down the hill into the newly founded *municipium* of Virunum, which had been established by Claudius as the capital of the now-Roman province of Noricum.[29] The settlement on the Magdalensberg provides the best evidence for Roman trade in finished metal goods and reflects on the urbanistic impact that the Roman economy had all across the ancient world.

Even when the Magdalensberg was not under direct Roman control, the settlement was laid out like a small Italian town with large, elongated *tabernae* opening up to the forum (figure 4). A basilica was constructed to facilitate trade, but unique evidence for long-distance trade comes from the *tabernae*.[30] Two *tabernae* on the north side of the forum (OR/22 and OR/21) can be clearly identified as smithies. Finished metal goods were stored and sold in cellars that were accessible from their large, single-fronted entrances (OR/26 and OR/23). The cellars were decorated with fine third- and fourth-style mythological wall paintings, which attest to the popularity of such decor in purely commercial contexts, even in cellars across the imperial border.

As in Pompeii, the owners of the *tabernae* scratched business notes onto their walls; 340 graffiti survived.[31] They were almost exclusively concerned with the wholesale of many thousand steel and bronze objects to north Italian merchants, who occasionally bought well over a ton of steel and bronze objects from a single shop. The owners of the two shops in ques-

tion were southern immigrants to Noricum. Both of them installed a cult niche to Mercury in their storage cellars. Italian merchants paid respect to the god by scratching vows for their safe return right next to the cult statue. The owner of *taberna* OR/22 left his own name, L. Opaius Verrucosus, in his cellar, OR/26. The family name Opaius appears to be of Oscan origin. The owner of OR/21 dotted the Greek capital letters Θ and χ into the wet plaster of his cellar wall (OR/23) before the next layer of plaster for the wall paintings was attached. In analogy to Roman headstones, these covered letters must have been addressed to the *th(eoís) ch(thoníois),* the gods of the underworld, an appropriate dedication for a basement. This attests to at least some familiarity with the religious and magical practices of the larger Mediterranean world.

L. Opaius Verrucosus and his next-door neighbor were drawn to Noricum and the Magdalensberg by *ferrum noricum,* which was mined and produced nearby. In the early Empire, it was the only iron product that qualified as steel by modern standards.[32] The Mediterranean entrepreneurs on the Magdalensberg clearly produced items intended for wholesale,

FIGURE 4. Last phase of the settlement on the Magdalensberg. The right side of the forum is still framed by shop houses. The temple and the basilica to the left were built at the expense of earlier shop houses.

because they only sold a small assortment of goods in large quantities. The steel objects were *anuli* (rings), of which no less than 500 were sold in a single installment; *disci* (plates), of which either 110–175 or 500–575 were purchased at once; *incudes* (anvils), of which 115 and 225 were sold in two single installments; *unci* (hooks) and *secures* (hoes), which were also mostly sold in the 500s. Bronze objects like *scifi* (cups) and *urcei* (pitchers), which were made with local tin, were sold in the hundreds too. The often considerable weight of these objects is occasionally recorded in graffiti and corroborated by an egg-shaped marble weight found in OR/26 with item numbers scratched on it. The graffiti in the cellars O/23 and OR/26 mention only a very small sample from the steel objects that were demonstrably produced in the *tabernae* of the Magdalensberg.[33] Arguably, the smithies specialized in a limited set of products, which was then marketed to wholesale merchants from northern Italy. Among them was a citizen of Volubilis, which, at the time, belonged to the Roman client kingdom of Mauretania. Remarkably, he had left northern Africa to trade metal in the eastern Alps.

Steel rings, discs, and anvils were hardly items for elite consumption. They were used and maybe even further processed by local artisans and consumers of all classes. The same applies to cheap and mass-produced quality tableware like *terra sigillata* and glass that the Italian metal merchants brought to the Magdalensberg in sufficient quantities to supply almost every single housing unit excavated so far.[34] These items of daily use came in addition to many cartloads of Italian amphorae filled with wine, olive oil, and *garum,* foodstuffs that the Mediterranean metalworkers and merchants in Noricum did not want to do without.[35] Low-status bulk items of this sort dominate the archaeological record all over the Roman world. The silk from China and the spices from India that the truly rich consumed in large quantities have all but vanished.[36] Trade touched the lives of all classes across the Roman Empire, both directly and indirectly.

With the possible exception of agricultural imports into the capital, Roman trade in commodities and finished products is difficult to quantify. Archaeological and epigraphic evidence on business transactions rarely yields as much information as the *tabernae* of the Magdalensberg. Still, the evidence from the Magdalensberg and elsewhere is at least as good a source for conceptualizing the ancient economy as the relatively few sur-

viving, mostly topical and ideologically charged literary comments on trade in ancient literature. One might even argue that detailed archaeological evidence has a distinct advantage over literary sources in that it helps us understand typologically identical or, at least, very similar but less well-preserved archaeological contexts. Of course, function does not necessarily follow form. Not every *taberna* was used as a shop or workshop. But there are enough finds to suggest that most of them were, and for what follows, only the general pattern matters.

The admittedly anecdotal evidence from Pompeii and Herculaneum, and the town on the Magdalensberg, provides us with new possibilities for conceptualizing the economic life that unfolded in the many thousand excavated *tabernae* of the Roman world. The occasionally well-excavated *taberna* in Pompeii or Herculaneum and the many metal workshops on the Magdalensberg indicate that the output of a small shop or workshop could be substantial and that a *taberna* might have been run by an artisan or merchant with far-flung business connections.

Roman artisans' practice of stamping their products allows us to reconstruct the geographical distribution of high-quality merchandise. Specialized bronze tools like pincers and brushes from the workshop of an Agathangelus, which were resold on the Magdalensberg, were found all over the Western half of the Roman Empire, in places as far apart as London and Pompeii.[37] Of course, some of these objects could have traveled as personal belongings and could have changed hands many times before they ended up in their final deposits. Nonetheless, the archaeologically and epigraphically attested profitability and reach of overland trade in manufactured goods has implications for our understanding of what appears to be a relatively uniform *taberna* economy.

As we will see shortly, *tabernae* looked very much alike all over the Roman world, and were located in identical or at least very similar urban socioeconomic contexts. There is no reason to believe that *tabernae* were used in radically different ways. With this architectural type, identical business practices spread across the Roman world. Artisans from Britain to Africa and from Spain to Syria stamped their wares and relied on *argentarii* to notarize the content of purses by sealing them with a *tessera nummularia*.[38] It is telling that the ancient technical term for *tessera nummularia* is unknown, even though they were used so uniformly and frequently in

daily economic life. The details of ancient trade and business transactions were of no concern to the writers of ancient literature, who did not care about how *tabernarii* worked and lived. Still, *tabernae* were the fundamental building block of the urban economy. With the exception of labor-intensive products such as bread, pottery, and textiles, all items made and sold in the Roman world were produced in *tabernae* until the tetrarchs created large factories *(fabricae)*, mainly to produce army equipment.[39]

In conceptualizing this mode of production as a *taberna* economy, we can arrive at a better understanding of the Roman economy as a whole and the socioeconomic underpinnings of ancient urbanism, which in turn made middle classes possible.

In Hopkins's theory on monetization through taxes and rents, merchants and artisans play a crucial role in the circulation of cash. Their businesses did not allow them to pursue an active interest in farming, and the vast majority of them must have relied on buying food in the local market. In doing so, they provided farmers with cash to pay their rents and taxes. In turn, artisans and merchants had to produce and trade "marketable and exportable goods" to recoup the taxes and rents they owed.

This system can be refined further. As critics of Hopkins's model have pointed out, silver coinage circulated mostly regionally and did not flow back into the capital.[40] Consequently, Hopkins modified his model by arguing that interregional trade and taxes were conducted in gold, a guess corroborated by some of the graffiti from the Magdalensberg. One might add that there is good evidence that large transactions were not paid in cash but in paper and on credit, even though the precise mechanisms remain unclear.[41] Still, the evidence for considerable regional cash flow points to economic exchange and trade that may have been triggered by rents and taxes but was ultimately rooted in the economic condition of artisans working in a *taberna* economy.

Unlike farmers and landlords, artisans were, to a much higher degree, dependent on customer demand. Ancient farmers faced much difficulty and hardship, but a lack in demand for food and other agricultural produce was not among their troubles. Even small urban landlords hedged themselves against adverse business fortunes by diversifying their portfolios in taking on more than one renter or investing in agriculture by buying an orchard or a small villa. Artisans lacked options of this sort. They

lived off their skills and their sales. It was in their interest to produce goods for wholesale to merchants, who could pay large sums in single installments and thus help *tabernarii* to get through periods of low or modest local demand.

As we know from the distribution patterns of manufactured items, only very little merchandise was as unique as *ferrum noricum* or as well made as the toiletries and medical instruments of Agathangelus to be traded over many hundred of miles. But on a more regional scale, objects wrought and stamped in one workshop were rather common. In the case of mass-produced objects like glass and *terra sigillata,* there is no doubt that they were made for wholesale trade on a regional market.[42] Dipinti on amphorae and graffiti on ceramics prove that they were marketed not by their producers but by wholesale merchants.[43] In the case of more durable manufactured items like metal cutlery, there are not enough finds to make a statistically sound claim. Still, it seems highly unlikely that only brittle and nonrecyclable tableware was sold regionally, while objects made by specialized metalworkers were only marketed locally. It is hard to imagine that in a Roman town of no more than a few thousand people, specialized craftsmen would have found enough customers that they were able to pay their rent and their taxes, and still have had enough cash to purchase raw materials and daily necessities. Otherwise, they would have had to give up their business and start a new one, like the unfortunate businessman abused in *CIL* 4, 10150 (see above Chapter 2).

If *taberna*-based artisans commonly did have more than a local market in mind, the specialization visible in the archaeological record would make sense. High-quality products not generally available would have been attractive merchandise for the regional traders who dominated Roman trade. The regional organization of long-distance trade is epigraphically well attested by inscriptions set up by and for *collegia* of *negotiatores* and *navicularii,* who were mostly tied to a town, a region, or a river system.[44] Even if the main business of these associations was to transport grain, wine, oil, or supplies for the army, they demonstrably also traded in manufactured goods, at least on the side.[45]

This model is partly speculative, but it explains how hundreds of *tabernarii* could survive in relatively small towns and still generate remarkable profits. Cicero's *tabernae* in Puteoli earned him 80,000 sesterces in the

first year that he was renting them out.[46] This is remarkable, because Cicero had gone to some expense when he hired an architect to rebuild two of them.[47] In all likelihood, their high profitability depended on their location in what was then the main harbor of Rome. It gave Cicero's *inquilini* access to long-distance traders. In the capital, profits were even higher. Juvenal mocked a Syrian freedman for bragging about his five *tabernae* in Rome, which made him 400,000 sesterces a year.[48] If *tabernae* had not been profitable, they would not have been such a dominant feature of Roman towns for well over 500 years, and for well over another millennium in the Islamic world, where the bazaar was (and in some cases still is) made up of *taberna*-lined shopping streets.

Interestingly, Peter Fibiger Bang has argued that the Asian bazaar with its many small merchants provides a good model for conceptualizing the urban markets of complex agrarian societies like the Roman Empire.[49] Just like a bazaar economy, Bang argues, Roman markets were characterized by a "parcelling of capital, low standardization of products, opportunistic speculation and the formation of segmented social networks."[50] With his model, Bang takes aim at the Braudelian concept of Mediterranean connectivity as envisioned by Horden and Purcell.[51]

Even if he were correct, his observations would still tie in with the following argument. The bazaarlike shopping streets of the Roman Empire may not have functioned within a fully integrated Mediterranean market, as Bang argues.[52] But the Roman urban market system worked so well on a local and regional level that it was adopted all over the Roman Empire. Despite regional differences in layout, *tabernae*, and with them small businesses of artisans and retail merchants, lined the main roads of Roman cities all across the empire, which no longer looked or felt like farming towns and allowed for the rise of urban middle classes, who shared a similar market situation: they depended on their skills and sales within a far-flung trade network.

Tabernae across the Empire

Tabernae were so common a feature of Roman cities that their ubiquity has been taken as a matter of course. Mostly, *tabernae* are seen as additions to houses and public buildings, which are the primary focus of current

archaeological interest. This view elides the fact that the many hundred *tabernae* lining the streets, squares, and temples of the Roman world effectively turned the public sphere into a bazaar. The spread of *tabernae* throughout ancient cityscapes meant the commercialization of urban life all over the empire, despite regionally distinct patterns. Hellenistic and later cities emerged as centers of production and trade, even in regions that lacked a strong and long-established tradition of urbanism. Again, the settlement on the Magdalensberg serves as a good starting point for a discussion of this phenomenon.

The oldest buildings on the Magdalensberg were *tabernae* surrounding the forum. Their single-fronted entrances were borrowed from Italian *tabernae*, while their elongated shape followed that of other shop houses in the northwestern provinces. With the exception of their elegantly decorated cellars, the *tabernae* of the Magdalensberg fit well into the typology of northwestern workshops and shop houses. Contrary to the current emphasis on political ideology as the driving force behind the dissemination of Roman urbanism, it is noteworthy that *tabernae* preceded the large public buildings, which were added to the forum over time.[53] The first was a basilica on its eastern side. With the incorporation of Noricum into the Roman Empire, the original market hall was razed and replaced by a new building on the northeastern corner of the forum. To the west of this new basilica a large temple was erected. The new basilica and the temple were constructed at the expense of half a dozen *taberna* houses, while two large courtyard houses went up on the west side of the forum. Still, its northwestern corner and its east and south sides were lined by *tabernae*. Most other houses in the city also continued to function as shop houses.[54]

The special position of the settlement on the Magdalensberg as a center for trading and refining local resources like iron, tin, gold, and rock crystal explains only in part why most of its housing units were *taberna* houses. In the northwestern provinces, shop houses made up the majority of all urban residential units, not only in newly founded cities and *vici*, but also in indigenous settlements, which experienced "Romanization" over time. This makes the northwestern provinces an interesting test case for the role of Roman cities as centers of production and trade. Roman-style urbanization introduced previously unknown architecture to northwestern Europe, which restructured and reframed politics, religion, and

leisure. But just as importantly, it also introduced new ways of doing business.

This emerges from Ardle MacMahon's study, *The Taberna Structures of Roman Britain*.[55] His comprehensive approach enables us to understand how imperial expansion changed the economic underpinnings of urban life at the very edge of the Roman world. As in other northwest European sites like Bliesbruck, *taberna* houses were the fundamental building block of early Romano-British settlements like London and Verulamium/St. Albans.[56] In the case of the *canabae* that grew around military camps, it intuitively makes sense that they provided business opportunities for merchants and craftsmen, because the soldiers stationed nearby had to spend their pay somewhere. In larger cities, the predominance of shop houses points to a more general and profound commercialization of urban life.

Unlike those in the heavily urbanized Mediterranean, most cities in Roman Britain were built on virgin soil. Construction was initially carried out in timber or wattle and daub. Still, the principles of Romano-British domestic architecture reflect strong Mediterranean influences. The rectangular shop houses dominating British cities were a departure from the round huts that were still being constructed after the indigenous fashion. Also, their wide shop fronts were a novelty.[57] Their elongated ground plans and position perpendicular to the street suggest a competition for street frontage.[58] Its commercial value was also recognized by the authorities. The famous cadastre from Arausio (Orange) shows that urban property taxes were calculated by street frontage and not by ground area. They ran up to one *denarius* per foot, a steep prize compared to four *asses* per rural *iugerum* (28.800 square feet or 2,520 square meters), which were calculated by ground area.[59]

In the towns of Roman Britain, there was obviously no shortage of artisans and shopkeepers who were interested in building shop houses in the center of town. Roman sites like Silchester and Caerwent were distinctly commercial in character, with *taberna* houses dominating in the city center. Purely residential units were confined to the fringes of town.[60]

The timber construction used in Britain limits the available evidence to ground plans. There is almost no surviving wall decoration and graffiti are also almost completely absent from the archaeological record. Still, the predominance of timber construction has its advantages for reconstruct-

ing economic life in Roman Britain. Wood houses have to be rebuilt over relatively short intervals. This results in a continuous sequence of building phases, which, in turn, throws more light on patterns of use and ownership than is the case with more durable masonry buildings. *Taberna* strip houses in Roman Britain were often rebuilt on the same spot and improved and enlarged in the process of rebuilding. Competition for street frontage limited expansion to the rear, which resulted in increasingly elongated ground plans. Permanent installations such as ovens and smelting pots often remained in the same spot, suggesting continued use as workshops.[61]

Unlike those in the Mediterranean provinces, *tabernae* were only rarely subordinate to a large residential property. If they were, the larger unit had typically been created by connecting several formerly independent shop houses.[62] It is noteworthy that in the Mediterranean, urban commercialization occurred in the opposite direction: there, shops were typically walled off from preexisting houses. In Britain and elsewhere in the northwestern provinces, urban settlements started out as commercial centers, not as farming towns.

As suggested by Tacitus in his discussion of Roman Britain, the cultural impact of Roman-style public architecture on the indigenous population was profound.[63] Still, towns in the northwestern provinces worked as a conduit for more mundane Roman business and material culture, too. The objects produced in the shop houses of the northwestern provinces followed Mediterranean prototypes. This must, at least in part, be due to the immigration of southern craftsmen, who, in Noricum, are attested by graffiti on the Magdalensberg. In Tacitus's narrative of Boudicca's uprising, London is such a commercial town, which is mostly inhabited by southern immigrants.

There is little indication that the commercialization of Romano-British cities was the result of government policies. Public structures like *fora* were surrounded by *tabernae,* as in Caerwent, but most workshops were constructed on private initiative.[64] Roman government intervention in urban life was primarily concerned with settling veterans in newly founded or preexisting communities, who, like during the Republic, were given land at the expense of the local population. The bad behavior of Roman veterans in the *colonia* Camulodunum famously triggered Boudicca's uprising, while the *oppidum* London and the *municipium* Verulamium remained

calm.[65] Tacitus claims that these two lower-status settlements had a combined population of 70,000 citizens and allies, who were slaughtered when the British razed the towns to the ground.[66] This number is almost certainly exaggerated, but it attests to large urban settlements with populations viewed as foreign or hostile by rebellious locals.

During the uprising, the Roman governor C. Suetonius Paulinus sacrificed London and Verulamium out of military concerns, because neither town was a legionary fortress or a *colonia*. This destruction is archaeologically well attested. Excavations at London and Verulamium reveal their distinctly commercial character.[67] Despite the governor's lack of concern for the merchants of London, a substantial number of artisans and merchants still moved to lesser-status towns like these in Roman Britain and elsewhere in the northwestern provinces. Initially, both cities were made up mostly of shop houses that must have either belonged or catered to the *copia negotiatorum,* which, in Tacitus, is the defining feature of pre-Boudicca London.[68] Unlike veterans, who had privileged access to native land, businesspeople depended on commerce and trade. This may explain the dominance of shop houses in the early Roman cities of Britain and in the northwestern provinces in general. The dominance of *taberna* strip houses in early Romano-British cities led Dominic Perring to conclude with Cristopher Walthew that the wealthy landowning elites originally lived in the countryside and did not move into the cities until the second century c.e.[69]

In the eastern Mediterranean, the connection between Roman political expansion and the migration of Italian merchants is well attested through literature and epigraphy from the late second century b.c.e. onward. The best-known site throwing light on this phenomenon is the port of Delos with its large population of Italian traders who freely mingled with their Greek and Phoenician counterparts. Before its destruction in 88 b.c.e. by Mithridates of Pontus, Delos played host to ethnic communities of foreign traders, who met in their own clubhouses and financed large public market buildings, while local businesses thrived in over 500 shops.[70]

Delos was not the only destination for Italian merchants in the first century b.c.e. Mithridates famously ordered the murder of 80,000 Italian immigrants to western Asia Minor, when he went to war with Rome. While many Greeks may have seen them as agents of Roman rule, there is little indication that this was the view of the Roman authorities them-

selves. Rome's control over the Mediterranean allowed for increased mobility of businesspeople, who performed government duties as tax farmers and contractors *(publicani)*.

The great prosperity of western Asian cities under Roman rule limits most of the readily available archaeological evidence to the first two centuries c.e., when Asia Minor and Syria experienced an unprecedented building boom. Still, most public buildings in Eastern cities had Hellenistic predecessors that were almost as impressive. In the course of the imperial period, even relatively small cities were rebuilt in marble, featuring flashy temples, theatres, *stadia,* market buildings, *nymphaea,* and, most importantly, colonnaded streets. Most of the construction was funded by a handful of leading local families. This explosion of euergetism has been framed culturally by the phenomenon of intercity rivalry, and socioeconomically by the well-worn concept of the consumer city.[71]

Especially in Asia Minor, Greek cities under Roman rule stressed their mythic origins and long, distinguished histories, often in competition with their neighbors. Success in this occasionally bizarre competition was measured by titles and honors that emperors and high-ranking officials bestowed on leading cities.[72] An impressive cityscape of marble buildings was as much part of the currency of competition as were widely recognized religious festivals and imperially sanctioned temples *(neokoriai)* dedicated to the imperial cult.[73] At first glance, the ostentatious spending of local elites, which made this competition possible, ties in nicely with the concept of the consumer city. From the perspective of public architecture, western Asian cities appear as a hub for within-group social competition between local leading families. Yet their munificence had strong commercial undertones, an issue that has been neglected in scholarship to date.

One of the most remarkable features of eastern cities is the expense that went into colonnaded avenues *(plateiai),* which featured many hundreds, if not thousands, of marble and granite columns.[74] Tellingly, classical archaeologists have focused on excavating the colonnades, but not on the hundreds of shops that opened up to them. As much as a *plateia* added to a city's beauty, it contributed to its "bazaarization" and its increased role as a commercial center.[75] In Phrygian Apameia, a *plateia* was named after the city's shoemakers,[76] in Lydian Sattai after the linen makers and shoemakers.[77]

From an aesthetic perspective, colonnaded streets have a powerful uni-
fying effect. On a *plateia,* a city can no longer be perceived as a series of
individual houses, but appears instead as a continuous façade. This had
major ramifications. Unlike Pompeii, where ostentatious façades and richly
decorated entrances singled out large and important houses, cities featur-
ing colonnaded streets prevented the rich and powerful from positioning
their residences prominently in public view. Influential citizens were pres-
ent on colonnaded streets and public squares through statues and monu-
ments in their own and their families' honor.[78] This public presence was,
however, not rooted in wealth alone, but instead linked to euergetism,
which gave eastern *poleis* a distinctly civic look.

This civic look was reinforced by the commercial character of their
colonnaded streets. The shops lining a *plateia* blocked all other architec-
ture from public view. As a result, the domestic sphere, which had been so
central to classical Greek and Roman aristocratic ideology, was almost
completely excluded from the monumental cityscape, while streets, squares,
and even temples were populated by artisans and merchants.

The best-known colonnaded street was constructed in second-century-
C.E. Apamea on the Orontes. It was of impressive proportions. The main
north-south avenue *(cardo)* of Apamea was 1.85 kilometers long and 20
meters wide. The colonnades flanking it were 7 meters deep and 12 meters
high. They were paved with mosaics. The shops opening up to them were
sheltered by an impressive two-story façade, which was decorated with
wall paintings and statues.[79] Altogether, the two porticoes housed over
two miles of shops. The *plateiai* of Apamea and elsewhere spread the ar-
chitecture of market halls along major urban arteries. Previously, this ar-
chitecture had been confined to central city squares. With the construc-
tion of *plateiai* in the Hellenistic East, main city streets were not only
transformed into shopping malls but also embellished as if they were the
main *agora.* In an architectural sense, the *plateia* did, in fact, supersede
the marketplace in its urbanistic role as the heart of town.

In many cities of the Hellenistic East, *agorai* were no longer crossed by
a main artery but, instead, merely placed alongside one. The *agora* and
other public squares were accessible through large *propylaia* interrupting
the colonnades of a *plateia,* but were no longer automatically traversed on
the way from one end of a city to the other. As a result, shopping streets,

and with them shops and workshops, became the defining feature of some of the largest and most prosperous cities in the ancient world.

Remarkably, commercial avenues of eastern cities served as the primary stage for displaying civic pride. The best-studied example is the *cardo* of Pamphylian Perge.[80] This *plateia* started at the old Hellenistic city gate, which, by the early second century c.e., had been restored as a monument to Perge's past and now housed a statue gallery of its main local deities, mythic founders, and leading citizens.[81] Immediately after the gate, it crossed a three-way arch and ended after 480 meters in front of a two-storied fountain house at the foot of the acropolis hill. From beneath the statue of the local river god Kestros, a cascade poured down into a canal that ran in a series of basins from the fountain house back to the Hellenistic gate. There it disappeared underground. The *cardo* was lined by porticoes, shops, and honorific statues, with archways marking intersecting streets.

Michael Heinzelmann has drawn attention to the street as an example of "collective euergetism."[82] Unlike those in Apamea and other Seleucid foundations in the Syrian Decapolis, the *cardo* of Perge was not part of the original town plan. Instead, it was created in the second century c.e. following an old street, which, in three slight bends, climbed up 20 meters from the city's main Hellenistic gate to the foot of the acropolis hill. As Heinzelmann pointed out, the construction of the *plateia* cut an aisle 50 meters wide through the heart of Perge.[83] The widening of the street and the construction of the porticoes and shops lining it affected many individual properties. Remarkably, all parties involved agreed on the project; they also seem to have paid for the section of the colonnades running along their property. This conforms to the financing of a *plateia* in Prusa, which was sponsored by Dio Chrysostomus (see below). It can also be demonstrated archaeologically.

Heinzelmann could show that architectural details in individual sections of the colonnades and the layout of the shops behind them differ from *insula* to *insula*. Still, the capitals and bases of the colonnades can be attributed to a single workshop. This implies that these differences were not caused by long delays in the *plateia*'s construction or the importation of prefabricated pieces from a variety of sources. Instead, individual landlords must have determined the design of their section of the *plateia* according to their tastes and means, while employing the same craftsmen.[84]

This also seems to apply to Perge's main east-west artery *(decumanus),* which is less well studied. The two *plateiai* of Perge attest to the civic pride of the city's landlords, who united to embellish their city. But it also shows their shared economic interests. The shops behind the porticoes could be sold or leased for profit. Some merchants and artisans intended to stay for some time. They had their names laid out in mosaic in front of their shops.[85] Civic pride went hand in hand with commerce.

Tellingly, Dio Chrysostomus encountered popular resistance when he sponsored the construction of a *plateia* in his hometown of Prusa without making provisions for shops. Dio was only concerned with Prusa's beauty vis-à-vis other Greek cities.[86] During construction, smithies and probably other shops on the main street that was to be transformed into the *plateia* were demolished.[87] This provoked popular anger. New shops were constructed elsewhere, but this was not good enough. There was no adequate replacement for prime retail space located at one of the city's main urban arteries. Ultimately, the demolition of one particular smithy triggered so much outrage, it seems to have scuttled the whole project, after only a short section of the colonnades had been completed. Several wealthy citizens who had initially agreed to contribute to the project apparently withdrew their support.[88]

As a member of the cosmopolitan imperial elite, Dio was out of touch with the local economic concerns of his less affluent fellow citizens. He preferred to represent himself as a wealthy landowner, even though he had constructed workshops close to his main residence, which he probably let for rent.[89] Infuriated over the delay (and quite possibly ultimate failure) of his project, Dio penned bitter accusations against his enemies in Prusa, which are revealing in their fixation on aesthetics and in their indifference toward urban economics:

> But there was a lot of talk—though not on the part of many persons—and very unpleasant talk too, to the effect that I am dismantling the city; that I have laid it waste, virtually banishing the inhabitants; that everything has been destroyed, obliterated, nothing left. And there were some who were violent in their lamentations over the smithy of So-and-so, feeling bitter that these memorials of the good old days were not preserved. One might have supposed that the Propylea at Athens were being tampered with, or the Parthenon, or that we were wrecking the Heraeum of the

Samians, or the Didymeium of the Milesians, or the temple of Artemis at Ephesus, instead of ridiculous ruins. . . . And yet there are some who were distressed to the signs of their former poverty and ill-repute disappearing, who, far from being interested in the columns which were rising, or in the eaves of the roof, or in the workshops under construction elsewhere, were interested only in preventing your ever feeling superior to that motley crew [of blacksmiths].[90]

Benefactors and magistrates wiser than Dio respected the concerns of businessmen and both preserved old and constructed new shops when embellishing their cities. This even applied to public buildings of great civic and political importance. Domitian granted Ephesus the construction of its first neocorate temple, an honor that significantly bolstered the city's status as the "metropolis of Asia."[91] The construction of the temple itself was one of the largest new building projects that Asia Minor had seen in centuries. It was constructed on a steep slope next to the political *agora* *(Staatsmarkt)* of Ephesus. The difficult terrain required terracing to provide a level building ground of 50 by 90 meters. Downhill, the northern temple terrace was shored up by a series of multistoried vaulted chambers.[92] They were sheltered by a marble façade overlooking a small plaza (the so-called Domitiansplatz). The façade featured anthropomorphic pillars representing defeated barbarians.[93] A flight of stairs allowed sacrificial processions to ascend right to the altar.

This richly decorated terrace wall hosted a latrine and a series of shops placed within the vaulted chambers. They functioned as *tabernae cum pergulis*.[94] On its east side, the *temenos* was lined by another row of vaulted chambers, which replaced preexisting *tabernae*.[95] Not only did the Ephesians make sure that the construction of their neocorate temple did not interfere with the commercial value of an older shopping street; they also opened up new shops in the terrace façade of a temple that, at the time of its construction, came second in importance only to that of the Ephesian Artemis. The magistrates in charge of the project were careful to preserve preexisting shops and eager to create new shops that would ensure a steady flow of urban rents to their city in addition to income from agricultural rents.[96] In Ephesus, the only epigraphically attested workshops might have been attached to one of the city's *gymnasia*.[97] As occasional epigraphic evidence shows, shops in public buildings could be public property and let for profit.

Shops are rarely mentioned in building inscriptions, which tend to commemorate the construction of much larger buildings and honorific monuments. Still, there is no doubt that cities owned and let *tabernae* for rent.[98] An unusual but all the more informative inscription from Aphrodisias mentions a thoughtful local benefactor who refused the great honor of an intramural tomb, which would have been constructed at the expense of "public workshops opposite the *bouleuterion,* because he did not want to lessen the revenue of the city."[99]

In addition to letting shops and workshops for rent, magistrates could also assign space to corporations and hawkers in porticoes that lacked *tabernae.* In the colonnades flanking the marble street *(Marmorstrasse)* of third-century-C.E. Ephesus, this space was measured in intercolumniations *(diástyla).*[100] If we imagine these traditional *stoai* without permanent shops as places of commerce and trade, it is hard to find a public space that was not populated by artisans and merchants. In Ephesus, a trade organization like the "union of Roman citizens doing business in Asia" asserted its presence on the city's main *agora* by erecting equestrian statues to the emperor, and may have contributed to civic building projects.[101] One of the four *stoai* delineating this market was referred to as "bankers hall."[102]

While there is some information about which businesses were clustered in which public buildings of Ephesus, it remains unclear where the merchants and artisans doing business in publicly owned shops and workshops lived. There were traditional *tabernae* with backrooms and *pergulae* in front of so-called Hanghaus 2, the substructures of Domitian's temple, and in the shops of the late antique *stoa* of the Alytarchs.[103] But the roughly 200 shops of the city's main *agora,* and the *tabernae* lining the façade of the so-called eastern gymnasium, lacked *pergulae* or backrooms, which could have served as permanent living quarters.

Unlike that of Italy or northwestern Europe, the domestic architecture of Ephesus and other Eastern cities seems dissociated from shops and workshops. This makes the two fully excavated domestic *insulae,* Hanghaus 1 and 2, difficult to assess socially. A few external staircases suggest apartments for rent on the second floor, mostly over modestly sized housing units. But without a direct architectural connection to shops and workshops, it is impossible to conclude whether they were rented by businesspeople.[104]

Nevertheless, cities in the eastern empire did not differ categorically from western cities. Structurally, Greek and Syrian cities shared the commercial disposition of cities in the West: major streets were lined by shops and workshops, while residential units showed a great variety in size and comfort. Regional cultural differences in urbanism did not translate into a widely diverging pattern of commerce and trade.

On the whole, many if not most cities of the Roman Empire were distinctly commercial in character. This raises questions about the socioeconomic status of artisans and merchants and, by extension, about the nature of Roman urban life. Leisured elite writers often portrayed artisans and merchants as part of a fickle and violent urban mob. Epigraphic and archaeological evidence point to a more nuanced historical reality. Urban businesspeople were well integrated into the socioeconomic fabric of their cities, both individually and collectively. If we accept the ancient *topos* that it is men and not buildings that make a city, the cities of the Roman Empire were the cities of middle-class artisans and businessmen.

Artisans and Merchants in Urban Life

The ubiquity of shops and businesses in Roman cities attests to the prominence of individual merchants and craftsmen in urban life. Collectively, artisans and traders left their mark on the cityscape by building clubhouses *(scholae)*, sanctuaries, tombs, and honorific monuments in the names of the professional associations to which they belonged.[105] This lively building activity need not reflect political influence or civic significance of artisans and merchants. But there is good evidence that it did. Professional associations of artisans and merchants did play an important social, economic, and political role. Their activities, building and otherwise, throw light on the dynamics of urban life in the commercial cities of the Roman Empire.

Artisans and merchants could and did influence local politics. As we have already seen, sympathy with a blacksmith in Prusa may have scuttled the pet project of Dio Chrysostomus, who was both wealthy and personally connected to the emperors Nerva and Trajan.

In a better-known episode, the silversmith Demetrius of Ephesus provoked a riot against the apostle Paul.[106] Demetrius feared that Paul's

missionary work in Ephesus and Asia Minor might cause him financial harm. Demetrius and his fellow silversmiths made a handsome profit from producing devotional shrines for Artemis and were concerned that they might lose this business with the further spread of Christianity.[107] Demetrius rallied his fellow craftsmen by reminding them, "this work [of making shrines] is the source of our wealth."[108] He also succeeded in stirring up unrest in the city. Ultimately, an angry mob dragged two of Paul's companions into the theatre.[109] The situation was only defused when the city clerk *(grammateùs)*, the chief magistrate of Ephesus, addressed the assembly: he assured the crowd of the city's unwavering commitment to Artemis, but also stressed that neither Paul nor his followers had broken the law. Conversely, the current assembly was unlawful and might cause trouble if the (obviously Roman) authorities were to inquire about the reason for this extraordinary meeting. If Demetrius and his fellow craftsmen were to press charges against Paul, they should do so in a court of law.[110]

In this episode, Lucas does not mention the Ephesian association of silversmiths, which is epigraphically well attested.[111] Still, the *synédrion tôn argyrokópon* of Ephesus has featured prominently in the discussion of the Demetrius episode, and that of the socioeconomic condition of Roman craftsmen. Demetrius has been labeled a guild master or union boss of the Ephesian silversmiths. This is neither supported by the Acts of the Apostles nor accurately reflects the role of influential craftsmen within the professional associations that did exist in antiquity.[112]

Contemporary scholarship has focused on the social aspects of ancient *collegia, synedria, synodoi,* and *koina.* All such voluntary associations had their own communal religious and social rituals.[113] Most of them were founded around narrowly defined trades. In what follows, I refer to all professional associations as *collegia* for simplicity's sake, even though the Latin word is more inclusive and just one of many Greek and Latin terms that refer to clubs of all kinds.

At least from the epigraphic record, *collegia* primarily emerge as an odd mixture between religious, dining, and burial clubs. To many scholars, self-help groups like seventeenth–nineteenth-century "friendly societies" seem to be a more fitting historical analogy to ancient *collegia* than medieval guilds or modern trade unions.[114] Membership in a *collegium* was not a prerequisite for practicing a trade, as was the case with medieval guilds.

Collegia could not legally enforce their internal charters and rarely enjoyed state privileges. The Senate and, after Augustus, emperors, governors, and jurists viewed *collegia* with suspicion, as a potential breeding ground for civic unrest. This was partly justified and may be reflected in the speech of the Ephesian city clerk in the Acts of the Apostles.[115]

Still, professional associations played an important and mostly constructive socioeconomic role. Nothing prevented individual *collegia* from brokering voluntary business arrangements between their members. There is at least one unambiguous example: the charter of an association of salt merchants from the Egyptian town of Tebtynis stipulated where and when individual members could sell salt and gypsum, even though the charter itself was probably not legally binding.[116] As Phillip Venticinque argued, tight social control within professional associations helped create a network of trust between businessmen working in the same field.[117] There is good reason to believe that Adam Smith's famous dictum that "people of the same trade seldom meet together, even for merriment and diversion, but the conversation ends in a conspiracy against the public" also applied to antiquity.

While neither Dio Chrysostomus nor the Acts of the Apostles explicitly refer to *collegia,* the blacksmiths of Prusa and the silversmiths of Ephesus appear as tightly knit groups. For mapping the social, economic, and political roles of artisans in urban life, it is not all-important to know whether the silversmith Demetrius or Dio's blacksmith nemesis were *collegia* presidents, or whether their fellow craftsmen were organized in a trade-based association. What matters here is that commercial concerns, whether the very real loss of prime commercial real estate or the idée fixe of a prominent silversmith, could trigger communal action. In Prusa and Ephesus, a distinct group of artisans enjoyed enough support among the general population to stir up trouble for rich councilmen like Dio, who saw his grand plans for Prusa foiled, or the *grammateùs* of Ephesus, who had to worry about Roman intervention.[118]

Arjan Zuiderhoek has argued that these two episodes reflect the complexities of political life in Greek cities that retained some form of popular government under Roman rule, and where artisans and shopkeepers remained an important part of the *demos.*[119] Already in the first century B.C.E., Cicero remarked that popular assemblies in Asia could easily be hijacked by the *egentes et leves,* if powerful outsiders chose to marginalize

the political influence of wealthy local elites *(locupletis homines)*.[120] Cicero indentified these "poor and 'thin' men" as craftsmen *(opifices)* and *tabernarii*. Similarly, Rome's artisans and *collegia* were singled out for their role in political violence.[121]

This role of *collegia* in communal strife has attracted much scholarly attention. But for the most part, the interaction between trade associations and the authorities must have been at least professional if not friendly. Local magistrates and craftsmen depended on each other, because ancient cities lacked a public maintenance department to carry out public works. Cities rarely hired (or owned) more than a couple of secretaries, and public magistrates employed only a skeletal administrative staff out of their own pockets. Most government functions and all public works had to be contracted out to local businesses. Outside Egypt, very few documents refer to such contractors *(redemptores)*.[122] But under rubric 93, the famous municipal law of Urso banned the *duumviri* from accepting gifts from *redemptores*. This concern about the corruption of public officials suggests a much closer relationship between urban craftsmen and local elites than is typically assumed. Papyri provide a much better insight into the deals struck by civic magistrates and contractors.

In supplying a city with bread or a gymnasium with olive oil, local magistrates dealt with individual businesspeople on a regular basis. These officials worked closely with *collegia* to manage large projects.[123] For instance, public baths required constant maintenance. Documents from Egypt suggest that the *collegia* of iron and glass workers were regularily involved in repairing the baths, probably by fixing up the piping and replacing windows.[124] In the absence of comparable evidence from any other part of the Roman world, we can only speculate as to whether similar arrangements were made in Italy or Asia Minor, but there is good reason to suspect that they were. In the *Satyrica*, the freedman Ganymede blames high bread prices in his fictional city to the collusion of the local *aediles* with the bakers.[125] Here, Petronius followed a common literary motive. Also in reality, bakers and market officials were often accused of collectively fixing bread prizes.

In contrast to the literary focus on violence and racketeering, Roman *collegia* also pursued their economic interests peacefully and legally. A famous inscription from 244 C.E. commemorates a remarkable victory the Roman *collegium* of fullers won in a twenty-year lawsuit against the office

of the *curator aquarum*.[126] The odds in this trial must have been stacked against the fullers. The *cura aquarum* was typically held by a junior senator at the beginning of his career. Young nobles towered over artisans and merchants, not only in respectability but also in very real legal terms. According to the ruling, the *collegium* was effectively freed from a tax levied on the commercial use of public water. Previously, these dues had been paid collectively by the *collegium;* this single payment gave all its members free access to public water. This arrangement must have been a motivation to join the *collegium* in addition to the legal protection that the *collegium* could provide. Also, powerful individuals acted as patrons of Roman *collegia* and intervened on their behalf.[127]

Yet, for the most part, *collegia* seem to have been in no need of legal support. At least in Rome and Ostia, conflicts between the government and professional associations must have been mitigated by the personal connections of some influential *collegium* members. For instance, the *collegium* of contractors and builders *(fabri tignarii)* counted many imperial freedmen among its ranks. There were also freedmen of leading senatorial families involved in the Roman construction industry. The rich epigraphic evidence on the *collegia* of the *fabri tignarii* in Rome and Ostia illustrates how the commercial interests of the local aristocracy and some leading craftsmen overlapped.

Imperial freedmen probably received their training as slaves and initially participated in imperial building projects.[128] When their services were no longer needed, they were freed to pursue their own business, but could be called upon whenever the emperor needed a reliable builder. A similar pattern seems to have applied to *fabri tignarii* freed by senators. Among the members of the *fabri* were former slaves of Statilius Taurus.[129] This ranking senator had always been a loyal ally of Augustus and was, as a result, co-opted to participate in the emperor's ambitious program for the beautification of Rome. Statilius Taurus also built Rome's first permanent amphitheater on his private property. Two generations later, the freedman Q. Haterius Tychicus—who erected one of Rome's most impressive funerary monuments for himself and his family—was freed by the Haterii who owned brickyards in Narni.[130] As his patrons, the Haterii were entitled to a share of his profits and could possibly expect him to use their bricks in his contracts.

This aristocratic outsourcing strategy mirrors the practice of letting commercial real estate. Renting out shops generated a steady income for landlords of all classes. It left the management of a *taberna*-based business to its tenant, who carried all the risk. The same applied to freed slaves like the freedmen contractors mentioned above, albeit on a larger scale. While senators like Statilius Taurus could probably rely on freedmen contractors for their private building projects, the Roman state seems to have had a vested interest in fostering *collegia* that served as a pool of highly qualified professionals, who were badly needed for running the government. In the fourth century C.E., this is well attested for the ship owners *(navicularii)* involved in the food supply of Rome and Constantinople.[131] But it also seems to have applied to the *fabri tignarii*. Their *collegium* was one of the few not disbanded following the "gang violence" of the first century B.C.E., which had also involved some *collegia*. Asconius Pedanius explained the survival of the *collegium fabrorum* with its usefulness for the city *(utilitas civitatis)*.[132] In many Roman cities, *fabri* doubled as builders and firefighters. Only a few very large cities had a specialized fire brigade like Rome's *(vigiles)*, which Augustus created as late as 6 C.E.[133] The *collegium fabrorum (tignariorum)* itself was reorganized in 7 B.C.E., right around the time when Augustus took up the *cura operum publicorum* as part of his ambitious project to transform Rome "from a city of brick into a city of marble." Frank Kolb suggested that the *princeps* himself had refounded the *collegium* to create a "functioning private construction industry."[134] Augustus's involvement is impossible to prove, but imperial interest in the *collegium* is corroborated by Pliny the Younger. In his panegyric to Trajan he compared the *optimus princeps* to past emperors who had bothered the Senate with trivialities, for instance, in having them debate the foundation of a *collegium fabrorum*.[135]

Despite Pliny's harsh verdict, imperial agency in the founding of the *collegium* would have made sense. Imperial building projects often required many thousands, if not tens of thousands, of workers. At least based on the small number of imperial freedmen enrolled in the Roman *collegium fabrorum tignariorum*, it is hard to imagine that they alone could have managed projects of the size of an imperial forum, an amphitheater, or imperial *thermae*. In recruiting contractors for large building projects like the Colosseum, the *collegium* of the builders must have been a convenient place to go. Q. Haterius Tychicus, who was not a freedman of the

Flavian dynasty, seems to have helped building the Colosseum and arches in honor of the new emperors. How he won these contracts is not entirely clear, but prominence in a large and well-known *collegium* may have helped.[136]

A cadre of well-connected contractors also belonged to the builders' club of Ostia. Quite a few of Ostia's builders rose to prominence in the city.[137] These remarkable examples of social mobility attest to the fortunes that could be made in the urban economy and also to the political connections that at least some *collegia* enjoyed. The *fabri tignarii* of Ostia provide rich information on the life of professional associations. Many inscriptions and the clubhouse of the *collegium* have survived. It was founded around the middle of the first century C.E. Its internal division into sixteen *decuriae* was modeled after the Roman *collegium fabrorum,* which was larger and included 1,500 members in sixty *decuriae.* As at Rome, membership in a *decuria* was capped at twenty-two *fabri.* Each *decuria* was headed by three *magistri quinquennales* and supported by three *scribae.* The *collegium* did not admit slaves and must have restricted membership to contractors or, at the very least, master builders.[138] The construction industry at Rome and Ostia employed thousands of workers and not just 1,500 and 400 *fabri,* respectively.

The relative exclusivity of the Ostian *collegium* is neatly illustrated by the success of all its known freedmen *magistri.* They did not dominate the *collegium* but, as so often in Roman epigraphy, are easily identifiable and thus lend themselves as a test group for social analysis. All freedmen *magistri* were *Augustales,* the highest office a former slave could hold. In addition, two freedmen masters were made honorary councilmen in receiving the *ornamenta decurionatus.* One of them, M. Licinius Privatus, paid a staggering 50,000 sesterces for the purely honorary rank of a *bisellarius in primis constitutus,* the highest distinction a *decurio* could achieve. His freeborn sons became full council members, while his grandsons entered the equestrian order.[139]

In the late second century C.E., the *magister quinquennalis* C. Iunius Euhodus commissioned a sarcophagus on which he and his wife, Metilia Acte, were represented as Admetus and Alcestis. In life, Metilia Acte had been the priestess of Cybele, a deity with a public cult and a large sanctuary in the city. The builder and his wife must have been figures of some

standing. At least on their sarcophagus, they were surrounded by close friends, whose distinctive portraits had been placed on the naked bodies of Greek heroes witnessing the death of Alcestis/Acte (see below, Chapter 4).

The clubhouse of the *fabri* complements the epigraphic evidence and gives further insight into the activities of the *collegium* (figure 5). It stood at the intersection of the *decumanus maximus* with the forum. The clubhouse occupied an entire block. Because of its size and very solid construction, it was first believed to have been built as a regular apartment block. Supposedly, the transformation into the *schola* of the *fabri tignarii* occurred only later. However, a close analysis of the building by Beate Bollmann has shown that it was designed as a clubhouse from the very beginning.[140] The *schola* was arranged around a porticoed courtyard. In the courtyard, a statue of Septimius Severus, dedicated by the *fabri tignarii,* was still found in situ. A large barrel-vaulted exedra at the far end of the courtyard was placed in the axis of the main entrance from the *decumanus.* The exedra was decorated with a marble podium that ran around its walls. The podium supported statues, probably those of the *lares* of the *collegium* and various emperors. The current layout of the exedra dates to

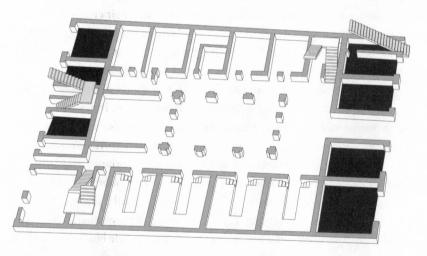

FIGURE 5. *Schola* of the *fabri tignarii* of Ostia. The commercial units rented out by the *collegium* are shaded in dark gray. External staircases leading to rental apartments are shaded in lighter gray.

the third century C.E. but probably mirrored an earlier arrangement. Further rooms opened up to the courtyard on its west and east sides. The function of the five western rooms is unclear. They could be locked but had windows onto the courtyard. The four eastern rooms were large purpose-built *triclinia*.

This layout reflects the epigraphically attested activities of Roman *collegia:* communal dining and religious ceremonies with an emphasis on the imperial cult. What makes the *schola* of the *fabri tignarii* particularly interesting is that it provides information on the financial clout of a well-to-do *collegium*. The *schola* of the builders could be mistaken for a remodeled residential *insula* by earlier scholars, because it included *tabernae* and *cenacula* for rent. The *collegium fabrorum tignariorum* was an urban landlord, and purposefully so. As Bollmann has shown, the layout of the courtyard differed from that of Ostian residential *insulae:* the axially placed exedra and the regular, purpose-built diningrooms indicate that the *insula* was designed from the start as a clubhouse; but *tabernae* and *cenacula* were also part of the original plan.[141] Obviously, the *fabri tignarii* conceived their *schola* as a meeting place and, at the same time, as a productive asset that could help support the *collegium*'s common fund in addition to the membership and other fees the *collegium* members had to pay.

The rental income the *fabri tignarii* derived from their clubhouse must have been substantial. The main north entrance of the *schola* was flanked by two independent *tabernae* each. They were located at a very busy spot, where the *decumanus maximus* intersected with the Ostian forum. A staircase on the exterior northwest corner of the *schola* led directly from the *decumanus* to at least one *cenaculum* on the second floor. In the first phase of the clubhouse, six *tabernae* and one exterior staircase were accessible from the street running south of the *insula*. A narrow corridor connected this street with a staircase in the southeast corner of the internal courtyard. It probably led to at least one *cenaculum*. If the *fabri* rented it out, only the *sottoscala* room beneath the staircase would still have served them as a latrine. It seems only the upper story (or probably stories) over the *schola*'s west wing was used by the *fabri*. It was accessible by a staircase on the northwest corner of the courtyard. Conversely, the shops in the two street façades and the upper stories over the north, east, and south wings of the *schola* were given over to at least a dozen tenants. This number must

be increased by at least three for each additional story above the second floor.

We cannot know exactly what profit these rentals generated for the *collegium;* but it is certain that, over a year, the *fabri* made at least tens of thousands of sesterces off their clubhouse.[142] This begs the question of what they did with all this money. It was more than enough to pay for many fancy dinners and other customary *collegium* expenses like the cult of the dead. Indeed, the *fabri* went to considerable expense to construct at least one public building: an elegant temple on the *decumanus maximus,* just a few blocks east from their centrally located clubhouse.[143] The inscription on the temple's front architrave credited the *collegium* as a whole for its construction. It only mentioned three *magistri quinquennales* by name for overseeing the project, but in much smaller letters than the rest of the dedication. If individual *fabri* had made additional contributions to the temple, they were not mentioned in the main building inscription.

The temple was dedicated to the deified Pertinax.[144] Septimius Severus used the assassination of this short-lived emperor as a pretext to usurp the imperial throne in 192 C.E., but claimed from 195 C.E. onward that he had been adopted by Marcus Aurelius. The inscriptions of the *fabri tignarii* demonstrate a keen awareness of this change in imperial self-fashioning: sometime between 192 and 194 C.E., they dedicated a temple to Pertinax. In 198 C.E., the statue of Septimius Severus in their clubhouse came with an inscribed base (*CIL* 6, 4569) that not only used the emperor's new *gentilicium* Antoninus, but also labeled him the son of Marcus Aurelius, the brother of Commodus, the grandson of Antoninus Pius, the great-grandson of Hadrian, the great-great-grandson of Trajan, and the great-great-great-grandson of Nerva. The *fabri* obviously felt compelled to express their loyalty to the new emperor in no uncertain terms, an indication that they may have seen themselves in conversation with the imperial authorities in nearby Rome. At least the temple of the *fabri* was highly visible. It towered over Ostia's main street on its high podium. The inscription on its front architrave surmounted the enclosure wall of the temple and would have been legible for anyone who cared to read it while passing by on the *decumanus.* As a dedication of the *fabri tignarii,* the temple and the small courtyard surrounding it were covered with marble. In addition to shoul-

dering the construction costs, the *fabri* must have paid a very large sum for the building plot. It had previously been occupied by the north wing of a large residential *insula,* which had to be partly demolished to make room for the temple.

In terms of size and urbanistic prominence, the clubhouse and the temple of the Ostian *fabri tignarii* compare favorably with the building activities of private individuals. Their *collegium* seems to have had as substantial a presence in the city as any leading family in Ostia. Legally, the *fabri* may have been nothing more than the voluntary association of economically independent contractors. But in their own perception, they seem to have been more of an institution that transcended its individual members, in both significance and time.

It is hard to imagine that the *fabri tignarii* who carefully planned their *schola* as a clubhouse and a productive asset, and who built a sanctuary to a state god, thought of themselves as a private social club that would not survive the death of its members. Indeed, the *collegium* endured for over three centuries, like many other professional associations. It is perhaps no coincidence that from the third century c.e. onward, the Roman authorities began to task *collegia* with collecting trade taxes and market fees.[145] This practice mirrors the government's attitude toward local elites, who were co-opted into running their communities. In the light of their institutional stability and internal coherence, *collegia* seemingly became a useful tool of government. Similarly, wealthy benefactors recognized *collegia* members as occupying a social stratum in their own right, from the later second century b.c.e. onward. Two honorific inscriptions from Italy ranked *collegia* members between *decuriones* and *plebs* for public distributions of money. They received less than councilmen but more than ordinary citizens.[146]

The *fabri tignarii* of Rome and Ostia may have been exceptionally wealthy, but other *fabri* were equally prominent in their communities. Already in the first century c.e., "the *collegium* of the *fabri* and those therein" in Britain built a temple to Neptune and Minerva "for the welfare of the *domus divina* by the authority of king Tiberius Claudius Cogidubnus . . . from their own money."[147]

Returning to Ostia, its many *collegia* made more of an architectural impact on the heart of the city than its aristocracy of *decuriones.* Perhaps

most leading men resided in houses outside the city's excavated core. If this had indeed been so, it would further underscore the commercial character of Ostia's city center. As Paul Zanker and Beate Bollmann have shown, most archaeologically identifiable Ostian clubhouses and *collegium* sanctuaries stood on the *decumanus maximus*.[148] The city's high street functioned like a commercial avenue, as described previously.

Still, *scholae* were not necessarily located near the *tabernae,* which were owned or leased by their members. For instance, the temple of the shipbuilders *(fabri navales)* on the *decumanus maximus* was not located close to the harbor and its dockyards.[149] This desire for public exposure on the *decumanus maximus* mirrored that of religious *collegia* like that of the *Augustales,* which was undoubtedly neatly woven into the social fabric of Ostia. At the very least, the urbanistic prominence of Ostia's trade-based *collegia* attests to their own institutional self-confidence and financial prowess.

While privately commissioned *scholae* and temples did not necessarily reflect civic significance, the increased public standing of Ostian trade-based *collegia* became manifest in the reorganization of the so-called Piazzale delle Corporazioni.[150] This square started out as a porticoed piazza, as it was customarily built behind the *scaenae frons* of a Roman theatre. According to Vitruvius, such an enclosure was either used for rehearsals by the chorus or served the theatre audience as a retreat in case of a sudden downpour.[151] As in Rome and many other cities, the Ostian square evolved into a multifunctional space. Its three porticoes were decorated with emblematic images of shipping and other trade-based associations in black and white mosaic. In the early third century, the porticoes of the *piazzale* were subdivided into small rooms by walling off the spaces between the porticoes' colonnades and rear walls. Each room was associated with a mosaic. There is no archaeological evidence for how these rooms were used. By analogy to the *topos* inscriptions of the bankers' hall in Ephesus (see above) and other porticoes in the Greco-Roman world, it is, however, very likely that they indicated the business presence of the shipping agency or professional association evoked by the mosaic.[152]

The installation of these *taberna*-like stalls must have been authorized by the city council. Already in the early second century C.E. the weigh masters *(sacomarii)* of Ostia had built a small *sacellum* into the southwest

corner of the Piazzale delle Corporazioni.[153] In 124 C.E., three members of the *collegium* added an altar to Silvanus. According to the altar's inscription (*CIL* 14, 51), it had been set up with permission of the *decuriones*. If adding an altar required the blessings of the city council, remodeling the entire plaza surely did as well.

The efflorescence of professional associations in the imperial period is not unique to Ostia. For this period, the available epigraphic and archaeological evidence on *scholae* and associated buildings increases dramatically.[154] In the absence of inscriptions, it is impossible to tell the difference between the *schola* of a professional association and that of a priesthood or aristocratic youth club. Also, the social standing of a *collegium* cannot be deduced from the design of its clubhouse or main sanctuary. The *scholae* of the *fabri tignarii* in Ostia and that of the physicians in Velia were equally grand affairs and included shops for rent.[155] Wherever residential quarters have been excavated, clubhouses are interspersed with houses, typically facing a main road. Most *scholae* date to the first century C.E. or later, but the phenomenon of building prominent clubhouses in residential areas can be traced back as early as the second century B.C.E. The construction of *scholae* on busy streets fit the dispersed commercial landscape of Mediterranean cities after the third century B.C.E. Public, commercial, and communal life now unfolded as much on streets as it did on public squares.[156] This phenomenon reflects more than just economic change. A private association could become one of the many points of identity that an ancient city had to offer. In the epigraphic record, well-to-do members of trade-based *collegia* focused on the offices and honors that they had held and received, in both their associations and their communities. An influential school of thought has, therefore, argued that those excluded from true political influence and participation found meaning and recognition in *collegia,* which mirrored the political hierarchy of their cities.[157] As we have already seen, the economic influence and clout of some *collegia* makes them appear far less marginalized than this view suggests. Still, *collegia* could indeed become a home for individuals who, in antiquity, were frowned upon.

Around the middle of the third century C.E., the pimp Sempronius Neikokrates commissioned a sarcophagus that showed intellectuals and muses.[158] It seemed only fitting to a pimp to express his hope that the muses might

rule his body after his death. On his probably self-composed epitaph (*IG* 14, 2000), Sempronius identified himself as a pimp ("énporos eumór- phon ... gynaikôn") but also claimed that he had been a "poet and cithar- ist and primarily a club member" ("málista dè kaì synodeítes"). As a gre- garious man of many talents, he still felt that his membership in an unnamed *synodos* (or *synodoi*) was what defined him most. Of course, Sempronius Neikokrates was not a respectable man by the standards of Rome's leisured literary elites. They surely would not have wanted to join his club(s). The same applied to the *collegium* of the public criers *(praecones)*, despite their grand *schola* on the south slope of the Palatine hill.[159] Moralis- tic writers may have turned up their noses at the association of actors and performers of Smyrna, even though they had existed for several centuries, had corresponded with Marcus Aurelius, and had the inscriptions to show for it.[160]

While differences in social status were not mitigated by pretty build- ings or showy inscriptions, it is important that the *scholae* of temples and trade- and occupation-based *collegia* stood tall in the cities of the Roman Empire. A new arrival to Rome could have confused the *schola* of the pub- lic criers with the seat of a posh priesthood. The Schola del Traiano in Ostia, which probably served as a clubhouse of the seaport's *navicularii,* could have, likewise, been easily mistaken for the residence of an aristo- cratic family.[161] As a matter of fact, the building was originally the town- house of C. Fabius Agrippinus, the *consul ordinarius* of 148 c.e.[162] Fausto Zevi has argued that it was acquired by a *collegium* after the last prominent scion of the family, another C. Fabius Agrippinus, was executed by Helio- gabalus in 215 c.e.[163] This attests in the very least to the financial prowess of the *collegiati* buying up the house and rebuilding it as their *schola.*

On an interpersonal level, this sense of status confusion is mirrored in the *Satyrica,* when the freedman Habinnas comes across as a *praetor* to the story's narrator (see Chapter 2). Petronius, Seneca, Martial, and Juvenal mocked or ranted about freedmen and commoners whose wealth and ex- travagant lifestyles belied their humble station and vulgarity. From the first century B.C.E. onward, Rome and other large cities provided well- bred and well-off writers with rich material for this kind of social satire. For a social analysis of Roman urban life, this literary snobbery is invalu- able but tells only one small part of the story. While Sempronius Nei-

kokrates may not have been welcome in a prominent *collegium* like that of the *fabri tignarii,* the self-confidence that merchants and artisans displayed in the construction of their *scholae,* temples, and tombs turns on more than a defiant response to aristocratic scorn. It reflects a lifestyle that is rooted in a new urban economy of production, which allowed for wealthy commercial classes who came to organize themselves into social middle classes. In the next chapters, we will see how these middle-class urban merchants and craftsmen could indulge in comforts and luxuries that put a novel twist on the tastes of literary and political elites, and developed their own forms of cultural expression.

4

In Search of Middle-Class Culture

Commemorating Working and Private Lives

Patterns of Culture

The new prominence of *tabernae* and clubhouses reflects the rise of commercial cityscapes and urban middle classes. Economically, these middle classes stood between the working poor and the leisured landowning rich, but mapping them culturally is far more difficult. It seems that the ancients did not conceive of anything like a "middle-class culture." But the archaeological evidence of tombs and houses suggests that there was, nonetheless, a distinct middle-class lifestyle. This applies in particular to visual culture, even though this may seem counterintuitive at first. The high degree of iconographic standardization in Roman art suggests that middle-class Romans imitated upper-class lifestyles, but on a smaller scale: we find the same objects and motifs in funerary and domestic art in the tombs and houses of the rich and those of middle classes.

This is, typically, explained through the aspirational use of upper-class status symbols by those lower down the social scale. But the evidence points to something more complicated and more interesting. While upper- and middle-class art drew from the same iconographic repertoire, images were used differently across social milieus. These differences in upper- and

middle-class art use show that we are dealing with distinct if overlapping lifeworlds. These differences are most obvious in middle-class funerary commemoration but can also be traced in the decor of middle-class houses, as we shall see in Chapter 5.

This is not to say that upper- and middle-class art uses were categorically different. Instead, the argument presented here rests on an analysis of quantifiable patterns of art use. These patterns show that while upper- and middle-class Romans were subject to the same forces of cultural change and followed the same broad artistic trends, there were still salient differences between them: art forms were not restricted to a specific milieu, but there were clear preferences for particular forms of cultural expression.

In the realm of funerary culture, such quantitative analysis is possible because the cult of the dead was highly conventional in all its aspects, from ritual to tomb decor—a fact mocked by Lucian, who remarked at the outset of his *On Mourning* that the bereaved, as in almost all cultures, "commit grief to the charge of custom and habit."[1]

In terms of tomb architecture and decor, this meant that Romans of all classes only rarely commissioned something entirely new. Instead, they picked their burial types and funerary decor from a highly standardized repertoire, which suited their means and needs but was generic enough to allow for subjective interpretations. In the absence of explanatory epitaphs, Roman tombs tell us more about the society that produced them than about the individuals who owned them. And indeed, the rare inscriptions that directly refer to stock images express such different sentiments in what seem like similar contexts that it is fair to assume that generic funerary art encouraged layers of personal meaning, which went well beyond what was actually represented.

For instance, the funerary relief of a Gaius Rubrius Urbanus followed the century-old convention of so-called *Totenmahl* reliefs: it shows the deceased reclining on a couch with a cup in hand. To his right sits a man in military dress, obviously a relative.[2] Such images had a long iconographic history but only became popular in the city of Rome when relatives and friends began to dine in mausolea on the holidays in honor of the dead. Appropriate monuments could come in the form of reliefs, as in the case of Rubrius Urbanus, or as life-sized statues like that of Flavius Agricola, which is discussed below. Flavius Agricola's epitaph states he is shown as the bon

vivant he was in life and encourages the mourners to enjoy likewise. By contrast, the epitaph of Rubrius Urbanus is rather glum:

> While life was granted him, he always lived sparingly
> saving for his heir, mean too with himself.
> Here he bade himself be artfully sculpted by skilful hand,
> Merrily reclining after his own demise,
> so that at least he might rest recumbent in death,
> and enjoy assured repose there lying.
> His son sits on his right, who followed soldiering
> and died before the sad funeral of his own father.
> Yet what good does a merry image to the dead?
> This is the way they ought rather to have lived.[3]

Clearly, the same motif could trigger reflections along similar lines (conviviality is the spice of life; enjoy life while living) but with a rather different personal tone (I lived the good life vs. I wish I had not been such a cheapskate). This should caution us against overburdening widespread stock motifs with either overly specific or totalizing interpretations. Of course, the iconography of funerary art alone can be highly revealing. For instance, it is meaningful that freedmen in the first century c.e. paraded their families on funerary reliefs, because a legal marriage was one of the advantages of freedom. And the iconography of military tombstones often reflects the esprit de corps of the Roman army. But it is highly problematic to construct patrons or viewers on the basis of assumptions that are not rooted in archeological or clearly defined social contexts. This is particularly so in the case of mythological sarcophagi from the city of Rome, which became popular in the second century c.e. They figure prominently in cultural history, because they have been associated with the intellectual movement of the so-called Second Sophistic and, therefore, the highly educated upper classes. But this social attribution is very unlikely. Instead, Roman metropolitan sarcophagi seem to have been bought primarily by middle-class Romans. This provides a cautionary tale about attempting to write a social history of art, which is mainly based on our notion of Roman cultural history as reflected in Greek and Latin literature. It also provides a good foil against which to develop the contextual, pattern-based approach followed in this chapter.

A recent trend in scholarship has, with great success, used ancient *ekphrasis* to reconstruct (highly intellectual and "super-literate") approaches to art viewing.[4] The surviving texts almost certainly reflect how sophists and learned poets demonstrated their erudition and wit. A key work is Philostratus's *Imagines,* in which the sophist walks an upper-class boy through the stunning picture gallery of his father. Philostratus links the mythological images that he sees to specific texts, for instance Homer's *Iliad,* even when image and text do not perfectly align. This literary art viewing is contrasted with the interpretations of the boy's nurse, who clearly knows the stories but reacts to them in an emotional way, for instance, by blaming Theseus for the abandonment of Ariadne.[5]

Of course, the *Imagines* are literary fiction, but it is likely that the core themes of most Greek myths were common knowledge by the second century C.E. and not the exclusive cultural capital of the rich and educated. Most middle-class Romans could probably not show off a deep knowledge of high literature when looking at a mythological image. But they probably knew the underlying story of the myth—in the way most contemporary Americans know the storyline of Little Red Riding Hood, even if they lack an intimate familiarity with Grimms' *Märchen* in the original language or any awareness of the intellectual, scholarly, and political agenda of the brothers Grimm.[6]

The issue of the educated upper-class viewer is further complicated by the fact that many educators themselves did not belong to the upper classes. For instance, Lucian was first apprenticed to his uncle as a sculptor before he went on to become a sophist. And even though it is fair to assume that most members of the upper classes received a first-rate education, which set them apart from the vast majority of Romans, it is a stretch to assume that most, let alone all, had literary or intellectual interests. Naturally, all ancient upper-class authors did, but they are a skewed sample. And, tellingly, most of them were newcomers to the imperial elite and not originally from Rome. To them, writing literature was also a means to get ahead. Being a talented and prolific author was a way to be noticed— which is why, in the imperial period, men like Lucan, Martial, and Statius wrote sycophantic poems, even for "bad" emperors. Of course, all of this does not preclude that some mythological sarcophagi were appreciated along the lines of Second Sophistic erudition. But the popularity of

mythological sarcophagi in the city of Rome cannot be not cogently connected to an intellectual movement, which was primarily a literary phenomenon. And, indeed, for all its impact, the culture of the Second Sophistic neither led to a Hellenization of funerary customs in the West, nor did it affect the way in which social elites praised their dead, who, in the Latin speaking world, would have been the major audience of Greek literature in the second and third centuries C.E.[7]

Indeed, the only historically sound way of determining the broader cultural significance of Roman metropolitan sarcophagi and other forms of funerary decor is to contextualize them, first, within funerary practice at large, second, within funerary ritual, and, third, where possible, within the social milieu in which they were demonstrably most popular. Following this method will allow us to detect class-specific patterns of cultural expression, which can be traced from the growth of monumental Roman necropoleis in the first century B.C.E. to the third century B.C.E. Within the limited space of this book, the focus will be on the city of Rome, but before we trace the development of tombs and funerary art in and around the capital, it is worth pointing out that similar features can be found elsewhere and that the trends observed fit within a larger pattern.

Tombs, Necropoleis, and Social History: An Overview

Cemeteries were a mirror of urban society and have been studied as such.[8] In analogy to honorific monuments in the cities of the living, tombs in Greek and Roman necropoleis commemorated the achievements of the dead. As in the case of political art, the praise of the deceased followed conventional social norms, but was, on the whole, more varied and diverse. Whereas only prominent figures in political life were honored through statues and public monuments, anyone who could afford a conspicuous tomb was free to build one. This allowed not only Roman upper classes but also middle-class artisans and businessmen to leave an imprint on public space as individuals and not just as members of well-to-do *collegia*.

In the context of social history, it has often been remarked that Roman craftsmen and traders proudly broadcast their professions on their tombs, despite the literary censure of all economic activities except agriculture.[9]

Indeed, there is no reason to believe that the aristocratic discourse on proper economic behavior influenced the self-image and self-fashioning of businesspeople in the Roman world. Instead, local conventions and the norms of middle-class lifeworlds determined what went on conspicuous tombs. These conventions open a window into the social world and the beliefs of both ancient upper and middle classes. But far more interesting is the funerary art that was intended for a more restricted audience.

From the second century c.e. onward, richly decorated sarcophagi were set up in both upper- and middle-class mausolea in and around Rome and other cities in the West. Roman mausolea were locked during most of the year and only rarely opened for funerals or the cult of the dead.[10] Consequently, sarcophagi were, with very few exceptions, only visible to mourners and visitors who either belonged to the *familia* of the deceased or to a *collegium* that arranged the burial of its members. As such, second- and third-century-c.e. sarcophagi allow for a more intimate view into middle-class culture, even while they follow fashions and conventions.

The discursive conventions of mausolea differ from those of the façades of middle-class tombs. Within the more intimate space of a middle-class mausoleum (originally) Greek myth and other imagery was used to express personal connections and emotions toward the deceased and, only very rarely, pride in one's commercial success or social respectability.[11] By contrast, the sarcophagi of Rome's political elites, typically, focused on the deeds of great family members, even within the confines of the burial chamber. These class differences in public self-fashioning and more intimate personal commemoration can be mapped against the backdrop of the changing landscape of Roman necropoleis.

Necropoleis of the first centuries b.c.e. and c.e.: Showy Tombs, Diverging Values

Large commemorative tombs only became common in the last century b.c.e. And the overwhelming majority were built for and by urban middle classes. This development in itself illustrates social and cultural changes caused by the economic transformation of ancient cityscapes. Here, recent archaeological scholarship has fundamentally changed our understanding of how to assess ancient necropoleis.[12]

Before the first century B.C.E., well-to-do Romans put far more effort into lavish funerals than into the decoration of their tombs. Senatorial families used public cremation ceremonies to celebrate the glorious history of their house and its elevated position in the Roman state, just as much as they honored the memory of the deceased.[13] Indeed, it was only from the second century B.C.E. onward that the façades of senatorial family crypts came to be decorated with statues and reliefs at all.[14] Less distinguished families seem to have made do with undecorated precincts. In Ostia and elsewhere, individual graves in Republican family tombs were left unmarked. But the charred remains of precious furniture and other grave offerings demonstrate that the more prominent members of a family were burned on splendid pyres.[15]

Once conspicuous funerary monuments did become fashionable, from the first century B.C.E. onward, it was initially almost exclusively among the upper classes and political elites. In the spirit of the showy self-promotion that characterized late Republican politics, such monuments rose above the walled enclosure of a family tomb. They were oriented toward at least one busy arterial road—ideally at a crossroads close to a gate—and functioned like a public monument: a massive socle with a large lettered inscription supported either a marble altar or portrait statues in an *aedicula* or a small tholos (figure 6).[16]

The portraits usually represented the family members for whom the tomb had first been constructed, and who were also named in the inscription. But many more people were usually buried in such a family tomb. These others remained anonymous on the public façade and also within the walled enclosure, because the burials themselves were left unmarked. Everyone important was mentioned in the inscription or even represented on the tomb, but no gravestone marked the spot where their urns had been deposited. This heightened interest in the public commemoration of a family and its most important dead came at the expense of decorating the actual burial spot. The official reaction toward the tomb of a senator, who, unusually, did care about what happened to his corpse can illustrate this better than the many showy tombs with bland interiors.

In the late first century B.C.E., the *aediles* allowed the heirs of the *praetor* Lucius Cestius Epulo to follow his will to the letter in erecting the famous Cestius Pyramid, a 37 meter (125 Roman feet) high monstrosity that

took 330 days to build.[17] But they banned them by edict from depositing Pergamene tapestries *(Attalica)* in the unusually large and lavishly decorated crypt, as Cestius had stipulated. Instead, his heirs sold the precious textiles, using the revenue to erect portrait statues of the deceased.[18] Roman law did not grant Cestius a pharaoh's burial but conceded him one of the most conspicuous tombs ever built. The *aediles* also did not mind that

FIGURE 6. Pompeii, tomb of Naevola Tyche. The tomb consists of a walled precinct and a tomb crowned by a marble altar. The burial chamber with its niches for urns was not decorated.

his heirs added two portrait statues, which made the tomb look like an honorific monument. As a matter of fact, their edict regulated what was acceptable at the time for members of the senatorial order: in the early Principate and the aftermath of Actium, even Egyptian-style buildings and decor were in order. Roman officials were understanding when it came to self-glorifying public commemoration but treated Cestius's taste for lavish grave offerings in a crypt with Egyptianizing wall painting as unacceptable.

This is not to say that contemporary Romans were only interested in ostentatious self-promotion. The eccentric Cestius was not the only one concerned with what happened to his remains. But the social norms of the late Republic and the early Principate encouraged conspicuous tombs for both upper and middle classes, which were not designed to accommodate the elaborate funerary cult that characterized later mausolea.

There were several reasons for this. Of course, the intense political competition of the late Republic and the desire for public recognition by nouveaux riches freedmen and businesspeople of the early Empire played an important role in the emergence of showy tombs. Among the senatorial aristocracy in Rome and the office-holding elites all over the Roman world, tombs became part of the symbolic currency that broadcast and helped to maintain the public status of a prominent family. Wealthy freedmen, themselves banned from public, but not from honorific, offices, could hope for a great career for their freeborn offspring. To this end, their tombs could be used to advertise their munificence toward their fellow citizens, typically in their role as priests of the imperial cult.[19] But there is much more to the emergence of what has been called *Gräberstrassen* (streets of tombs) all over the Roman Empire:[20] what started as an elite practice was picked up by urban middle classes, who came to dominate the landscape of Roman necropoleis.[21]

The exemplary study of Michael Heinzelmann on the necropoleis of Ostia clearly shows that the first altar and *aedicula* tombs were built by the city's political elites close to the city gates or at the crossings of important cross-country roads.[22] But in the course of the early Empire the gaps between these free-standing monuments were filled by nonelite tombs. They followed the architectural type of upper-class tombs and consisted of a walled enclosure with a large lettered inscription facing the street. Oc-

casionally they were decorated with a relief. Some even included an altar monument.[23]

The desire of such local middle classes to be buried in a permanently visible tomb fueled the suburban real estate market. Even miles from the city, narrow strips of agricultural land were parceled out, and identical lots at prominent street crossings were sold to families or funerary associations, which were made up of unrelated individuals. Business-savvy developers seem to have bought up a number of adjoining lots and constructed rows of six or seven funerary precincts on them. These tombs were almost certainly not precommissioned but were built in anticipation of quickly finding buyers.[24]

In the case of Ostia, the growth of its necropoleis is, of course, directly related to the growth of the city. But the phenomenon outlined above can also be observed elsewhere in the Mediterranean world, where the emergence of monumental subelite tombs cannot be explained by population growth alone. First of all, it is striking that so many tombs in the late Republic and the early Empire were built by unrelated members of professional associations and other clubs or, alternatively, by freedmen who were not buried with the *familia* of their former master.[25] This attests to an archaeologically visible group of well-off city dwellers, who lived outside the framework of a *familia* clan, but were still concerned with their final resting place. This is all the more remarkable because they could not hope that their tombs would be tended after their death. With no surviving family members or heirs, only the tomb and its inscription would keep the memory of the deceased alive, a concern expressed in many surviving epitaphs, which, tellingly, often address anonymous passersby.[26] This goes far beyond showy self-fashioning. It attests to the desire to be remembered in a culture where many middle-class businessmen were no longer closely tied to the family clans that had dominated urban life in previous centuries.

At Trimalchio's dinner party many of the less well-to-do guests fall into this category. High human and social mobility in the early Empire had created a segment of society that, while not nearly as atomized as contemporary urban populations, did not provide the security of tightly knit social networks that had characterized Roman cities in previous centuries. Here, tombs become an important source for social history. In a world in which

literature was almost exclusively written by leisured political elites, inscriptions and images on tombs provide us with rare statements that nonelites made about themselves. A combination of spatial organization, layout, decor, and epitaph provides us with a good sense of what urban middle classes considered worthy of remembrance.

Of course, most Roman epitaphs were as conventional as Roman funerary art. Rare exceptions notwithstanding, they reflected a personal choice from a rich repertoire of widely available formulae rather than an attempt to capture the core personality of the deceased.[27] By analogy, funerary art drew from largely standardized mortuary imagery. But precisely because these choices were so conventional, they allow for reconstructing the social mores of diverse layers of society.

Middle-Class Pride: The Value of Success

Scholars have, thus far, interpreted sub- and nonelite tombs of the late Republic and the early Empire primarily in relation to the tombs of the political elite. On this view, wealthy freedmen and the lower strata among the decurional order constructed tombs as a means to broadcast their social and political aspirations.[28] Again, Petronius's *Satyrica* has been used in support of this thesis. There is more to these monuments, but Trimalchio's fictional tomb provides a good stating point.

Toward the end of his dinner party, Trimalchio reads out his will, which includes detailed stipulations for the construction of his tomb. Its resemblance to excavated tombs of the early Empire is striking, as has often been noted.[29] Though unusually large, its layout and decor are highly conventional. Trimalchio's tomb consists of a funerary precinct measuring 100 by 200 feet. It is to be planted with vines and fruit trees and to include a monument facing the road. Trimalchio wishes for statues of himself, his wife holding a dove, her puppy, and his own *puer dilectus*, presumably in an *aedicula*. For the relief decor, probably on its base, Petronius imagines several well-tried motifs in contemporary funerary art: Trimalchio dispensing money as a *sevir augustalis*, diners at a public banquet that he gave at his own expense, the fights of his favorite gladiator, and ships in full sail evoking Trimalchio's commercial success. The only unusual relief represents wine jars sealed with gypsum and a slave crying over a broken amphora.

All the conventional elements appear, frequently in combination, on the tombs of local elites and wealthy freedmen, as has often been stressed.[30] But they differ in one crucial aspect from Trimalchio's tomb. The epitaphs commissioned by actual local elites list the honors and achievements of the deceased in a matter-of-fact and highly formulaic way. By contrast, Petronius lets Trimalchio compose an epitaph, which is as garrulous as it is self-conscious:

HERE LIES C. POMPEIUS TRIMALCHIO, FREEDMAN OF
 MAECENAS.
HE WAS NOMINATED SEVIR [Augustalis] IN HIS ABSENCE.
HE MIGHT HAVE BEEN A MEMBER OF EVERY DECURIA IN
 ROME, BUT DECLINED.
PIOUS, BRAVE, HONORABLE, HE GREW FROM LITTLE, AND
 LEFT 30 MILLION
AND NEVER HE LISTENED TO A PHILOSOPHER.
FAREWELL; AND YOU TOO!

Here, Petronius carries his caricature of Trimalchio as an obnoxiously pompous but, at the same time, deeply insecure social climber to a new extreme. On the one hand, Trimalchio is proud of his public honors, the highest a freedman could achieve. On the other, he is aware that they are irrelevant for the senatorial aristocracy he is trying to ape. Only in his absence is he made *sevir Augustalis,* and it is beneath him to have solicited a position in Rome as other wealthy freedmen did. This elevates him above his peers who covet these honors and offices, as does his staggering wealth. But the true extent of his social pretension is expressed by his claim never to have listened to a philosopher. This statement befitted conservative Roman nobles, who liked to display an entirely theatrical, and sometimes even self-ironic, anti-intellectualism in public.[31]

Despite Petronius's depiction, there is no evidence that local leading men or the rich freedmen in their orbit felt ambiguous about their social status and achievements. The patrician Petronius may have laughed at them and their insignificant achievements, but within the lifeworld of local elites these honors mattered, whatever the senatorial nobility might have thought of them. The actual tombs and epitaphs of craftsmen display pride in local prominence and commercial success. An extreme

example is the tomb of the baker-contractor Eurysaces in Rome, who has frequently been compared to Trimalchio. But the difference between this Roman bread baron and Petronius's fictional freedman could not be greater.[32]

Eurysaces built his tomb during his lifetime for himself and his wife Atistia. It stood in an angle formed by the bifurcation of the Via Praenestina and the Via Labicana. Eurysaces must have spent a fortune on this piece of prime funerary real estate. He also went a long way to commission a monument that would stand out by its design and its decor. Remarkably, its aesthetic is not simply un-antique. Its strict geometrical decor makes it look so modern that it came to influence the Bauhaus and the futuristic strain in Italian fascist architecture. The monument is trapezoidal at its base and consists of an *opus caementitium* core, which was covered with travertine. Its decor only survives on three sides. On the bottom, two sets of vertical tubes support a plain frieze, which carries the main inscription. Above, nine portholelike openings in three horizontal rows represent the round bowls in which wooden kneading machines would have been installed in a contemporary Roman bakery. As Lauren Petersen first noticed, such bread-kneading machines may have actually been installed in the openings.[33]

This extravagant façade is crowned by a frieze glorifying the art of bread making. On the now destroyed side facing the fork in the road, Eurysaces and his wife Atistia appeared as statues in high relief. They stood on a small box that carried a second inscription:

ATISTIA WAS MY WIFE
[and] LIVED AS AN EXCELLENT WOMAN
THE PARTS OF HER BODY AS FAR AS THEY REMAIN ARE
IN THIS BREADBASKET[34]

Seemingly, Atistia died before Eurysaces, who was already mentioned in the main inscription, which was repeated on all three surviving sides of his tomb:

THIS IS THE MONUMENT OF MARCUS VERGILIUS
 EURYSACES
THE BAKER-CONTRACTOR. IT IS APPARENT.

In the light of their unusual imagery, it seems fair to guess that Eurysaces composed the two inscriptions all by himself. Eurysaces's monument is one of the few known middle-class tombs that preserve the authentic voice of its owner. Unencumbered by artistic or epigraphic convention, Eurysaces tells who he was, how he became rich, and that he liked to think of the repository of his wife's (and probably his own) urn as a breadbasket. Unlike Trimalchio, he does not try to appear as someone he is not.

Eurysaces almost certainly wanted to make a splash and build a tomb that would be noticed and remembered. This is a perpetual concern in Greek and Latin epitaphs. In the *Satyrica,* Trimalchio wishes for a sundial on his tomb "so whoever wants to know the time will read my name, whether he wants it or not."[35] But unlike Trimalchio, Eurysaces flouted all convention in the decor of his tomb and seems to have been uninterested in acquiring—or at least in advertising—public honors. So much unconventionality seems to have come with a peculiar sense of humor. Not only did Eurysaces wish for a breadbasket to hold his remains; the last word of the main inscription, *apparet* or "it is obvious or apparent," may be a winking comment on his bread-themed tomb.[36]

Just like the pyramid of the *praetor* Cestius, who was among those dearest and nearest to the emperor himself, Eurysaces's tomb is an extreme outlier in the landscape of Rome's early imperial necropoleis. But this does not mean that it cannot tell us a lot about Roman funerary conventions. Cestius's pyramid allows us a glimpse of what the new imperial government found acceptable in regard to Roman aristocratic tombs. On a different social level, Eurysaces's monument attests that wealthy nonelite Romans who, like Eurysaces, died without offspring found their lives as successful businessmen perfectly worthy of commemoration.

While no other baker built a monument quite like it, scenes of milling and baking appear on other bakers' tombs.[37] One or two generations after Eurysaces's death, the *sevir augustalis* Publius Nonius Zethus commissioned a marble monument for himself and his fellow freedwoman, Nonia Hilaria.[38] The inscription of the sarcophagus-shaped block, which was meant to hold eight urns, is framed by the image of a donkey milling grain and various sieves and bushels. As a priest of the imperial cult, Nonius Zethus could have chosen from a rich repertoire to emphasize his

office. But he also wished to be remembered by his trade, as did several other bakers up until the third century C.E.—and not just bakers.

All across the empire, and in particular in Rome and in the northwestern provinces, images of trade and craft were chosen over other equally conventional forms of funerary art.[39] Unfortunately, our evidence is too fragmented and decontextualized to arrive at statistically relevant conclusions on how many artisans and merchants preferred to be remembered by their business. But, at least in the city of Rome, the images themselves eloquently attest to an idiosyncratic discourse that was unrelated to the monuments of the political elites. This has already been noticed by Sandra Joshel for the epitaphs of working men and women from the city of Rome.[40] But the same argument can be made even more forcefully on the basis of visual culture. This is particularly striking when it comes to the mode of portraiture that was chosen for middle-class tombs. Here the gaunt and careworn faces of many successful businessmen project an ethos that can be studied without knowing the exact context of the monuments in question.

Middle-Class Pride: The Value of Work

Eurysaces's monument not only differed in its iconography from the monuments of the sociopolitical elites; his portrait was strikingly different from the vast majority of contemporary portraits of Roman noblemen or those wishing to imitate them.[41] At first glance, it recalls the portrait of a stern Republican politician. Eurysaces is shown as a determined old man with sunken cheeks and furrowed brows. His receding hair is cropped short and his old, thin skin is grooved by deep nasolabial folds. In the second century B.C.E., leading senators were portrayed as old but energetic men.[42] While glancing upward and violently turning their heads like Alexander the Great, they were shown with flabby skin, crow's feet, and, occasionally, even toothless lips. By the middle of the first century B.C.E., such extreme signs of age had gone out of fashion.[43] Men like Cicero, Caesar, and Crassus no longer looked very old but simply aged. Under Augustus and the Julio-Claudian emperors, old age, famously, disappeared almost completely from the portraits of the ruling classes, prominent counterexamples notwithstanding. Augustus, who died at seventy-six, was never

shown as anything but a serene and handsome middle-aged man, and the same held true for his successors and most senators. It is true that Agrippa and some senior senators were shown old and wrinkled on the Ara Pacis. It is also the case that Vespasian's age was, famously, flaunted through his portraits, likely as a reaction to the full and luxuriant faces of Nero, Otho, and Vitellius. But these clearly were exceptions.

It is, therefore, all the more remarkable that when middle-class tombs appeared in the later first century B.C.E., most men (and, tellingly, almost exclusively men) chose to be portrayed with signs of old age. Only a small minority copied upper-class fashions. The most famous example of the latter is the funerary altar for Lucius Calpurnius, a freedman of Claudius, who went on to become an *argentarius* in the Macellum Magnum, where he loaned money to grocers and seems to have organized auctions.[44] On his tomb he is shown with Nero's full face and high-maintenance *coma in gradus formata* hairstyle, while holding a fish and a wax tablet. Again, these are the rare exceptions. Flabby wrinkled skin, gaunt faces, receding hairlines, and plain baldness were so common in nonelite funerary portraiture that modern archaeology has employed the concept of *Zeitgesicht*, or "period face," to explain this phenomenon.[45]

This term underlines that portraits cannot be understood as more or less accurate personal likenesses but are, instead, a combination between an iconographic convention and a few personal features of the sitter. While showy tombs of the first centuries B.C.E. and C.E. were later abandoned for richly decorated interiors, as we shall see later, businessmen continued to prefer looking stern and aged on their tombstones, well into the late second century C.E., and long before signs of age and short-cropped hair became fashionable again for portraying the social elites of the third century. The long run of this iconographic type implies that working Romans attached a specific significance to this kind of representation, changing fashions in aristocratic portraiture notwithstanding. So what do these middle-class portraits signify?

At this point, the scholarly consensus seems to be that at least the Julio-Claudian portraits are a sign of nonelite traditionalism harkening back to the imagery and possibly also the political values of the dead republic.[46] This is problematic for historical and chronological reasons. Unlike the senatorial aristocracy, nonelites all over the Roman Empire seem to have

embraced the new monarchy. And when stern, old faces showed up on nonelite tombstones, this mode of portraiture had, exceptions notwithstanding, already fallen out of fashion with the social and political elites for at least one if not two generations. Furthermore, middle-class portraits lack iconographic quotations from Hellenistic ruler portraiture such as violently turned heads and open mouths. It is, therefore, entirely possible that the Republican nobility and successful businessmen of the imperial period chose to look old for different reasons. The similarities between these two sets of portraits would then be just a matter of using the same iconographic ciphers for old age, as they were invented in the Hellenistic period for representing haggard fishermen, peasants, and prostitutes. Even though there is no decisive evidence for ideological overlap between the portraits of Republican nobles and imperial middle classes, the evidence we do have is suggestive.

Luca Giuliani has convincingly argued that both the gerontocratic nature of the senate and the patriarchal structure of Roman aristocratic families led to the positive connotations of old age in the second and early first centuries B.C.E.[47] In this period, the consulship was, first as a matter of practice and later as a matter of law, open only to men over forty years of age. Additionally, only former consuls were eligible for the censorship and all higher administrative positions in the state. Similarly, Roman clans were ruled by patriarchs whose *patria potestas* over all their male and unmarried female offspring was protected by law and, (only) in ideology, held up as a bastion of Roman morals.

This patriarchal role was also attractive to many middle-class Roman men. For freedmen, assuming the legal role of a *pater* was one of the more important trappings of their life's success, because as slaves they had had no right to their offspring. On a rather typical relief in the Museo Gregoriano Profano in Rome, two freed slaves of a Quintus Servilius were labeled *pater* and *mater,* while the name of their freeborn—and thus fully enfranchised—son Publius Servilius Globolus was followed by the letter F for *filius.*[48] By contrast, his father and mother had no legal parents and were, conversely, marked by the letter L as the freed slaves of their patron.

Even freeborn citizens liked to emphasize that they had been the head of a family. Either in the late first or early second century C.E., the shoe-

maker Gaius Iulius Helius (who despite his Greek cognomen was not necessarily a freedman[49]) commissioned a marble altar for himself, his daughter, one of his freedmen (almost certainly his daughter's husband), and her offspring and freedmen (figure 7).[50] His bald, stern, and aged portrait appeared on a bust in high relief. It even featured a big hairy wart underneath the left corner of his mouth. As a result, it looked very much like an ancestral portrait in the collection of a distinguished Roman clan.[51] Apparently, Gaius Iulius Helius was keen on being remembered as the founding patriarch of his daughter's family. But Helius was not just proud of his progeny but also of his profession. In the pediment above his portrait, a pair of cobbler's lasts appears between the letters D and M, which stand for *Dis manibus.*

This points to another possible interpretation of the aged portraits of Roman artisans and businesspeople. In the portraits of Roman Republican nobles, old age stood for the experience that they had gathered in the service of the Roman state. For a craftsman it could stand for prolonged business success. This was almost certainly the case with Gaius Helius. In his inscription he mentioned not only that he had been a shoemaker *(sutor),* but also that his shop was located at (or in the immediate vicinity of) the Porta Fontinalis on the Campus Martius (SVTOR/PORTA FONTINALE). In the highly transient and ever-shifting landscape of Rome's commercial real estate, it must have been no small feat to hold on to a business in such a prominent spot. Indeed, other craftsmen also found the location of their shops worthy of commemoration, often on unusually costly marble monuments.[52] In this context, the aged faces of successful craftsmen would express "the old virtues of hard work, accepted responsibility, community identity," as Natalie Kampen suggested for the portraits of craftsmen from Ostia. These "show people who work for their living. . . . They are far from the great wealth of Eurysaces as they are from the power of a Republican senator. Yet, the tradition of veristic representation was sufficiently flexible . . . that it could survive when . . . its aristocratic ideology [was] filtered out."[53]

Interestingly, even artisans who had risen to the level of the local elites chose the old craftsman type for their funerary monuments. Around the middle of the first century C.E., the sculptor Quintus Lollius Alcamenes appeared as a man of ripe old age on his tombstone (figure 8).[54] According

FIGURE 7. Funerary altar of the shoemaker C. Iulius Helius. His cobbler's lasts are displayed above his veristic portrait. Note the wart underneath the left corner of his mouth.

to the inscription, he had been a *decurio* and had even become mayor *(duumvir)*. Given his profession and *cognomen,* which evoked one of the greatest Greek sculptors of the classical period, it seems fair to assume that Quintus Lollius Alcamenes put some thought into the unusual iconography of this relief. He chose to be represented in the guise and pose of a Greek intellectual. But unlike a philosopher or poet, Lollius Alcamenes is sitting not on a throne but on the *bisellum* of a *duumvir.* Nor is he gesticulating as though lecturing or rehearsing the meter of a poem. Instead, he looks at a bust in his raised left hand while holding a modeling stick in his right. The portrait bust is that of a young man, whose smooth face and carefully arranged locks stand in marked contrast to the old wrinkled skin and short thin hair of the deceased. It is remarkable that artisans who had held public office like Quintus Lollius Alcamenes—or the baker and *sevir augustalis* Publius Nonius Zethus discussed above—

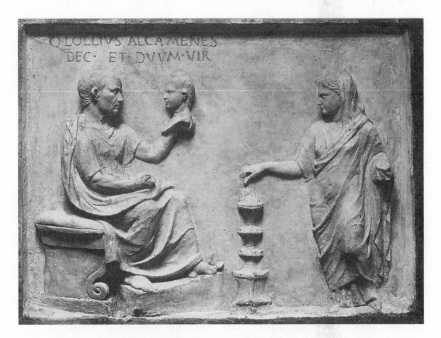

FIGURE 8. Funerary relief of the *duumvir* Q. Lollius Alcamenes. He sits on a mayoral chair while sculpting the portrait of a young man with a modeling stick (now partly broken off). A woman, presumably his wife, is burning incense on a candelabrum.

insisted on being remembered for both their craft and their public office. In their middle-class lifeworlds, working for a living was not incompatible with political respectability, despite the ideology of the landowning nobility.

For senators like Petronius or Tacitus, the social mobility and new respectability of urban artisans was a matter of ridicule or a symptom of decadence. To them, their professional successes did not matter and their local prominence was meaningless. A good example of this aristocratic disregard is the shoemaker Vatinius, who entered Nero's entourage. Tacitus could only imagine that Nero had initially picked him up for fun and singled him out as the butt of cruel jokes. But Vatinius had met Nero not as a jester but in his capacity as a magistrate in Beneventum.[55] There, Vatinius caught Nero's attention by giving a (presumably outstanding) gladiatorial show to mark the imperial visit. Vatinius may have been a boor. And, of course, Tacitus primarily disliked him for his close association with Nero. But for Tacitus, Vatinius's profession was as indicative of his bad character as was his deformed body and face. The fact that he had risen from a shoemaker's shop was a flaw, not an achievement. Tacitus's contemporary Gaius Iulius Helius, the shoemaker from the Porta Fontinalis, obviously thought otherwise. His tomb broadcast his shop, his lasts, and his big, hairy wart just as proudly as Tacitus's epitaph listed his *cursus honorum*.[56]

This juxtaposition reflects the different worlds in which each man lived, even though their tombs were part of the same urban space. There is no reason to believe that Helius's tomb was a defiant response against or, alternatively, inept emulation of aristocratic commemorative practices. While they shared in the culture of publicly perpetuating the *memoria* of the deceased, they found different achievements worthy of commemoration.

From Public Display to Private Commemoration: Love and Affection on Roman Tombs of the Second and Third Centuries C.E.

Aristocratic contempt for manual labor, as expressed in ancient literature, did not stop artisans, shopkeepers, and traders from commemorating their

professional success on expensive and sophisticated marble reliefs. Their tombs and monuments commemorated different kinds of achievements and their mode of portraiture was meaningfully different. But middle-class tombs differed from the monuments of Rome's nobility and other political elites in further respects too. From the late first and early second century C.E. onward, middle-class tombs also stood out because of their highly emotional depictions, expressing grief and love for the deceased. This represents a major cultural shift in Roman funerary commemoration. It not only manifested itself in epitaphs, statues, and reliefs but also in the architecture of the tombs themselves.

In the first two centuries B.C.E. and C.E., great effort had been lavished on the public façades of Roman tombs built by all classes. From the late first century C.E. onward, this emphasis shifted toward the interior of spacious and well-decorated mausolea.[57] Now the main intended audience of funerary art was no longer fellow citizens and strangers walking down an arterial road but mourners visiting the tomb. This development is also reflected in the layout of Roman necropoleis.

In the second century C.E., even large and well-decorated tombs were now frequently built at some distance from the road, with narrow alleyways leading up toward them.[58] In addition, tombs began to serve as dining rooms for the customary funerary meals in honor of the dead. Throughout Italy, but especially around Rome and Ostia, some mausolea functioned much like *triclinia* in the houses of the living. Three masonry couches under a vaulted ceiling occupied the floor of a small mausoleum, while the urns and sarcophagi were kept in niches covering the walls.[59]

There is no indication that the ancients found this macabre.[60] A famous mid-second-century-C.E. monument from inside "mausoleum R" under St. Peter's in Rome invited mourners to enjoy themselves: "friends, who read this, listen to my advice: mix wine, tie the garlands around your head and drink deep. And do not deny pretty girls the sweets of love. When death comes, earth and fire consume everything."[61] The man speaking from the grave was a Flavius Agricola from Tibur (figure 9). He had lived happily with his wife Aurelia Primitiva for thirty years, and was survived by their son Aurelius Primitivus. His life-affirming epitaph was written on the base of a life-sized marble statue that represents him lying bare chested on a couch. In accordance with the inscription, Flavius Agricola is holding

a drinking cup and crowning himself with a wreath. The monument once stood in a niche and served as the repository of his urn. It had been inserted in a hole at the feet of his statue. In the course of the funerary banquet, its lid would have been lifted and the mourners would have sprinkled Flavius's ashes and *oscula* with wine.[62]

Flavius Agricola's monument was not unique. In the first half of the second century C.E., it was popular to mark the graves inside a tomb by statues that showed the deceased either sleeping or drinking on a couch. These so-called *kline* monuments (couch monuments) chronologically overlapped with the first relief-decorated sarcophagi in the city of Rome, which were also intended to mark graves for a limited audience. Unlike sarcophagi, *kline* monuments were used in connection with urns, but both types of monu-

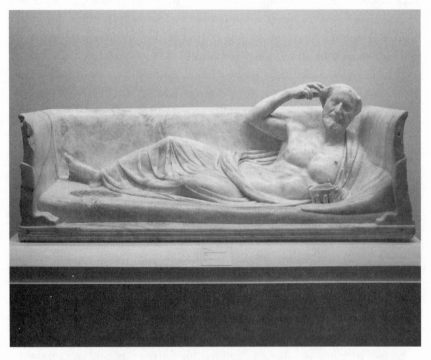

FIGURE 9. *Kline* monument of Flavius Agricola. The deceased holds a wine cup as he crowns himself. His urn was deposited in the shallow depression at his feet. The life-affirming but nihilistic epitaph of Flavius Agricola was destroyed on papal orders.

ment were an expression of the same cultural trend. The statues and reliefs on the outward-facing tombs of the first two centuries B.C.E. and C.E. had, almost exclusively, shown the dead in their public roles as office holders, good citizens, or successful craftsmen. By contrast, second-century-C.E. funerary art focused on the personal lives of the deceased and removed their images from public view. What mattered now was the continued interaction with the living at funerary banquets—as in the case of Flavius Agricola, similar statues and sarcophagi with *Totenmahl* reliefs—or the loving memory of those left behind, as we shall see.

First-century-C.E. funerary statues had looked like honorific monuments, following the typology of toga-draped officials or, in the case of women, decently dressed ladies, such as priestesses and benefactors.[63] Now, the dead were shown lying down at dinner or sleeping. Several epitaphs and poems stress the emotional significance that such images of the dead had for their surviving loved ones. Portrait statues were commonly understood as realizations of the dead. The epigram on the monument of Flavius Agricola tellingly opened with the lines: "Tibur was my home; Flavius Agricola my name. Yes, I'm the one you see reclining here, just as I used to once at dinner." Of course, statues as substitutes for lost lovers appear as a literary *topos* from the fifth century B.C.E. onward. But only in Rome were statues demonstrably used in this way. Exceptions notwithstanding, almost all Greek funerary reliefs lacked portrait features and typecast the deceased as good citizens and wives by using standardized iconographic formulas.[64] Roman funerary statues represented the dead in a completely different way. First, they were portrait statues and, second, they deviated from norms of public praise.

Dining bon vivants reminded the living of the good company that the dead had been, but some middle-class patrons wanted more dignified images by which they could remember their lost loved ones. From the late first and early second century C.E. onward, it became fashionable to represent the deceased in the guise of deities and, occasionally, heroes.[65] This elevation of the dead was not an actual apotheosis, but analogous to the rhetorical superlatives that, in Greco-Roman literature, stressed the almost superhuman qualities of a beloved or powerful person. A Roman matron in the guise of Venus was not conflated with the goddess but appeared instead as her husband's goddess of love.[66]

The high emotional value of such statues is expressed in a Silva (5, 1) that Statius composed for Domitian's freedman secretary Abascantus as a consolation on the death of his wife Priscilla. Statius dwells at great length on tears that Abascantus cried over the death of his beloved wife. He starts out with the Pindaric *topos* that his poem will outlast the statues in Priscilla's honor, which in the context of the poem are, interestingly, a solace to her bereaved husband.[67] Toward the end of the *Silva* Statius describes the actual statues in Priscilla's tomb on the Appian Way and provides a contemporary view of the houselike mausolea described above:

> Here your matchless consort softly laid you, Priscilla, covered by Sidonian purple in a wealthy dome; for he could not abide the smoke of burning and noise of the pyre. Length of time will have no power to wither nor labors of years to harm; such care is taken for your body, so much wealth the venerable marble breathes out. Soon you are made anew into various semblances: here shines Ceres in bronze, here the Cnosian maid, in that clay is Maia, Venus (no wanton) in this stone. The deities accept your beauteous features without complaint. Servants stand around accustomed to obey. Then couches and tables are duly prepared, always at hand. It is a house, yes a house! Who would call it somber sepulcher?[68]

The statues in Priscilla's tomb house praised her beauty and fertility as if she had been Venus, the Cnidian Aphrodite, or Ceres and Maia, the Bona Dea. Her sepulcher was suitable for elegant feasts in her honor and not perceived as a dark and depressing place.

Priscilla's tomb and its decor were not a literary fiction. Just a generation after the *Silva* in her honor was composed, another imperial freedman, Marcus Ulpius Crotonensis, built a tomb for his son of the same name and his wife Claudia Semne also on the Appian Way.[69] The tomb was excavated from 1792 to 1793 and, as a result, only poorly documented. But its inscription and most of its marble architecture as well as some of the statues decorating it have survived in various collections. The building inscription and a series of eighteenth-century drawings of the excavation allow for a schematic reconstruction.

Claudia Semne was probably buried in a small mausoleum, which also contained niches for about a dozen urns.[70] Her tomb was marked by a couch

monument that showed her sleeping, with her dress slipping from her right shoulder. This Aphrodite motif was repeated on a tympanum that contained Claudia Semne's bust in high relief (figure 10). To reinforce her similarity with Venus, her portrait was flanked by two cupids. Indeed, Marcus Ulpius Crotonensis said in the inscription of the tomb that he wanted his wife to be represented in the guise of the gods *(in formam deorum):*

FOR CLAUDIA SEMNE AND
MARCUS ULPIUS CROTONENSIS HIS SON
CROTONENSIS, IMPERIAL FREEDMAN MADE THIS [tomb]
THIS MONUMENT INCLUDES
A GARDEN IN WHICH [there are] A TRICLINIUM
A VINEYARD, A WELL AND NICHES
IN WHICH [there are] STATUES OF CLAUDIA
SEMNE IN THE GUISE OF THE GODS JUST AS WHEN
I HAVE BUILT A WALL AROUND IT
THIS TOMB DOES NOT PASS ON TO AN HEIR[71]

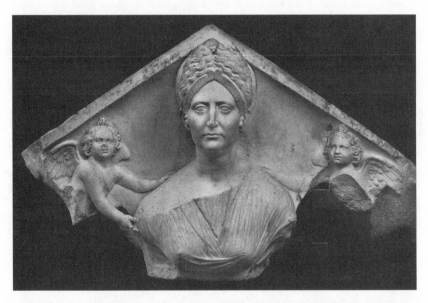

FIGURE 10. Marble pediment from the tomb of Claudia Semne. The deceased is shown with an elegant contemporary hairstyle. Iconographically, she is assimilated to Venus. Her thin undergarment has slipped from her right shoulder and she is flanked by cupids.

The statues mentioned in the inscription were two statuettes of Claudia Semne in the guise of Venus and Spes and a presumably life-sized statue of her as Fortuna. The niches in which they stood were crowned by pediments. These were decorated with the symbols of the respective goddesses. The pediments for Venus and Spes were triangular, while that for Fortuna was rounded. This arrangement suggests that the three statues stood in the same wall, with the statue of Claudia Semne as Fortuna occupying the central niche.[72] Presumably, in front of these statues stood an altar with garlands hanging between four *bucrania*. It was dedicated to Fortuna, Spes, Venus, and the *memoria* of Claudia Semne.[73]

This distinction is important. It clearly shows that Marcus Ulpius Crotonensis did not actually think of his wife as a deity. The goddesses who, borrowing Statius's words, accepted Claudia Semne's (not exactly beauteous) features were clearly distinct from her. This is also expressed in the layout of the inscription. Fortuna occupies the first and Spes and Venus the second line of the short text. The *memoria Claudiae Semnes* in lines 4 and 5 is separated from the deities by an *et,* which occupies a full line. This sets the monument of Claudia Semne apart from imperial women who were not just represented as goddesses but were also officially deified by the Senate. As imperial freedmen, Priscilla's Flavius Abascantus and Claudia Semne's Ulpius Crotonensis must have been aware of this crucial difference. So what did it mean to them to commemorate their wives *in formam deorum?*

Henning Wrede has argued that nonimperial women in the guise of goddesses like Fortuna, Spes, and Venus were celebrated as their husbands' Good Fortune, Hope, and Venus.[74] As a rhetorical technique, this has many parallels in Latin literature. Already in Plautus's second-century-B.C.E. play *Persa,* the parasite Saturio addresses his patron as "my earthly Jupiter."[75] In Plautus's *Pseudolus* the lovesick Caliodorus wants to sacrifice to the pimp Ballio, as if he were Jupiter.[76] Later, such praise is well attested in speeches, poems, and epitaphs that were neither humorous nor ironic.[77] In the context of public praise, it is often impossible to decide whether this is just rhetorical hyperbole. But in the context of mostly inaccessible tombs, it is hard to believe that turning one's spouse into Fortuna, Spes, or Venus expressed anything but a genuine sentiment toward the deceased. Indeed, it seems to reflect a new way of talking about lost loved ones.

Before the second century C.E., the dead had been almost exclusively praised for fulfilling their traditional duties as citizens and, more rarely, as husbands and wives, at least in visual culture.[78] Interestingly, this mode of commemoration continued throughout Roman antiquity. It was not superseded but only complemented by more emotional expressions. For instance, Marcus Ulpius Crotonensis honored his eighteen-year-old son of the same name with two togate statues.[79] They stood in the same tomb garden in which Claudia Semne appeared *in formam deorum*. It still mattered to Crotonensis that his son had been a fully enfranchised Roman citizen and also a knight, which was evidenced by his equestrian shoes. But a third, now lost, statue showed the younger Marcus Ulpius Crotonensis as a half-naked hunter in the manner of Greek heroes. Unfortunately, neither the statue nor its base survive. This makes it impossible to know by which heroic (or maybe divine) comparison his father wanted to remember him. But we know from the base of one of the surviving toga statues that the older Marcus Ulpius Crotonensis remembered him as his "sweetest" *(dulcissimus)* son.[80] On an architrave, which also belonged to the tomb, Claudia Semne appears as a "sweetest wife" *(uxor dulcissima)*.[81]

Recalling the dead with such affection became common in the second century C.E. Before that date, it was rare, sometimes generating self-conscious concern. For instance, in the late first century C.E., a Q. Sulpicius Eugrammus and his wife Licinia Ianuaria set up an altar tomb on the Via Salaria. It was intended for their entire family, but, in its decor, singled out their eleven-year-old son, Q. Sulpicius Maximus.[82] As a *wunderkind,* he had participated as a Greek poet in Domitian's Capitoline Games of 94 C.E. On the altar, Maximus is represented as a *togatus* holding a scroll and declaiming poetry. His parents had an anthology of his Greek epigrams inscribed to his right and left. Two more poems were written underneath the Latin epitaph. Maximus's parents were self-conscious about this unusual monument and felt compelled to explain their rationale for honoring a boy in such a conspicuous way: Maximus's poems were a proof of his talent so that "the parents would not appear to have been overcome by their emotion" (and thus to have overstated their son's importance as a poet).[83] At the end of the inscription, Sulpicius Eugrammus and Licinia Ianuaria call themselves "most unlucky" *(infelicissimi)*. They do not refer

to Maximus as their sweetest but, instead, as their "most dutiful" *(piisi-mus)* son.

Among the aristocracy, Cicero obviously met with Atticus's disapproval one and a half centuries earlier, when he decided to build not just a tomb but a sanctuary *(fanum)* for his beloved daughter Tullia.[84] Cicero wanted no less than her "apotheosis." He had come up with this idea by reading philosophy on how to manage his "biting grief." Probably, he was thinking about a stoically colored version of a Greek hero cult.[85] It seems that Cicero wanted his daughter to be remembered for her virtues as if she had been a great philosopher or a public figure. Accordingly, he planned a magnificent complex with marble columns on a highly visible spot that would endure through the ages.[86] Atticus seems to have been concerned that such a monument might appear to be an unseemly expression of parental grief.[87] He, consequently, counseled Cicero to build Tullia's *fanum* on the grounds of Cicero's Tusculan villa, but Cicero declined. He was concerned about his property changing hands and wanted the tomb to be seen by as many people as possible.[88] Yet, in the end, Cicero seems to have given up on the *fanum* idea and conformed to the social norms of his age and aristocratic milieu. As we can glimpse from his letters to Atticus, Cicero's incapacitating grief was considered inappropriate if not unmanly by his peers and even by close friends. Building a sanctuary for his daughter could have permanently damaged his reputation.

Amazingly, the concerns of a Cicero or a Quintus Sulpicius Eugrammus had become mostly irrelevant by the second century C.E. Rich freedmen and even less wealthy freed and freeborn Romans tearfully and unselfconsciously commemorated their lost loved ones in inscriptions and even represented them as deities and heroes. At the very top of Roman society, the famously wealthy and well-connected sophist and senator Herodes Atticus built three monuments for his wife Annia Regilla.[89] It probably came close to what Cicero had envisioned almost exactly 200 years earlier for his daughter Tullia.

Annia Regilla was buried in Greece, but received at least one shrinelike cenotaph on her ancestral estate at the third milestone of the Appian Way in Rome.[90] The building was excavated in 1765 and cannot be reconstructed accurately. We only know that it featured caryatids. But there is a

long Greek inscription by the poet Marcellus of Side explaining its signifi-
cance.[91] Regilla was not deified. In the poem, "she is neither mortal nor
divine."[92] As such, Annia is on the same level as Greek heroes. She re-
mains distinct from the empress Faustina the Elder, who features in the
inscription, because Regilla had attended her in her youth and worshipped
her as a priestess after Faustina's official deification. In the inscription,
only members of the imperial family are compared to gods, most impor-
tantly Herodes Atticus's former student and friend Marcus Aurelius, who,
in the context of the poem, is consoling the bereaved husband: "to him,
grieving without respite, Zeus and the emperor, who is like Zeus in nature
and intelligence, has given consolation."[93]

The cenotaph is an extreme outlier in the landscape of senatorial tombs,
even by the standards of the second century c.e. This is easily explained by
the circumstances of Annia Regilla's death.[94] She died, eight months preg-
nant, after a beating at the hands of one of her husband's most trusted
freedmen. Herodes Atticus was summoned to Rome and charged by An-
nia's brother with murder for ordering the attack. He almost certainly es-
caped a conviction only because of his friendship with the emperor.[95] In
the aftermath of the trial, Herodes's grief was both widely noted and be-
lieved to be false.[96]

The prominent role that Marcus Aurelius plays in the inscription of
Annia Regilla's cenotaph shrine was probably Herodes Atticus's way of
telling his peers that questioning his innocence or the sincerity of his grief
meant no less than challenging the emperor. Despite these disturbing cir-
cumstances, Annia's shrine shows that a man of Herodes's standing found
it appropriate to commemorate his wife with heroic honors and not hold
back his grief, genuine or not. On his family tomb in Athens, Herodes
recorded his tears at the early deaths of three of his children also.[97] Yet
Annia Regilla's extraordinary cenotaph also shows that the divine allu-
sions in the tombs of rich and literary imperial elites were of a different
quality than those in the tombs of imperial freedmen and their wives.

Reading through the seventy-three lines of Regilla's tomb inscription
requires an excellent knowledge of literary Greek but, even more impor-
tantly, a good understanding of the subtleties of Greek mythology and
religious practice. Greek and philosophically educated Roman aristocrats
thought that divine qualities turned people into heroes. Just comparing a

"divine person" to a god without specifying in what sense (for instance, in terms of nature and intelligence, as seen above) was shallow, if not ridiculous. This may explain why Rome's social and political elites never seem to have represented their dead in the guise of gods.

This is important. Aristocrats and commoners shared in a culture of displaying grief, and more rarely affection, but they did do so in a different vernacular. In marked contrast to the intellectualized hero cult for the aristocratic dead, the divine comparisons in Priscilla's and Claudia Semne's tombs would likely have been understood by most Romans. Most importantly, their statues in the guise of goddesses recalled the statues of imperial women in the imperial cult.[98] There is indeed a considerable overlap between the milieu that honored emperors and lost loved ones in the guise of gods. Most private funerary statues *in formam deorum* were commissioned by freedmen, who were also a driving force behind the imperial cult. Henning Wrede has suggested that imperial freedmen started the fashion with the imperial cult in mind.[99] This is certainly possible but cannot be shown conclusively. What matters in the context of milieu-specific funerary commemoration is that praising the dead for being somehow godlike did not originate with Rome's hyper-educated social and political elites but was, instead, rooted in the culture of wealthy commoners who were not necessarily imperial freedmen.

From Divine Comparisons to the Evocation of Myth: Love and Loss on Middle-Class Tombs

One of the earliest archaeologically known examples of likening family members to gods is the famous templelike tomb that the contractor Q. Haterius Tychicus built for himself and his *familia* on the Via Labicana in Rome.[100] It is paradigmatic for the use of not just divine but also mythological imagery in later second-century-c.e. funerary art. The tomb and its garden were badly damaged by early archaeological exploration. Already in the Renaissance, one of the reliefs came into the possession of the Mellini family.[101] It is now lost but survives in a drawing. When the tomb was excavated in 1848, it was only poorly documented. But it can be reconstructed with some difficulty on the basis of its surviving marble decoration, now kept in the Museo Gregoriano Profano.[102]

Its decor combined traditional motifs of middle-class funerary art with a novel mode of evoking pain and grief. This is an early example of how high praise for the deceased was combined with a visual expression of feelings of love and loss. In this respect, the tomb of the Haterii foreshadowed how Roman sarcophagi referenced the death of loved ones.

Like many other businessmen, Haterius had himself represented on his tomb as an old man with warts and a receding hairline. His portrait was put on a bust in high relief, with a snake curling at its base.[103] Like the portrait of the shoemaker Iulius Helius and many other working men, it recalls a bust in a portrait gallery. It is also typical of his social milieu that Haterius advertised his commercial success on his tomb. One relief, which probably decorated the outside of the tomb, showed the public buildings that he had been commissioned with. Another commemorated the construction of his own temple tomb: it stands finished next to a large building crane, which is operated by several men in an enormous tread wheel (figure 11).[104]

The tomb's interior decor is shown hovering above the scene.[105] It features a *kline* monument for Haterius's wife, Hateria Helpis, who is reclining half-naked in the guise of Venus while watching over playing toddlers and babies (figure 12). She appears again as a fully naked Venus standing in an *aedicula*. Both the couch monument and the statue in the niche recall Claudia Semne's roughly contemporary tomb on the Appian Way. We also find erotic images on the inside of the tomb in combination with the praise of matronly respectability: two of Hateria Helpis's portraits, which probably decorated the outside of the temple tomb, show her as a decently dressed lady.[106] Commemorating her as a naked Venus and a Venuslike mother inside the tomb was perfectly compatible with representing her as a Roman matron in the face of the general public.

Haterius followed the pattern established for the tombs of Priscilla and Claudia Semne in religious matters also. Haterius's tomb may have looked like a temple with four prostyle columns. But unlike a temple to the imperial cult, it was not dedicated to his wife (or himself).[107] Instead, it contained at least one statue and possibly altars to various other deities. On the marble lintel over the tomb's main entrance, four busts representing Mercury, Proserpina, Pluto, and Ceres greeted the mourners.[108] The gods of the underworld marked the entry into the realm of the dead. In addition,

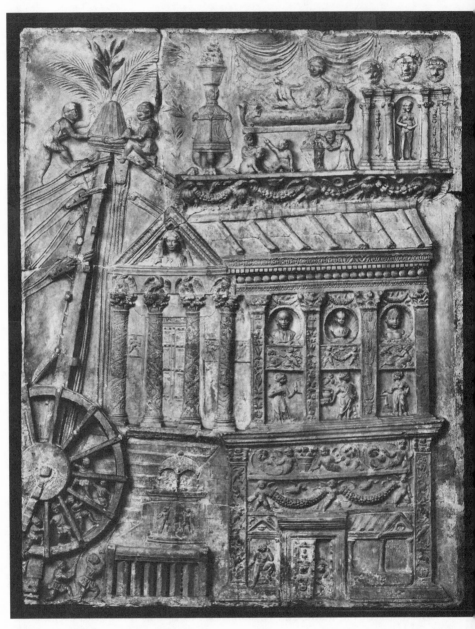

FIGURE 11. Relief from the tomb of the Haterii. It represents the templelike tomb, its surrounding wall, and the adjacent garden over the roof of the monument. Note the portraits of Haterius's three young children over the reliefs of the Fates.

the now-lost relief from the Mellini collection showed a woman labeled Hateria sacrificing with covered head *(capite velato)* in the tomb's garden, which featured a pillared bust of Hateria Helpis.[109] The labeling of the figure suggests that she was shown as a priestess of Ditis Pater (*sacer*[. . .] *Ditis Pa*[. . .]).

Like the tomb of Claudia Semne, the tomb garden of the Haterii may have contained an altar, this time dedicated to the king of the dead. At any rate, there was a statue of Silvanus, which a Q. Haterius Anicetus and his brother Crescens had dedicated in the fulfillment of a vow.[110] But the tomb of the Haterii is not just another example of using visual superlatives to describe the qualities of dead family members or to create a sacred atmosphere in a tomb garden. It also introduced a highly emotional mode of employing mythological imagery to express grief over the death of beloved children and spouses.

Haterius used the tomb's decor to evoke the three Fates and the rape of Proserpina. This fits the tomb's main inscription. It refers to two of Haterius's daughters as virgins wrested from life *(virgines raptae).*[111] This was a

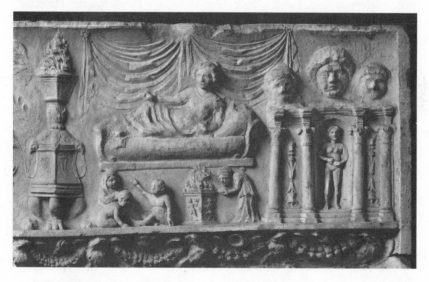

FIGURE 12. Detail of a relief from the tomb of the Haterii. It shows Hateria Helpis in the tomb's garden, reclining Venuslike on a couch while supervising playing toddlers and an older child. Hateria Helpis appears again in a niche, this time as a naked Venus.

common trope for expressing tragic and premature death. It was some-
times combined with an accusation against the cruel Fates *(crudelia Fata)*
for stealing away a beloved child or spouse.[112] In this context, it is interest-
ing that the crane relief shows that the long side of the temple tomb was
decorated with images of the three Fates underneath three clipeate por-
traits of young children.[113] A now badly damaged relief, probably from the
tomb's other side, showed the rape of Proserpina.[114] If this was a reference
to Haterius's family tragedies, a dramatic death myth served to allude to
his daughters' deaths—just as the Venus comparison served to underline
his wife's beauty.

Modern scholarship has explained mythological imagery of this kind
as reflecting the desire of nouveaux riches freedmen to show off their affin-
ity to Greek culture, emulating aristocratic lifestyles.[115] Of course, the
tomb of the Haterii is full of references to the (originally) Greek under-
world. In addition to the reliefs of Proserpina and the three Fates, a pedi-
ment, which may have belonged to an *aedicula* from inside the tomb, had
a Cerberus in its tympanum.[116] But unless one assumes that simply know-
ing the deities of the underworld was a badge of culture (which it almost
certainly was not), there is no reason to believe that Quintus Haterius
wanted to display erudition. We only know for certain that he wanted to
show off his wealth and express his grief over the death of his young
children. This helps us conceptualize the representational interests of
well-to-do middle-class Romans.

Commercial success could be displayed easily. The sheer size and richly
carved marble elements of Haterius's tomb broadcast his wealth, while the
construction reliefs and probably the (now badly damaged) main inscrip-
tion made clear how he had acquired it. But finding a visual expression for
grief and pain was much harder. Contemporary epitaphs often touchingly
speak of the heart-wrenching pain that the death of a child inflicted on
the bereaved parents.[117] This was easily done without mythological allu-
sions, which is why elaborate mythological comparisons are not common
in inscriptions for children and also spouses.

By contrast, putting the horror of a loved one's death into appropriate
images was not an easy thing to do. Of course, there was a time-honored
tradition of representing mourners at a wake or during a funeral pro-
cession. There was even one on the tomb of the Haterii, which shows a

woman with a Flavian hairdo on a bier.[118] She is surrounded by wailing women, chest-beating relatives, and a lute player. But in a society in which professional wailing women were first and foremost a sign of wealth, and mourning was primarily a public and social act, such images did not work very well as an expression of personal grief, which is one of the main preoccupations of second-century-C.E. funerary epitaphs. In fact, the only available iconographic prototypes for representing a horrific or tragic death and the grief that it caused could be found in the representations of Greek myths. Here, the tomb of the Haterii prefigured the development of second-century-C.E. funerary art.

The relief with the rape of Proserpina is badly damaged, but it contains so many iconographic elements of later Persephone sarcophagi that it can be reconstructed with some probability. It showed Ditis Pater/Pluto/Hades carrying off Proserpina/Persephone in his chariot, which was led by Mercury/Hermes. As on early to mid-second-century sarcophagi, Proserpina presumably struggled with her kidnapper, even though her figure has broken away. Still, the horror of her abduction is expressed by the panicked flight of her three playmates, who, in their frantic escape, drop the flowers that they had been picking when Hades showed up. The drama of the scene is further heightened by Demeter's hot pursuit of Hades in her snake chariot. Even for those unfamiliar with the story (and by the early second century C.E., Romans of all classes almost certainly were), the relief served as an effective image of the horrifying and sudden death of a young woman and the terror that it inflicted on her friends and her mother.[119]

Given that two daughters of Haterius Tychicus were referred to as *virgines raptae* in the tomb's main inscription, it is probably not far-fetched to see a connection between their premature deaths and what the fourth-century poet Claudian labeled the *raptus Proserpinae*. For anyone literate enough to read contemporary tombstones, the pairing of the "cruel Fates" with three small children (one toddler boy, a prepubescent boy, and a little girl) probably also made immediate sense.

It is important to stress that the use of myth on the Haterii tomb was straightforward and did not lay claim to extraordinary erudition, which was a status symbol among Roman aristocrats—at least among those who wrote literature. This is key to understanding the cultural specificity of

middle-class funerary art. Here a comparison with the tomb of Annia Regilla is instructive. It also references the myth of Persephone/Proserpina but on an entirely different scale, both in terms of actual architecture and intellectual pretension.

The decor of the Haterii tomb was too conventional to prove that its images were conceived (or seen) as a direct reference to the loss of the Haterii children. Haterius Tychicus surely knew his Greek mythology and may even have enjoyed literature in writing or as a performance. But he was almost certainly not an intellectual like Herodes Atticus, who used his wife's tomb to broadcast his exceptional literary refinement. As mentioned above, Herodes Atticus commissioned a famous scholar-poet from Asia Minor to compose the metric inscription for her lavishly decorated cenotaph on the Appian Way. Like Haterius, he also referenced the myth of the Greek underworld, but this time by creating a sacred park on his wife's estate, which he named Triopion after a Demeter sanctuary near Knidos.[120]

It was in keeping with Roman aristocratic tradition to name villas or individual rooms and gardens after famous buildings and landscapes. But even within this cultural context the Triopion is a unique and very learned choice. While little is known of the three shrine monuments that Herodes built for his murdered wife, we know he commissioned images with a novel iconography to decorate them. The three surviving caryatids, which decorated the building excavated in 1765, did not follow any established statuary type and were given unusual dresses and attributes. They were almost certainly made in Athens, to Herodes's own specifications, because they were signed in Greek by the Athenian sculptors Kriton and Nikolaos.[121]

By contrast, Haterius Tychicus composed the epitaph and the imagery for his family tomb from familiar standardized motifs. Not even the crane relief was unique. A treadmill-operated crane was also shown on a contractor's votive relief from Capua.[122] The Venuslike representation of his wife was very close to that from the tomb of Claudia Semne, and the rape of Proserpina became one of the most popular death myths on Roman sarcophagi, as we shall see shortly.

It may seem unfair then to compare the underworld-themed tomb of the Haterii to the remodeled estate of the Annii Regilli on the Appian

Way, which evoked the myth of Demeter and Persephone not only on a much grander scale but also in a far more erudite way. Even in comparison to other senators, Herodes Atticus was a dazzling personality. Few Roman aristocrats from the East flaunted their Greekness as openly as he did.[123] And not every Roman senator could claim to be a close friend of the emperor. But despite the unusual size of Annia Regilla's Triopion, the mode in which she was commemorated resonated with the tombs of many Roman aristocrats, both in the Greek-speaking East and the Latin-speaking West. And this aristocratic mode was distinct from what middle classes found appropriate for their tombs. Roman senators and knights moved in a lifeworld in which political deeds were paramount, while middle classes only rarely did. This gave middle classes the opportunity to focus on the emotional response to death and loss, while the aristocracy of officeholders typically used their tombs to create an achievement-based family history full of outstanding role models.

Deeds and Role Models: The World of Senatorial Tombs

The Homeric language of Regilla's epitaph and the style of the sculptures from the Triopion squares well with upper-class tombs from contemporary Athens. There, members of the local upper classes commissioned sarcophagi that were not always locked away in a small mausoleum but displayed publicly instead. They referenced great literary representations of death, most importantly that of Hector in the *Iliad*. On a series of so-called Achilles sarcophagi, Hector's corpse is dragged around Troy, ransomed by Priam, and washed by his relatives.[124] In general, these sarcophagi were decorated with the Homeric and Athenian myths that mattered most to educated Greeks of the period, colored by the intellectual movement of the so-called Second Sophistic. There were even sarcophagi decorated with the Battle of Marathon.[125] But no such themes seem to appear on Roman middle-class sarcophagi—which would have reinforced a claim to erudition, not just in the Greek East but also in the Latin West. And there was little thematic overlap with sarcophagi produced in the city of Rome.

While Regilla's epitaph and tomb conformed to Athenian models in terms of its Homeric language and Greek decor, the focus on her friendship with a state goddess and her high social status in the epitaph tie in with how senators typically commemorated their dead in Rome. Occasionally, senatorial tomb inscriptions speak affectionately about a spouse, but only in combination with praising achievements and aristocratic virtues, which dominate senatorial epitaphs.[126] As in most of the inscriptions, senatorial funerary art of the second century C.E. focuses almost exclusively on the social prestige of the deceased. Unlike in the Greek East, status was not expressed through references to culture and the great mythic past, which legitimized Eastern elites (for instance, Herodes Atticus cast himself in all earnest as a descendant of Kekrops and Theseus).[127] Instead, they commemorated social rank and public deeds. Tellingly, in the second century C.E., a status-focused iconography emerged for the sarcophagi of Roman senators and also knights.

On the tombs of working men (and rarely women), scenes from their professional lives were mostly restricted to the façade, whereas the inside of the tomb was, rare exceptions notwithstanding, decorated with emotionally charged erotic and mythological imagery. By contrast, the tombs of Roman senators and knights broadcast the *cursus honorum* of the deceased on the main inscription and, if there were relief-decorated sarcophagi, repeated this catalog of achievements in visual form.[128] Only five mythological sarcophagi are among the roughly 100 pieces that can be attributed to members of the senatorial order with any certainty. Instead, marble workshops in the city of Rome came up with distinct patterns to suit the specific needs of their aristocratic customers, which were, tellingly, never used lower down the social scale.[129]

The best-known group among these so-called *vita-romana* sarcophagi always consists of three scenes.[130] On the right, the deceased is shown as a high-ranking military commander receiving a captured barbarian family. In the center, he is represented as a young man performing a sacrifice as a junior magistrate. And on the left he is shown marrying a decently veiled lady in the presence of Concord, Cupid, and Venus. The scenes do not follow in chronological order. Instead, they represent a senatorial picture-book life. The deceased had a long successful career in the service of state, which led him from the tribunate to a high command, an honor that was typically reserved for men of consular rank. At home, he continued the

family line by marrying a demure lady, with whom he lived not just in love but also in concord.

At least one of these three elements, which are success as a magistrate, military virtue, and a good traditional marriage, appears on almost all relief-decorated senatorial sarcophagi, typically in combination but often with shifting emphasis. On the so-called battle sarcophagi, the deceased is shown as a horseman in the midst of battle, but on the surviving sarcophagus lid, his wife and his clemency toward barbarians appear.[131] Other senators focused on the marriage scene, while again others had themselves portrayed as surrounded by lictors in a public procession, which may (at least occasionally) refer to a *processus consularis*.[132]

This thematic overlap between the outward commemoration of aristocratic virtue on the tomb's façade and the corresponding praise addressed to the mourners visiting the tomb is striking in comparison to most middle-class mausolea. But it is not at all surprising in the context of an aristocracy in which noble birth alone was not enough to secure prestige. A family's status also depended on the continued success of its male members as leading magistrates of the state. Through family rituals like funeral processions, the young men of an aristocratic family were constantly reminded of the achievements of their most distinguished ancestors, whom they were expected to emulate. Egon Flaig convincingly argued that senatorial families put enormous pressure on their boys to succeed.[133] Portrait galleries in family residences and ancestor masks at funerals were part of this culture, as were sarcophagi, seemingly.

This was a holdover from the Republican period. Already in the third century B.C.E., the subterranean crypts of Roman aristocrats were decorated with images and inscriptions commemorating their major achievements. The famous third-century Esquiline paintings showed a high-ranking magistrate dealing with Rome's southern neighbors (possibly Samnite tribes).[134] And the inscription on the famous sarcophagus of Lucius Cornelius Scipio Barbatus, the censor of 280 B.C.E., praised his virtues in a metric inscription:

LUCIUS CORNELIUS SCIPIO BARBATUS SPRUNG OF GNAEUS
 HIS FATHER
A MAN STRONG AND WISE WHOSE APPEARANCE WAS
 MOST IN KEEPING WITH VIRTUE

WHO WAS CONSUL, CENSOR, AEDIL AMONG YOU. TAURASIA,
 CISAUNA
[and] SAMNIUM HE CAPTURED [and] HE SUBDUED ALL OF
LUCANIA AND TOOK HOSTAGES[135]

The Cornelii of the third and second centuries B.C.E. were unusual in
that they did not cremate their dead but buried them in sarcophagi instead
of urns.[136] But as the Esquiline paintings suggest, the custom of parading
the achievements of great senatorial ancestors was not restricted to public
ceremonies like the *pompa funebris,* but also to the far more restricted fu-
nerary commemoration within the crypt of a *familia* clan. What mattered
were role models for a glorious family history. This is why part of the in-
scription of Lucius Cornelius Scipio Barbatus's sarcophagus was erased.[137]
Whatever had been written there was felt to be inappropriate for the eyes
of later-born Cornelii who came to visit the crypt.

Controlling family history and sticking to clearly defined role models
mattered all the more in senatorial families, because, especially under the
empire, such family clans were not necessarily defined by close blood rela-
tions. Great names were frequently acquired only through marriage and
adoption, and even original members of the family were often only distant
relatives of the most distinguished exponents of the clan.[138] This made
passing on the torch more a matter of handing down a specific ethos than
continuing the family through actual procreation, even though that mat-
tered as well.

In this milieu, displaying individual grief was not the major concern.
Even though personal feelings were occasionally displayed on an epitaph,
the drama of death and mourning was only referenced on a single *vita-
romana* sarcophagus. There the presentation of captured barbarians was
replaced by a depiction of the death of Adonis.[139] This relative rarity of
mythological imagery on senatorial sarcophagi aligns with what we know
about the eulogies for senators, their family members, and other upper
classes in the Latin-speaking West *(laudationes).* While Cassius Dio claims
that Tiberius compared Augustus to Hercules in his eulogy, mythological
examples were peripheral to a *laudatio.* Instead, the virtues of the deceased
were first praised through concrete examples as in the remarkable *laudatio
Turiae* and in what survives of the *laudatio Murciae.*[140] In a speech deliv-

ered on the forum *(laudatio pro rostris),* this was followed by praising the distinguished history of the clan of the deceased—with notoriously little concern for facts. On the public and often highly politicized occasion of a senatorial funeral, detailed references to Greek myth were unnecessary and, potentially, worrisome.

This is because most of the Greek myths chosen for sarcophagi were, just like the divine bodies of funerary statues in *formam deorum,* not at all suited for visualizing the role models described above. Venus, for instance, was not just beautiful but also an adulteress. A statue of a Roman matron in the guise of Venus or that of a couple as Mars and Venus could be willfully (or ironically) misinterpreted, just as Ovid had done with the cult statues of the same two deities in the temple of Mars Ultor on the Forum of Augustus.[141] In a milieu in which elegant conversation was in large part about learned witticisms, it was not a good idea to make the ambiguous and racy world of Greek myth an integral part of the discourse about the virtuous dead.

This is exactly where clearly identifiable senatorial sarcophagi differ significantly from clearly identifiable middle-class sarcophagi. Of course, most relief-decorated sarcophagi cannot be securely attributed to a specific class or social milieu.[142] In and around the city of Rome, sarcophagi were rarely inscribed, probably because they stood in family tombs where the identity of the dead was known to the mourners. Thanks to postantique marble hunting, almost all of these tomb contexts are now lost to us. But it is remarkable that there were only four Dionysiac sarcophagi and one Meleager sarcophagus among the clearly identifiable senatorial pieces. This is not because senatorial sarcophagi were not inscribed. On the contrary, senatorial sarcophagus inscriptions form a relatively large group within the available corpus. Henning Wrede counted twenty-nine inscribed senatorial sarcophagi. Among them a single child's sarcophagus was decorated with the discovery of Ariadne by Bacchus and a sarcophagus for a praetor's son with the god's triumphal *thiasos* from India, while the two mythological sarcophagi for actual senators were decorated with more generic Bacchic motifs. Only one Meleager sarcophagus for a senator was decorated with an actual mythological narrative.[143]

This is statistically relevant. As in other epigraphic samples, senators and their closest family members are clearly overrepresented for their

numbers.[144] If the custom of decorating sarcophagi with mythological imagery had indeed originated with educated elites, as has often been surmised, we would expect to see more than five of them commissioned by and for a senator or a close family member. Instead, we find a rank-centered senatorial sarcophagus iconography, while inscribed mythological sarcophagi were almost exclusively used by freedmen and freeborn commoners. If we look at the earliest examples of mythological sarcophagus art, as we now will, it is not hard to see why Rome's political classes preferred to commission *vita romana* sarcophagi that better suited their interests and needs.

"Mighty Comparisons in Little Matters": Myth on Middle-Class Sarcophagi

The earliest known mausoleum with relief-decorated sarcophagi is the so-called Tomba di Medusa, which stood close by the "old" Via Tiburtina.[145] Its superstructure was built with bricks from a factory that belonged to a freedman of Marcus Aurelius's mother, Domitia Lucilla. The bricks are dated to the years 132 and 134 C.E., which allows for a fairly precise dating of the building into the second quarter of the second century.[146] When the tomb was discovered in 1839, it still contained three mostly intact sarcophagi. The find was well documented for its time, which makes the Tomba di Medusa one of the few tombs for which we know the original sarcophagus decor.

Unfortunately, only the tomb's cubic socle with the burial chamber survives to this day. Its brick superstructure and with it the inscription are now gone. This leaves us with little clue as to who built the tomb. Nevertheless, it is fair to assume that it did not belong to an eminent family, because it did not stand directly on a major road. Instead, the tomb must have faced an alley north of the old Via Tiburtina, because the door leading into it opened to the north and not toward the old Via Tiburtina, which ran south of it. Such a location is typical for middle-class second-century-C.E. mausolea, whose owners could afford a well-built tomb but no prime funerary real estate on an arterial road. Like other such mausolea, it stood in a narrow enclosure or garden, which by the third century C.E. had been encroached upon by ramshackle housing.

The decor of the tomb was rather typical. The now-destroyed super-structure seems to have contained a statue in a marble *aedicula*.[147] The floor of the burial chamber was done in mosaic and its walls were covered with painted stucco. There were also three sarcophagi.[148] They stood in the three niches opposite and to the left and right of the entrance.

The tomb takes its archaeological nickname from the largest of the three sarcophagi in the niche opposite the entrance. It was decorated with two Medusa heads over hanging garlands (figure 13). The garlands were held up by two cupids and a satyr. This was a rather typical choice of images, which combined apotropaic Medusa heads watching over the entrance with the cheerful imagery of Dionysiac revelry.

Whereas the central sarcophagus probably referenced the customary funerary meals and served as a protection for the tomb, the two smaller sarcophagi in the two lateral niches visualized the horror of death. The sarcophagus to the left of the entrance was decorated with the slaying of the Niobids.[149] The sarcophagus on the other side of the chamber showed three scenes from the myth of Orestes.[150] On the left of the Orestes sarcophagus, Orestes and Pylades visit the spirit of Agamemnon, who is standing upright in his tomb with his bowed head hooded by a shroud. In

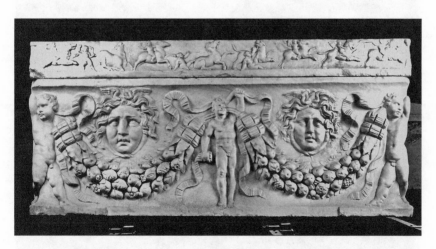

FIGURE 13. Rome, sarcophagus from the Tomba di Medusa. The Gorgons' heads faced the entrance of the tomb. Two *putti* and a smiling satyr are holding festive garlands, which reference the cult of the dead.

the center, Orestes avenges his father by killing his mother and uncle. This raises the Furies, who chase Orestes to Delphi, which is shown on the right (figure 14).

On both sarcophagi, the high drama of the myths is represented with baroque theatricality. Amphion and Niobe try to protect their children from Apollo and Diana shooting at them from the sarcophagus lid, while an old pedagogue and a haggard nurse clutch a dead boy and embrace a dying girl. The children's grimacing faces reflect the horror of the attack and their painful deaths. While the cuirassed Amphion bravely holds his shield against the arrows, Niobe screams in anguish while two of her little daughters cling to her dress for protection (figure 15). Also with great emotion, Orestes and Pylades gesticulate furiously at Agamemnon's tomb, as they learn how he died. And in the murder scene in the center, the mortally wounded Aegisthus is thrown head over heels from Agamemnon's throne, next to the already slain Clytemnestra. An old nurse turns from the crime in horror, while the Furies arrive from the right. In the final scene, Orestes grasps Apollo's tripod in Delphi, fighting off his pursuers with a drawn sword.

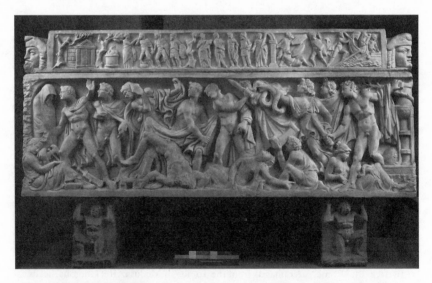

FIGURE 14. Rome, Orestes sarcophagus from the Tomba di Medusa. Note the theatrical gestures of the protagonists.

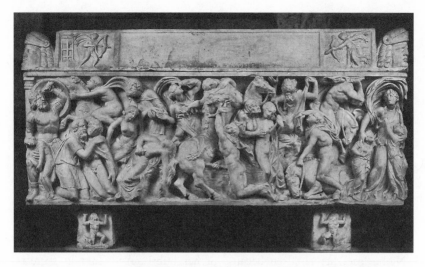

FIGURE 15. Rome, Niobid sarcophagus from the Tomba di Medusa. Apollo and Diana appear only on the lid of the sarcophagus shooting the children of Amphion and Niobe. The visual focus is on the horror of their deaths, the despair of Niobe, and the brave but futile resistance of Amphion.

Traditionally, such mythological sarcophagi have been interpreted as an erudite way of "talking" about the dead.[151] Indeed, the scenes on the two sarcophagi from the Tomba di Medusa overlap so closely with literary representations of the myths that their iconographic prototypes were probably created with literary models, or rather literarily inspired iconographic prototypes, in mind. But that does not say much about their reception. The iconography of neither piece was created for the Tomba di Medusa. From the same period, sixteen such Orestes and eleven Niobid sarcophagi survive from the city of Rome.[152] Like other (presumably) middle-class art patrons or buyers, the owner (or owners) of the Tomba di Medusa chose their sarcophagus motifs from a rather limited set of available prototypes. Every sarcophagus was a unique piece, but the scenes decorating it followed standardized patterns.

This raises two questions: first, does it make sense to assume that such conventionally decorated sarcophagi were part of a learned, or rather pedantic, discourse about the dead and their virtues? Second, were mythological images on sarcophagi generally understood as paradigmatic and

exemplary stories about death, which were somehow applicable to the deceased?

There are several problems with the interpretative pattern underlying these two questions. First, sarcophagi for adults almost always contained more than one burial. This was also true in the Tomba di Medusa.[153] Unfortunately, the bones excavated in 1839 are now lost, which makes it impossible to determine the gender, age, and genetic relationships of the people buried together in the three sarcophagi. But it makes it seem rather unlikely that the images on the two mythological sarcophagi made a metaphorical statement about just two individuals.

Second, an all too literary interpretation of the sarcophagi would have led to a comparison of the *familia* buried in the Tomba di Medusa with the sacrilegious family of the archvillain Tantalus.[154] Tantalus's daughter Niobe loses her children because of her hubris. And Tantalus's great-grandson Orestes shows filial piety in avenging his father but does so by murdering his mother. Just on the basis of the images on the sarcophagi, an ill-meaning—and not necessarily highly educated—viewer could easily have cast the family of the deceased as a cursed house of nefarious parricides.

A way out of this dilemma is to argue that, in Roman funerary art in general, mythological comparison only occurred selectively. Orestes would appear only as a model son, not as the murderer of his mother.[155] And Niobe would be seen only as the model of a grieving mother, not as an impious mortal challenging the gods. This was so in the case of a few epitaphs, as we will see below. But such an interpretation was not in line with the intertextual viewing practices of witty intellectuals like Lucian or pedantic schoolmasters like Philostratus. Instead, it resonated with poems of well-read nonelites, who would probably not have been considered learned (*docti*) by the flashy upper-class intellectuals in Rome. Of course upper-class poets often spoke in mythological exemplars, but just evoking a myth was, naturally, not enough to secure applause. One had to get it right or risk ridicule. And even clever mythological analogies of learned poets could backfire. Nero committed a terrible blunder when he played Orestes on the stage.[156] If he had intended to justify the murder of his mother Agrippina through this mythological comparison (which actually worked on some level), the plan went horribly wrong. At least, second-century-C.E. Roman

writers did not accept the analogy as an excuse for the murder of Nero's po-
litically ambitious mother (and rumored assassin of her husband Claudius,
who had been Nero's adoptive father), but reported his mythological role-
play as the confession of an inexcusable crime.

This ambiguity of Greek myth allowed ancient writers to cast mytho-
logical stories in the way that best suited their narrative intentions. For
instance, in ancient novels, mythological paintings often serve as a plot
device to fire up the imagination of the protagonists, who see their own
personal situation reflected in the image.[157] If this was how mythological
images were mostly viewed (and there is a lot to suggest that they were),
it would be impossible to come up with a general and widely accepted
meaning for each type of mythological sarcophagus. And indeed, we have
to accept the strong possibility that most mythological sarcophagi were
not bought because the mythological narrative reflected a commonly un-
derstood way of talking about the dead, but because they triggered indi-
vidual and utterly subjective responses. Likewise, these can no longer be
reconstructed.

This, however, does not mean that we cannot situate mythological sar-
cophagi within a broader cultural and social context. There are still com-
mon features, which tell an interesting story. But it is unlikely that espe-
cially the middle-class Romans buying such sarcophagi intended them to
function as conversation pieces, inviting mourners to discourse on how
the myth in all its complexity reflected on the dead.

There are two main reasons for this: first, the choice and also the repre-
sentation of sarcophagus myths followed obvious fashions: sarcophagus
buyers picked their pieces from a highly standardized and very limited
repertoire, which changed over time.[158] Unlike a Herodes Atticus, middle-
class sarcophagus customers did not aim at creating a system of unique
and sophisticated mythological references in their mausolea. Instead, they
bought into existing patterns. Second, by the late second and early third
centuries C.E., there was demonstrably no interest in mythological analo-
gies that were reasonable by the underlying mythological narrative. The
protagonists on standardized mythological sarcophagi by then were often
given the portrait features of one or more people, who were buried to-
gether in a sarcophagus.[159] This frequently resulted in identifications that
ran contrary to the core theme of the myth. For instance, the tragic story

of Achilles and Penthesilea is not the first myth that comes to mind for commemorating nuptial love in a long and successful marriage with many children. But it was nonetheless featured on the sarcophagus one Paeus Myron commissioned for himself, his most dutiful *(sanctissima)* wife, and his sweetest *(dulcissimi)* children. It was also featured on four other pieces for couples.[160]

Today, these idiosyncratic portrait identifications are typically explained with the diffusion of aristocratic culture among nonelites. Two generations after sarcophagi were supposedly created for philhellenic intellectuals, they are believed to have been taken up by buyers who were interested not in specific myths but, instead, in a general vision of happiness.[161] But there is little to suggest that mythological sarcophagi were used in an overly intellectual way, even when they were first created. In their groundbreaking book on Roman sarcophagi, Björn Ewald and Paul Zanker have argued for "letting the images speak for themselves" *(Die Bilder sprechen lassen)*. Instead of interpreting sarcophagus imagery with the myth in mind, we should, the argument goes, take the visual narratives seriously in their own right.[162] In doing so, we find that the imagery on early sarcophagi primarily expressed emotions that made immediate sense in the context of funerary ritual: the pain caused by sudden death, the love that the survivors felt for the deceased, and/or their ongoing affection for them.[163] This is true for 197 out of the 268 second-century-C.E. mythological sarcophagi that have been published so far.[164] The remaining seventy-one were decorated with only four myths celebrating bravery, a point we shall return to: the heroic couple Meleager and Atalanta hunting the Calydonian boar (twenty-eight), the labors of Heracles (sixteen), Achilles's discovery among the daughters of Lycomedes (fourteen), and Iphigenia's rescue from Tauris by Orestes and Pylades (thirteen).

Apart from this group, most second-century sarcophagi emphasize the horror of death in the same narrative style as the sarcophagi in the Tomba di Medusa. Thirty showed the rape of Persephone. Thirty-eight dealt with the death of Meleager in one form or another. Sixteen were devoted to the beautiful Adonis, another great hunter, who died in Venus's loving arms. Sixteen more represented Orestes and Pylades murdering Aegisthus and Clytemnestra, fourteen Medea's murder of Kreusa and her own two little

sons, eleven Apollo and Artemis slaughtering the children of Niobe, eleven Alcestis on her deathbed, and eleven more the rape of the daughters of Leucippus.

No obvious narrative theme connects these myths. But they are related on a visual level: the tragic death or abduction of the mythical protagonists is always met with horror by a host of onlookers crowding the scene.[165] They invariably show their emotions through theatrical gestures and a wild play of features. Alternatively, they are shown full of anguish, like Venus on Adonis sarcophagi:[166] the goddess is visibly distressed when she witnesses her lover's hunting accident, which is typically represented on the right side of the sarcophagus. In the other scene on the left, she is tenderly caressing the wounded Adonis, while a concerned-looking surgeon vainly tries to save his life.

As images, all these mythological depictions are effective in expressing the intense emotional pain caused by losing a loved one, and, in the case of the Adonis sarcophagi, they commemorate the tenderness that the bereaved felt for the deceased. Similarly, twenty-five Endymion sarcophagi from the second century C.E. show an uncharacteristically alluring Luna descend from the sky to visit her eternally sleeping lover.[167] There is no way to know for sure, but it seems plausible that this image of undying love would have resonated with mourners regularly visiting a crypt.

As with the sarcophagus themes mentioned above, the basic theme of the actual Endymion myth would have made the image more attractive to relatives and friends visiting the tomb. Conversely, viewing the image as an all-too-specific representation of a literary text would have ruined it as an effective image of love. After all, the various stories about Endymion were contradictory and, occasionally, problematic.[168]

Other scenes of loss and suffering would have thrown a bad light on the mourners themselves, if they had understood the sarcophagi in question as conversation pieces to show off their literary knowledge. Of all popular sarcophagus myths, only the abduction of Proserpina has a happy ending. The others are just as problematic as the ones from the Tomba di Medusa: Meleager is killed by his own mother for slaying his uncles; Alcestis dies in her weak husband's place, and he is not man enough to bring her back from Hades himself but must enlist Hercules to do so; Medea is a barbarian

witch, killing her own children; and the rape of Phoebe and Hilaeira by the Dioscuri is not mitigated by happy marriage as in the case of Proserpina but ends with the murder of Castor.

The problematic aspects of these popular death myths made them less suitable for the tombs of Roman political elites, who preferred *vita romana* sarcophagi in their tombs but felt otherwise free to have their walls, floors, and silverware decorated with the same motifs. It was one thing to dwell on racy Greek myths in one's dining room or park, but an entirely different matter to use them in connection with one's glorious ancestors, who, exceptions notwithstanding, had to conform in no uncertain terms to a clearly defined catalog of virtues—both in public and within the *familia*. Middle classes, on the other hand, were under less scrutiny and were free to pick and choose the aspects of a story that they liked best. In addition, they were used to playful adaptations of myth in pantomimes and other types of performances, which, unlike upper-class snobs, they had no reason to snub. And of course, very few working men and women had the leisure and education to partake in high culture and to read the great classics or mythographic handbooks that listed all of a story's aspects plus the protagonists' genealogies.[169]

Indeed, the scenes chosen for sarcophagi never dealt with a myth as a whole but only with one single episode. This allowed for an idiosyncratic interpretation of myth, which was one characteristic feature of the middle-class epitaphs mentioned above. The most famous is the long (and rather unusual) poem in honor of the freedwoman Allia Potestas, which her former patron and lover Aulus Allius composed for her.[170] It probably dates to the late second or early third century C.E., but is already full of "vulgarisms in idiom and orthography,"[171] which occasionally appear in some literary texts of the fourth century. After the standard lamentation against the "Cruel ruler of Fate and harsh Proserpina," Aulus Allius praises his former mistress as industrious and chaste, before changing the tone of his poem:

> She was beautiful with lovely eyes, was golden haired,
> There was an ivory gleam in her face
> Such as they say no mortal had,
> And on her snow white breasts the shape of her nipples was small
> What about her legs? She had quite the pose of Atalanta on the comic stage[172]

Very few Roman epitaphs were sexually so explicit. Beauty was often praised in women but rarely in such pornographic detail. Also, the reference to the comic stage is unique.[173] In the eyes of respectable upper-class Romans, female pantomime dancers were no different from prostitutes.[174] Still, Aulus Allius found the comparison flattering. If he did not have an actress called Atalanta in mind, the choice of the mythic Atalanta would be odd. As a masculine heroine hunting with men, she was, from a literary perspective, neither the chaste lady of the house that Allia Potestas supposedly was, nor the precious beauty of the lines quoted above. But it seems that Aulus Allius was not bothered by such concerns. In what followed, he used an idiosyncratic mythological analogy to describe a ménage à trois that had included Allia Potestas, himself, and another man:

> She was not sparing, but generous with her lovely body.
> She kept her limbs smooth and the hair was sought out everywhere.
> . . .
> She while she lived so managed her two young lovers
> That they became like the model of Orestes and Pylades.
> One home contained them and there was one spirit between them.
> After her, now these same two grow old apart from each other,
> What such a woman wrought, now cruel words tear.
> Look what a woman once wrought at Troy.
> I beg that it may be right to use mighty comparisons in little matters[175]

The friendship between Orestes and Pylades was proverbial. Only in this very limited sense can the analogy between the two heroes and Allia's two lovers work. Otherwise, it is ludicrous. In literature, Pylades stands by Orestes's side no matter what. By contrast, Allius loses his friend after the death of their shared mistress. Also, the Troy analogy is inappropriate. Probably Allius wanted to say that Allia Potestas turned her two lovers into good friends, whereas Helen made bitter enemies of Paris and Menelaus.[176] Yet Helen did not stir up trouble *at* Troy *(ad Troiam)*, but was taken there from her husband's home. Again, Allius seems unconcerned with the finer points of the myth and only asks the readers to forgive him "using mighty comparisons in little matters" *(exemplis in parvo grandibus uti)*, which is a quote from Ovid's *Tristia* and clearly shows that we are dealing with maybe a bad but possibly well-read poet.[177]

The rest of the poem reads almost like an excuse to justify the bombast of the epitaph: Allius is weeping without end,[178] carries Allia's name on a golden bracelet,[179] and worships her portrait.[180] And of course, Allius hopes that his former slave and mistress will live as long as the verses in her honor survive, which, strangely enough, came true.

If the late second–early third-century dating of the inscription is correct, Allius would have composed the epitaph around the time that portrait identifications became common on mythological sarcophagi. But it already throws light on how selectively myth could be understood on earlier sarcophagi. Whereas the mythological sarcophagi about murder, rape, death, and undying love did not necessarily require a direct identification of a deceased family member with a mythic protagonist, the sarcophagi celebrating bravery probably did. Here, the Meleager sarcophagus of Verrius Euhelpistus and his wife Verria Zosime provides us with an example of how mythological comparisons worked.[181] They did with images what Aulus Allius tried in Allia Potesta's epitaph: mythological sarcophagi made "mighty comparisons in little matters."

The sarcophagus of Verrius Euhelpistus and his wife Zosime is badly damaged. Only a fragment and its lid survive. But its archaeological context is known, which allows for sociocultural analysis. The sarcophagus belonged to a mausoleum on the so-called Isola Sacra, which served as the necropolis of Portus, the artificial harbor of Rome next to Ostia.[182] The architectural history of the mausoleum is complicated (figure 16). It originally consisted of a so-called *columbarium* from the second quarter of the second century c.e., which combined niches for urns with niches for sarcophagi (so-called *arcosolia*). At a later date, the tomb was significantly enlarged. An antechamber was built in front of the *columbarium*. To the left, the addition of another large building effectively doubled the mausoleum's size. This annex had two stories. On the ground floor, four niches could have contained sarcophagi. On the upper story, an anteroom with a mosaic floor led to a cruciform burial chamber with three more *arcosolia*. The enlargement of the tomb was the work of Verrius Euhelpistus, because the main inscription was attached to the façade of the annex.[183] It simply stated that Verria Zosime and her husband had made the tomb for themselves, their freedmen, and the descendants of their freedmen.

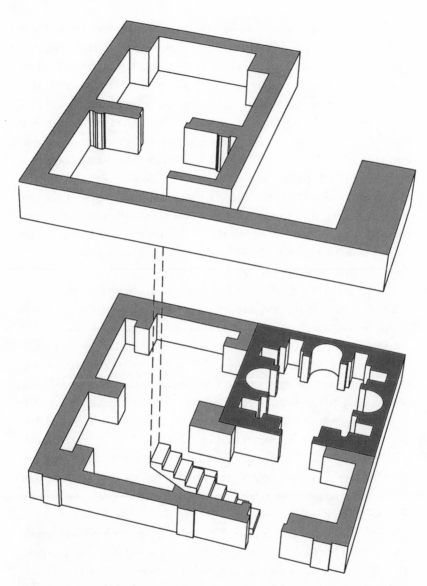

FIGURE 16. Tomb of Verrius Euhelpistes on the Isola Sacra. The walls of the older *columbarium* are drawn in dark gray. The additions to the tomb no longer contain niches for urns but instead *arcosolia* for sarcophagi.

This inscription was flanked by two terra-cotta plaques. Each shows a smith working against the background of finished products.[184] Another terra-cotta plaque over the entrance also represents a smith at work. Two of the smiths are busy at an eggcup-shaped table. The same working table was represented on the mosaic floor in the antechamber on the second floor of the annex.[185] Obviously, Verrius Euhelpistus had made his money with a smithy. Like other working men, he proudly broadcast his business on the façade of his tomb. Also typical for his milieu, Verrius bought a mythological sarcophagus for himself and his wife.

Unfortunately, we do not know where exactly in the tomb the sarcophagus stood, but it must have been placed in a prominent position. After all, Verrius Euhelpistus was the legal founder of the *familia* buried in the mausoleum. While he and his wife seem to have died without children who could have tended their tomb, the inscription on their sarcophagus ensured that the children of their freedmen could identify their grave and honor them. In this social context, mighty mythological comparisons for the master and the mistress were not entirely implausible. Indeed, the sarcophagus focused on the couple Meleager and Atalanta (figure 17). On the fully preserved lid, the two heroes are lying on a couch and drinking in the company of Hercules and the Dioscuri, while the Calydonian boar is being cooked.[186] This motif often appears on the lids of Meleager sarcophagi. The actual hunt is then shown on the sarcophagus proper: Meleager and Atalanta kill the boar, again surrounded by other great heroes.[187] This was almost certainly so on the sarcophagus of Verrius Euhelpistus and Verria Zosime. The part with the couple is not preserved, but the surviving fragment follows the standard iconography of other Meleager sarcophagi so very closely that there is no reason to believe that the central scene was altered.[188]

So why Meleager and Atalanta?[189] Again, the myth itself was utterly unsuitable if applied in scholarly detail to a happily married couple. Though married to another woman, Meleager falls in love with Atalanta during the Calydonian boar hunt and offers her its hide in an attempt to woo her. When his uncles claim the hide for themselves, he slays them in anger. In turn, his own mother, Althea, kills him by magic. As in the case of the other sarcophagus myths, a pedantic interpretation of the story would have stood in the way of an effective praise of the dead. But the sarcophagus works rather well for a married couple, if the mythological analogy is

dramatically reduced to "heroic love match." This is not as far-fetched as it may seem at first. In Lucian's "On pantomimic dance," the love drama of Atalanta, Meleager, and Althea features among the ballets that were popular in Verrius's lifetime.[190]

Visually, the sarcophagi present an effective image of a great couple. In killing the boar, the athletic Meleager appears as the epitome of male virtue. He is supported by a stunningly beautiful (and often elegantly coiffured) lady with a bow. On the lid, the two then dine together as a loving couple with their distinguished friends. As a matter of fact, the myth of Meleager and Atalanta decorated at the very least four sarcophagi that were intended for a husband and wife.[191] The two other sarcophagi that can be linked to an individual were bought by *the vir clarissmus* Titius Sulpicius Seranus and an Aurelius Vitalis, who served as centurion in the first cohort of the Praetorian Guard (arguably the most elite unit of the

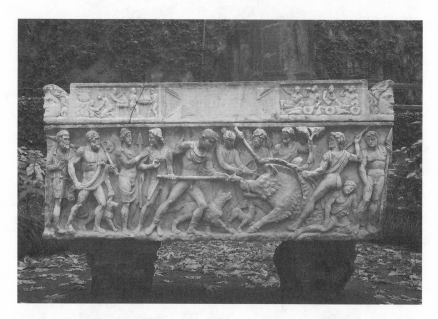

FIGURE 17. Frascati, Meleager sarcophagus. On the body of the sarcophagus, Meleager and Atalanta kill the Calydonian boar. On the lid, flanking the inscription, the heroes recline on the right and the boar is cooked on the left. The sarcophagus of the Euhelpisti looked nearly identical, which attests to the high standardization of Roman sarcophagi.

Roman army) (figure 18a).[192] In these two cases, the analogy was probably less about a heroic couple in love than about the senator's and the officer's manliness. Another second-century-c.e. legionary even chose the *cognomen* Meleager (if he had not inherited it).[193]

This difference in emphasis is important. As set pieces that arranged standard scenes in a cookie-cutter manner, different buyers could be attracted to the same type of sarcophagus for different reasons. Aurelius Vitalis had in all likelihood very good reason to fancy himself an expert

FIGURE 18A. Meleager sarcophagus of the third-century-c.e. centurion Aurelius Vitalis, who had his portrait put on the hero's body.

spearman and skilled hunter, whereas Verrius Euhelpistus probably did not. Instead, the freedman entrepreneur felt that a famous heroic couple was just the right analogy for his marriage, especially vis-à-vis his audience, who were his freedmen and their offspring. Tellingly, later sarcophagi differentiated the myth of the Calydonian boar hunt along these two main lines of interpretation: they either focused on Meleager and Atalanta as a loving couple (figure 18b) or likened the owner of the sarcophagus to the hunting Meleager by putting his portrait on the hero's body.[194]

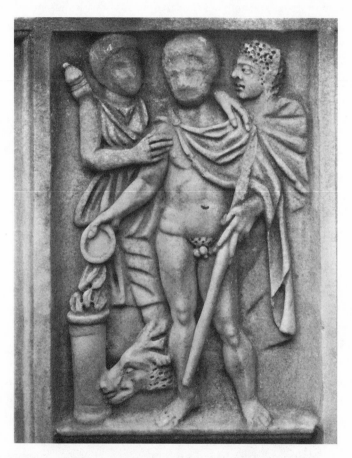

FIGURE 18B. Meleager sarcophagus in Wilton House, England. The piece was intended for a couple whose portraits—though never carved—were meant to be attached to the bodies of Meleager and Atalanta. The two heroes are shown affectionately together while offering a sacrifice after the killing of the boar.

Such portrait identifications were a semantic step removed from the sarcophagus scenes discussed so far. They narrowed down the meaning of the image. Previously, the mourners visiting the tomb had several and often overlapping means of relating to a sarcophagus image. They could see it as an appropriate expression of the horror of death, identify themselves with any given figure in the scene, or even understand the image as an allegory or simile. Now, the sarcophagus owner determined how the image was to be viewed. It became a "mighty comparison" and not much else.

The most extreme example is the sarcophagus of C. Iunius Paleuhodus, who was one of the presidents *(magister quinquennalis)* of Ostia's contractors' *collegium,* and his wife, Metilia Acte, who served as the priestess of Cybele.[195] Paleuhodus and his wife take the roles of Admetus and Alcestis, and three hunting companions of Admetus/Paleuhodus were identified through portraits. Since the sarcophagus inscription does not mention any children of the couple, these men could have been friends, relatives, or even *collegium* mates of the deceased. If the sitters of these three portraits visited the tomb, they would have viewed the image with assigned roles. This semantic narrowing went hand in hand with a reduction in the repertoire of mythological sarcophagi. From literary and intellectual perspective, the myths in all their detail had their problematic aspects, but the stories were now visually better suited to focus on one main protagonist or a mythic couple.[196]

In the late second and early third centuries c.e. only four types of mythological sarcophagi were produced in any significant quantity: the rape of Persephone remained popular, with thirty pieces surviving from Rome,[197] but it was now eclipsed by the story of Endymion and Selene, which decorated forty-three sarcophagi. The death of Meleager sharply fell in popularity (only five pieces are attested), but his hunt with Atalanta seems to have remained a hot seller: twenty-three sarcophagi represented the couple hunting the Calydonian boar. The fourth popular myth was the tragedy of Hippolytus and Phaedra, which was put on thirty sarcophagi:[198] Theseus's wife, Phaedra, falls in love with her stepson Hippolytus and tries to seduce him. When Hippolytus rejects her, Phaedra commits suicide, but only after accusing her stepson of rape in a suicide note. Infuriated, Theseus asks Poseidon to destroy his son upon

reading the letter. Poseidon grants the wish and Hippolytus dies a horrible death. It is noteworthy that the tragic core of the story did not appear on the sarcophagi.

Unlike on earlier murder sarcophagi, the most terrifying aspects of the myth were not put into images. On the left side of Hippolytus sarcophagi, Phaedra is simply shown as an alluring lady on a throne with cupids swarming around her. Hippolytus is standing before her, ready to go hunting. To those unfamiliar with the myth, the scene could have looked like a farewell between two lovers.[199] On the right side, Hippolytus is then shown boar hunting on horseback. As an image of female beauty and manly virtue, the two scenes were perfectly suitable for gender-based portrait identification. Again, an all-too-literal evocation of the myth would have stood in the way of such an interpretation. Indeed, putting portraits on the protagonists' bodies even required altering the mythological scene, and not just on Hippolytus sarcophagi.

Portrait identification often significantly changed the tone of sarcophagus images in comparison to earlier pieces, which were decorated with the same myth. For instance, on a famous early third-century-C.E. sarcophagus in the Capitoline Museums, Proserpina is transformed from the panicked girl kidnapped by Pluto into the Venuslike bride of the king of the underworld, who is now calmly riding with her groom in his chariot.[200] Demeter is still pursuing her daughter, and Athena and another flower-picking friend of Proserpina are still present, but the scene has lost all its visual drama. The buyer of the sarcophagus must have felt that a shrieking girl was not a good image for the woman identified with Proserpina. Instead, it mattered that she had been beautiful, which required representing her naked.[201]

Similarly, the sarcophagus of the contractor Iunius Paleuhodus and his wife Metilia Acte was an appropriate image for the love between the two, when it came to the death scene. But when Hercules is restoring Alcestis to her husband on the right side of the sarcophagus, only Admetus was given the features of Iunius Paleuhodus. Alcestis is not likened to Metilia Acte. It probably mattered that the deceased contractor was shown shaking hands with Hercules in the presence of Hades and Proserpina. But Alcestis's return from the dead (and the problematic role that Admetus played in the affair) were of no interest to the couple. Either

Euhodus did not know the story very well (which is unlikely), or he, understandably, did not care very much about this particular aspect of the myth.

On sarcophagi that were decorated with less popular myths, mythological comparisons were still idiosyncratic. There is no indication that they were chosen by individuals who were interested in a fitting analogy or simile for the specific circumstances of their lives. For instance, on the already mentioned sarcophagus of Paeus Myron and his family, the death of Penthesilea is turned into an image of tenderness.[202] Paeus Myron had the portraits of himself and his wife, Agrippina, put on the bodies of Achilles and Penthesilea (figure 19). The scene is the Trojan War. The Amazons have come to fight the Greeks. In the midst of the battle, Achilles/Paeus is affectionately lifting up Penthesilea/Agrippina, while warily keeping an eye on the fighting. Penthesilea/Agrippina is either dead or dying, because her right arm is slipping from Achilles/Paeus's shoulders. This implies that she was holding onto him in the first place, which is not compatible with the myth itself: Achilles fell in love with Penthesilea in the moment he killed her. According to some authors, he even raped her corpse. But the gesture makes the sarcophagus an effective image of tender love and cruel death. It also flattered the couple. Paeus is shown as a heavily muscled hero, Agrippina as a beautiful woman with a firm, youthful body. This erotic mode of representation nicely complemented the portrait busts on the sarcophagus lid, which showed the couple as good citizens in toga and *stola*. The sarcophagus is by no means exceptional. On at least five Achilles/Penthesilea sarcophagi of this type a (presumably married) couple was identified with the two heroes.[203]

As Ewald has shown, such heroic portrait identifications reinforced gendered role models.[204] But even if we leave the field of conventional praise, mythological comparisons were not at all compatible with what upper-class literati would have said in writing. On a unique sarcophagus in Cliveden (Buckinghamshire), a freedwoman called Valeria used the story of Theseus and Ariadne to express her grief over the death of her "sweetest son," the imperial freedman Artemidorus (figure 20).[205] He had worked as a clerk in the emperor's archive of records and died seventeen days after his seventeenth birthday. On the left of the sarcophagus, Artemidorus/Theseus is shown as a hunter, which, as we have seen, was a

common way to praise manliness (figure 20a). This is made explicit by the personification of Virtus (manly virtue) standing next to the young man. The hunting scene is unrelated to the Theseus myth, another indication that a close literary analogy was not Valeria's main concern. This also applies to the right side of the sarcophagus. Here, Artemidorus/Theseus is abandoning Valeria/Ariadne on Naxos (figure 20b). He appears again on the right-hand corner, putting his foot on the slain Minotaur. But the main scene is Theseus's abandonment of Ariadne. This was a common motif in the highly standardized world of Roman art. It came in two variants. In the first version, Ariadne is sleeping on the island while Theseus is boarding his ship. In the other, Ariadne has just woken up from her slumber and bursts into tears when she sees her faithless lover sailing

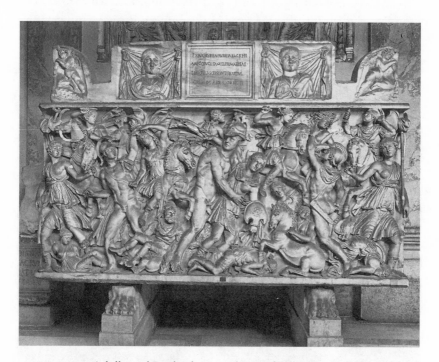

FIGURE 19. Achilles and Penthesilea sarcophagus of Paeus Myron and his wife and children. The couple is shown on the body of the sarcophagus as beautiful half-naked heroes in a dramatic battle scene and then on its lid as decently dressed citizens. Four more sarcophagi of this type were bought by a couple, assuming the role of Achilles and Penthesilea.

away.[206] Iconographically, the scene on the Cliveden sarcophagus follows the second type. But Valeria/Ariadne is not sleeping. Her eyes are open and her brows are contracted. This is common for generic portraits of distressed women on sarcophagi, but not in actual portraiture. Probably, Valeria wanted to give a visual expression of her grief, but in doing so altered the internal logic of the image. From a pedantic perspective, the sarcophagus was not even "visually literate."

Of course, there is no way to know what exactly Paeus Myron or Valeria had in mind when they commissioned their sarcophagi. But it is obvious that they made an emotional statement about themselves and their lost loved ones. This set the decor of middle-class tombs apart from the funerary art of the political elites, even though men like Paeus Myron and freedwomen like Valeria still visualized and commemorated their status and the achievements that mattered in their milieu. Paeus Myron made a point of being a free Roman citizen and Valeria highlighted in her son's epitaph that he had been an imperial freedman in a position of great responsibility. All these examples strongly suggest that the culture of the

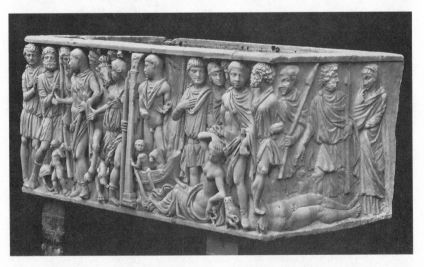

FIGURE 20A. Sarcophagus of Artemidorus and his mother Valeria. The sarcophagus is decorated with three scenes from the life of Theseus: the slaying of the Minotaur, his abandonment of Ariadne, and a generic hunting scene. These express the deceased's virtue, and Virtue appears personified to his left.

middle-class mausolea was one of pride in one's achievements and senti-
mental love for family members.

Remarkably, Roman middle classes found a milieu-specific vernacular
for dealing with death. This is all the more important if we consider the
sheer number and visibility of middle-class tombs vis-à-vis their upper-class
counterparts. From Rome, hundreds of middle-class mausolea survive,
whereas the only known aristocratic (and nonimperial) tomb of the second
century C.E. is the eccentric Triopion of Herodes Atticus. Just as the streets
and public places of Roman cities were colonized by middle-class business-
people, the necropoleis of Rome and elsewhere were taken over by the
broad middle segment of society that had come to dominate city life.

This has implications for how we interpret Roman culture and society
as reflected through art. Today, it is standard to understand Roman art as
an expression of "elite" culture. If motifs and the use of certain objects

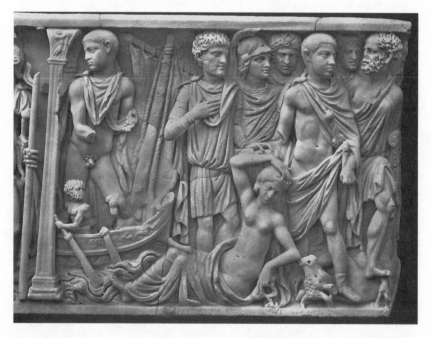

FIGURE 20B. Artemidorus/Theseus abandons Valeria/Ariadne. Note the anguish
and open eyes of Valeria, who, according to the iconographic tradition of this scene,
should be sleeping.

seem to "trickle down the social scale," this is taken either as a symptom of status usurpation or, less harshly put, as an expression of social aspiration. But this view quickly becomes problematic if we concede that most expensive art was not made for elites but for subelites like Rome's middle classes. At least in terms of sarcophagi from Rome, we can be almost certain of this. Both sarcophagi with mythological narratives and nonnarrative sarcophagi, usually decorated with images of Dionysiac revelry or sea creatures, were almost exclusively made for members of the middle classes.

Only three members of a senatorial family were demonstrably buried in sarcophagi, which were decorated with popular Bacchic images, while the *consul suffectus* Gaius Bellicus Natalis Trebonianus had commissioned a— very early—garland-sarcophagus, which was, among other things, decorated with an encounter between Pan and a Hermaphroditus. And only one man of senatorial rank opted for a Meleager sarcophagus. With the exception of the sarcophagus of Trebonianus, none of the sarcophagi stands out by its design. They follow the same iconographic ciphers and motifs that were used for nonelite buyers, as was the case with two sarcophagi in Herodes Atticus's family tomb in Athens, one of which was decorated with cupids and the other one with garlands. Only one of the three decorated sarcophagi (a fourth one was plain) may have been made to Herodes's orders. It showed Leda and the Dioscuri, referencing Spartan myths.[207]

This leads to a central problem in the social assessment of Roman art. If the same standardized motifs were used by buyers of all classes, can we assume that they all neatly fit genuinely aristocratic or intellectual patterns of interpretation? In the case of sarcophagi, the answer is by now quite clear. From the idiosyncratic use of myth on middle-class sarcophagi, we can safely assume that workshops were creating emotionally charged images from hackneyed motifs that had long been used in Rome's art industry.[208] These were combined in a cookie-cutter manner, which is reflected in the awkward compositions of Rome's earliest sarcophagi.[209] Later, motifs were almost never made to the specifications of a patron but, at best, tweaked to suit the interests of a picky buyer. When it became clear which sarcophagus motifs were most popular, the already limited repertoire of mythological imagery was even further reduced.

From this perspective, most of Roman art was both fashion and market driven. Of course, we know that some (and probably most) Romans looked

at such standardized images with what Mary Beard called "intelligent eyes."[210] But this does not mean that they were created with the idea of viewers who felt the urge to quote poetry or burst into grandiloquent speeches as soon as they saw a mythological image.

This may seem banal at first, but it matters for Roman cultural and social history. It suggests that art was not an aristocratic status symbol that expressed a claim to erudition, but instead a commodity to be enjoyed. As a result, it is not only our understanding of Roman funerary art that must be revised. The standardized imagery of Roman houses must come under scrutiny as well. This kind of art has always been an important subject for understanding Rome's social and cultural history. As on sarcophagi, standardized images decorated Roman houses, most notably in the Vesuvian cities. If these were not made to upper-class tastes and did not reflect the social aspirations of nonelite Romans, the lifeworld of middle-class Romans appears in a new light.

5

Decor and Lifestyle

The Aesthetics of Standardization

Like the images on sarcophagi, Roman domestic art has long been interpreted through the lens of literary upper-class culture. On this view, domestic decor in general—from wall painting to garden decoration—was created as a reflection of the tastes and lifestyles of the rich and educated. This aristocratic paradigm and the resulting focus on the townhouses *(domus)* and villas of Rome's political and social elites is rooted in discussions of elite housing in Roman literature, most importantly in Cicero and in Vitruvius.[1] These studies have established that the houses and, by extension, the domestic arts of Rome's late Republican and early Imperial aristocracy served—at least in part—to set the stage for the public business of their owners, which was mostly conducted "at home."[2]

But the overwhelming majority of surviving domestic art does not come from aristocratic *domus* and villas but instead from sub- and nonelite houses in the Bay of Naples. The standard approach has been to assume that sub- and nonelite patrons more or less accurately copied aristocratic fashions in wall painting and statuary.[3] This methodological shortcut may seem plausible, because Roman art is highly standardized. Indepen-

dent of their social setting, paintings, mosaics, and statues in the Roman world are based on the same iconographic types. Further, elite and nonelite art is often executed to the same artistic standards. For instance, third-style wall painting in small nonelite Pompeian houses like the Casa del Sacerdote Amando (I 7, 7) can stand comparison with the wall decoration of the rich villa at Boscotrecase.[4] But this chapter shows that we must carefully reconsider whether using the lens of aristocratic culture to understand and interpret these images might cloud our view.

First, it requires us to assume that literature reflects reality in terms of mainstream mores, when the evidence suggests that, on the contrary, these works were a reaction to the mainstream. Cicero was concerned with proper aristocratic behavior in a republic gone awry. Vitruvius's work was an attempt to systematize and define good architectural practice, when a major building boom in the early Principate saw a remarkable diffusion of buildings, in both social and geographic terms. Vitruvius's book in particular is an attempt to claim the sole privilege of interpretation of what constituted good and socially acceptable architecture, rather than a manual of current trends in Roman building.

Second, the archaeological evidence from nonelite houses points to a more complex and exciting historical reality. For instance, the concept of elite imitation cannot explain why sub- and nonelite patrons frequently refashioned popular iconographic types, seemingly to suit their personal tastes and interests.

Finally, the role of domestic art in the houses and villas of Roman social and political elites cannot be understood strictly as representative self-fashioning. Educated elites in particular had a more playful attitude toward the art surrounding them than is typically assumed: standardized images were endowed with ad hoc meaning, not by changing their iconography as was done lower down the social scale, but through witty reinterpretations. Consequently, standardization did not limit artistic meaning for either middle or upper classes. On the contrary, it allowed for a more personal approach to domestic art.

Overall, the development of a personalized mode of viewing art was made possible through the rise of urban middle classes who were keen to surround themselves with pleasant and ready-made atmospheric images that they could enjoy and fill with meaning.

Approaches to Standardization in Roman Art

To date, scholars have rarely acknowledged the possibility that standardization could still provide opportunities for art to have a multiplicity of meanings. Traditional art history has condemned it as unoriginal, while more recent scholarship has worked with a "trickle-down" model to explain its spread: Roman aristocrats borrowed their art from Greece, which then found its way down the social scale. On this model, the meaning of art did not change through the process, or at least not much.[5] The adoption of Greek art represented a commitment to Greek culture with clearly legible references to canonical works of literature and specific cultural spheres: the world of the gymnasium, the theatre, or Ptolemaic royal luxury.[6]

This strictly formalistic approach assumes that Roman art patrons were iconography experts who used domestic art as a set of signs for communicating straightforward messages. In essence, the complex visual world of the Roman house, which included not only wall painting and statuary but also furniture and objects of daily use, is studied in analogy to public monuments meant to convey the views of their patrons.[7] This interpretative approach toward domestic art assumes that it was primarily about broadcasting the persona that the landlord wanted to project or expressing his social ambitions toward a cultured upper-class life.[8] This is hermeneutics run amok. Still, the trickle-down model provides a good contrast against which a class-specific and reception-based model can be developed.

Roman artists, or rather artisans, worked from a rich but remarkably standardized repertoire. Truly unique images were rare. Most paintings, mosaics, sculptures, and reliefs were inspired by a limited set of widely used prototypes. We know that the designs of popular statues and luxury silver vessels were disseminated through plaster casts, and we have good reason to believe that picture books existed for well-liked paintings.[9] In an age before Benjaminian mechanical reproducibility, no two statues or paintings were identical, but they looked very much alike if they were based on the same iconographic type.[10] As a result, many art historians have been quick to dismiss most of Roman art as derivative, a verdict that others have worked hard to overturn.[11]

With the shifting focus of classical archaeology toward a historical and sociological approach to visual culture, the debate over Roman artistic originality has lost much of its relevance and has been recently criticized as anachronistic by Christopher Hallett: at least, Roman aristocrats and writers admired craftsmanship as much as they valued originality and thought that excellent copies after a plaster cast were just as good as, or sometimes even better than, the original.[12] With the debate on artistic originality fading out, we can take a fresh look at the cultural implications of standardization in Roman art. In reconstructing the lifeworld of Roman middle classes, the widespread diffusion of standardized images is an important aspect of urban aesthetics and can help to steer the debate on subelite art use away from the stylistic analysis by which it has so far been dominated.

One of the first scholars to analyze Roman art culturally and socially was Gerhart Rodenwaldt, but only by means of the conceptually flawed stylistic dichotomy between naturalistic art borrowed from Greece and the more abstract and expressive "people's art" of Italy *(Volkskunst)*.[13] Ranuccio Bianchi Bandinelli reinterpreted this stylistic dichotomy as a matter of class and divided Roman art into the social categories of "patrician art" *(arte patrizia)* as opposed to "plebeian art" *(arte plebea)*.[14] Rodenwaldt's and Bianchi Bandinelli's approaches have been abandoned for almost thirty years. But it is still a commonplace that Greek-style sculptures, and mythological wall paintings in particular, were firmly rooted in the cultured lifestyles of wealthy and educated upper classes as we know them from ancient literature.[15] This assumption allows modern scholars to use writers like Cicero and Varro to explain aristocratic villa decor and poets like Ovid and Horace to interpret the mythological love stories on Pompeian walls in terms of high culture. As we shall see later, Roman domestic decor did indeed originate in the social practices of Rome's senatorial aristocracy, but the practice of decorating houses with statues and wall painting was, when adopted by urban middle classes, given a new range of meanings.

Wallace-Hadrill offers the most elaborate narrative of trickle-down aesthetics. Using Bourdieu's concept of social distinction, he has argued that those lower down the social scale not only aspired to the lifestyles of their betters but also used upper-class status symbols to set themselves

apart from the even less fortunate.[16] Wallace-Hadrill's model mirrors the aristocratic bias of Roman literature about the conventional and ultimately poor taste of rich social climbers, with Petronius's caricature of the boorish nouveau riche Trimalchio standing as the classic example. This narrative may well reflect the view of Rome's literary and social elites. But aristocratic snobbery is not the only evidence we have for social history; the archaeological evidence tells a different story. As I hope to show, there were differences between aristocratic and middle-class image use. Those lower down the social scale did not simply ape their betters, even though, at first glance, aristocratic and middle-class domestic art seem to be mapped along a cultural continuum.

At least in Pompeii, middle-class houses and even *tabernae* were decorated with the same standardized imagery as upper-class mansions and villas in Campania.[17] But a shared iconography does not automatically imply its common reception across milieus. Standardized and widely used imagery is open to multiple and sometimes idiosyncratic interpretations, which can be glimpsed in the archaeological record. This should caution us against the all-too-common error of totalizing interpretations of Roman domestic art. For instance, mythological wall painting and statuary are not just (or even primarily) a means to display learning or refinement. To date, the main interpretative framework for Pompeian and other domestic art has been the Roman aristocratic house, which has been typically analyzed on the basis of Cicero's writings and Vitruvius's *De architectura*. But the Roman noble house is a problematic and artificial construct. Tellingly, an idealized drawing or model occasionally replaces an extant ruin in illustrations.[18] The archaeological evidence is messier and much more interesting. It points to a broad bandwidth in Roman housing and domestic art, most of which was not aristocratic in nature. Again, Pompeii provides the best starting point to reevaluate recent debates on the meaning of domestic decor.

A Cultural Continuum? The Art of Middle-Class Houses in Pompeii

Wallace-Hadrill has used the uniformity of Pompeii's domestic decor to argue that its art reflects the tastes of the imperial aristocracy "by and for

whom" it was "patently generated."[19] Paul Zanker has even gone so far as
to claim that Pompeian wall painting and garden decor allows us to con-
clude that sub- and nonelite lifestyles were "totally oriented towards the
realm of values *(Wertewelt)* and the lifestyle of the rich."[20] But what did
ordinary Pompeians know of the lifestyles and values of the rich if the
conditions of their own lives were so very different? The context of much
of Pompeii's domestic art makes it seem unlikely that we can interpret it
along the lines of elite lifestyles in the city of Rome, or as a means of show-
ing off status and education by aping the fashions of the imperial aristoc-
racy. Here, the archaeological evidence casts doubt on the usefulness of
aristocratic houses as described in the elite literature for understanding the
domestic art of those far lower down the social scale.

As argued above, Pompeian houses and households can be mapped on
a broad economic continuum, which allows for contextualizing their do-
mestic decor according to economic class but not necessarily social rank.
Like other ancient Mediterranean towns, Pompeii was not zoned as cities
are today, but instead was characterized by socially mixed housing and
households with fluid boundaries between work and leisure, and what we
nowadays consider public and private. When a home in Pompeii was suf-
ficiently large, its owners almost invariably walled off *tabernae* and apart-
ments for rent. Often, *taberna* were attached to their own living quarters.
In larger houses, such *taberna*-based businesses were almost certainly run
by a slave or freedman, in smaller houses probably by the owner or main
occupant himself.

In the absence of inscriptions, the rank of Pompeian landlords remains
unclear, even though it is fair to assume that the local *decuriones* lived in
the city's largest houses. This is a rather crude measure, but it reflected an
ancient custom, at least during the Republic. In the famous municipal law
of Tarentum, membership in the *ordo decurionum* required owning a
house with at least 1,500 roof tiles. Conversely, modern attempts by Mat-
teo Della Corte and others to identify the *decuriones'* houses through
painted election notes and graffiti do not, for the most part, hold water
and have been largely discredited.[21] At any rate, the continual gradation of
house sizes and attached rental units points to widely diverging patterns
of wealth among the hundred or so largest *domus,* which were probably
mostly owned by local councilmen. Because large properties were also

owned by absentee landlords and freedmen ineligible for public office, some members of the city's aristocracy must have lived in houses many times smaller than that of Pompeii's late mayor, Cn. Alleius Nigidius Maius.

It is noteworthy that the size of a house, which to some extent reflects economic fortunes, does not always match the richness or quality of domestic decor.[22] Small statues and high-quality mythological wall paintings were a fixture in houses of all sizes and derived from the same iconographic prototypes. This casts doubt on the common interpretative approach of associating mythological wall painting and other domestic decor with the staging of upper-class social rituals like the morning *salutatio* or luxurious *convivia* for high-ranking guests.[23] Of course, Pompeians of all classes showed off to visitors. The reception areas of the largest and probably most visited houses were particularly well decorated. But the overwhelming majority of house owners (or main occupants) lacked a large clientele (if they had any clients at all) and the means to throw a *convivium* Trimalchio-style. This meant a much smaller and, for the most part, less distinguished audience for their decor.

Roman houses were not strictly private in the modern sense of the word, but they were also living space, which means that the decor was probably geared just as much toward residents as visitors.[24] As we shall see later, even Cicero's villas were decorated for his personal enjoyment and not just for impressing guests. Similarly, the most elaborate wall paintings in Pompeii's *tabernae* are found not in the single-fronted sales rooms but instead in adjacent living quarters, which customers or visitors probably never or only rarely entered. The backroom of *taberna* V 2, 14 with scenes from the *Iliad* and the *Odyssey* is a good example.[25] This suggests that the current interest in domestic art as primarily a means of public self-fashioning is too narrow. Arguably, statues and wall paintings served to conjure up an atmosphere the landlord desired.

This applied to luxurious Campanian villas as well as to the houses of Pompeian businessmen. A particularly well-preserved example is the Casa dell'Ara Massima (VI 16, 15.17), which Jas Elsner associates with "wealthy and educated elites" because of its elegant wall paintings,[26] but which instead seems to have been owned, or at least inhabited, by a local businessman or artisan (figure 21).

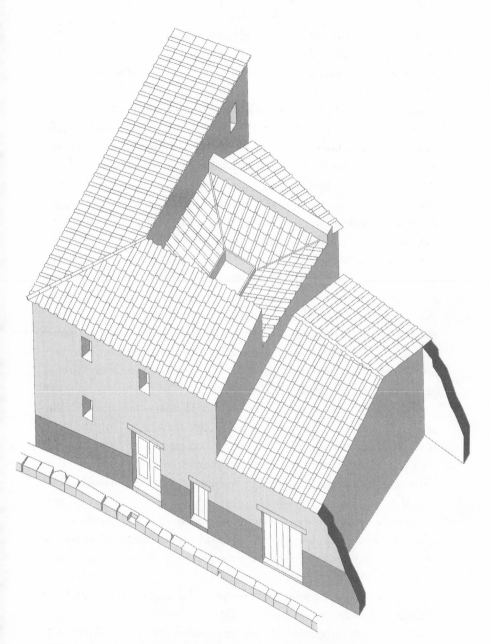

FIGURE 21. Casa dell'Ara Massima (VI 16, 15.17). The *taberna* to the right directly connects with the *atrium* of the main house, which suggests that it was operated by the landlord. The middle door opens up to an external staircase leading to an apartment on the second floor.

At some time between 60 and 70 C.E., most rooms of the Casa dell'Ara Massima were decorated to such a high standard that the house has been used as a textbook example for the fourth Pompeian style of wall painting. Klaus Stemmer, who published it in the *Häuser in Pompeji* series, perceived a mismatch between its small ground area of about 180 square meters and its rich domestic decor.[27] The house was arranged around a small *atrium*. Only the ground floor could have been used by the landlord. The upper story was rented out and made accessible from the street through an external staircase (VI 16, 16). Given the house's small size, we can be fairly sure that its owner or main occupant personally ran the single-fronted *taberna* attached to the north side of the house (VI 16, 17). It originally covered about a fifth of the available ground area before it was subdivided: the southern corners of the *taberna* were walled off to install a small kitchen and a latrine. A corridor between these two service rooms connected the *taberna* with the *atrium*. These makeshift installations suggest that space was at a premium, which is also confirmed by the finds in the rooms surrounding the *atrium*. Two of the three richly decorated chambers south of the *atrium* were cramped with elegant furniture and other belongings, while one *apotheca* and three other rooms opening up to the *atrium* were used for storage of some kind.[28]

Still, the landlord chose to turn the second floor of his house into a productive asset by converting it into a lettable *cenaculum*. Only the relatively small and crowded ground floor was occupied by the owner and his family, unless he also let it for rent and lived elsewhere. At any rate, the main occupant of the ground floor was almost certainly the artisan or merchant who ran the *taberna*. Unfortunately, the excavation report does not provide enough information to reconstruct his business, but the finds of a large bronze scale, a lead weight, and 120 bronze fishing hooks in one of the well-decorated rooms south of the *atrium* (G) indicate some retail business.[29] Whether owner or tenant, the living conditions of the house's main occupant did not reflect the lifestyle of Pompeii's or other "wealthy and educated elites" in the Roman world.

These modest circumstances notwithstanding, the Casa dell'Ara Massima was lavishly decorated with mythological wall paintings and well-made furniture. Almost all decor elements of the house derived from iconographic types that were connected with originally aristocratic life-

styles and fashions. They attest to the standardization of domestic decor, which transcended rank and class.

The west wall of the *atrium,* which greeted visitors entering through the long and narrow *fauces,* sported the house's best wall painting. A small niche was placed in the axis of the entrance. It still contains a painting of Narcissus and a marble water basin placed in front of it.[30] Above the niche, a large landscape painting is set as a centerpiece into lively colored trompe l'oeil architecture. Two tall stage doors flank the central panel. A flight of three stairs leads up to each of them. The waist-high doors of these entrances have been flung open by two women stepping down the stairs. They do not appear to be actresses, but a dark blue curtain drawn from the landscape painting and a theatrical mask in a niche next to the left stage door reference the theatre. The ensemble is flanked by two tall statues standing before elegantly embroidered blue curtains: to the left by a statue of Neptune holding a dolphin, to the right by a winged Victory. Such *scaenae frons*-like wall paintings became popular in the late second century B.C.E.[31]

The subject matter of the landscape painting had been in fashion for over three generations before the house was decorated: it follows the iconographic type of Egyptian sanctuaries on a rocky island in the flooded Nile. But we can no longer associate it with a specific place.[32] The Narcissus image in the central niche is a common motif too. It follows a prototype portraying the half-naked young hero sitting provocatively on a rock while gazing at his own reflection in a pond.[33] Over fifty variations on this theme have been found on Pompeian walls. The example from the Casa dell'Ara Massima is set in a painted frame with perspectively drawn bronze shutters, as if it were a Greek masterpiece on a wooden panel displayed in public or aristocratic picture galleries *(pinacothecae)* (figure 22a). Yet, the painting does not seem to aim at accurately reproducing a famous image of a well-known mythological subject: Narcissus looks upward, and clearly not at his own reflection in the pond. If we take the image seriously, Narcissus is merely portrayed as a pretty boy sitting by a pool and not as the self-centered hero cursed to fall in love with his own reflection, the key theme in the literary telling of his myth.[34]

By contrast, the main representational interest in the Casa dell'Ara Massima is in mirror images per se. The painting of Narcissus's reflection

in the pool was mirrored in the water basin placed before it, a clever self-referential arrangement that was also used for staging other Narcissus paintings, which often have him looking upward.[35] Consequently, Narcissus's ethereal skyward gaze in the Casa dell'Ara Massima does not appear to be a mistake by an ignorant painter but instead a conscious and common choice. It is entirely possible that the literary focus on self-love was simply not a concern for painters and/or patrons, who preferred to represent Narcissus as an alluring young man, often as a pendant image of other similarly objectified female mythological beauties.[36]

Variations on common mythological motifs are often found in middle-class contexts. They are interesting in themselves and are discussed below, but they also point to a larger issue in the interpretation of highly conventional and standardized decor such as Pompeian wall painting: iconographically set types can be employed and changed in multiple ways and, as a result, carry more than just one meaning. Is a pretty boy sitting by a pond still Narcissus if he is not entranced by his own reflection? Is a trompe l'oeil architecture with hanging curtains still a *scaenae frons* if it frames

FIGURE 22A. K. Stemmer, Casa dell'Ara massima (VI 16,15–17), Häuser in Pompeji 6 (Munich: Hirmer, 1992) Abb. 200. Narcissus from the Casa dell'Ara Massima. Narcissus is looking neither at his own reflection in the pool in front of him nor at the viewer.

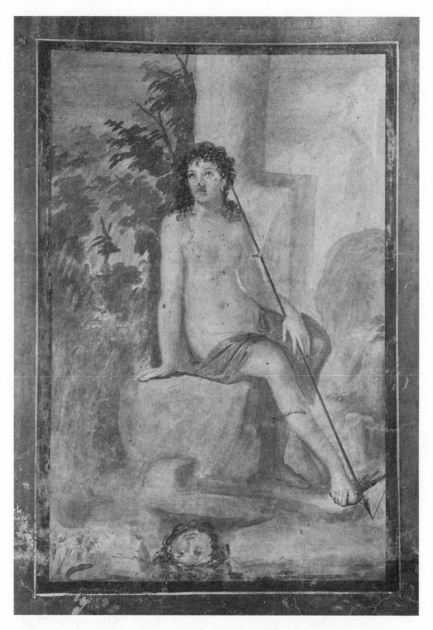

FIGURE 22B. Narcissus from the so-called House of Octavius Quartio (II 2, 2). Again, Narcissus is looking upward and not at his reflection in the pool.

a Nilotic landscape painting? Or is a single image in a painted frame an ersatz *pinacotheca?*

Here we touch on a major question in recent discussions of Roman domestic decor. In which way were images legible as references to specific cultural spheres and in which way do they share a common meaning? This is an important issue for the argument at hand. If Pompeian wall painting constituted a single semantic system with clearly legible iconographic elements, it would be milieu blind. This is the current scholarly consensus. It rests on the assumption that individual motifs reference specific cultural spheres, like the theatre, or the "dream worlds" of royal palaces in the Greek East, but first and foremost the Roman aristocratic villa. This premise seems doubtful and has to be reconsidered before returning to class-specific modes of viewing standardized images.

While the debate may seem overly technical at first, it is nonetheless important because the question of mimesis is at the heart of the sociocultural analysis of Roman domestic decor.

How Mimetic Was Roman Wall Painting?

Current research prefers to answer questions of this sort with Wallace-Hadrill's concept of "allusion," which he formulated in antithesis to the widespread opinion that Pompeian wall painting was illusionistic.[37] In his interpretation of Roman domestic decor, wall painting purposefully alludes to existing architecture, not through accurate imitation but through allusion to some of its elements: public spaces like boldly painted *basilicae,* theatres, and sanctuaries in the late Republic, more subtly drawn *pinacothecae* and gardens under the Empire.[38] These visual cues to civic life and luxury, Wallace-Hadrill argues, were used as a means to express the social hierarchy of rooms in an upper-class house, which served as an appropriate setting for the activities taking place there. Under this model, decoration is derived from the Roman idea of *decor.*[39]

Propriety doubtless played a key role in the choice of domestic decor. For instance, nonmythological sex scenes are almost exclusively confined to so-called *cubicula,* small rooms that could be locked by a door and thus provided the necessary privacy for rest, sleep, and intercourse, but also for intimate conversations or, in Rome, even secret trials presided over by the

emperor.[40] But how far can we push the analogies between decor and ac-
tual domestic life? Vitruvius, Wallace-Hadrill's main guide to Roman
domestic decor, argued for the significance of architectural quotations,
which, as a matter of fact, come closer to imitation than to allusion. To
Vitruvius, noble houses serve as the primary venue for the public business
of leading citizens and should therefore be equipped with "libraries and
basilicas that compare, not in a dissimilar manner, to the magnificence of
public works."[41]

The owners of aristocratic country houses occasionally went beyond
allusion, making explicit reference to specific places. Cicero named two of
his peristyle gardens in his favorite villa at Tusculum after Athens's most
famous *gymnasia:* the Academy and the Lykeion, which he had liked to
visit as a young student in Greece. In a letter to his friend and art agent
Atticus, he specified that the decor which he ordered for these two peri-
styles should be *gymnasióde,* so that he could fit them out accordingly.[42]
This direct reference to Greek *gymnasia* appears again in Cicero's *De ora-
tore.* In this fictional dialogue, the protagonists discuss the cultural con-
notations of the columned gardens on Cicero's favorite Tusculum estate,
which are the imagined setting of their conversation: the cultured phil-
hellene Catulus compares them to Greek *gymnasia.* He associates them
primarily with philosophical disputations, while the pragmatic Crassus
stresses the role of *gymnasia* physical education.[43]

These and other literary testimonies are enough proof that the taste of
Rome's educated cultural elites in domestic and particularly villa decor
overlapped at least in part with Wallace-Hadrill's Vitruvian concept of
allusion. But does this tool of analysis work for the lifeworld of Pompeii's
middle classes? In a seminal 1979 article and later in a 1995 book on Pom-
peian domestic decor, Zanker argued that "middle class *(Mittelschicht)*"
landlords consciously imitated the villa lifestyle of the rich in the design
and decor of their town houses. In his opinion, the many well-decorated
small and medium-sized houses in the city reflect the "taste of a broad
class of well-to-do Pompeians that was totally oriented towards the realm
of values *(Wertewelt)* and the lifestyle of the rich."[44] In his argument,
Zanker is mainly concerned with sculpture gardens, complete with elegant
fountains and large-scale illusionistic frescos opening up painted garden
walls as windows into game parks or other idyllic wildernesses. But in his

opinion, Pompeian wall painting in general not only copies, more or less accurately, upper-class domestic decor; it is also meant to conjure up a villa world of luxury through offering "a variety of associations. The aim was to bring to mind objects of desire and dream-worlds as plainly as possible."[45]

There is no doubt that at least iconographic motifs taken from luxurious villa life inspired Pompeian wall decoration. Again, the Casa dell'Ara Massima provides a case in point. The well-decorated so-called *tablinum* G opening onto the south side of the *atrium* could be seen to allude, all at once, to a *pinacotheca,* a theatre, a game park, and a fancy garden with flowering plants and water birds.[46] The wall painting on the *tablinum*'s southern rear wall is lost, but frescos have survived on the lateral east and west walls. These walls are decorated in what has come to be defined as classic fourth-style wall painting. Each wall is divided into three horizontal zones: a black socle with water birds and flowering plants supports a central zone that is divided into three large monochrome panels. The central yellow panel is framed by two strips of perspectively drawn stage architecture on a white background. On both walls, the central yellow panel serves as the backdrop for a mythological picture in a square frame. The two lateral panels are painted red and decorated with a white *pelta*-shaped band. A circular dish in the middle of each red panel is laden with fruits and nuts. The yellow top zone on both walls rests on a perspectively drawn stage roof with coffered ceilings. Here, the painting does not purport to represent any existing architecture. Instead, it dissolves the top quarter of the wall into an intricate framework of slender columns and broad, "embroidered" bands. One of the horizontal borders is clearly modeled after the fence of a game park with peacocks sitting on it. Two deer walking on ornamental bands also belong to the world of a *paradeisos*. A garlanded, *tholos*-shaped tripod in the center of the composition rests on a frieze of fish separating it from a marble basin below, which contains a sacred object covered by a purple veil.

In combination, all these architectural elements do not conjure up a specific building, but as motifs can be traced to various parts of an aristocratic villa, as described in Latin literature: from the first century C.E., Roman aristocrats created game parks, fish ponds, and sanctuaries on the grounds of their villas and enjoyed dining in aviaries and indoor as well as outdoor *pinacothecae*.[47]

This so-called *tablinum* in a craftsman's or merchant's house probably did not function like architecturally comparable reception rooms in upper-class houses. So can we still say that it alludes to aristocratic country life as Wallace-Hadrill would suggest? Or could it qualify as "villa-imitation *(Villenimitation)*," as in Zanker's model? The evidence suggests otherwise.

Strikingly, Zanker himself assumes that most Pompeians were unaware of the iconographic tradition and architectural prototypes which inspired the fanciful architectural frames that were popular in third- and fourth-style wall painting. If this were so, their imitation of the elite would have been almost a subconscious matter.[48]

Indeed, it would be hard to claim that Pompeian wall painting of the first century c.e. tried to evoke any existing buildings. Architectural vistas moved away from straightforward architectural allusion.[49] Around 30 B.C.E., the late second style of wall painting gradually abandoned plausible if fictitious architectural representations. The early and mature second styles are known for their grandiose architectural prospects. According to Zanker, these "open walls" were modeled after the grand vistas that Roman aristocrats came to appreciate in the palaces and parks of Hellenistic kings.[50] The late second and third styles, on the other hand, abandon trompe l'oeil architectural vistas for "picture galleries" on mostly monochrome walls.[51]

Already in the late second style, architectural elements are reduced to structurally implausible framing elements, which continue into the third and ultimately the fourth style of Pompeian wall painting, as seen in the Casa dell'Ara Massima. With the exception of possible allusions to picture galleries, the third and fourth Pompeian styles are, therefore, hard to reconcile with the allusion model.

Furthermore, the first and second styles were far less mimetic than is often assumed. Arguably, stucco and painting were used to beautify a room after the fashion of a public building or villa, without trying to imitate, compete with, or even allude to such spaces. As with many other aspects of Roman architecture, the claim that architectural mimesis was a common practice is based on a problematic passage in Vitruvius. Since it is so central to the semantics of Roman wall painting, it is worth revisiting.

As elsewhere in his book, Vitruvius does not give an accurate descrip-
tion of the architecture of his time but rather states how, on his view, ar-
chitecture ought be. This reflects a complex social reality. Vitruvius fan-
cied himself as an intellectual and as a theoretician who wanted to
reorganize the construction industry of his time along the lines of Greek
science.[52] This included the application of wall painting. The problem that
Vitruvius faced was that such decor was no longer restricted to the social
elites but had become almost universally available. In this context, Vitru-
vius felt that (pseudo)educated men like himself had to reclaim the sole
privilege of interpretation of what constituted appropriate decor.

Vitruvius famously complained that in his own time—that of Augus-
tus and the late second style—the straightforward representation of "what
is or could be" had been given up.[53] Mimetic paintings "of buildings, col-
umns and gables, . . . the varieties of landscape gardening, . . . the images
of the gods, or the representations of myths" had fallen out of fashion.[54]
Now, he complains, "all these things, which used to be modeled after the
truth, are disdained by bad taste. . . . Instead of columns there rise up
stalks; instead of gables, striped panels with curled leaves and volutes.
Candelabra uphold pictured shrines and above the summits of these, clus-
ters of thin stalks rise from the roots in tendrils with little figures seated
upon them at random."[55] Vitruvius uses the Apaturius episode to illustrate
this superficially stoic ideal of mimetic truth. This much-discussed pas-
sage deserves to be quoted in full because of the revealing way in which it
attempts to breathe meaning into what most people probably did not
consider particularly meaningful:

> At Tralles, Apaturius of Alabanda created a stage painting (scaenam)
> with an elegant hand in a tiny theatre that they call the ecclesiasterion.
> In this he showed columns, statues and centaurs supporting architraves,
> round tholoi roofs, projecting pediment angles and cornices decorated
> with lion heads which provided outlets for the rain from the roofs; fur-
> ther a second storey in the façade in which there were tholoi, porticoes,
> half pediments and all kinds of roof ornaments. When therefore the
> appearance of this stage by its bizarre composition (asperitas) charmed
> the eyes of all, and they were already at the point of applauding it, Li-
> cymnius the mathematician came forward and said, that the people of
> Alabanda . . . had the reputation of being stupid because of one not very

great fault: a lack of propriety *(indecentia)*. In the *gymnasium* the statues were all of [orators] pleading cases, in the forum of [atheletes] holding disks, running or throwing javelins. The disposition of the statues was improper because of their location *(indecens inter locorum proprietates status signorum)* and thus added a blemish to the city's reputation. Let us see to it that the *scaena* with its paintings does not make us Alabandans and Abderites.[56]

In what follows, Licymnius points out, rather narrow-mindedly, that one cannot have "buildings with columns and elaborate gables above your roof-tiles. For the latter stand upon floors, not above roof-tiles." He concludes with a stern warning: "if we approve in pictures what we cannot justify in reality, we are added to those cities which, because of such faults, are esteemed slow-witted."[57]

Andreas Grüner's careful analysis of the terms used in this passage shows that Vitruvius considered *ratio* in real as well as painted architecture as a moral imperative and illogical, nonmimetic use of architectural elements as indecent *(indecens)*, if not downright insane.[58] At the end of the chapter on wall painting, Vitruvius wishes for "the immortal gods to bring about that Licymnius come back to life and correct this madness *(amentia)* and the errant fashions *(errantia instituta)* of the decorators."[59] In the larger context of Vitruvius's work, this episode represents two of his main concerns. First, it is one of many forced and clumsy attempts to anchor the profession of architecture in the (half-understood) intellectual debates of his time. Second, it restricts the interpretation of architecture and art to what Vitruvius himself found appropriate. In this context, it is not at all surprising that Vitruvius likely made up the story to serve his literary agenda. But it is also useful for answering the question at hand. Does Pompeian domestic decor follow a Vitruvian sense of *decor* and therefore function as an allusion to "things that are or may be," and if so, how do we evaluate the mimetic qualities of highly conventional and standardized wall painting?

First of all, it is doubtful that the customers and painters of late first-century-B.C.E. wall painting thought as hard about the architectural plausibility of their trompe l'oeil frescos as Vitruvius did. At least in the Tralles episode, poor Apaturius initially "charms the eyes" of the citizens until the pedantic Licymnius demolishes his work. Tellingly, Vitruvius is not content

to point out the impossibility of Apaturius's painted architectures and thus proceeds, through his mouthpiece Licymnius, to insult the artist's hometown as a place where basic rules of propriety do not apply. As we know from the rich corpus of Greek inscriptions from Asia Minor, the local cities gave much consideration to where honorific statues for orators and athletes should be placed, as was the case in the Latin-speaking West.[60] Only by raising the compositional principles of public wall decoration to the same level of civic importance can Licymnius convince his fellow citizens that Apaturius's painting matters politically and must be reworked according to "the reason of truth" *(ad rationem veritatis)*.[61]

It is implausible that such considerations carried much weight from day to day. Most importantly, the highly educated sociopolitical elites, Vitruvius's intended audience, fully embraced the new style. Aristocratic and upper-class houses were still decorated with a sense of propriety regarding the placement of figural paintings and statues. But they were now displayed against the background of implausible architectural frames. From the archaeological evidence, it seems Vitruvius's argument that wall decor should follow logical design principles was largely ignored. His ideals of mimetic truth and allusion were never core design principles of Roman wall painting. And taking his statement as authoritative has reduced the interpretation of Roman wall painting to an issue of mimesis and a matter of referencing concrete spaces and cultural contexts.

Perhaps modern scholarship has adhered to Vitruvius's narrative of stylistic and semantic change in Roman wall painting because it at least seems to fit its chronological development:

> Painting represents what is or may be, such as men, houses, ships, and other things, the forms and precise figures of which are transferred to their representations. Hence those of the ancients who first used polished coats of plastering, originally *imitated* the variety and arrangement of inlaid marbles *(imitati sunt primum crustarum marmorearum varietates et conlocationes)*. Afterwards the variety was extended to the cornices, and the yellow and red frames of panels, from which they proceeded to the representations of buildings, columns, and the projections of roofs.[62]

This passage describes the stylistic change from the first to the second Pompeian style. But the chronological accuracy of Vitruvius's account

does not necessarily mean that, in the good old days of the republic, the first and second styles were indeed about imitation or even allusion. Vitruvius's argument for representational truth is little more than an attempt at systematizing current design and architecture along the lines of half-digested Platonic philosophy. It does not reflect the actual development of Roman wall painting.

Vitruvius's claim that wall painting went from mimetic truth to bizarre monstrosity *(monstra)* is hard to reconcile with the available evidence. Of course, most of our corpus comes from the Vesuvian cities, which may not be wholly representative of what Vitruvius saw at Rome. But the few bits and pieces of first-century-B.C.E. wall painting that have survived in the capital do not deviate much from what has been found around the Bay of Naples.[63] Neither the first nor the early and mature second styles strictly follow nature or existing architecture. The stucco incrustations of the first style are modeled after the ashlar masonry of temples and other public buildings. But they are not painted to closely imitate the texture of colored marble, as Vitruvius claims. Where the stucco is painted with marble veins, the patterns and colors can only rarely be linked to that of a known variety of stone. Instead, they resemble modern marbled paper.[64]

Stuccoed ashlar walls are sometimes left marble white as on the main façade of the Casa di Giulio Polibio (IX 13, 1.3). But especially on interior walls, such blocks are frequently painted with bright colors that would not appear to reference or allude to existing architecture. A typical example comes from the *atrium* of the Casa di Sallustio (VI 2, 3–5.30.31). There, the lowest course of stuccoed orthostates is painted black, while the blocks in the upper courses alternate between yellow, red, and purple. Fancifully marbled blocks crown the stuccoed ashlar wall. Clearly, the decorators made full creative use of stucco and paint and did not feel restrained to limit their imagination to "what was or could be." The same holds true for second-style wall painting. Even in its earliest form as seen in the Casa dei Grifi on the Palatine Hill in Rome, the perspectively drawn columns and cornices do not imitate an actual colonnade.[65] And here too, the texture of its painted alabaster veneer does not conform to any known variety of stone.

Tellingly, all attempts to determine the architecture on which the vistas of the second style might be based have generated only literary parallels. Most often quoted is Athenaios's second-century-C.E. description of the

Thalamegos, the royal barge of Ptolemy IV.[66] In this vein, the vistas of the mature second style are perhaps better understood as a visual equivalent to literary descriptions of grandiose architecture and not so much as a direct reference or allusion to Ptolemaic barges and palaces, about which we have no archaeological knowledge.

As a result, Vitruvius's sharp dichotomy between the mimetic styles that were used *ab antiquis* and the insane monstrosities *(monstra)* of his own decadent day *(nunc)* should be taken with a grain of salt. From the late second century B.C.E. onward, Roman landlords must have understood and appreciated that their decorators used their imaginations to create effects in painting that could not be achieved in colored stone. Even the best *opus sectile* cannot compete with a fresco in the depth and richness of its colors. In a mosaic of colored stone, illusionistic depth through shading and highlighting is completely unattainable. Doubtlessly, actual marble veneer was much more expensive and consequently more luxurious than a painted one. But that does not at all imply that first- and second-style frescoes were nothing but cheap imitation. If we take the archaeological evidence seriously, there is no discernible trace of a Vitruvian obsession with representational truth in surviving wall painting, a point that Vitruvius himself made for the wall decor of his own time.

Where does this leave the concept of allusion and with it the notion that Roman wall painting structured domestic life through clearly legible iconographic references, in particular to public buildings and aristocratic villas? The answer suggested here is that wall painting did not in fact serve this function, at least not as straightforwardly as suggested by Wallace-Hadrill and Zanker. When Cicero named two peristyles in his Tusculum villa after his favorite *gymnasia* in Athens or when Augustus referred to his study as "his little Syracuse or *technophyion*" ("little laboratory," probably after the study of Archimedes), we have no reason to believe that Cicero's garden *gymnasia* or Augustus's *technophyion* were decorated to reflect these associations.[67] Such names were a matter of personal practice and not of decor. In the case of Cicero's Lykeion and Academia we know this with some certainty. The names were of personal significance to Cicero, but associating colonnaded villa gardens with *gymnasia* was the fashionable thing to do in the mid-first century B.C.E. As we shall see shortly, Cicero made no attempt to personalize the decor of his *gymnasia* as an homage to the

Lykeion or the Academia. Rather they appear as a conventional garden *gymnasium*.

This absence of specific iconographic references does not, of course, mean that the term *gymnasium* carried no generic cultural associations. But we should be careful not to interpret a garden *gymnasium* as a reference to an actual Greek *gymnasion*. Here, the concept of allusion is unhelpful because it obscures what a garden *gymnasium* meant to Cicero and his contemporaries. Unlike a Paul Getty, Cicero and his peers lacked the antiquarian ambition to faithfully rebuild a Greek *gymnasion* in order to recreate its atmosphere. To Roman aristocrats, the term *gymnasium* was merely a shorthand for a colonnaded courtyard, suitable for exercise and conversation.[68] These pastimes may have been understood as (originally) Greek cultural practices, but the Roman garden *gymnasium* was not used or perceived as an authentically Greek space, in which Roman statesmen could assume the role of Greek thinkers. We are not dealing with the Roman equivalent of eighteenth-century chinoiserie, which involved European monarchs and their courtiers dressing in fanciful Chinese costumes and having tea in Chinese-style pavilions. Roman garden *gymnasia* were, if anything, a fantasy of Greece, and, much unlike baroque chinoiserie pavilions, purposefully so.

Here, we return to the potential of standardized images to create personalized settings. Common iconographical types were, on the one hand, specific enough to conjure up generic associations like Greek learning, rural piety, or the playful eroticism of a literary Arcadia. But, on the other hand, they were vague enough to be endowed with personalized meaning. Cicero's *gymnasia* are a good starting point for discussing this phenomenon among Rome's hyperliterate upper classes, which then serves as a contrast with ancient middle classes.

Standardization and Multiple Meanings in Upper-Class Settings

Cicero decorated his houses with conventional imagery but with a specific idea in mind. We know this because of his private letters.[69] They provide immediate insight into the reception of Roman aristocratic villa decor. Unlike in *de domo sua,* Cicero does not conceptualize his villas as a

political symbol, but casually talks about which imagery he personally enjoys. Most of Cicero's letters concerning his houses and villas have been carefully analyzed by Roman archaeologists, primarily as a chapter in the history of "art collecting."[70] While Cicero has disappointingly (or rather revealingly) little to say about art collecting and art connoisseurship, he opens a unique window into his personal attitudes and those of his peers.

The best-known series of letters concerns the decor of Cicero's favorite estate at Tusculum, the above-mentioned Tusculanum. They were probably written between the winter of 68 B.C.E. and the summer of 65 B.C.E. and addressed to Cicero's friend Atticus. Atticus was, at the time, living in Greece and in a position to help Cicero with procuring Greek marble statues for his villa. In his first letter, Cicero asks Atticus to send him garden decor. Cicero blindly trusts Atticus to find what he "thinks suits his Tusculanum."[71] Only in the second letter, presumably written shortly afterward, does Cicero provide his friend with a very broad thematic idea: "If you can find any *ornamenta* that are *gymnasióde* and fit for the place you know well, please do not let them slip."[72] In two subsequent letters on the subject, Cicero gives no further specifics. We only know that he was pleased with Atticus's first choice of "Megarian statues" *(Megarica signa)* and "herms of Pentelic marble with bronze heads."[73]

Cicero asked for more but remained vague: "send me," he writes, "statues and so forth which suit the place [at Tusculum], my interests and your taste, as much and as soon as possible. But first and foremost what you think suits a *gymnasium* and a *xystus*."[74] The term *gymnasióde* reappears in a third letter.[75] Here Cicero urges Atticus to send him the pieces that he had already bought and further "whatever you have of this genre and what you think worthy of my *Academia*. Do not hesitate or worry about money. This is the genre I delight in: I look for what is most *gymnasióde*."[76]

Richard Neudecker and Miranda Marvin argue on the basis of these letters that Cicero was not the art collector he was long believed to be.[77] Indeed, his letters leave little doubt that he did not care about buying individual pieces, but rather about an ensemble that somehow suited a *gymnasium*. Tellingly, he wanted Atticus to buy as many statues as possible and only specified the genre *(genus)* he liked best. Marvin stresses the context-bound significance of Cicero's statues and concludes that most Roman domestic statuary served to conjure up an atmosphere.[78] But what does this

mean? As we have seen, Roman wall painting was not mimetic in a strict sense and statuary was not used to recreate an authentic Greek *gymnasion*.

Here, a first-century-C.E. garden can provide insight into the atmospheric nature of villa decor. The richest and best-studied aristocratic garden belongs to the Villa dei Papiri just outside Herculaneum.[79] It probably comes close to what Cicero considered a *gymnasium* or a *xystus*. Like a Greek *gymnasion* with a covered running track *(xystus)*, it was laid out as an elongated colonnaded courtyard. But here the architectural parallel ends. Unlike a functional *gymnasion* or *xystos*, the garden was, at least in part, designed from a vantage point and meant not only to be walked in but also viewed as a diorama from the main house.

The garden opens up to a *tablinum*-like room in its center axis, which, in turn, communicates with the villa's living quarters. About a third of the available garden space is taken up by a sixty-six-meter water basin. It ends in two semicircular basins and was lined with a fence. Hermaic pillars topped by portraits of Greek statesmen and thinkers served as fence posts, which recall Cicero's bronze heads on marble herms.[80] But these herms would have been barely visible from the so-called *tablinum*. From there, the garden was designed to look like a bucolic wilderness populated by bronze statues of three deer, a prancing piglet, and a sleeping satyr at the east end of the pool that faced the house.[81] This ensemble was flanked by herms of Apollo and Diana to the right and a herm of Heracles to the left. Those could be viewed as tokens of rural piety. But we should not take this idyllic scene too seriously. On the left edge of the pool and probably still visible from the *tablinum* stood a fine marble statuette of Pan having intercourse with a goat.[82] Piggish as it is, this was certainly meant to be funny. Unlike copulating quadrupeds, the goat is lying on her back and breathing through her mouth while gazing at Pan lovingly.

Humanizing goat sex in an idyllic wilderness was obviously not at odds with the well-attested literary interests of the villa's owner, who had a library full of Greek books and statues of Greek intellectuals in his house and garden *gymnasium*. Three statues of Greek philosophers and orators overlooked the bucolic ensemble.[83] They were not visible from the so-called *tablinum* as each statue was placed in front of a column facing the garden. They were not part of the diorama described above, but marked the spot where the *tablinum* opened onto the colonnade.

Cicero referred to such portrait statues as fixed points in aristocratic gardens. In a letter to Atticus, he wishes to sit on a bench under the portrait of Aristotle.[84] His Brutus is set meaningfully *in pratulo propter Platonis statuam*.[85] It is very unlikely that the Aristotle portrait in one of Atticus's villas was its only garden decor. But Cicero singled it out as a meaningful spot, just as he chose to set his self-glorifying discourse on Roman eloquence under a statue of his favorite philosopher. Obviously, individual decor pieces could be seen in isolation from the surrounding artwork. It was up to the viewer to make personal connections.

This compartmentalized way of art viewing points to a larger design principle in Roman art: wall painting and statuary were arranged according to formal criteria, within loosely defined thematic settings. Neither the owner of the Villa dei Papiri nor Roman art buyers in general were interested in a Wagnerian *Gesamtkunstwerk,* in which all decor elements firmly tied into an intellectually coherent program.[86] Instead, popular and much-copied pieces like animals and satyrs were grouped together and arranged by formal criteria, typically as pendant images.[87] The sleeping satyr is mirrored by a lively drunken satyr lying at the other end of the basin, even though they were sixty-six meters apart. And further on we will see that inverting motifs served as a compositional principle in arranging the mythological images on Pompeian walls as well.

Unlike the sleeping satyr facing the house, the drunken satyr had neither wild animals nor hermaic pillars for company. In the absence of a clearly defined vantage point, such a diorama would not have made sense at the far end of the garden. Instead, bronze statues of two runners and a Hermes referenced the world of the Greek *gymnasion*.[88]

Here, then, we have three distinct thematic groups: Greek philosophers and orators, an idyllic Arcadian setting, and two athletes overseen by Hermes, the god of the *gymnasion*. A fourth group consisted of four *peplos*-wearing girls in the south colonnade, which may or may not recall classical Athens.[89] In addition to the Greek kings and thinkers on the herms lining the pool, two more hermaic portraits of a female poet and Seleucus I Nikator were set up somewhere in the northwest corner of the garden.[90]

A learned visitor to the garden might have woven these thematically disparate groups together in an ad hoc manner, but there is no reason to believe that the garden decor was acquired or set up according to an overarching

idea. The garden contains some rare portraits of Hellenistic kings and a few unidentified poets. But, like almost all other pieces found in the villa, these busts follow long-established iconographic types. They were made in Campania during the early principate and mostly represent men of great historical significance.[91] Therefore, their selection seems to have been as much determined by the plaster casts available to local workshops as by the interests of the landlord. At least in 79 C.E., they were not combined in any historically meaningful way. This recalls Cicero's manner of acquiring *hermae Pentelici cum capitibus aëneis.* In his part of the correspondence, Cicero only mentions their material and not whom they represented. Since portrait herms were a fixture of Greek *gymnasia,* they were good enough for him.

Cicero's approach to such generic *gymnasium* decor seems to have been more emotional than intellectual.[92] While the portraits of Aristotle and Plato had significance for him, Cicero felt at ease with a more playful approach to the statues of other Greek intellectuals *(palliati).* In a letter to his brother Quintus, Cicero applauds humor or at least irony in domestic decor. Here, Cicero praises a landscape gardener *(topiarius)* who, on his own initiative, had created the illusion of ivy-selling statues in Quintus's villa at Arpinum: "I have commended the *topiarius.* He has so enveloped everything with ivy . . . that the *palliati* themselves appear to be gardening and to be offering ivy for sale."[93] Cicero was obviously amused that the rhetorical gestures and poses of Greek cultural heroes could be subverted in this way and did not feel that it took away from their dignity or undermined a carefully designed program. We do not know how the bushes and trees in the garden of the Villa dei Papiri were trimmed, but the Pan statuette also seems to attest to a sense of humor. If the owner of the villa actually read the Greek books in his library, he might have been just as educated as Cicero and did not have to show off his learning and cultural competence by putting up portrait statues of famous intellectuals. Indeed, he might have been amused by some of the, one might say, overly learned modern interpretations of his garden decor.

At least in the *Satyrica,* the hypereducated Petronius found almost as much to ridicule in the pompous ekphrastic poem of the pederastic schoolmaster Eumolpus as in Trimalchio's crass misinterpretations of the mythological scenes on his silver cups.[94] In antiquity as well, a patrician with an assured sense of style did not have anything to prove. Unlike nouveaux

riches, like Trimalchio, or unemployed academics like Eumolpus, superliterate Roman upper classes could take for granted that their peers were familiar with Greek culture and literature. They did not have to show it off in order to gain social recognition or find employment. Consequently, in the elegant aristocratic literature of the Julio-Claudian and Flavian ages, generic domestic decor like philosopher portraits was typically mentioned as a matter of course. Only truly exceptional and storied pieces warranted detailed attention. Here, the oeuvre of the late first-century-C.E. poet Statius is instructive.

In a famous poem on the villa of his friend Pollius Felix, Statius devotes only ten lines to Pollius's statues, paintings, portraits, and tableware made of Corinthian bronze.[95] But he dwells at length on the villa's marvelous location on the Gulf of Sorrento and on one single room (diaeta), which was decorated with expensive opus sectile combining precious stones from all over the known world.[96] Of course, Pollius's villa decor could not go without mention, but it was not worth going into detail either. Many men in Pollius's circles owned such decor, but probably not all of them had a villa in such a stunning spot or a diaeta fitted out to rival the splendor of the imperial palace in Rome. Conversely, Statius devoted a whole poem to a small bronze statue belonging to a Novius Vindex.[97] It had, supposedly, been made by Lysippos for Alexander the Great and later passed on to Hannibal and Sulla. Both Statius and Martial, who devoted two epigrams to Vindex's showpiece, refer to it as the Herakles Epitrapezios, a statuette to be displayed on a table during a convivium.

This context is important. We have no indication that Roman aristocrats gave visitors a great tour of their houses or of their art collections, as was (and often still is) customary among Europe's and North America's bourgeoisie. But we know that the fictional Trimalchio and the first-century-C.E. Novius Vindex showed off their precious tableware at dinner parties. Petronius and Martial ridiculed their blatant name dropping and ludicrous claims to art connoisseurship.[98] But their botched attempt at making elegant conversation does, in fact, reflect how and on which occasions highly educated Roman upper classes did talk about individual works of art. While ensembles of domestic art were typically only mentioned in passing, a cup, a statue, or an individual painting could become a conversation piece at a dinner party. The actual iconography of Trimal-

chio's silver cups and Vindex's Herakles Epitrapezios seems to have been less important than the literary and historical connotations they conjured up. They served, primarily, as a starting point for talking about mythology and history.

In an upper-class context, the same could be said about the name of a villa or a villa garden. As we have seen above, Cicero did not care very much about finding specific decor for his two *gymnasium* gardens, but named them Academia and Lykeion for mostly literary associations. Moreover, when Cicero inquired about the Amaltheion, a garden in one of Atticus's villas, he asked about its decor *(ornatus)* and its layout *(topothesia)*—so that he could make one for himself in Arpinum—but also urged his friend to send him "whichever poems and stories" he had about Amaltheia.[99] Literary representations of Zeus's foster mother mattered at least as much for his enjoyment of such a garden as any artwork he could procure.

As a matter of fact, we know for sure that Cicero was not any more careful about decorating his Arpinatum than he was about his favorite Tusculanum. This time, not Atticus but another friend, Marcus Fadius Gallus, was charged with buying statues for it.[100] But unlike Atticus, Gallus failed to please. Not only did he get the wrong statues, but he also bought them at so inflated a price that Cicero tried to get them off his hands. Of course, Cicero did not blame Gallus but one of his freedmen, who supposedly relayed Cicero's wishes incorrectly. But this is little more than a way of saving face. It is clear from the letter that Cicero had not ordered specific statues and that the information the freedman had been asked to convey had been, at best, a vague thematic idea.

Like Cicero's Tusculane Academia and Lykeion, his Arpinate Amaltheion may have been conceived as a conventional peristyle garden, which did not contain any decor that was out of the ordinary. Indeed, from the little that we know of Atticus's Amaltheion, it did not contain any visual references to Amalthea. In *de legibus,* Cicero mentions its magnificent plane trees and from the letter quoted above we know that there was a verse inscription celebrating Cicero, maybe in connection with his portrait.[101] There is no reason to believe that Atticus's Amaltheion was decorated in the spirit of the Habsburgs' Achilleion on Corfu.[102] And indeed, building a villa around a central mythological theme is a nineteenth-century

idea. At least in Pompeii, none of the houses excavated so far shows decor centered on just one myth or mythological cycle.

This is true not only of houses but of individual rooms. Only a handful of Pompeian rooms sport wall paintings from just one mythological narrative. Conversely, several hundred others combine images from unrelated myths. Modern scholarship has tried to weave these unconnected myths into a coherent narrative by postulating that they were chosen around an allegorical theme, for instance hubris and divine punishment.[103] But if Roman patrons wanted allegory, they commissioned straightforward images in which deities and personifications were used to convey a clear message in no uncertain terms. In the private sphere, very few such images—which were typically placed in the entrance of a house—have survived. Most famous are the Priapus in the doorway of the Casa dei Vettii (VI 15,1) and the Mercury in the Casa dei Dioscuri (VI 9, 6–7).[104] Trimalchio's painted *curriculum vitae* stands as a literary example.[105] So how were mythological images chosen? Here, we face a profound cultural difference between the visual culture of Rome and that of more recent European history.

As Katharina Lorenz has recently suggested, mythological wall paintings were combined as pendant images for strictly formal reasons.[106] Any viewer could have seen additional connections but these were not originally intended. Lorenz's model is best illustrated by a passage in Achilles Tatius's *Leucippe and Cleitophon*, which is concerned with the two paintings in the temple of Zeus Kasios at Pelusium:

> At the *opisthodomos* we saw a double picture and the painter had signed it: Euanthes the painter. The picture represented both Andromeda and Prometheus, both chained. *I believe that is why the painter put them together.* The pictures are also akin in other respects. Each had a rock as a prison; each had a beast as a torturer. His coming from the air, hers from the sea. Their rescuers were both Argives, and related to each other: his rescuer is Hercules, hers is Perseus. The one shot down Zeus' bird with his bow, the other fought Poseidon's sea monster in close combat.[107]

This juxtaposition is hard to reconcile with more recent and academic European aesthetic sensibilities. The painter combines myths not for nar-

rative coherence but for purely formal analogies. As a viewer with literary interests, the narrator sees further connections, in this case the antithetical symmetry of the two paintings and the—forced—genealogical connection between its main protagonists.[108] But this is part of an intellectual game that transcends the actual picture and the intention of its patron or artist.

Disappointingly unintellectual as it may seem, the Euanthes method of combining paintings dominates the archaeological record in Pompeii. A characteristic example comes from a *cubiculum* in the Casa di Vettii (VI 15, 1 d) with a continuous frieze of fish and a familiar sex scene.[109] The mythological images on two opposite walls tie in thematically. They are decorated with inverted love stories in a maritime setting. In one, Ariadne cries over her lover Theseus abandoning her by ship; in the other Hero happily awaits her lover Leander swimming toward her tower. The same compositional principle can be found in the much smaller (and definitely nonelite) Casa del Sacerdote Amando, which contains some of Pompeii's very best third-style frescoes (I 7, 7b). Here the lovers Perseus and Andromeda were juxtaposed with Galatea and Polyphemus. Andromeda is tied to a rock and about to be attacked by a sea monster with Perseus flying to the rescue, while Galatea rides on a *ketos* to her lover Polyphemus roaming free on his rocky island.[110]

Yet mythological images were not picked at random. Often, there is a (vague) connection between the potential uses of a room and the paintings chosen for it. For instance, many *cubicula*—like the above-mentioned room in the Casa dei Vettii (VI 15, 1 d)—were decorated with love stories and sex scenes, because they provided the necessary privacy for intimacy and intercourse.[111] The well-known cupids in the large room *q* of the Casa dei Vettii are busy making and selling garlands, perfume, wine, jewelry, and luxury garments, as they would be consumed or worn during a *convivium*.[112] The association with a dinner party is further reinforced by a vignette in which cupids honor Bacchus through a *thiasos*.

A more literary but equally blunt connection between wall painting and the food, wine, and conversation enjoyed at a dinner party is attested in the Casa degli Epigrammi (V 1, 18), a well-sized *atrium* peristyle house. Here, five bucolic paintings in a large exedra *(y)* are combined with Greek epigrams written underneath them.[113] The pictures themselves follow the

compositional principle outlined above: "five variations on the outdoor sanctuary, all with a background of blue sky and green trees" conjure up a bucolic world in which Pan wrestles with Eros, hunters sacrifice to Pan, Homer is set a riddle by fishermen, and a goat nibbles on a vine, shadowed by a statue of Dionysos, who appears again on the last and very badly preserved wall.[114] The epigrams refer to the wall paintings above. Pan will be defeated by Eros; the three hunters sacrifice what they catch: birds, land animals, and fish. The riddle given to Homer is written underneath the painting, and the goat being led to the sacrifice is also described in an epigram: its death will avenge the vine it has eaten, but a new vine will eventually spring from the goat droppings.[115] All these paintings reference a *convivium* in its various aspects: the food caught by the hunters, the wine provided by Dionysos, the riddles being asked and erotic love conquering all. Even if the guests did not read Greek, they could have linked the bucolic scenes to what they were enjoying at a party.

While steeped in bucolic poetry, the paintings in the Casa degli Epigrammi were chosen in the same spirit as the "still lives" and actual *convivium* scenes decorating other entertainment rooms in Pompeii.[116] As in the case of aristocratic villas, mythological imagery in Pompeii was chosen to serve as an atmospheric backdrop for domestic lifeworlds. Depending on the interests of the landlord, this may have included contemplation of mythological wall painting along literary lines. But in Pompeii, this was not the norm, at least not from what the town's graffiti suggest.

There are only three unambiguous clues that Pompeian viewers looked at mythological wall painting with literature in mind.[117] One comes from the so-called House of Lucretius Fronto (V 4, a), where an image of Pero and Mikon came with an epigram explaining the scene.[118] Another is a one-line epigram from the House of Julius Polybius. It was scratched into the kitchen wall (IX 13, 1–3 *nk*). Leach argued that it refers to a wall painting of Dirce's punishment in the house's largest entertainment room *(ee)*: "Look there are not only those Theban women but Dionysus and the royal maenad."[119] While the connection between this epigram and the Dirce painting is not entirely clear, the third and last example clearly referred to a mythological image. It comes from the so-called House of Fabius Ululitremulus (IX 13, 5), which has not been fully excavated, but may (or may not) have been a fullery.[120]

The main entrance of the house was flanked by two pictures: on the left Romulus with the *spolia opima,* on the right Aeneas with his father, Anchises, and his son, Ascanius, fleeing from Troy. Underneath the Romulus vignette, Fabius Ululitremulus, whose *cognomen* could be loosely translated as "he who trembles before screech owls," had endorsed his candidates for the aedileship in a painted election note. This plea was enthusiastically supported by some of the town's fullers, who wrote *fullones* to the left and right of the *programma.* Obviously, an anonymous passerby found this funny and commented on the image and the election note with a witty hexameter, which was based on the first line of Virgil's *Aeneid:* "I sing of the fullers and the screech owl, not arms and the man" *(fullones ululamque cano, non arma virumque).* The joke is not quite clear. Probably, it mocked the election note as an inappropriate caption for the Romulus picture, which is why it was not written underneath the image of Aeneas, where it would have been more appropriate. But other interpretations are possible. Still, it attests to lighthearted situational humor, which shows that mythological imagery did not just prompt heavy-handed intellectual responses.

Yet these three poems are exceptions. Most Pompeian diners reacted to the decor of many elegant entertainment rooms not with high-pitched poetry or a witty line: they scratched graffiti into the painted walls while lying on their couches, seemingly without prompting an intervention by their host.[121] Most graffiti show gladiators, which seems like a plausible conversation topic at dinner parties. The most remarkable series of gladiatorial graffiti comes from a luxurious dining room in the Casa del Criptoportico (I 6, 2).[122] It is one of the few examples where wall decoration actually imitates a picture gallery in painting. In the first century B.C.E., the billionaire and art connoisseur Lucullus had started a trend by dining in his famous *pinacotheca,* which assembled Greek masterworks painted on wooden tablets. A century later, this luxurious fashion inspired the decoration of a dining room in Pompeii. But, at least in the case of the Casa del Criptoportico, the replication of an elegant dining ensemble did not inspire everyone to a conversation about art.

Neither the Casa del Criptoportico nor the Casa degli Epigrammi can compare in luxury and elegance to the Villa dei Papiri or the world conjured up in Cicero's letters. Still, by Pompeian standards their owners were presumably well off if not rich. They may have belonged to the town's decurional

order and, by extension, to the upwardly mobile milieu of Cicero's or Vespasian's fathers. By analogy to the well-attested social ambitions and prospects of such "local elites," it is entirely possible that the owners of large, well-decorated houses aspired to the domestic decor and culture of the imperial aristocracy. It is also possible that they had enjoyed a first-rate education in Naples or Rome and did appreciate their wall painting and sculpture with the irony and metropolitan refinement of a Cicero, Ovid, Horace, or Martial, who had all been born into "local elite" families of equestrian rank or lower. Yet most well-to-do Italians and provincials did not send their children to Rome, where all major Latin writers acquired their intellectual polish. And, tellingly, none of them left again, at least not willingly or for long. That does not mean that a small Pompeii-sized Italian town was an intellectual wasteland, but just like Ovid's Tomis or Martial's Bilbilis it almost certainly was in comparison to Rome.

While a few of Ovid's most famous lines were scribbled on the walls of some of Pompeii's largest houses, it is unclear whether this reflects a deep familiarity with his poetry and its larger intellectual context, or the straightforward popularity of some of his best lines.[123] This dilemma parallels the question whether it is legitimate to "read" the Greek love stories on Roman walls with the specific poetic and representational interests of Ovid's *Metamorphoses* or other equally well-known literary texts in mind.

Today, it has become fashionable again to stress close connections between wall painting and literature. After all, poetry and painting were described as twin arts by the poet Simonides as early as the sixth century B.C.E..[124] But the archaeological record does not support this as much more than literary trope. The representational interests of elegant highbrow literature and a conventional and relatively cheap medium like wall painting rarely match up closely. And even when they occasionally do, standardized images based on Greek myths were often altered to a point where the core theme of the story was not of primary interest, as in the case of the upward-looking Narcissi mentioned above.

So what did such images mean to Pompeii's landlords? Unlike Hellenistic kings, who commissioned paintings on wood, they hired local painters to decorate their walls with well-tried images from a limited and conventional repertoire. Here, a closer look at Pompeian wall painting itself can provide answers.

Standardization and Multiple Meanings in
Middle-Class Settings

Pompeian wall painting is traditionally classified by August Mau's four styles, architectural allusions (e.g., *scaenae frontes* and *pinacothecae*), and mythological content. These are useful categories of classification but not for interpretation.[125] As discussed above, Vitruvius complained that the architectural elements in the wall painting of his own time were implausibly combined and did not reflect actual buildings. By analogy, a series of wall paintings rarely illustrated a myth or a narrative theme sequentially. For instance, the stories of Theseus and Ariadne, and Hero and Leander are not connected, but in the Casa dei Vettii the juxtaposition of the two myths makes perfect sense (see above). Of course, the viewing experience of an Ovid aficionado may have been colored by Hero's and Ariadne's letters in the *Heroides*.[126] But the images and their combination work very well without knowing Ovid's poems, not least because the poems significantly deviate from the visual narrative of the paintings.

If Pompeian landlords wanted literary allusions on their walls, they commissioned the appropriate paintings. But tellingly, there are only a few walls from Pompeii that may have deliberately referenced literature as opposed to a well-known mythological scene. These are confined to a single room, while more generic mythological wall painting is used throughout the rest of the house.[127] One of the handful of rooms that may have been decorated with literature in mind belongs to the so-called House of Octavius Quartio (II 2, 2).[128] Interestingly, this house is often evoked as the classic example for middle-class aspiration in domestic decor. Here, we can test the hypothesis that all nonelite domestic decor was a conscious attempt to copy aristocratic lifestyles.

The House of Octavius Quartio is medium sized, but stands out because of its enormous garden, which takes up most of the *insula* II 2 (figure 23). From the outside, it is unimpressive. Its main entrance is flanked by a *thermopolium* and a shop.[129] These two *tabernae* are connected to the *atrium* of the house. This implies that they were probably run by dependents of the owner. Unlike many other houses of its size, there is no *tablinum* at the far end of the courtyard, which would have been suitable for formally receiving guests or even clients. Instead, there is a small peristyle.

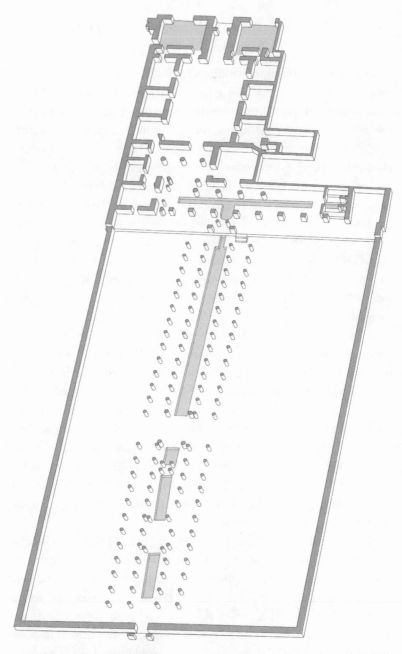

FIGURE 23. So-called House of Octavius Quartio (II 2, 2). A canal on the narrow veranda links a garden *triclinium* with a small sunroom. The Homeric room of the house is situated in the axis of the main canal in the garden.

are devoted to the story of Hercules and Deianeira: they deal with the slaying of Nessos, his fateful gift to Deianeira, and Hercules's suicide on the pyre.

With the exception of the first Trojan War and Hercules's death, all these scenes are attested on Pompeian walls but in a different narrative style. Other scenes of Hesione's liberation and Nessos's death focus on the hero liberating a woman in distress and the glory of a heroic couple.[133] The prototypes used in the House of Octavius Quartio are more subtle and more invested in the telling of the story. Also, the frieze above the marbled socle zone is unusually highbrow. It retells the *Iliad* through a series of major scenes: the plague in the Greek camp, the fight by the ships, the *aristeia* of Patroclus, the arming of Achilles, Hector's death, the games in Patroclus's honor, and the ransoming of Hector. In terms of style, these vignettes are remarkable too. They are labeled in Greek and resemble late classical or early Hellenistic painting, as we know it from Macedonian chamber tombs.

For a cultured viewer, these two sets of images would have been tied together as a combination of the two Trojan Wars. Making this connection required some erudition, which might have been appreciated by more sophisticated diners, despite the poor artistic execution of the paintings themselves. But does the presence of these motifs prove that the owner of the house was a cultured man with a serious interest in Greek and, in particular, Homeric poetry? Under Zanker's model, it would also be possible that we are dealing with the cultural pretension of a Trimalchio-like parvenu: in the *Satyrica*, Trimalchio hires Greek-speaking actors to perform Homeric scenes at his dinner party. But from his explanations to his guests, it is obvious that Trimalchio knows neither Greek nor the *Iliad*.[134]

Such interpretations stress the importance of (originally) Greek myth as cultural capital, which Pompeian landlords, supposedly, liked to show off. But if this was so, the owner of the House of Octavius Quartio would have limited such a display of erudition to a single room. The rest of his house and the pergola were all decorated with standardized mythological images. As in most other Pompeian houses, they were used to conjure up an atmosphere in the manner described above. More importantly, the painter commissioned with painting the walls of the House of Octavius Quartio altered at least one of the hackneyed motifs in his repertoire to

This courtyard opens onto a pergola over twenty meters long overlooking the garden. This pergola is the outstanding architectural feature of the house. Despite its narrowness, a one-meter-wide canal runs across its entire length. On the west side of the pergola the canal ends in front of a sunroom *(diaeta)*. On the east side of the pergola, the canal once flowed into a basin. This basin is flanked by two masonry couches for outdoor dining. There is also an indoor dining room. It is accessible from the peristyle but communicates with the pergola through a large panoramic door. In the axis of this door, a second canal springs from the foot of the pergola. This canal is oriented south and splits the garden in half.

To Paul Zanker, this ensemble constitutes a "miniature villa" par excellence.[130] The peristyle with a *diaeta* and a dining room, the pergola and the two canals all seem to be scaled-down versions of similar features in aristocratic villas. Even the statuary decor of the House of Octavius Quartio appears to be a miniature version of what was common in aristocratic parks. Statuettes of muses and satyrs, hunting dogs and their prey are all attested as life-sized statues in the country houses of the rich.[131] Indeed, the scale of the garden ensemble in the House of Octavius Quartio is striking. At least, in terms of architecture it is puzzling. Given the size of the garden, one wonders why the peristyle, its adjoining rooms, and the pergola had to be so small. There was more than enough space to build bigger and there is no good reason to assume that a more generous use of space and proportions would have meant great additional expense.

There is little doubt that the individual garden and decor elements in the House of Octavius Quartio were, as motifs, derived from aristocratic villas. But their unusual scale and peculiar arrangement makes one wonder whether the owner of the house deliberately referenced the lifestyle of the educated rich—and in doing so demonstrated that he could only afford a scaled-down version of it. The only indication that the house was decorated by a person with literary interests is the wall paintings in the indoor dining room mentioned above. They are arranged in three tiers. Over a socle of marbled blocks, a small frieze supports a series of scenes from the life of Hercules.[132] Their style, composition, and iconography square well with the little we know about Hellenistic painting. They show the liberation of Hesione, Laomedon's punishment at the hands of Hercules, and Priam's subsequent enthronement as king of Troy. The next three scenes

better fit the decorative scheme that his client wanted. This shows a re-
markable disinterest in telling a myth in anything resembling one of its
literary versions.

The painting in question belonged to the decor of the outdoor dining
ensemble described above: the two masonry couches of the *biclinium* and
the water basin between them were shadowed by an elegant façade.[135] A
pillared niche in the form of an artificial grotto rose above the basin. It
was flanked by two paintings. On the right was a Narcissus, who, like the
Narcissus in the Casa dell'Ara Massima, was looking upward and not at
his own reflection in the water (figure 22b).[136] The picture on the left side
was inspired by the story of Pyramis and Thisbe (figure 24a).[137] This myth
was not as popular as that of Narcissus but is attested in three other Pom-
peian houses. The three examples other than that from the House of
Octavius Quartio are close replicas after a shared model.[138] They show
Pyramis and Thisbe under a mulberry tree with Thisbe's bloodstained gar-
ment hanging from the branches. These versions are highly erotic (figure
24b). They come very close to pictures of lovemaking, if Pyramis were not
bleeding from a chest wound and Thisbe was not falling onto her lover's
sword. For anyone familiar with Ovid's telling of this dramatic scene in
the *Metamorphoses,* the resemblance would have been striking: the set-
ting by a mulberry tree and a funerary *stela,* as well as the gender of the
lioness, are all mentioned in the poem.[139] The same literary analogy would
not have applied to the painting in the House of Octavius Quartio. It is
composed of the same elements but laterally reversed and less erotic. Most
importantly, it alters the story. Pyramis is represented as a hunter with a
hunting spear lying next to him. He bleeds not from a chest wound but
from many parallel cuts over his legs and torso. Here, the lioness in the
background suggests that Pyramis has been clawed to death in a hunting
accident. When his (naked) lover finds him, she commits suicide with an
indeterminate object painted as a black line, which may be a fragment of
the spear.[140]

Interestingly, this painting was signed by a Lucius, who seems to have
done the other walls as well. He was not the best painter in Pompeii, and
the artistic quality of the Pyramis and Thisbe piece is particularly low. In
changing the story, Lucius could not simply reproduce an iconographic
prototype. His version required him to paint Thisbe from scratch. Neither

perspective shortening nor shading and highlighting were his forte, which is why her body is plump and ill proportioned. But Lucius still thought his creation worthy of his signature. Whether his take on the Pyramis and Thisbe motif would have pleased a superliterate viewer is a different matter.

FIGURE 24A. "Pyramis and Thisbe" in the House of Octavius Quartio (II 2, 2). The scene still contains the tree with bloodstained garment and the lioness, but Pyramis is shown as a hunter, who has been clawed to death.

If, even in nonelite houses, mythological wall paintings were used as conversation pieces, as has been often assumed, the owner of the house would have made a fool of himself if he had taken the picture as a starting point to discourse on the myth of Pyramis and Thisbe.[141] He would have been no different from Trimalchio, who bungled up the stories on his silver cups, or Lucian's two ignorant pantomime dancers who conflated

FIGURE 24B. Pyramis and Thisbe from the so-called House of Lucretius Fronto (V 4, a). In this standard version of the scene, Thisbe is committing suicide over the body of Pyramis, close to the tomb of Ninos in the background.

Cronus with Thyestes and assimilated Semele with Glauce.[142] If this were so, the landlord of the House of Octavius Quartio would have commissioned a room with Homeric myths in a genuinely Greek manner and at the same time flaunted his ignorance of a love myth, which was probably well known in his own time.[143] This is certainly possible but unlikely. It is one thing to misinterpret the images on an heirloom piece like Trimalchio or to confuse the meaning of two dance steps. But it is an entirely different matter to have an existing iconographic type altered to tell a new story. Doing so suggests a purpose. And there is good reason to believe that there was one.

As Katharina Lorenz has suggested, the two paintings in the *biclinium* are pendant images of the wall paintings at the opposite end of the canal.[144] There, the garden wall of the *diaeta* is decorated with the story of Actaeon and Diana. It is split into two vignettes, which are separated by the door opening up to the pergola. On the left side, a naked Diana is kneeling at a pond. Her iconographic type is not that of a virgin goddess but that of a Venus. Surprised while bathing, Diana is trying to cover herself, but this only draws more attention to her naked and uncharacteristically womanly body. On the other side of the door Actaeon is killed by her hunting dogs. As in other Pompeian houses, the image of the alluring half-naked boy Narcissus mirrors that of an equally objectified female, who, this time, is even sitting by a pond. And Actaeon's death mirrors that of "Pyramis as a hunter," who is not a lanky boy as on the three other paintings from Pompeii, but a heavily muscled man like Actaeon.

This focus on pictorial rhymes is the preferred method of combining images in Roman houses. It focuses on visual as opposed to literary narratives and parallels. And it is employed not as a means to create an allegorical diagram, which would have catered to literary interests, but to conjure up atmospheric connotations. On the pergola in the House of Octavius Quartio, the dominant theme is that of a wilderness inhabited by fierce creatures and beautiful deities and heroes. The two sets of images discussed above are too far apart from each other to be viewed together, but that is common with pendant images, for instance the two fauns at the end of the elongated pool in the Villa dei Papiri.[145] Along the canal were more paintings and statues to evoke a romantic wilderness, which wove

the four paintings into the desired decorative scheme. There were statu-
ettes of hunting dogs flanking the canal and paintings of fleeing deer on
the pergola walls.[146]

Another mythological painting decorated the wall west of the large
panoramic door leading into the "Homeric room." It showed Orpheus
singing to the beasts, which is attested in another Pompeian garden and
later became a classic in domestic decor.[147] The walls of the actual garden
were painted accordingly. On the garden wall of the *diaeta* was a dramatic
hunt that even involved a panther.[148] And at the fountainhead of the sec-
ond canal running south through the garden was another painting of
Diana and Actaeon.[149] Diana's iconographic type differs from that on the
pergola. Because she no longer serves as mirror for Narcissus, she is now
shown from behind as a magnificent female act, inspired by images of the
Graces and not of a virgin girl.

It has long been common to interpret the paintings in the garden
of the House of Octavius Quartio as a riff on Ovid's *Metamorphoses*. In-
deed, the myths of Narcissus, Pyramis and Thisbe, Actaeon and Diana,
and Orpheus singing to beasts all appear in the *Metamorphoses*.[150] But
which myth does not? And iconographically, only Actaeon reflects the
key theme of the *Metamorphoses:* his transformation into a deer is indi-
cated by a pair of small antlers growing from his forehead. By contrast,
Narcissus is not even looking at his own reflection, and the painting of
the dying hunter and his self-immolating lover is so far removed from the
story of Pyramis and Thisbe as told on other Pompeian walls (and in
Ovid's *Metamorphoses*) that it is not even clear whether it still represents
the myth.

If the pergola had been decorated with the *Metamorphoses* in mind, we
could at least expect that Lucius would have faithfully used prototypes
that were fully compatible with Ovid's telling of the stories. This would
not have been hard to do. As we have seen, other paintings of Thisbe's
suicide nicely coincided with Ovid's version of the scene. Similarly, other
representations of Narcissus featured the nymph Echo, whom Ovid seems
to have inserted into the story.[151] But instead of using such images, which
originally may have even been inspired by Ovid's poetry (or vice versa),[152]
Lucius tweaked the prototypes available to him and used body types for
his figures that he (and presumably his client) liked best.

As we have seen, two Pompeian landlords who did want to reference literature had epigrams painted right next to appropriate wall paintings. In the Casa degli Epigrammi, sympotic epigrams come with images (and not the other way around). And in the so-called House of Lucretius Fronto, a painting of Pero and Mikon is explained by a poem painted into the picture. Even in the House of Octavius Quartio, individual characters in the *Iliad* frieze are labeled. Here, viewers were invited to test their literary knowledge (or just their literacy) against the paintings. With all other wall paintings from Pompeii and elsewhere we have no way to know for sure whether such an approach was intended or not. But given the focus on nonliterary pictorial rhymes and idiosyncratic changes to the available iconographic prototypes, it seems that literary references did not matter nearly as much as is commonly assumed. Here, a look at the sarcophagi discussed in Chapter 4 can be helpful, where there is no doubt that mythological imagery was used idiosyncratically.

Of course, even the earliest mythological sarcophagi postdate all Pompeian wall paintings by two generations. And houses are socially and emotionally far more complex than tombs. In contrast to middle-class mausolea, domestic art was viewed on many more occasions and in different social settings. Another issue is that we have a pretty good idea what went on in middle-class tombs but can only little more than guess how life unfolded in a nonaristocratic *domus*.[153]

All this is as obvious as it is banal: both tomb and domestic decor follow fashions and social norms, but tombs have a much narrower function. The reception of funerary art was guided by epitaphs and ritual, which makes it easier to construct hypothetical viewers. In domestic decor this is much harder to do. Unless we use a political paradigm and assume that the owner of every middle-class house was a little Cicero (or maybe another Trimalchio) who wanted to project his persona through his house, we can only safely assume that wall painting and statues were used to create an ambience. And here patterns are visible that are comparable to what we have seen on sarcophagi.

First off, mythological imagery was primarily used for its visual potential. What we find on walls and in tombs is almost always individual scenes from a given myth. Even sarcophagi that depict more than one episode never tell the full story. This focus on specific moments is par-

ticularly striking on Pompeian walls, which would have been an ideal canvas for extended visual narratives. That such narratives very rarely occur (as in the Homeric room of the House of Octavius Quartio) shows that they were an option, but not a popular one. It was precisely not what most Pompeian landlords wanted. We do not know of Homeric tableaus in the tradition of the famous marble Tabulae Iliacae, which combined both image and text, and required a good knowledge of the *Iliad* to be enjoyed properly.[154]

Not only the rarity or absence of such images is indicative of the representational interests of Pompeian landlords. The formal development of the mythological scenes themselves shows a growing disinterest in illustrating the underlying stories. If our traditional chronology of Pompeian wall painting is correct, figural wall painting started off with megalographic friezes on late Republican second-style walls. In the third style of Pompeian wall painting (which roughly coincides with the reign of the Julio-Claudians), these friezes were replaced with mythological scenes in discreetly framed panels.[155] These panels tell myth through many-figured scenes in richly detailed landscapes. Often, two or more episodes of the same story are shown in the same picture.[156] But by the fourth style, these sequential narratives were phased out and replaced with relatively static images, which focused on an individual hero or, just as frequently, on a (typically loving) couple (figure 25).[157]

This mirrors the formal development of late second- and early third-century-C.E. sarcophagi. In contrast to early sarcophagi, later sarcophagus narratives were streamlined so that they put the spot on individual heroes or couples. The narrative was shortened and refocused on beauty, male virtue, or the mutual affection between the protagonists. This cannot have been a function of a changing zeitgeist, because the same development occurred in two subsequent centuries and in two different media. It seems instead that we are dealing with the internal logic of an art industry. The artisans painting walls and carving sarcophagi began by creating images that combined well-tried motifs in an almost cookie-cutter-like manner. The resulting available pastiche of images was subsequently narrowed to reflect what clients seemed to like best.

It seems that middle-class art buyers were not seeking narrative. Instead, the decoration of Campanian houses exhibits the same festive

Dionysian world evoked by most nonnarrative sarcophagi and the stuc-
coed walls of second-century tombs. Images of dramatic love fit this
(mostly) happy world better than complex narratives set in crowded imag-
inary landscapes. Similarly, the statuettes found in smaller Pompeian
houses almost exclusively belong to Dionysos's *thiasos* or represent naked
Aphodite or Diana, who was a mainstay in Roman garden decor and
sometimes even seems to have received cult. These were complemented by
putti and wild animals.[158] Of course, these motifs are also attested by stat-
ues in the villas of Roman aristocrats. But in nonelite houses, they are not

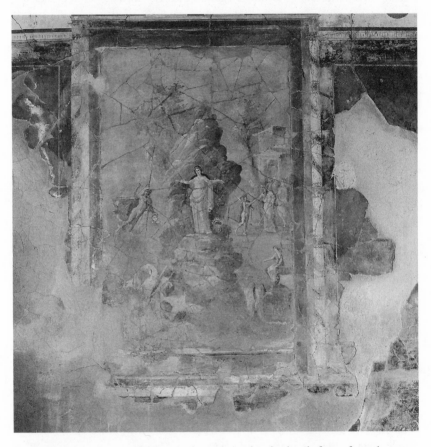

FIGURE 25A. Perseus liberates Andromeda on this third-style fresco from the
so-called Casa del Sacerdote Amando (I 7, 7). Several scenes from the myth are set
against an impressive landscape.

complemented by statues and pillared portraits of great intellectuals or copies of famous works of art.[159]

In the *Satyrica*, Trimalchio's *curriculum vitae* is painted as a frieze in his *atrium*. When the narrator of the novel asks which pictures are *in medio* (wherever this may be), the majordomo replies: "the Iliad and the

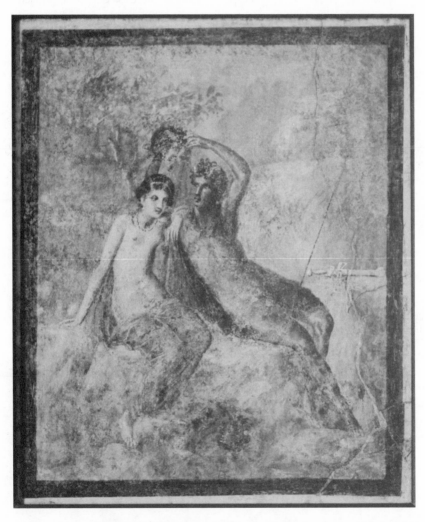

FIGURE 25B. Perseus and Andromeda watch the head of Medusa in the reflection of a pond. In this fourth-style fresco, they are, characteristically, shown as happy lovers. The landscapes and narrative scenes popular in earlier paintings have fallen out of fashion.

Odyssey and the gladiator's given by Laenas."[160] Trimalchio, mixing high and low, makes himself the butt of another joke because he fails to understand that displaying his love for gladiators undercuts his claim to culture. But no such house has been found in one of the Vesuvian cities, and this is surely telling.

On a large scale, only the cryptoporticus in the Casa del Criptoportico (I 6, 2) and the neighboring Casa del Sacello Iliaco (I 6, 4) are decorated with scenes from the *Iliad* (and the *Odyssey*).[161] This subterranean cloister was connected to the dining room mentioned above. There, the owner of the house had the walls decorated as if it were a *pinacotheca,* but still allowed his guests to scratch gladiatorial fights onto the paintings.[162] Most other Pompeian landlords did not even bother with such images. Typically, there were no Homeric friezes or painted poems. Rather, atmospheric pictures visually enhanced gardens with bucolic or cynegetic scenes, reception rooms with merry scenes, and secluded cabinets with erotic scenes.

From Philostratus's early third-century-c.e. work, *Imagines,* we learn that most Pompeian wall paintings were far less detailed and crowded than the paintings on wooden tablets, "which had been collected with real judgment" by one of Philostratus's Neapolitan hosts and which are the subject of the discourse.[163] As Michael Squire has argued, second-century sophists like Philostratus and Lucian found viewing art socially divisive.[164] One had, supposedly, to know literature to be schooled in viewing paintings to discourse on them properly. Petronius felt the same way and probably believed that the Trimalchios of his world should keep their thoughts to themselves.

But I have shown that most middle-class art buyers were not trying to ape the lifestyle of the rich and educated. The workshops working for them may have taken their repertoire from what was common in the houses and villas of the rich, but they adjusted it to the wishes of their less distinguished customers. These middle-class customers could have asked for the same stuff that they may have seen in the houses of their patrons but rarely chose to do so. Instead they chose to alter images according to their own tastes and the meaning they themselves wished to communicate.

6

Conclusions

Urban life is multifaceted. This is why two literary descriptions of the same city can differ so fundamentally that they may seem to describe different places. One of the best-known books on urban imagination plays with this theme. In his *Invisible Cities* of 1972, Italo Calvino invents a conversation between Marco Polo and Kublai Khan. Marco Polo tells the khan about various cities in his vast realm. Each of these cities is viewed through a lens of thematic reduction. There are "cities of trade" just as there are "cities of desire." At one point the khan, wary of the tall stories he is offered up, asks Marco Polo why he never talks about his hometown, Venice. The answer is key to much of what Calvino has to say about urban life: "Sire," Marco Polo replies, "every time I describe a city I am saying something about Venice."[1] This illustrates how hard it is to reconstruct urban life from one perspective alone. There are not just individual views and experiences that color the perception of any given city. There are also wholly different ways to conceptualize urban life.

Roman social and cultural history has been written primarily from the perspective of highly educated political elites. Their cities are "cities of competition," where public spaces and houses alike serve as a stage for

status display. In these cities, economic and cultural capital is used as a
means to reinforce one's social status and to formulate one's cultural and
political identity. This reflects the world of Greco-Roman literature, in
which nonelites are of little concern to upper-class writers. When ordi-
nary Romans show up in literature, they appear as a footnote to aristo-
cratic lives or as a source of humor. In the period under discussion, these
are almost exclusively freedmen, whose supposed lack of class is ridi-
culed, as in the *Satyrica,* or whose newly won influence and wealth are
decried, as in Juvenal's *Satires.* They resemble modern-era depictions of
nouveaux riches, who try to ape aristocratic culture, but mostly without
success.

Strikingly, this ancient narrative has been widely accepted by current
scholarship. "High culture" such as "art" is typically considered to have
been produced for and by the upper classes. And while some aspects of elite
culture may have "trickled down the social scale," this is widely considered
to have amounted to nothing more than "elite imitation." This elitist view
has encouraged scholars to turn to ancient literature as the main source for
understanding most forms of cultural production. This book has argued
otherwise. The sheer contempt or even venomous hostility of some elite
writers for nonelite cultural usage masks a far more complex historical real-
ity: the cultural world of the Roman Empire was one in which the trap-
pings of what was formerly elite culture in the late Republic had become
universally available. Well-decorated houses and tombs and a basic famil-
iarity with Greek myth were no longer the preserve of the aristocracy.
What was formerly a telltale sign of class and erudition in the late Republic
was now commonly used by a new and substantial segment of society.

As a reaction, intellectual elites redefined what talking about Greek
myth and looking at Greek statues and paintings meant to the educated
gentleman. Philostratus's much-studied early third-century-c.e. *Imagines*
are overtly about teaching a well-bred boy how to look at the mythological
panel paintings in his father's collection. In Philostratus's narrative, his
own well-informed interpretations compete with the old wives' tales of the
boy's nurse, whose interpretation of the Ariadne myth is colored by her
sympathy for the abandoned heroine. This points to the subjective and
emotional responses that seem to have been the norm among ancient art
viewers. From the perspective of Roman intellectuals, art viewing was

"socially divisive." But not because nonelites did not understand the art of their betters, as some second-century writers like Lucian and Philostratus would have us believe.[2] Cultural usage could become socially divisive because most cultural references, motifs, and images were now the common property of upper and middle classes alike. In a world in which a wall painting of the same Greek myth could adorn the dining room of a senator and the cramped *atrium* in an artisan's house, the question was no longer what constituted "high culture" but instead who had the sole privilege of interpreting it.

All this reflects a major socioeconomic shift. From the first century B.C.E. onward, cities all over the Mediterranean basin changed profoundly in character. What had been mostly farming towns with owner-occupied houses of roughly the same size transformed into commercial cities in which artisans and traders worked in a *taberna* economy. The Roman Empire created markets, which allowed for an unprecedented degree of specialized production, not just of luxury but also of mass-produced consumer goods. This allowed for the rise of commercial urban middle classes, who now had the means to consume what had previously been restricted to wealthy, landholding upper classes. Even in a small town like Pompeii, successful artisans and shopkeepers could afford decent quality wall painting, well-made furniture, and, occasionally, (small-scale) marble sculpture. These urban businessmen initially bought from the same workshops as the upper classes, but soon their aggregate demand for painting and sculpture gave rise to many more, typically local, workshops that now primarily catered to their needs. A new art industry had been created and with it distinctly middle-class modes of art usage began to emerge.

It has long been assumed that sub- and nonelites commissioning wall painting and sculpture wanted to imitate the lifestyles of the aristocracy and that this was a mechanism of social distinction. Here the caricature of the rich freedman Trimalchio in the *Satyrica* has played an important role. Though fabulously wealthy, Trimalchio cannot buy class and social recognition. He decorates his palatial townhouse with images of the *Iliad* and the *Odyssey,* but combines them (embarrassingly) with a painted frieze representing his own *curriculum vitae* and images of his favorite gladiators; he hires Greek-speaking actors but does not understand them; he invites a professor of rhetoric but has no interest in what he has to say; he

shows off his storied silver cups, which are *cimelia* like the ones with which powerful Roman aristocrats liked to impress their guests.[3] But he does not know their history, claiming that the mythical king Minos gave them to his former patron, and he confuses the myths represented on them. In short, Trimalchio's attempts to ape the very pinnacle of elegant Roman society but lacks the refinement to do so successfully.

The account of Trimalchio's dinner party is such a convincing and powerful piece of storytelling that classicists have long believed that there must have been nouveaux riches freedmen like that. Also, many features of first-century-c.e. domestic and funerary art and architecture overlap so closely with the archaeological record that the *Satyrica* has been taken as an accurate account of nonelite lifestyles.[4] But like all good satire, Trimalchio and his house are pieces of poetic imagination, which comically distort, rather than mirror, existing social trends. Even within the *Satyrica*, Trimalchio is introduced as an exceptional character. If we turn to the archaeology of actual middle-class houses and tombs, there is little evidence for slavish elite imitation. Instead, we are confronted with a system of cultural expression that uses the same iconographically set types as the social elites but recombines them in a new way. They have a new meaning in a new context.

By the first century c.e. it becomes increasingly hard to talk about a "trickle-down effect." It seems instead that both upper- and middle-class Romans are subject to the same cultural trends but express them differently. This is most apparent in funerary culture. By the early imperial period, both elite and nonelite tombs broadcast the success of their builders through portraits and reliefs. Aristocrats praised their service to the state, while middle classes often commemorated their success as urban businessmen. This is remarkable, because elite ideology condemned any involvement in craft and trade. Men like Tacitus considered it a blemish to have risen from a shoemaker's shop, whereas his contemporary Julius Helius proudly depicted his lasts above his publicly displayed funerary portrait. He even informed anyone who cared to read his epitaph that he had run a shop close to the Porta Fontinale. By contrast, Tacitus's epitaph listed all his offices and achievements. Both tombs celebrated a life's success, but they praised what mattered in two different lifeworlds that coexisted in the same urban space. They shared the same mode of self-promotion, but this

self-promotion differed greatly in content. Similar discrepancies also manifested themselves in class-specific portraiture styles and in the class-specific interior decor of mausolea, when it became common to bury the dead in lavish marble sarcophagi. Again, both aristocrats and middle classes took up similar customs but found different modes of cultural expression.

The growing importance of tomb interiors corresponded with a greater emphasis on the emotional ties between the deceased and their surviving loved ones. In crypts and private tomb gardens, beloved spouses, children, and parents were now remembered with statues and sarcophagus reliefs that no longer focused primarily on their achievements but on their emotional significance for the mourners visiting the tomb. Both upper and middle classes took up this trend, but in remarkably divergent forms. In particular, Rome's rationally organized sarcophagus industry produced set pieces, which clearly catered to different milieus.

While Romans of all classes liked to buy sarcophagi decorated with Bacchus's *thiasos* and equally fleshy parades of amorous sea creatures, only three were definitely acquired by Roman senators. Most socially (and culturally) attributable pieces show a clear divide between upper- and middle-class sarcophagi. Rome's nobility continued its long tradition of praising the achievements of their glorious dead on their sarcophagi, with a loving marriage now represented as part of a good aristocratic life. Middle classes also praised love and affection but in a wholly different vernacular. They likened their deceased loved ones to deities and heroes and picked dramatic scenes that visually expressed the horror of premature and tragic death or enduring love through Greek myths. These (metropolitan Roman) sarcophagi have often been connected to philhellene, second-century-C.E. intellectual movements like the so-called Second Sophistic.

But this is not defensible. As we have seen, myth on middle-class sarcophagi was used in an idiosyncratic way. Like popular pantomimes, they focused on individual scenes with little interest in the larger narrative context of the story. Later portrait identifications on mythological sarcophagi went so far beyond any reasonable interpretation of the myth as we know it from literature that it is occasionally even unclear whether the sarcophagus buyer cared about the story at all.

Sarcophagi from the city of Rome are a clear case where we can get a glimpse into the workings of Rome's art industry. The scenes on

mythological sarcophagi were composed in a cookie-cutter manner by combining motifs available for at least a century. These prototypes may initially have been taken from elite art but were, over time, simplified to suit the representational interests of their customers.

A similar trend is visible in the first century C.E., when the mythological images on Pompeian walls went from a series of subsequent scenes in a panoramic landscape (which may have been influenced by Hellenistic painting) to static images that focused on (a typically loving) couple. Furthermore, Pompeian landlords sometimes had standardized images altered, which shows that referencing a great Greek masterpiece or particular myth was not their primary concern. Instead, art was used to conjure up a pleasant atmosphere, enhancing the bucolic themes of courtyards and gardens or Dionysiac themes of dining and relaxation rooms.

Vitruvius complained that the wall painting of his own time was intended to "charm the eyes," rather than represent reality. His pseudointellectual rant against the wall painting of his own time is another instance where a (would-be) member of Rome's elite claimed the sole privilege of interpretation of a socially diffused art form. And indeed, the graffiti scratched onto Roman wall painting attest to a plethora of responses. Good-quality bucolic wall painting in the storage rooms of the Magdalensberg in Carinthia, Austria, doubled as a ledger for the blacksmiths selling mass-produced steel goods. Many elegant dining rooms in Pompeii had gladiators and *venationes* scratched onto their colorfully painted walls, which probably reflects a popular conversation topic among the guests attending a first-century-C.E. dinner party.

Conversely, in the so-called House of Propertius in Assisi, we find a unique example of a truly literary engagement with wall painting.[5] Almost all framed panels in the excavated cryptoporticus of this house had famous Greek quotations or newly composed Greek poetry written underneath them. Some of these short texts were later replaced or amended, which demonstrates a continued intellectual engagement with the texts and images.[6] At one point, this house must have been a special place. As late as 367 C.E. a visitor recorded a visit to the "House of the Muse" *(domus Musae).*[7] Interestingly, the wall paintings in the House of Propertius were probably not initially intended for erudite art viewing. The inscriptions postdate the paintings by at least a generation, when the house was probably upgraded

to the *domus Musae*. As Michael Squire recently pointed out, image and text in Assisi do not always match perfectly, which is unsurprising.[8] The standardized images in Assisi were not composed on the basis of the equally conventional poetry that was written underneath them. As set pieces, they were open to interpretation and therefore marketable to both middle-class buyers and hyperliterate individuals alike.

Standardized images like those in the House of Propertius could become the focus of erudite games or they could be used to enhance a house's atmosphere. They could also become a ledger for blacksmiths or the canvas for the gladiatorial graffiti of dinner guests. There was no de facto monopoly on what wall painting should mean or what purpose it should serve.

This is not to say that there was no genuinely upper-class art. The grottoes at Sperlonga, aristocratic villas with their statue galleries of great cultural heroes, and the literarily attested picture galleries and palaces like the ones in Philostratus's *Imagines* and Lucian's *On the House* differed greatly from what was common in middle-class culture. And even though it is in all likelihood the wishful thinking of professional rhetoricians and poets that such places were conceived as an invitation to burst into grandiloquent speeches, superliterate upper classes clearly showed an interest in literary versions of the stories underlying the images surrounding them. Yet, even upper-class responses to standardized art were personal and subjective, at least according to our ancient narratives. Famously, Brutus's wife Porcia burst into tears when she saw a painting of Hector and Andromache just before her husband's departure. And Petronius invented a picture gallery with homoerotic love stories so that Encolpius could see his loss of Giton reflected in myth.[9]

Still, most Roman senators had to be considerate when it came to buying art. They mostly avoided mythological sarcophagi because Greek death myths were far too ambiguous for praising the glorious dead. They moved within a world in which even harmless standardized images could become politically charged (like a statue of Demosthenes in one of Brutus's villas).[10] It is on the basis of such relatively subtle differences that we can distinguish class-specific cultural usage. But this subtlety should not blind us to the differences between aristocratic and middle-class culture.

In the realm of domestic and funerary art, Rome's political elites lived in a culture in which erudition could matter as much as political status.

By contrast, middle classes picked freely and idiosyncratically from what was culturally available. They did not care whether the decor of their houses and tombs was perfectly aligned with literary interests. Instead, the culture that was produced for and by them was primarily intended for consumption and not for status display. In Wallace-Hadrill's terms, Rome's cultural revolution was in large part driven by a consumer revolution. But I have argued that, rather than through subelites' imitation of elites, this came about through the rise of what can justifiably be termed urban middle classes.

Notes

Index

Notes

1. Class, Stratification, and Culture

1. The most prominent (and brilliant) account of ancient middle classes is Mikhail Rostovtzeff's *Social and Economic History of the Roman Empire,* which was published in 1926. Rostovtzeff, a Russian émigré who left Petersburg in the aftermath of the Bolshevik Revolution, claimed that Rome's emperors had deliberately fostered an "urban middle class" in an attempt to break the power of the landed aristocracy, which had run the Roman Republic. But in the process, this middle class, supposedly, transformed from a commercial class into a bourgeoisie of rentiers, whose wealth was built on "the systematic exploitation of the lower classes." M. Rostovtzeff, *The Social and Economic History of the Roman Empire* (Oxford: Clarendon Press, 1926), xi. This system, Rostovtzeff argued, exploded in an economic crisis as early as the second century C.E. and forced Rome into state capitalism and, ultimately, "oriental despotism." It has often been noted that this is how Russia's bourgeois intelligentsia explained the demise of the czarist monarchy and the subsequent rise of the Soviet state. Rostovtzeff was self-conscious about this. He believed that "all of the past is repeating itself." On this view and the close connection between Russian revolutionary and Roman socioeconomic history in Rostovtzeff's work, see M. A. Wes, *Michael Rostovtzeff, Historian in Exile* (Stuttgart: Franz Steiner, 1990), 65. For a summary of more recent debates

on the concept of "middle class" in Roman economic and social history, see W. V. Harris, *Rome's Imperial Economy: Twelve Essays* (Oxford: Oxford University Press, 2011), 31–32.

2. Finley's criticism belongs in the context of the so-called primitivist-modernist debate. It began in late nineteenth-century German academia and continued, in various forms, well into the twentieth century. At its core was a fundamental disagreement about the use of economic and other social theory within the discipline of history. For a brief (and simplified) summary of the debate and Finley's place in it, see I. Morris's foreword to M. Finley, *The Ancient Economy: Updated with a New Foreword by Ian Morris* (Berkeley: University of California Press, 1999), ix–xix. For a passionate defense of Finley and his approach, see P. Fibiger Bang, *The Roman Bazaar: A Comparative Study of Trade and Markets in a Tributary Empire* (Cambridge: Cambridge University Press, 2008), 15–60. For Finley's rejection of the concept of class in its broader historiographical and ideological context, see M. Nafissi, *Ancient Athens and Modern Ideology: Value, Theory and Evidence in Historical Sciences: Max Weber, Karl Polanyi and Moses Finley* (London: Institute of Classical Studies, School of Advanced Study, University of London, 2005), 247–262. For a criticism of class in Finley's own words, see *The Ancient Economy*, 48–51; for an ad hominem attack against Rostovtzeff and his intellectual companions, see M. Finley, *Ancient Slavery and Modern Ideology* (Princeton, NJ: Markus Wiener, 1998), 120–122. For a summary of the use of class in Roman history and a theoretically informed discussion of the concept, see Harris, *Rome's Imperial Economy*, 15–26.

3. On various definitions of the middle class and its virtues in the developed world, see D. McCloskey, *The Bourgeois Virtues: Ethics for an Age of Commerce* (Chicago: University of Chicago Press, 2006), 69–78. For a collection of essays on Europe's various middle classes and their origin in the nineteenth century, see J. Kocka and A. Mitchell, eds., *Bourgeois Society in Nineteenth-Century Europe* (Oxford: Berg, 1993).

4. For a book-length version of this argument, see D. McCloskey, *Bourgeois Dignity: Why Economics Can't Explain the Modern World* (Chicago: University of Chicago Press, 2010), in particular 366–376, 403–404, 406–419.

5. Ibid., 21–25; Finley, *The Ancient Economy*, 50–61, on the low status of commerce and its economic consequences.

6. A. Wallace-Hadrill, *Houses and Society in Pompeii and Herculaneum* (Princeton, NJ: Princeton University Press, 1994), 173–174, on a *plebs media* as opposed to a middle class. On various models of elite imitation, see A. Wallace-Hadrill, *Rome's Cultural Revolution* (Cambridge: Cambridge University Press, 2008), 315–355. On the participation of the *plebs* in Rome's culture of luxury, see 454. For a recent summary of the issues involved in speaking of middling classes

as opposed to middle classes, see B. W. Longenecker, "Exposing the Economic Middle: A Revised Economy Scale for the Study of Early Urban Christianity," *Journal for the Study of the New Testament* 31 (2009): 268–269. Longenecker's argument against using class is correct, but only if one uses the term in a Marxist sense: in Marxism there can be no class without class consciousness. But the Marxist notion of class is by no means the universally accepted or only definition of class.

7. *IGR* 4, 841.

8. On the monument and its social, cultural, and technological context, see T. Ritti, K. Grewe, and P. Kessener, "A Relief of a Water-Powered Stone Saw Mill on a Sarcophagus at Hierapolis and Its Implications," *Journal of Roman Archaeology* 20 (2007): 139–163.

9. Ibid., 139.

10. On Cicero's agrarian ideology, see Finley, *The Ancient Economy,* 4–44.

11. T. Fröhlich, *Lararien- und Fassadenbilder in den Vesuvstädten. Untersuchungen zur "volkstümlichen" Pompejanischen Malerei* (Mainz: v. Zabern, 1991).

12. G. Zimmer, *Römische Berufsdarstellungen,* Deutsches Archäologisches Institut (Berlin: Mann, 1982), 156–157, cat. no. 79.

13. On both paintings, see most recently P. Zanker, "Vivere con i miti. Pompei e oltre," in E. La Rocca, S. Ensoli, S. Tortorella, and M. Papini, eds., *Roma. La pittura di un impero* (Milan: Skira, 2009), 94.

14. Petronius, *Satyrica,* 46.

15. P. Veyne, "La 'plèbe moyenne' sous le haut-empire romain," *Annales* 55 (2000): 1169–1199. Zanker uses "middle-class" *(Mittelschicht)* throughout his extensive work. In this context the most important publication is P. Zanker, *Pompeii: Public and Private Life* (Cambridge, MA: Harvard University Press, 1998).

16. Veyne, "La 'plèbe moyenne,'" 1182–1183, on the "imagerie révélatrice" of the *plebs media.*

17. C. Nicolet, "Les ordres romains. Définition, recrutement et fonctionnement," in C. Nicolet, ed., *Des ordres à Rome* (Paris: Publ. de la Sorbonne, 1984), 7–21.

18. For population estimates of the Roman Empire and its elites, see now W. Scheidel and S. J. Friesen, "The Size of the Economy and the Distribution of Income in the Roman Empire," *Journal of Roman Studies* 99 (2009): 66–67, 75–78.

19. This is best expressed in the epigraphic habit of political elites, which focuses on their *cursus honorum.* On this see W. Eck, "Elite und Leitbilder in der römischen Kaiserzeit," in J. Dummer and M. Vielberg, eds., *Leitbilder in der Spätantike: Eliten und Leitbilder* (Stuttgart: Steiner, 1999), 31–55. Eck, 46–67, rightly stresses that this also applies to a small group of imperial freedmen, who could hold government positions of great power and influence.

20. For a recent analysis of urban life along these lines, see J. R. Patterson, *Landscapes and Cities: Rural Settlement and Civic Transformation in Early Imperial Italy* (Oxford: Oxford University Press, 2006), 221–264.

21. See Strabo 3, 5, 3 on the 500 knights of Cadiz and Padua. See Patterson, *Landscapes and Cities*, 222–223, on varying wealth requirements for the *ordo decurionum*. For variations among the *Augustales* it is instructive to compare their *scholae* in Herculaneum and Misenum: B. Bollmann, *Römische Vereinshäuser: Untersuchungen zu den Scholae der römischen Berufs-, Kult- und Augustalen-Kollegien in Italien* (Mainz: v. Zabern, 1998), 348–354, 356–363. In Puteoli, the *Augustales* were even prestigious enough to have a local quaestor, C. Laecanius Philumenus, in their midst, who was—despite his Greek cognomen—both freeborn and a member of the *ordo decurionum:* K. Jaschke, *Die Wirtschafts- und Sozialgeschichte des antiken Puteoli* (Rahden: Verlag Marie Leidorf, 2010), 242.

22. Veyne, "La 'plèbe moyenne,'" 1170. One upshot of the focus on freedmen is that in Roman archaeology nonelite art and epigraphy is seen as an expression of freedmen culture. For a critical appraisal of "freedmen art," see L. H. Petersen, *The Freedman in Roman Art and Art History* (Cambridge: Cambridge University Press, 2006). On freedmen in epigraphy, see H. Mouritsen, "Freedmen and Decurions: Epitaphs and Social History in Imperial Italy," *Journal of Roman Studies* 95 (2005): 38–63.

23. K. Marx, *Das Kapital,* Karl Marx, Friedrich Engels Gesamtausgabe 2, 6 (Berlin: Dietz, 1987), 186–210.

24. Finley, *The Ancient Economy,* 49. Here it may be worth pointing out that Marx, much to the chagrin of orthodox Marxists, never defined class as a term and used *Klasse* synonymously with *Schicht* (stratum) and *Stand* (status group). Even more importantly, Marx never intended the abstract model outlined above for historical analysis but used more "concrete" models to analyze society, which, for instance, allowed for intermediate classes like middle classes. On these issues, see A. Giddens, *The Class Structure of the Advanced Societies* (New York: Barnes & Noble, 1973), 28–32. See also G. E. M. De Ste. Croix, *The Class Struggle in the Ancient Greek World: From the Archaic Age to the Arab Conquests* (Ithaca, NY: Cornell University Press, 1981), 32.

25. Weber's *Habilitationschrift,* famously, dealt with *Agrarverhältnisse im Altertum.* This is the Weber to whom Finley referred. But as Nafissi, *Ancient Athens and Modern Ideology,* 69–71, shows, Finley did not follow Weber's remarkable intellectual development. In Nafissi's words, Finley's Weber is a "reassembled" one. The Weber used in this book is the Weber of *Economy and Society,* which he wrote a decade after his work on ancient agriculture.

26. M. Weber, *Economy and Society: An Outline of Interpretative Sociology,* ed. Guenther Roth and Claus Wittich (Berkeley: University of California Press, 1978), 302.

27. Ibid., 303.

28. Ibid., 303–304.

29. Ibid., 306–307.

30. Studying economic growth is at the heart of the Oxford Roman Economy Project, which has stimulated most contemporary research on the ancient economy. For a recent summary of current research, see the essays in A. Bowman and A. Wilson, eds., *Quantifying the Roman Economy: Methods and Problems* (Oxford: Oxford University Press, 2009). For a critical appraisal of the approach, see W. Scheidel, "In Search of Roman Economic Growth," *Journal of Roman Archaeology* 22, (2009): 46–70. The literature on self-fashioning or self-representation in Greek and Roman archaeology is immense. In this book, I mostly engage with the seminal work of Andrew Wallace-Hadrill and Paul Zanker on self-fashioning and elite emulation. Recently, Petersen, *The Freedman in Roman Art;* and P. Stewart, *The Social History of Roman Art* (Cambridge: Cambridge University Press, 2008), have argued for a more socially nuanced application of these terms.

31. This social mobility caused a great deal of anxiety among the upper classes. For "fretting" aristocrats, see Wallace-Hadrill, *Rome's Cultural Revolution*, 350–351.

32. Finley did not dismiss archaeology altogether. Still, he believed that textual and archaeological evidence represented "two kinds of evidence of the past." M. Finley, *Ancient History: Evidence and Models* (New York: Viking, 1985), 20. And he was highly skeptical that archaeology was of any help in reconstructing ancient social and working lives (*Ancient History*, 24–25; *The Ancient Economy*, 75).

33. Finley, *The Ancient Economy*, 137–138.

34. Scheidel and Friesen, "The Size of the Economy," 89–90.

2. In Search of Ancient Middle Classes

1. Social ranking reflected economic inequality, but while (a relatively low) threshold of wealth was necessary to belong to the higher orders, legal distinctions played at least as great a role. On this mismatch of social rank and economic class, see W. Scheidel, "Stratification, Deprivation and Quality of Life," in E. M. Atkins and R. Osborne, eds., *Poverty in the Roman World* (Cambridge: Cambridge University Press, 2006), 40–59. On economic theory in antiquity, see M. Finley, "Aristotle and Economic Analysis," *Past and Present* 47 (1970): 3–25; against K. Polanyi, "Aristotle Discovers the Economy," in K. Polyani, C. M. Arensberg, and H. W. Pearson, eds., *Trade and Market in the Early Empires: Economies in History and Theory* (Glencoe, IL: Free Press, 1957), 64–94. For a summary and discussion of this debate, see J. K. Davis, "The Ancient Economy: Models and Muddles," in H. Parkins and C. Smith, eds., *Trade, Traders and the Ancient City* (London: Routledge, 1998), 240–242.

2. A. Wallace-Hadrill, *Rome's Cultural Revolution* (Cambridge: Cambridge University Press, 2008), 313–355.

3. P. Bourdieu, *La Distinction: critique sociale du jugement* (Paris: Editions de Minuit, 1979).

4. Wallace-Hadrill, *Rome's Cultural Revolution*, 126–128, 449.

5. Euripides, *Hiket.* 238–245; Aristotle, *Politics* 1295a25–1297b14.

6. The debate on the identity of the *mésoi* is controversial: I. Morris, *Archaeology as Cultural History: Words and Things in Iron Age Greece* (Malden, MA: Blackwell, 2000), 114–119, argued for a purely ethical interpretation of the term. On the *plebs media,* see P. Veyne, "The Roman Empire," in P. Veyne, ed., *A History of Private Life,* vol. 1 (Cambridge, MA: Harvard University Press, 1987), 131–134; and more importantly, P. Veyne, "La 'plèbe moyenne' sous le haut-empire romain," *Annales* 55 (2000): 1169–1199. On the dominance of a dichotomous socioeconomic model in modern scholarship, see Scheidel, "Stratification," 42–45. For a more balanced view of the Roman social spectrum, see O. M. van Nijf, *The Civic World of Professional Associations in the Roman East* (Amsterdam: J. C. Geiben, 1997), 21–23; and Scheidel, "Stratification." On the cities of the Greek East, see A. Zuiderhoek, "On the Political Sociology of the Imperial Greek City," *Greek, Roman and Byzantine Studies* 48 (2008): 436–445. On the cities of imperial Italy, see J. R. Patterson, *Landscapes and Cities: Rural Settlement and Civic Transformation in Early Imperial Italy* (Oxford: Oxford University Press, 2006).

7. For an account of social mobility in urban life, see Patterson, *Landscapes and Cities,* 184–263; and L. E. Tacoma, *Fragile Hierarchies: The Urban Elites of Third Century Roman Egypt* (Leiden: Brill, 2006), on elite mobility.

8. Patterson, *Landscapes and Cities,* 237–239.

9. See most recently D. P. Kehoe, "The Early Roman Empire: Production," in W. Scheidel, I. Morris, and R. P. Saller, eds., *The Cambridge Economic History of the Greco-Roman World* (Cambridge: Cambridge University Press, 2007), 550–559. Yet it is worth pointing out that at an urbanization rate of roughly 20 percent in Renaissance Italy, half of the peninsula's GDP was produced in cities. It does not seem entirely unreasonable to assume similar urbanization rates for most of the ancient world and a correspondingly high economic output of ancient cities.

10. L. De Ligt, "Demand, Supply, Distribution: The Roman Peasantry between Town and Countryside: Rural Monetization and Peasant Demand," *Münstersche Beiträge zur antiken Handelsgeschichte* 9, no. 2 (1990): 49–55.

11. Greek and Roman housing became a focus of archaeological research with the groundbreaking books of W. Hoepfner and E.-L. Schwandner, *Haus und Stadt im klassischen Griechenland: Wohnen in der klassischen Polis,* rev. ed. (Munich: Deutscher Kunstverlag, 1991); and A. Wallace-Hadrill, *Houses and*

Society in Pompeii and Herculaneum (Princeton, NJ: Princeton University Press, 1994). More recent work has altered our understanding of urban life in Roman Italy: J. DeLaine, "The Commercial Landscape of Ostia," in A. MacMahon and J. Price, eds., *Roman Working Lives and Urban Living* (Oxford: Oxbow Books, 2005), 29–47; M. Heinzelmann, "Die vermietete Stadt. Zur Kommerzialisierung und Standardisierung der Wohnkultur in der kaiserzeitlichen Grosstadtgesellschaft," in R. Neudecker and P. Zanker, eds., *Lebenswelten. Bilder und Räume in der römischen Kaiserzeit. Symposium am 24. und 25. Januar 2002 zum Abschluss des von der Gerda Henkel Stiftung geförderten Forschungsprogramms "Stadtkultur in der Kaiserzeit"* (Wiesbaden: Ludwig Reichert, 2005), 113–128; F. Pirson, *Mietwohnungen in Pompeji und Herkulaneum: Untersuchungen zur Architektur, zum Wohnen und zur Sozial- und Wirtschaftsgeschichte der Vesuvstädte* (Munich: Friedrich Pfeil, 1999); and P. M. Allison, *Pompeian Households: An Analysis of Material Culture* (Los Angeles: Cotsen Institute of Archaeology, University of California, Los Angeles, 2004). M. Trümper, *Wohnen in Delos: Eine baugeschichtliche Untersuchung zum Wandel der Wohnkultur in hellenistischer Zeit* (Rahden: Leidorf, 1998), has made important contributions to the study of Hellenistic housing, while N. Cahill, *Household and City Organization at Olynthus* (New Haven, CT: Yale University Press, 2002); and B. A. Ault, *The Excavations at Ancient Halieis, vol. 2. The Houses: The Organization and Use of Domestic Space* (Bloomington: Indiana University Press, 2005), have focused on classical Greek domestic architecture. In R. Westgate, N. R. E. Fisher, and J. Whitley, eds., *Building Communities: House, Settlement and Society in the Aegean and Beyond,* British School of Athens Studies 15 (London: British School at Athens, 2007), 1, J. Whitley notes the continued groundswell of interest in the subject of urban life.

12. Wallace-Hadrill, *Houses and Society,* 75–77.

13. For instance, space in the houses of Olynthus was divided along gender lines. The *andron,* where the men would come together for their *symposia,* was directly accessible from the street so that contact with the women inside the house would be minimized. This was not so in the Latin-speaking world, where women enjoyed a higher degree of personal freedom and public visibility (Wallace-Hadrill, *Houses and Society,* 8–9).

14. On the concept of household in classical archaeology, see, most recently, Allison, *Pompeian Households;* B. A. Ault, "*Oikos* and *Oikonomia:* Greek Houses, Households and the Domestic Economy," in Westgate et al., *Building Communities,* 259–265; and B. Bergmann and L. Nevett, "Housing and Households," in S. E. Alcock and R. Osborne, eds., *Classical Archaeology* (Malden, MA: Blackwell, 2007), 203–243. For a socioeconomic analysis, see R. P. Saller, "Household and Gender," in Scheidel et al., *The Cambridge Economic History,* 87–112.

15. On the concept of economic flow between "cellular structures" in antiquity, see Davis, "The Ancient Economy," 243–251.

16. On fourth-century-B.C.E. Pompeii and its socioeconomic similarities with contemporary Greek cities, see J. Sewell, *The Formation of Roman Urbanism 338–200 B.C.E. between Contemporary Foreign Influence and Roman Tradition,* Journal of Roman Archaeology Supplementary Series 67 (Portsmouth RI: Journal of Roman Archaeology, 2010), 117–121.

17. Hoepfner and Schwandner, *Haus und Stadt,* 301–320.

18. Most notably, Christian Meier in his foreword to the first edition of Hoepfner and Schwandner, *Haus und Stadt im klassischen Griechenland* (Munich: Deutscher Kunstverlag, 1986). Also, D. Hennig, "Besitzgleichheit und Demokratie," in W. Schuller, W. Hoepfner, and E.-L. Schwandner, eds., *Demokratie und Architektur. Der hippodamische Städtebau und die Entstehung der Demokratie. Konstanzer Symposion vom 17. bis 19. Juli 1987* (Munich: Deutscher Kunstverlag, 1989), 25–30; and R. Étienne, "Review of *Haus und Stadt im klassischen Griechenland: Wohnen in der klassischen Polis,* by W. Hoepfner, et al.," *Topoi* 1 (1991): 38–41.

19. For a summary of the debate, see the comments by W. Koenigs in F. Rumscheid, *Priene: Führer durch das Pompeji Kleinasiens* (Istanbul: Ege Yayinlari, 1998), 28–32.

20. Hoepfner and Schwandner, *Haus und Stadt,* 68–225.

21. Cahill, *Household and City Organization,* 169–179.

22. On small mills and their use, see R. Frankel, "The Olynthus Mill, Its Origin, and Diffusion: Typology and Distribution," *American Journal of Archaeology* 107 (2003): 1–21.

23. Cahill, *Household and City Organization,* 264.

24. Ault, *"Oikos."*

25. Cahill, *Household and City Organization,* 275–281.

26. On settlement patterns on the Chalkidiki, see E. Winter, *Stadtspuren: Zeugnisse zur Siedlungsgeschichte der Chalkidiki* (Wiesbaden: Reichert, 2006). For the landscapes of classical and Hellenistic Greece, see S. E. Alcock, *Graecia Capta: The Landscapes of Roman Greece* (Cambridge: Cambridge University Press, 1993), 33–117. On settlement patterns in Italy, see Patterson's overview (*Landscapes and Cities,* 9–88). As in Hellenistic Greece, Italy shows a trend toward fewer but larger rural settlements. This may suggest larger landholdings. At this point, one is left to speculate whether this reflects urban decline or rather an economic shift toward greater division of labor between peasants in the countryside and artisans and shopkeepers in the cities.

27. Pirson, *Mietwohnungen in Pompeji und Herkulaneum.* For the argument in brief summary, see F. Pirson, "Rented Accomodation at Pompeii: The Insula

Arriana Polliana," in R. Laurence and A. Wallace-Hadrill, eds., *Domestic Space in the Roman World: Pompeii and Beyond,* JRA supplement 22 (Portsmouth, RI: Journal of Roman Archaeology, 1997).

28. Pirson, *Mietwohnungen in Pompeji und Herkulaneum,* 174.

29. Heinzelmann, "Die vermietete Stadt."

30. B. W. Frier, *Landlords and Tenants in Imperial Rome* (Princeton, NJ: Princeton University Press, 1980); F. Kolb, *Rom: Die Geschichte der Stadt in der Antike* (Munich: C. H. Beck, 1995), 441–444; R. Laurence, *Roman Pompeii: Space and Society,* 2nd ed. (London: Routledge, 2007), 136–140.

31. Kolb, *Rom,* 289–292, 442–443.

32. P. M. Allison, "Roman Households: An Archaeological Perspective," in H. M. Parkins, ed., *Roman Urbanism beyond the Consumer City* (London: Routledge, 1997), 112–146; Allison, *Pompeian Households.*

33. Consumption of landed wealthy elites serves as the engine of the urban economy in Weber's "consumer city" model, which is based on literary sources: M. Weber, *Handbuch der Staatswissenschaften,* vol. 1, 2nd ed. (1898), s.v. Agrargeschichte (Altertum), 66–85. More recently, "the demands of the peasantry, individually small but sizeable in aggregate" have been identified as a "significant contribution to urban incomes": N. Morley, "The Early Roman Empire: Distribution," in Scheidel et al., *The Cambridge Economic History,* 579; see also L. De Ligt, *Fairs and Markets in the Roman Empire: Economic and Social Aspects of Periodic Trade in a Pre-Industrial Society* (Amsterdam: J. C. Gieben, 1993), 146–149; and Kehoe, "The Early Roman Empire," 559. On demand driven by urban population growth, see Patterson, *Landscapes and Cities,* 261. D. Engels, *Roman Corinth: An Alternative Model for the Classical City* (Chicago: University of Chicago Press, 1990), 149–150, 173–178, even argued that Roman cities were "service cities," catering to the needs of the surrounding countryside. But for the most part, elite consumption is seen as the raison d'être of urban industry: "Urbanization developed above all as a result of the decision of the elite to invest a significant portion of the surplus they controlled in centralization and the built environment. . . . As in Rome, the demands created by their habits of consumption and their building projects gave employment to thousands of craftsmen and other workers, whose needs also had to be supplied" (Morley, "The Early Roman Empire," 578).

34. Saller, "Household," 111, insists against A. H. M. Jones, "The Cloth Industry under the Roman Empire," *Economic History Review* 13 (1960): 184, that "the archaeological evidence of loom weights suggests that weaving at home was not completely displaced by professional production in the empire." This statement must be qualified. Loom weights were indeed found in Pompeian houses, but are only "consistent with the presence of a single loom": P. M. Allison, *The Insula of the Menander at Pompeii, vol. 3. The Finds: A Contextual Study* (Oxford:

Oxford University Press, 2006), 356. This is a sharp decrease from the many looms found in the houses of Olynthus. On the relatively limited number of loom weights in Pompeii, see Allison, *Pompeian Households*, 146–148. This pattern also applies to the so-called *Hanghäuser* of Ephesus. Only *Wohneinheit* two (out of six) yielded a single loom: E. Trinkl, "Artifacts Found Inside the Terrace Houses of Ephesus, Turkey," in C. Gillis and M. L. Nosch, eds., *Ancient Textiles: Production, Craft and Society: Proceedings of the First International Conference on Ancient Textiles, Held at Lund, Sweden, and Copenhagen, Denmark, on March 19–23, 2003* (Oxford: Oxbow Books, 2007), 82. These single looms were probably more a matter of tradition and conservative ideology than of self-supporting household production. Livia was, famously, praised for weaving Augustus's toga herself (Suetonius, *Augustus* 74). This was hardly an economically relevant activity of the *domus Augusti*. A mostly ideological function of domestic looms in the Roman Empire is also suggested by the finds of elaborately carved third-century-c.e. distaffs in the *Hanghäuser* of Ephesus. These were clearly not functional items, which is confirmed by the fact that they show no wear. They were probably used in wedding ceremonies: E. Trinkl, "Zum Wirkungskreis einer kleinasiatischen Matrona anhand ausgewählter Funde aus dem Hanghaus 2 in Ephesos," *Jahreshefte des Österreichischen Archäologischen Institutes in Wien* 73 (2004): 301–302; Pliny, *naturalis historia* 8, 194. Such *Prunkrocken* (show distaffs) were also used as grave offerings and were represented on sarcophagi as a defining symbol of matronly virtue: Trinkl, "Zum Wirkungskreis," 299–300. On the funerary symbolism of spinning, see also D. Cottica, "Spinning in the Roman World: From Everyday Craft to Metaphor of Destiny," in Gillis and Nosch, *Ancient Textiles*, 220–228; and L. Lovén, "Wool Work as a Gender Symbol in Ancient Rome: Roman Textiles and Ancient Sources," in Gillis and Nosch, *Ancient Textiles*, 229–236.

35. M. Flohr, "*Nec quicquam ingenuum habere potest habere officina?* Spatial Contexts of Urban Production at Pompeii, A.D. 79," *Bulletin Antieke Beschaving* 82 (2007): 132–133, 148.

36. For instance, *P. Oxy.* VI 908.

37. Most bakers' bills like *P. Oxy.* VI 908 were issued for public officials in charge of food provision. See P. Venticinque, "Common Causes: Guilds, Craftsmen and Merchants in the Economy and Society of Roman and Late Roman Egypt" (PhD diss., University of Chicago, 2009).

38. J. DeFelice, "Inns and Taverns," in J. J. Dobbins and P. W. Foss, eds., *The World of Pompeii* (London: Routledge, 2007), 474 n. 1, counts ninety-four "businesses that served food and/or drink." This number does not include forty-two *hospitia* and *cauponae*, which served overnight guests, and nine *stabula*, which had "access to facilities for horses." On the design of such taverns, see A.

MacMahon, "The Shops and Workshops of Roman Britain," in A. MacMahon and J. Price, eds., *Roman Working Lives and Urban Living* (Oxford: Oxbow Books, 2005), 48–69. On tavern life and its representation, see J. Clarke, *Art in the Lives of Ordinary Romans and Non-Elite Viewers in Italy, 100 B.C.–A.D. 315* (Berkeley: University of California Press, 2003), 160–168.

39. F. Pirson, "Shops and Industries," in Dobbins and Foss, *The World of Pompeii*, 463–466.

40. For an unabashedly modernistic interpretation of these as rationally organized manufactories, see W. O. Moeller, *The Wool Trade of Ancient Pompeii* (Leiden: Brill, 1976), who is roundly criticized by M. Finley, *The Ancient Economy*, 2nd ed. (London: Hogarth, 1985), 195; W. Jongmann, *The Economy and Society of Pompeii* (Amsterdam: J. C. Gieben, 1988), 158–170; and Wallace-Hadrill, *Houses and Society*, 119. For a recent approach, see also D. Robinson, "Re-thinking the Social Organisation of Trade and Industry in First Century A.D. Pompeii," in MacMahon and Price, *Roman Working Lives and Urban Living*, 88–105.

41. For issues of demand and market fluctuations, see P. F. Bang, "Imperial Bazaar: Towards a Comparative Understanding of Markets in the Roman Empire," in P. F. Bang, M. Ikeguchi, and H. G. Ziche, eds., *Ancient Economies, Modern Methodologies: Archaeology, Comparative History, Models and Institutions* (Bari: Edipuglia, 2006), 60–63; and Hawkins, "Work in the City: Roman Artisans and the Urban Economy" (PhD diss., University of Chicago, 2006). On changing careers, see *CIL* 4 10150 and below.

42. Petronius, *Satyrica* 74: "Sed hic qui in pergula natus est, aedes non somniatur."

43. Ibid. 38: "Itaque proxime casam hoc titulo proscripsit: C. Pompeius Diogenes ex kalendis Iuliis cenaculum locat; ipse enim domus emit." Perhaps the *cenaculum* is located in the *domus* he bought, but the Latin is too ambiguous to be sure.

44. Ibid., 77.

45. Ibid., 73.

46. Ibid., 76.

47. Ibid., 72: "Sic calet tanquam furnus."

48. Ibid., 75–76.

49. Ibid., 65.

50. Ibid., 38.

51. Ibid., 46. From an economic point of view, Echion is not an unrealistic character. Already, in the early first century B.C.E., the freedman P. Confuleius Sabbio achieved some wealth as a *sagarius*. The *sagum* was a coarse cloak, which was mostly worn by slaves, but there was obviously money to be made in cheap textiles like *sagum* making and/or selling. It allowed Sabbio to build a house in the heart of Capua: M. Pagano and J. Rougetet, "La casa del liberto P. Confuleius

Sabbio a Capua e i suoi mosaici," *Mélanges de l'Ecole française de Rome. Antiquité* 99 (1987): 754. He commemorated its construction with a mosaic inscription: "P. Confuleius P. M. l. Sabbio sagarius / domum hanc ab solo usque ad summum / fecit arcitecto Safinio T. f. Fal. Pollione" (Pagano and Rougetet, "La casa," 756).

52. Petronius, *Satyrica* 46: "Quod si resilierit, destinavi illum artficium docere, aut tonstrinum aut praeconem aut certe causidicum, quod illi auferre non possit nisi Orcus."

53. Pirson, *Mietwohnungen in Pompeji und Herkulaneum,* 161.

54. See DeLaine, "The Commercial Landscape," 33, 35–36, on the bazaarlike markets.

55. For an introduction to the terminology and functioning of Roman markets, see J. M. Frayn, *Markets and Fairs in Roman Italy: Their Social and Economic Importance from the Second Century* B.C. to the Third Century A.D. (Oxford: Oxford University Press, 1993), 1–11. On market days, see De Ligt, *Fairs and Markets;* on permanent markets as opposed to fairs, 11–13 and 48–49.

56. Wallace-Hadrill, *Houses and Society,* 118–142.

57. Ibid., 3–16, 93–117.

58. For the rank-based allocation of urban building plots and agricultural land, see E. Fentress's pioneering article "Frank Brown, Cosa and the Idea of the Roman City," in E. Fentress ed., *Romanization and the City: Creation, Transformation and Failures,* Journal of Roman Archaeology Supplementary Series 38 (Portsmouth RI: Journal of Roman Archaeology, 2000), 11–24. For a recent discussion of this issue, see Sewell, *The Formation of Roman Urbanism,* 121–122.

59. Livy 41, 8, 8.

60. For the history of Fregellae, see G. Colasanti, *Fregellae: Storia e Topografia* (Rome: Loescher, 1906).

61. Strabo, *Geography* 5, 3, 10.

62. For a summary account of the excavations, F. Coarelli, *Enciclopedia dell'arte antica classica e orientale,* suppl. 2 (Rome: Instituto della Enciclopedia Italiana, 1994), s.v. "Fregellae." On the baths, see V. Tsiolis, "Fregellae: Il complesso termale e le origini degli edifici balneari urbani nel mondo romano," in M. Osanna and M. Torelli, eds., *Sicilia ellenistica, consuetudo italica: Alle origini dell'architettura ellenistica d'Occidente: Spoleto, Complesso monumentale di S. Nicolò, 5–7 novembre 2004* (Rome: Edizioni dell'Ateneo, 2006), 243–255.

63. E. De Albentiis and M. Furiani, *L'antica Fregellae e il Museo di Ceprano: Archeologia e tradizioni* (Rome: Palombi Editori, 1997), 50–51.

64. F. Coarelli, "Fregellae, Arpinum, Aquinum. Lana e fullonicae nel Lazio meridionale," in M. Cébeillac-Gervasoni, ed., *Les élites municipales de l'Italie péninsulaire des Gracques à Néron: Actes de la table ronde de Clermont-Ferrand, 28–30 novembre 1991* (Naples: Centre Jean Bérard, 1996), 199–205.

65. On the friezes, see F. Coarelli, "Due fregi da Fregellae. Un documento storico della prima guerra siriaca?" *Ostraka* 3 (1994): 93–108.

66. K. Welch, "*Domi Militaeque:* Roman Domestic Aesthetics and War Booty in the Republic," in S. Dillon and K. Welch, eds., *Representations of War in Ancient Rome* (Cambridge: Cambridge University Press, 2006), 110–113.

67. Coarelli, "Due fregi," 95.

68. On architecture of the façades, A. Hoffmann, "Elemente bürgerlicher Repräsentation. Eine späthellenistische Haussfassade in Pompeii," in *Akten des XIII Internationalen Kongresses für Klassische Archäologie, Berlin 1988* (Mainz: P. von Zabern, 1990), 490–495.

69. Most influentially, Finley, *The Ancient Economy,* 40–61.

70. On the Casa di Diana and Middle Republican Cosa, E. Fentress, *Cosa V: An Intermittent Town: Excavations 1991–1997,* Memoirs of the American Academy in Rome, supplementary volumes, vol. 2 (Ann Arbor: University of Michigan Press, 2003), 14–16. For the *tabernae* on the Palatine, A. Carandini, "Il Palatino e il suo sistema di montes," in M. Cristofani, ed., *La grande Roma dei Tarquini* (Rome: Bretschneider, 1990), 97–101.

71. Livy 40, 51, 5: "vendidit in privatum."

72. Ibid. 41, 27, 10.

73. Ibid. 41, 27, 12.

74. At Rome: ibid. 23, 25, 1; 26, 11, 7 (Hannibal offers for sale "tabernas argentarias quae circa forum Romanum essent"); 26, 27, 2 ("fuit pluribus simul locis circa forum incendium ortum. eodem tempore septem tabernae quae postea quinque, et argentariae quae nunc nouae appellantur, arsere," and similarly ibid. 27, 11, 16); ibid. 35, 40, 8 (the *tabernae* of the Forum Boarium that face the Tiber burn down). Mention of a forum surrounded by *tabernae* at Aricia (ibid. 30, 38, 9) and Minturnae (ibid. 36, 37, 3); similarly, Privernum (ibid. 27, 11, 4).

75. H. Schaaf, *Untersuchungen zu Gebäudestiftungen in hellenistischer Zeit* (Cologne: Böhlau, 1992).

76. The stoa first appears in a decree honoring Antiochus for his generous gift (*SEG* IV 470). It is mentioned again in an honorific decree for his mother Apame (*SEG* IV 442). On the inscriptions, see W. Günther, *Das Orakel von Didyma in hellenistischer Zeit. Eine Interpretation von Stein-Urkunden* (Tübingen: Wasmuth, 1971), 29–35. On the building, see Schaaf, *Untersuchungen zu Gebäudestiftungen,* 26–39.

77. *SEG* IV 442 and *SEG* 470.

78. List by Schaaf, *Untersuchungen zu Gebäudestiftungen,* 143.

79. J. J. Coulton, *The Architectural Development of the Greek Stoa* (Oxford: Clarendon Press, 1976), 86. On the development of market buildings, see now

V. Köse, "The Origin and Development of Market-Buildings in Hellenistic and Roman Asia Minor," in S. Mitchell and C. Katsari, eds., *Patterns in the Economy of Roman Asia Minor* (Swansea: Classical Press of Wales, 2005), 139–166.

80. T. Wiegand and H. Schrader, *Priene. Ergebnisse der Ausgrabungen und Untersuchungen in den Jahren 1895–1898* (Berlin: G. Reimer, 1904), 295–297.

81. M. Trümper, "Modest Housing in Late Hellenistic Delos," in B. A. Ault and L. C. Nevett, eds., *Ancient Greek Houses and Households: Chronological, Regional, and Social Diversity* (Philadelphia: University of Pennsylvania Press, 2005).

82. P. Karvonis, "Les installations commerciales dans la ville de Délos à l'époque hellénistique," *Bulletin de correspondance hellénique* 132 (2008): 195–196.

83. On ephemeral shops, see Karvonis, "Les installations commerciales," 159–160; on commercial buildings, 196–211.

84. M. Wolf, *Die Häuser von Solunt und die hellenistische Wohnarchitektur,* Deutsches Archäologisches Institut Rom, Sonderschriften 14 (Mainz: v. Zabern, 2003), 79–80.

85. This observation is a commonplace since Wiegand and Schrader, *Priene,* 297. On the architecture of large shop doors in the Greek East, see Karvonis, "Les installations commerciales," 185–188. For three well-studied examples, see P. Karvonis and J.-J. Malmary, "L'Étude architecturale de quatre pièces polyvalentes du Quartier du théâtre à Délos," *Bulletin de correspondance hellénique* 133 (2009): 203–226. These doors were lavishly framed, possibly to draw customers' attention. For the development of Greek shop architecture in general, see P. Karvonis, "Typologie et évolution des installations commerciales dans les villes grecques du IVe siècle av. J.-C. et de l'époque hellénistique," *Revue des études anciennes* 110 (2008): 57–81.

86. On the urban investment strategies of landed elites, see Wallace-Hadrill, *Houses and Society,* 118–142; H. M. Parkins, "The Consumer City Domesticated? The Roman City in Elite Economic Strategies," in H. M. Parkins, ed., *Roman Urbanism beyond the Consumer City* (London: Routledge, 1997), 83–111.

87. For a classic account of senatorial nonagricultural business interests, see J. H. D'Arms, *Commerce and Social Standing in Ancient Rome* (Cambridge, MA: Harvard University Press, 1981), 48–71.

88. Finley, *The Ancient Economy,* 41–43.

89. Cicero, *De off.* 1, 150–151. It is important that Cicero did not object to large-scale commerce. He only condemned retail merchants buying from wholesale merchants (*De off.* 1, 150: "Sordidi etiam putandi, qui mercantur a mercatoribus, quod statim vendant"). As J. Paterson, "Trade and Traders in the Roman World: Scale, Structure, and Organisation," in H. Parkins and C. Smith, eds., *Trade, Traders and the Ancient City* (London: Routledge, 1998), 151–152,

observes, Cicero was friendly with large-scale *negotiatores* and had warm words for wholesale *mercatores,* whom he called "wealthy and honest men" (mercatores homines locupletes atque honesti) in his second speech against Verres (2, 5, 154).

90. H. W. Pleket, "Wirtschaft," in H. Kellenbenz, J. H. D'Arms, and F. Vittinghoff, eds., *Handbuch der Europäischen Wirtschafts- und Sozialgeschichte 1: Europäische Wirtschafts- und Sozialgeschichte in der römischen Kaiserzeit* (Stuttgart: Klett, 1990), 45.

91. On shops in Puteoli: Cicero, *ad Atticum* (14, 9, 1 and 14, 10, 3). They earned Cicero at least 80,000 sesterces a year. On Cicero's other urban properties, see *ad Atticum* 1, 14, 7 and 12, 32, 3.

92. I. Wallerstein, "Bourgois(ie) as Concept and Reality," in E. Balibar and I. Wallerstein, eds., *Race, Nation, Class: Ambiguous Identities* (London: Verso, 1991), 139–151.

93. Finley, *The Ancient Economy,* 51. It does not matter that Trimalchio never arrived in the upper class. What matters is that he tried.

94. Plutarch, *Cicero* 1, 1.

95. Cass. Dio 46, 4, 1–3.

96. Suetonius, *Augustus* 2; 4.

97. To Cicero, even his father's death was only worth a few words: "pater nobis decessit a. d. IV Kal. Dec." (Cicero, *Ad Atticum* 1, 2, 1). According to Plutarch, *Cicero* 8, 2, the orator seems to have received no more than 90,000 sesterces from his father's estate, a very modest sum and only slightly more than his shops in Puteoli brought him in a single year. According to Suetonius, *Augustus* 1, 3, "Augustus himself wrote nothing more [about his origins in his memoirs] than that he came from an old and rich equestrian family in which his father was the first to become a senator."

98. Plutarch, *Cicero,* 1, 1; Suetonius, *Augustus,* 2, 1–2.

99. Degrassi, 1046.

100. Suetonius, *Augustus* 2, 3: "tranquillissime senuit."

101. Tac., *Ann.* 13, 27.

102. H. Mouritsen, "Mobility and Social Change in Italian Towns during the Principate," in H. M. Parkins, ed., *Roman Urbanism beyond the Consumer City* (London: Routledge, 1997), 59–92; Patterson, *Landscapes and Cities,* 238.

103. For epigraphically attested craftsmen of bouleutic status in the East, see van Nijf, *The Civic World,* 21–22; see also Venticinque, *Common Causes.*

104. Cass. Dio 46, 4. transl. Loeb.

105. Cicero, *De legibus* 2, 3.

106. An inscription by the local *aediles* of Arpinum mentions *fullonicae* (*CIL* 10, 5682). Another fragmentary inscription from Arpinum may suggest that

Cicero's family kept his father's fullery, even after Cicero and his brother had made it big in Rome. Coarelli, "Fregellae," 202–204, argued that *CIL* 10, 5678 is linked to this family business. It mentions Cilix, the slave of an L. Tullius in a dedication to [*pa*]*tri Mercurio lan*[—]. Coarelli suggested that this was a dedication to Mercurius *lanarius*. Mercury was the patron deity of at least one *lanarius*, the well-known Verecundus of Pompeii, who dedicated one of his shop signs to the god: Clarke, *Art in the Lives of Ordinary Romans*, 105–112. According to Coarelli "Fregellae," 202, L. Tullius could be Cicero's uncle or cousin. One might add that the inscription mentions a Philodemus as the overseer of the unspecified building project. This could be Cicero's freedman Philodemus, who managed his building projects in and around Arpinum. Still, the reconstruction *lanarius* is uncertain and the names could be a coincidence. Philodemus was a very common slave name.

107. Suetonius, *Vespasianus* 4, 3. Of course, Suetonius's biographies have to be taken with a grain of salt, but Patterson, *Landscapes and Cities*, 196–198, could show that Vespasian makes for a good case study in elite mobility.

108. See A. Maiuri, *L'ultima fase edilizia di Pompei* (1942; repr., Naples: Arte Tipografica, 2002), 217; with further elaboration, P. Castrén, *Ordo populusque Pompeianus: Polity and Society in Roman Pompeii*, 2nd ed., Acta Instituti Romani Finlandiae 8 (Rome: Bardi, 1983). For a discussion and reevaluation of the theory, see Mouritsen, "Mobility," 59–70; Pirson, *Mietwohnungen in Pompeji und Herkulaneum*, 41–42; N. Monteix, "Amadeo Maiuri et les boutiques d'Herculaneum: Approche historiographique," in E. C. de Sena and H. Dessales, eds., *Metodi e approcci archeologici: L'industria e il commercio nell'Italia antica*, British Archaeological Reports International Series 1262 (Oxford: Archeopress, 2004), 291–299.

109. On the most recent excavations and plans, see A. Laidlaw, "Excavations in the Casa di Sallustio: A Preliminary Assessment," in R. T. Scott and A. R. Scott, eds., *Eius Virtutis Studiosi: Studies in the Memory of Frank Edward Brown (1908–1988)*, Studies in the History of Art 43 (Washington, DC: National Gallery of Art, 1993), 217–233. For a description of the house, *Pompei: Pitture e Mosaici* 4 (1993): 87–147.

110. Pirson, *Mietwohnungen in Pompeji und Herkulaneum*, 244 nos. 52 and 53.

111. P. Zanker, "Die Villa als Vorbild des späten pompejanischen Wohngeschmacks," *Jahrbuch des Deutschen Archäologischen Instituts* 94 (1979): 490–492.

112. P. Zanker, *Pompeii: Public and Private Life* (Cambridge, MA: Harvard University Press, 1998), 145–160.

113. The other comes from the so-called Praedia Iuliae Felicis. From its name in the advertisement, it was obviously an estate that was rented out by an absentee landlord (or landlady). It consisted of a bath and several *tabernae* and cenacula over a subpartitioned *atrium* house. It also included a large garden. Heavy mod-

ern reconstructions defeat any closer analysis: Pirson, *Mietwohnungen in Pompeji und Herkulaneum,* 47–52.

114. Mouritsen, "Mobility," 68–70.

115. *CIL* IV 138: "Insula Arriana / Polliana [C]n. Al[le]i Nigidi Mai / locantur ex [k(alendis)] Iulis primis tabernae / cum pergulis suis et c[e]nacula / equestria et domus conductor / convenito Primum [C]n. Al[le]i / Nigidi Mai ser(vum)."

116. Pirson, *Mietwohnungen in Pompeji und Herkulaneum,* 23–47.

117. Laurence, *Roman Pompeii,* 134, believes that *domus* is a singular and argues that the Casa di Pansa was, like the Praedia Iuliae Felicis, let by an absentee landlord, and claims that this was the rule. While theoretically possible, this is no reason to assume that most urban property owners did not live in the main part of their subdivided house. It is unlikely in the case of the *duumvir* Nigidius Maius, who needed a representative townhouse, and even less likely in the case of the many much smaller houses where shops and apartments were walled off and rented out. If all these houses had been owned by absentee landlords, the number of resident house owners in Pompeii would be cut in half. There are also clear counterexamples like the house of L. Caecilius Iucundus (see below).

118. W. F. Jashemski, *The Gardens of Pompeii, Herculaneum and the Villas Destroyed by Vesuvius, vol. 2. Appendices* (New Rochelle, NY: Caratzas, 1993), 128.

119. For the most recent summary of results, F. Pirson, "Spuren antiker Lebenswirklichkeit. Fragestellung, Methodik und Ergebnisse der Untersuchung eines innerstädtischen Architekturkomplexes in Pompeji," in Neudecker and Zanker, eds., *Lebenswelten,* 129–145; with a more detailed preliminary report in J.-A. Dickmann and F. Pirson, "Die Casa dei Postumii in Pompeji und ihre Insula. Fünfter Vorbericht." *Mitteilungen des Deutschen Archäologischen Instituts. Römische Abteilung* 109 (2002): 243–316.

120. Pirson, "Spuren," 138.

121. Ibid., 138. A. Mau and J. Overbeck, *Pompeji in seinen Gebäuden, Alterthümern und Kunstwerken* (Leipzig: W. Engelmann, 1884), 294: "IIX ID IVL AXVNGIA P CC / ALIV MANVPLOS CCL." Even if the lard was bought, it must have been intended for further processing (maybe for soap?). Even a large household could hardly have used up 140 pounds of lard before it went bad.

122. Flohr, *"Nec quicquam ingenuum";* Robinson, "Re-thinking."

123. Robinson, "Re-thinking," 94.

124. Ibid., 98.

125. Wallace-Hadrill, *Houses and Society,* 118–141, still linked commerce and trade almost exclusively to the urban portfolio of the landholding elite, while others, like Robinson, "Re-thinking," 89, have warned against ignoring the middle and lower classes, who owned more businesses in Pompeii than the landed gentry.

126. Wallace-Hadrill, *Houses and Society,* 65–90.

127. Ibid., 103.

128. V. Gassner, *Die Kaufläden in Pompeii* (Vienna: VWGÖ, 1986).

129. See K. Stemmer, *Casa dell'Ara massima: (VI 16, 15–17),* Häuser in Pompeji 6 (Munich: Hirmer, 1992); M. Staub Gierow, *Casa del Granduca (VII, 4, 56) und, Casa dei Capitelli figurati (VII, 4, 57),* Häuser in Pompeji 7 (Munich: Hirmer, 1994).

130. Pinarius Cerialis (and his wife Cassia) is identified as the owner of the house through *programmata* on its façade and graffiti in the courtyard: M. Della Corte, "Scavi sulla Via dell'Abbondanza (Epigrafi inedite)," *Notizie degli scavi di antichità* (1927): 101–106. The gems were published by U. Pannuti, "Pinarius Cerialis, gemmarius pompeianus," *Bolletino d'Arte* 60 (1975): 178–190.

131. Another mosaic inscription, "lucrum gaudium" (profit is pleasure), is found in the much more modest Casa di Lucrum Gaudium (VI 14, 39). This mosaic illustrates the socioeconomic continuum among Pompeians (see below).

132. Pirson, *Mietwohnungen in Pompeji und Herkulaneum,* 243 nos. 33–35.

133. J. Andreau, *Les affaires de Monsieur Jucundus* (Rome: École Française de Rome, 1974), 60–62.

134. Robinson, "Re-thinking," 95.

135. Wallace-Hadrill, *Houses and Society,* 101–103.

136. Parkins, "The Consumer City."

137. Pirson, *Mietwohnungen in Pompeji und Herkulaneum,* 161.

138. Seneca, *Ep. 56,* 1.

139. Justinus Martyr, *Trypho* 2. Pirson, *Mietwohnungen in Pompeji und Herkulaneum,* 147–148.

140. Suetonius, *Vitellius* 7, 2.

141. Pirson, *Mietwohnungen in Pompeji und Herkulaneum,* 51.

142. *CIL* 4, 10150: "[Cum] de[d]uxisti octies, tibi superat (=superest), ut (h)abeas sedecies. Coponium fecisti. Cretaria fecisti. Salsamentaria fecisti. Pistorium fecisti. Agricola fuisti. Aere minuntaria fecisti. Propola fuisti. Laguncularia nunc facis. Si cunnu(m) linx<s>e<e>ris, consummaris omnia." Translation after J. T. Peña and M. McCallum, "The Production and Distribution of Pottery at Pompeii: A Review of the Evidence, Part 1: Production," *American Journal of Archaeology* 113 (2009): 63.

143. Pirson, *Mietwohnungen in Pompeji und Herkulaneum,* 138.

144. P. Temin, "The Labor Market of the Early Roman Empire," *Journal of Interdisciplinary History* 34, no. 4 (2004): 525.

145. Many Italian towns had less than 100 *decuriones;* Patterson, *Landscapes and Cities,* 222–225. Pompeii almost certainly so; Jongmann, *The Economy and Society of Pompeii,* 320; Mouritsen, "Mobility," 79. At least some of the 100 largest

houses must have belonged to freedmen, who were excluded from the *ordo decurionum.* On differences within the *ordo,* see Patterson's discussion in *Landscapes and Cities,* 240–241.

3. From Commercial to Middle Classes

1. The house in question is Hanghaus 2, Wohneinheit 2. On the graffiti, see H. Taeuber, "B. IV Graffiti," in F. Krinzinger, ed., *Hanghaus 2 in Ephesos. Die Wohneinheiten 1 und 2; Baubefund, Ausstattung, Funde* (Vienna: Verlag der Österreichischen Akademie der Wissenschaften, 2010), 474–475.

2. First published in K. Hopkins, "Rome, Taxes, Rent and Trade," *Journal of Roman Studies* 70 (1980): 101–125. A revised version appeared in K. Hopkins, "Rome, Taxes, Rent and Trade," *Kodai* 6–7 (1995–1996): 41–75. Quoted after K. Hopkins, "Rome, Taxes, Rent and Trade," in W. Scheidel and S. v. Reden, eds., *The Ancient Economy* (Edinburgh: Edinburgh University Press, 2002), 190–230.

3. Hopkins, "Rome," 217.

4. Ibid., 207–208.

5. Ibid., 229. On tenancy, see now Kehoe's overview: D. P. Kehoe, "The Early Roman Empire: Production," in W. Scheidel, I. Morris, and R. P. Saller, eds., *The Cambridge Economic History of the Greco-Roman World* (Cambridge: Cambridge University Press, 2007), 557–559. For absentee landlords, it made good economic sense to lease land for cash. Anything else caused undesirable hassle. Pliny the Younger provides an excellent case in point. When his tenant farmers found themselves unable to pay their money rents, Pliny was forced to introduce a sharecropping system, which drove up transaction costs: "One would be to let farms not for money rent but for a fixed share of the produce, and then make some of my servant overseers to keep a watch on the harvest. There is certainly no more just return than what is worn from the climate and seasons, but this method requires strict honesty, keen eyes, and many pairs of hands" (Pliny, *epist.* 9, 37, 2, trans. Loeb).

6. Hopkins, "Rome," 219.

7. On technologically advanced rigging and pumps of Roman ships, see C. Beltrame, "The Rigging and the Hydraulic System of the Roman Wreck at Grado, Gorizia, Italy," *International Journal of Nautical Archaeology* 34 (2005): 79–87.

8. On Indo-Roman trade, see now R. Tomber, *Indo-Roman Trade: From Pots to Pepper* (London: Duckworth, 2008). For an overview of trade, see A. I. Wilson, "Economy and Trade," in E. Bispham, ed., *The Short Oxford History of Europe 2: Roman Europe* (Oxford: Oxford University Press, 2008), 170–202.

9. B. Ward-Perkins, *The Fall of Rome and the End of Civilization* (Oxford: Oxford University Press, 2005), 142–146. This demand can be preliminarily quantified through statistical analysis of transport amphorae found in northwestern Europe; see B. Ejstrud, "Size Matters: Estimating Trade of Wine, Oil and Fish-Sauce from Amphorae in the First Century A.D.," in T. Bekker-Nielsen, ed., *Ancient Fishing and Fish Processing in the Black Sea Region* (Aarhus: Aarhus University Press, 2005), 171–181.

10. On mines, see A. I. Wilson, "Machines, Power and the Ancient Economy," *Journal of Roman Studies* 92 (2002): 1–32; and C. Domergue, "Les mines et la production des métaux dans le monde méditerranéen au Ier millénaire avant notre ère. Du producteur au consommateur," in *L'artisanat métallurgique dans les sociétés anciennes en Méditerranée occidentale: techniques, lieux et formes de production: Actes du colloque organisé à Ravello du 4 au 6 mai 2000* (Rome: École Française de Rome, 2004), 129–159.

11. See W. V. Harris, "The Late Republic," in W. Scheidel, I. Morris, and R. P. Saller, eds., *The Cambridge Economic History of the Greco-Roman World* (Cambridge: Cambridge University Press, 2007), 511–539, for an introduction to the economy of the late Republic: "Conventionally enough, this chapter will attempt to answer questions about economic growth: did per capita GDP grow in the late Republic, and what determined whether it did or not?" (511).

12. On the origins and the history of the debate, see J. K. Davis, "The Ancient Economy: Models and Muddles," in H. Parkins and C. Smith, eds., *Trade, Traders and the Ancient City* (London: Routledge, 1998), 233–242; and P. F. Bang, "Imperial Bazaar: Towards a Comparative Understanding of Markets in the Roman Empire," in P. F. Bang, M. Ikeguchi, and H. G. Ziche, eds., *Ancient Economies, Modern Methodologies: Archaeology, Comparative History, Models and Institutions* (Bari: Edipuglia, 2006), 52–56.

13. Ward-Perkins, *The Fall of Rome.*

14. Ibid., 137.

15. The outstanding example is the Braudelian, P. Horden and N. Purcell, *The Corrupting Sea: A Study of Mediterranean History* (Oxford: Blackwell, 2002).

16. For an introduction to the archaeological debate on the consumer city, see A. I. Wilson, "Urban Production in the Roman World: The View from North Africa," *Papers of the British School at Rome* 70 (2002): 231–234 and 237–257, for a discussion of various North African sites. See also D. J. Mattingly, D. Stone, and L. Stirling, "Leptiminus (Tunisia): A Producer City?" in D. J. Mattingly and J. Salmon, eds., *Economies beyond Agriculture in the Classical World* (London: Routledge, 2001), 66–89, on Leptiminus. A. I. Wilson, "Timgad and Textile Production," in Mattingly and Salmon, *Economies beyond Agriculture,* 271–296, on Timgad. C. R. Whittaker, "The Consumer City Revisited: The Vicus and the

City," *Journal of Roman Archaeology* 3 (1990): 110–118, argued that most production was carried out in *vici,* not in towns.

17. W. Scheidel, "In Search of Roman Economic Growth," *Journal of Roman Archaeology* 22 (2009): 46–70.

18. For a more recent example of this approach, including an extensive bibliography, see R. Laurence, S. E. Cleary, and G. Sears, *The City in the Roman West, c. 250 BC–c. AD 250* (Cambridge: Cambridge University Press, 2011), which traces the rise of the Roman city and the ideology of *romanitas* by counting "Roman" buildings like amphitheaters and baths.

19. Tacitus, *Agricola* 21. On this passage in the context of Italian urban culture, see J. R. Patterson, *Landscapes and Cities: Rural Settlement and Civic Transformation in Early Imperial Italy* (Oxford: Oxford University Press, 2006), 179.

20. For a nuanced example and discussion of this approach, see Patterson, *Landscapes and Cities,* 90–183.

21. See N. Monteix, "Les boutiques et les ateliers de l'Insula VI à Herculaneum," in *Contributi di Archeologia Vesuviana 1,* Studi della Soprintendenza archeologica di Pompei 17 (Rome: Bretschneider, 2006), 7–76, for an exemplary study of an *insula* in Herculaneum.

22. N. Morley, "Markets, Marketing and the Roman Elite," in E. Lo Cascio, ed., *Mercati permanenti e mercati periodici nel mondo Romano* (Bari: Edipuglia, 2000), 212, convincingly argues that rent-paying shopkeepers and artisans bought their food at the periodic *nundinae,* where local peasants sold their surplus produce.

23. While lions are usually associated with imperial games in Rome, the skeleton of a lioness has been found on a boat during the excavation of Pisa's Roman harbor at San Rossore.

24. On ingots, see Domergue, "Les mines"; and N. Monteix, "Les lingots de plomb de l'atelier VI, 12 d'Herculanum et leur usage. Aspects épigraphiques et techniques," in *L'artisanat métallurgique,* 365–378. As D. S. Reese, "Industrial Exploitation of Murex Shells: Purple-Dye and Lime Production at Sidi Khrebish, Benghazi (Berenice)," *Libyan Studies* 11 (1979): 86, could demonstrate, purple dye was dissolved in an alkaline solution to allow transporting it as an insoluble pigment, which was then redissolved by its final users. This elaborate system proves that not only finished textiles but also the necessary raw materials were traded. On epigraphically attested *purpurarii* in Italy, see L. Hughes, " 'Dyeing' in Ancient Italy? Evidence for the *purpurarii,*" in C. Gillis and M.-L. Nosch, eds., *Ancient Textiles: Production, Craft and Society: Proceedings of the First International Conference on Ancient Textiles, Held at Lund, Sweden, and Copenhagen, Denmark, on March 19–23, 2003* (Oxford: Oxbow Books, 2007), 87–92. We are best informed about the trade in Egyptian blue *(caeruleum),* because it was

the business of Cicero's friend C. Vestorius of Puteoli. He made a fortune pro-
ducing it. According to Pliny (*Nat. hist.* 33, 162), it cost 11 *denarii* per pound, and
was, according to Vitruvius (7, 11, 1), used in wall painting, but, judging from the
archaeological evidence, never in large quantities. On Vestorius's business, see
J. H. D'Arms, *Commerce and Social Standing in Ancient Rome* (Cambridge, MA:
Harvard University Press, 1981), 49–55; and A. Wallace-Hadrill, *Rome's Cultural
Revolution* (Cambridge: Cambridge University Press, 2008), 360.

25. M. Pagano, "Un'officina di *plumbarius* a Ercolano," in *L'artisanat métal-
lurgique*, 353–363.

26. Monteix, "Les lingots."

27. Morley, "Markets," 216–221.

28. See most recently F. Glaser, "Der Name der Stadt auf dem Magdalens-
berg," in G. Koiner, ed., *Akten des 10. Österreichischen Archäologentages in Graz:
7.–9. November 2003* (Vienna: Phoibos, 2006), 39–42; and G. Piccottini,
"VIRVN[. . .] oder VIRV(ivus) F(ecit)," *Carinthia* 195 (2005): 570–574.

29. On the Magdalensberg and its history, see G. Piccottini, "Die Stadt auf
dem Magdalensberg. Ein spätkeltisches und frührömisches Zentrum im südli-
chen Noricum," in *Aufstieg und Niedergang der römischen Welt*, 2, 6 (Berlin: Wal-
ter de Gruyter, 1977), 263–301. On Virunum, see H. Vetters, "Virunum," in
Aufstieg und Niedergang der römischen Welt, 2, 6 (Berlin: Walter de Gruyter,
1977), 302–354.

30. H. Dolenz, "Eisenverarbeitung auf dem Magdalensberg," in H. Straube,
Ferrum Noricum und die Stadt auf dem Magdalensberg (Vienna: Springer, 1996),
140–167; and H. Dolenz, *Eisenfunde aus der Stadt auf dem Magdalensberg*,
Archäologische Forschungen zu den Grabungen auf dem Magdalensberg 13,
Kärntner Museumsschriften 75 (Klagenfurt: Verlag des Landesmuseums für
Kärnten, 1998), 15–48.

31. The inscriptions were published by R. Egger, *Die Stadt auf dem Magda-
lensberg ein Grosshandelsplatz. Die ältesten Aufzeichnungen über den Metallwaren-
handel auf dem Boden Österreichs,* Österreichische Akademie der Wissenschaften,
philosophisch-historische Klasse, Denkschriften 79 (Graz: H. Böhlaus, 1961).

32. H. Straube, *Ferrum Noricum und die Stadt auf dem Magdalensberg*
(Vienna: Springer, 1996), 26–139.

33. The metal finds of the Magdalensberg have been studied and presented
in two monographs by Dohlenz, *Eisenfunde aus der Stadt auf dem Magdalensberg*,
and N. Schütz, *Eisenfunde aus der Stadt auf dem Magdalensberg 2*, Archäologische
Forschungen zu den Grabungen auf dem Magdalensberg 14, Kärntner Museums-
schriften 77 (Klagenfurt: Verlag des Landesmuseums für Kärnten, 2003).

34. M. Schindler and S. Scheffenegger, *Die glatte rote Terra sigillata vom
Magdalensberg*, Kärntner Museumsschriften 62, Archäologische Forschungen zu

den Grabungen auf dem Magdalensberg 5 (Klagenfurt: Verlag des Landesmuseums für Kärnten, 1977), 14–15.

35. On trade in general, see Piccottini, "Die Stadt," 291–295. On imported oil, wine, and *garum amphorae* on the Magdalensberg, see more recently V. Maier-Maidl, *Stempel und Inschriften auf Amphoren vom Magdalensberg: wirtschaftliche Aspekte,* Kärntner Museumsschriften 73, Archäologische Forschungen zu den Grabungen auf dem Magdalensberg 11 (Klagenfurt: Verlag des Landesmuseums für Kärnten, 1992), 129–132; and T. Bezeczky, *Amphorenfunde vom Magdalensberg und aus Pannonien: ein Vergleich,* Kärntner Museumsschriften 74, Archäologische Forschungen zu den Grabungen auf dem Magdalensberg 12 (Klagenfurt: Verlag des Landesmuseums für Kärnten, 1994), 13. The *taberna* NG/34 contained a ceramic depot, which was destroyed by fire and can be associated with the well-documented Titi Kanii of Aquileia who also shipped amphorae to the Magdalensberg; S. Zabehlicky-Scheffenegger, "TK. Zur kommerziellen Verbindung des Magdalensberges mit Aquileia," in M. Kandler, S. Karwise, and R. Pillinger, eds., *Lebendige Altertumswissenschaft: Festgabe zur Vollendung des 70. Lebensjahres von Hermann Vetters* (Vienna: A. Holzhausen, 1985), 252–254. G. Piccottini, "Neue Belege für den Handel in der Stadt auf dem Magdalensberg," *Münstersche Beiträge zur antiken Handelsgeschichte* 9, 2 (1990): 84–85, argued that a servile *institor* of the Kanii made iron fibulae on the Magdalensberg that were stamped LEAND(er) T(iti) CAN(ii servus).

36. On the scale of the luxuries trade, see Hopkins, "Rome," 222–223.

37. On Agathangelus, see K. Gostenčnik, "Agathangelus the Bronzesmith: The British Finds in Their Continental Context," *Britannia* 33 (2002): 227–256. Gostenčnik (229) locates his workshop in southern Gaul.

38. On *tessera nummularia*, see J. Andreau, *La vie financière dans le monde romain: Les métiers de manieurs d'argent (IVe s. av. J.-C.–IIIe s. ap. J.-C.)* (Rome: École Française de Rome, 1987), 486–506.

39. Ward-Perkins, *The Fall of Rome,* 102–103.

40. Hopkins, "Rome," 208–218. Most importantly, C. Howgego, "The Supply and Use of Money in the Roman world, 200 B.C. to A.D. 300," *Journal of Roman Studies* 82 (1992): 1–31; and C. Howgego, "Coin Circulation and the Integration of the Roman Economy," *Journal of Roman Archaeology* 7 (1994): 5–21.

41. Harris, "The Late Republic," 521–522.

42. On patterns of trade and production, see most recently Ward-Perkins, *The Fall of Rome,* 87–104; and Wallace-Hadrill, *Rome's Cultural Revolution,* 403–421. For *taberna*-based pottery production in Pompeii, see J. T. Peña and M. McCallum, "The Production and Distribution of Pottery at Pompeii: A Review of the Evidence, Part 1: Production," *American Journal of Archaeology* 113 (2009): 57–79.

43. For trade, see introduction, J. Paterson, "Trade and Traders in the Roman World: Scale, Structure, and Organisation," in H. Parkins and C. Smith, eds., *Trade, Traders and the Ancient City* (London: Routledge, 1998), 145–164. On wholesale merchants see ibid., 153–154 and 159–162. On amphora stamps, graffiti, and dipinti, see ibid., 162–163. For a known *garum* negotiator, see S. Martin-Kilcher, "Lucius Urittius Verecundus, négociant à la fin du Ier siècle, et sa marchandise découverte à Mayence," in B. Liou, L. Rivet, and M. Sciallano, eds., *Vivre, produire et échanger: Reflets méditerranéens: Mélanges offerts à Bernard Liou,* Archéologie et histoire romaine 8 (Montagnac: Mergoil, 2002), 343–353.

44. For instance, the *navicularii maris Hadriatici ad Ostia;* A. Pellegrino, "I navicularii maris Hadriatici ad Ostia," in *Miscellanea greca e romana II* (Rome: Istituto Italiano per la Storia Antica, 1987), 229–236. The organization of Roman river trade on the lower Danube has been recently studied by O. Bounegru, *Trafiquants et navigateurs sur le Bas Danube et dans le Pont Gauche à l'époque romaine* (Wiesbaden: Harrassowitz, 2006); that of the Rhône by M. Christol and J. L. Fiches, "Le Rhône. Batellerie et commerce dans l'antiquité," *Gallia* 56 (1999): 141–155.

45. On trade and the Roman army, see P. Middleton, "The Roman Army and Long-Distance Trade," in P. Garnsey and C. R. Whittaker, eds., *Trade and Famine in Classical Antiquity* (Cambridge: Cambridge Philological Society, 1983), 75–83.

46. Cicero, *ad Atticum* 14, 10, 3.

47. Cicero, *ad Atticum* 14, 9, 1.

48. Juvenal, *Satires* 1, 105.

49. Bang, "Imperial Bazaar," 79–84.

50. Ibid., 80.

51. Ibid., 56.

52. Ibid., 77–78.

53. Piccottini, "Die Stadt," 274–287.

54. Ibid., 289–295.

55. A. MacMahon, *The Taberna Structures of Roman Britain* (Oxford: British Archaeological Reports, 2003). See also A. MacMahon, "The Shops and Workshops of Roman Britain," in A. MacMahon and J. Price, eds., *Roman Working Lives and Urban Living* (Oxford: Oxbow Books, 2005), 48–69.

56. D. Perring, *The Roman House in Britain* (London: Routledge, 2002), 31, 55–60, 64–66. On the *taberna* strip houses of Bliesbruck and the artisans living in them, see now the catalog in J. P. Petit and S. Santoro, eds., *Vivre en Europe romaine: De Pompéi à Bliesbruck-Reinheim* (Paris: Errance, 2007). For a list of British examples with bibliography, see MacMahon, *The Taberna Structures,* 26.

57. MacMahon, *The Taberna Structures*, 30–31.

58. Ibid., 26–28.

59. A. Piganiol, *Les documents cadastraux de la colonie romaine d'Orange* (Paris: Centre National de la Recherche Scientifique, 1962), 330–334.

60. MacMahon, *The Taberna Structures*, 27.

61. Ibid., 28, 32–33, 127–128.

62. For instance, in Wroxeter *insula* VIII, site VI. See ibid., 33, for further examples.

63. Tacitus, *Agricola* 21.

64. See MacMahon, *The Taberna Structures*, 67–68, on the forum of Caerwent and other forum *tabernae*. Most *taberna* strip houses were built separately and did not share common walls or drainage systems and also evolved individually. "Commercial planned retail" seems to be mostly absent from British sites (ibid., 36–37).

65. Tacitus, *Annales* 14, 31.

66. Ibid., 14, 33.

67. On London, see D. Perring and S. Roskams, *Early Development of Roman London West of the Walbrook* (London: Museum of London/Council for British Archaeology, 1991), 102–107. On the shops, see J. Hall, "The Shopkeepers and Craft-Workers of Roman London," in A. MacMahon and J. Price, eds., *Roman Working Lives and Urban Living* (Oxford: Oxbow Books, 2005), 125–144. On Verulamium, see R. Niblett, *Verulamium: The Roman City of St. Albans* (Stroud, UK: Tempus, 2001).

68. Tacitus, *Annales* 14, 33.

69. D. Perring, "Spatial Organisation and Social Change in Roman Towns," in J. Rich and A. Wallace-Hadrill, eds., *City and Country in the Ancient World* (London: Routledge, 1991), 285. See also C. V. Walthew, "The Town House and the Villa House in Roman Britain," *Brittania* 6 (1975): 189–205.

70. On Italian and Phoenician traders, see most recently C. Hasenohr, "Italiens et Phéniciens à Délos. Organisation et relations de deux groupes d'étrangers résidents (IIe–Ie siècles av. J.-C.)," in R. Compatangelo and C.-G. Schwentzel, eds., *Etrangers dans la cité romaine. Actes du Colloque de Valenciennes (14–15 octobre 2005) "Habiter une autre patrie: Des incolae de la République aux peuples fédérés du Bas-Empire"* (Rennes: Presses Universitaires de Rennes, 2007), 77–90. On the archaeology of traders, shops, and clubhouses on Delos, see M. Trümper, "Modest Housing in Late Hellenistic Delos," in B. A. Ault and L. C. Nevett, eds., *Ancient Greek Houses and Households: Chronological, Regional, and Social Diversity* (Philadelphia: University of Pennsylvania Press, 2005); and M. Trümper, "Negotiating Religious and Ethnic Identity: The Case of Clubhouses in Late Hellenistic Delos," *Hephaistos* 24 (2006): 113–140.

71. For a detailed introduction to intercity rivalry and the role of elite patrons, see E. Stephan, *Honoratioren, Griechen, Polisbürger: Kollektive Identitäten innerhalb der Oberschicht des kaiserzeitlichen Kleinasien* (Göttingen: Vandenhoeck and Ruprecht, 2002), 140–158. On the consumer city model in the debate, see P. Niewöhner, "Welkende Städte in blühendem Land? Aizanoi und die Verländlichung Anatoliens im 5. und 6. Jh. n.Chr. Vorbericht über eine Untersuchung im Umland Aizanois," *Archäologischer Anzeiger* no. 1 (2003): 222–228. On intercity rivalry and elite patronage in Italy, see Patterson, *Landscapes and Cities,* 126–127 and 139–140. For a politically more nuanced interpretation of patronage in the Greek East, see A. Zuiderhoek, "On the Political Sociology of the Imperial Greek City," *Greek, Roman and Byzantine Studies* 48 (2008): 432–436.

72. Already in antiquity, there were jokes about the extremes to which local elites took intercity rivalry: P. Brown, *Power and Persuasion in Late Antiquity: Towards a Christian Empire* (Madison: University of Wisconsin Press, 1992), 18. On more serious criticism, see Stephan, *Honoratioren, Griechen, Polisbürger,* 146–147. For a book-length study of the "the follies of the Greeks," see now A. Heller, *"Les bêtises des grecs": conflits et rivalités entre cités d'Asie et de Bithynie à l'époque romaine,* 129 a. C.–235 p. C. (Pessac: Ausonius, 2006).

73. I. Maupai, *Die Macht der Schönheit: Untersuchungen zu einem Aspekt des Selbstverständnisses und der Selbstdarstellung griechischer Städte in der Römischen Kaiserzeit* (Bonn: Habelt, 2003), 307–327. On *neokoriai,* see now B. Burrell, *Neokoroi: Greek Cities and Roman Emperors* (Leiden: Brill, 2004); and M. Carter, "Neokoria and Imperial Cult in the Greek East," review of *Neokoroi: Greek Cities and Roman Emperors,* by B. Burrell, *Journal of Roman Archaeology* 18 (2005): 635–637; on festivals and intercity rivalry, see A. Chaniotis, "Konkurrenz und Profilierung von Kultgmeinden im Fest," in J. Rüpke, ed., *Festrituale in der römischen Kaiserzeit* (Tübingen: Mohr Siebeck, 2008), 70–85. See now also A.-V. Pont, *Orner la cité: enjeux culturels et politiques du paysage urbain dans l'Asie gréco-romaine* (Pessac: Ausonius, 2010).

74. On colonnaded streets, see A. Segal, *From Function to Monument: Urban Landscapes of Roman Palestine, Syria and Provincia Arabia* (Oxford: Oxbow Books, 1997), 3–53; G. Bejor, *Vie colonnate: paesaggi urbani del mondo antico* (Rome: Bretschneider, 1999); and M. Heinzelmann, "Städtekonkurrenz und kommunaler Bürgersinn. Die Säulenstrasse von Perge als Beispiel monumentaler Stadtgestaltung durch kollektiven Euergetismus," *Archäologischer Anzeiger* (2003): 197–220.

75. On the economic function of *plateiai,* see M. Mundell-Mango, "The Commercial Map of Constantinople," *Dumbarton Oaks Papers* 54 (2000): 194–197. She concludes that the *stoai* of late antique Constantinople housed no less than 2,600 shops and workshops. There were probably many more. The Hagia Sophia alone owned a thousand shops in the city. They were let to artisans and

shopkeepers. Premodern Ottoman Constantinople sported no less than 23,000 *taberna*-like shops. To date, the *tabernae* of the bath-gymnasium complex of Sardis, which opened up to the city's main colonnaded avenue, have yielded the richest finds, thanks to a sudden destruction in the early seventh century C.E. The complex was published in J. S. Crawford, *The Byzantine Shops at Sardis,* Archaeological Exploration of Sardis Monograph 9 (Cambridge, MA: Harvard University Press, 1990). On bazaarization, see Bejor, *Vie colonnate,* 108–110.

76. *IG* 4, 790.

77. *TAM* 5/1, 1, 79, 80, 81, 146. On professional and neighborhood organizations attached to *plateiai,* see O. M. van Nijf, *The Civic World of Professional Associations in the Roman East* (Amsterdam: J. C. Gieben, 1997), 181–183.

78. On this new role of *plateia* as "linear forum," see A. Hoffmann, "Platz für Ehrenstatuen. Gadaras Hauptstrasse, ein lineares Forum," in J. J. Emerick and D. M. Deliyannis, eds., *Archaeology in Architecture: Studies in Honor of Cecil L. Striker* (Mainz: v. Zabern, 2005), 89–98.

79. A comprehensive study on the *plateia* of Apameia has not yet been written. Measurements by J. Balty and J.-C. Balty, "Apamée de Syrie, archéologie et histoire, 1. Des origines à la Tétrarchie," in H. Temporini, ed., *Aufstieg und Niedergang der römischen Welt* 2, 8 (Berlin: Walter de Gruyter, 1977), 127 fn. 174. On the shop façades and their wall paintings, see L. Reekmans, "Fresques des portiques de la grande colonnade," in J. Balty, ed., *Apamée de Syrie: Bilan des recherches archéologiques 1965–1968. Actes du Colloque tenu à Bruxelles les 29 et 30 avril 1969* (Brussels: Centre Belge de Recherches Archéologiques à Apamée de Syrie, 1969), 117–123. On the mosaics, C. Dulière, *Mosaïques des portiques de la grande colonnade: Section 7, 16–17* (Brussels: Centre Belge de Recherches Archéologiques à Apamée de Syrie, 1974).

80. Heinzelmann, "Städtekonkurrenz."

81. Ibid., 200–205. On the gate, see T. S. Scheer, *Mythische Vorväter. Zur Bedeutung griechischer Heroenmythen im Selbstverständnis kleinasiatischer Städte* (Munich: Maris, 1993), 187–201; on the fountain, C. Dorl-Klingenschmid, *Prunkbrunnen in kleinasiatischen Städten: Funktion im Kontext* (Munich: Friedrich Pfeil, 2001).

82. Heinzelmann, "Städtekonkurrenz."

83. Ibid., 205.

84. Ibid., 205–215.

85. J. İnan, "Perge kazısı 1981 çalışmaları," *Türk arkeoloji dergisi* 26, 2 (1983): 18, fig. 66–70; Heinzelmann, "Städtekonkurrenz," 208–209.

86. Dio Chrys., *Or.* 47, 12–14.

87. Dio Chrys., *Or.* 40, 9.

88. Dio Chrys., *Or.* 45, 6.

89. See T. Bekker-Nielsen, *Urban Life and Local Politics in Roman Bithynia: The Small World of Dion Chrysostomos* (Aarhus: Aarhus University Press, 2008), 119–120, on Dio's self-image as a landowning aristocrat; 120–140 on his life and career. Bekker-Nielsen (126) takes Dio's sarcasm at face value when he claims that some of the demolished buildings possessed true "historical and sentimental value." If this had been the case, Dio would not have had to mention the new shops rising elsewhere.

90. Dio Chrys., *Or.* 40, 8–9, trans. after Loeb.

91. H. Thür, "Ephesos. Bauprogramme für den Kaiser," in E.-L. Schwandner, ed., *Macht der Architektur, Architektur der Macht. Bauforschungskolloquium in Berlin vom 30. Oktober bis 2. November 2002* (Mainz: v. Zabern, 2004), 225–228; P. Scherrer, "Die Stadt als Festplatz. Das Beispiel der ephesischen Bauprogramme rund um die Kaiserneokorien Domitians und Hadrians," in J. Rüpke, ed., *Festrituale in der römischen Kaiserzeit* (Tübingen: Mohr Siebeck, 2008), 41–42.

92. H. Vetters, "Domitiansterrasse und Domitiansgasse," *Jahreshefte des Österreichischen Archäologischen Institutes in Wien* 50, 1972–75, Beiblatt (1972/1973): 311–330.

93. See most recently A. Landskron, "Die Pfeilerfiguren der Domitiansterrasse in Ephesos," in B. Brandt and F. Krinzinger, eds., *Synergia: Festschrift für Friedrich Krinzinger 1* (Vienna: Phoibos, 2005), 187–219.

94. Vetters, "Domitiansterrasse," 314.

95. Ibid., 327.

96. For instance, the city of Ephesus used rent from lands belonging to the Artemision to finance the paving of a street: *IK* 12, 495; G. Alföldy, "Epigraphische Notizen aus Kleinasien I: ein *beneficium* des Augustus in Ephesos," *Zeitschrift für Papyrologie und Epigraphik* 87 (1991): 157–162. For the finances of Ephesus, as well as Bithynian and Lycian cities, see H. Schwarz, *Soll oder Haben? Die Finanzwirtschaft kleinasiatischer Städte in der Römischen Kaiserzeit am Beispiel von Bithynien, Lykien und Ephesos (29 v.Chr.–284 n.Chr.)* (Bonn: Habelt, 2001). There is also good literary evidence for Italian cities receiving income from agricultural rents, sometimes even from land in the provinces. Capua received 1.2 million sesterces a year from lands on Crete, which Augustus had given to the city (Velleius Paterculus 2, 81, 2). This income was still available in Cassius Dio's time (49, 14, 5). On this and other examples, see Patterson, *Landscapes and Cities,* 186–187.

97. *IK* 12, 443.

98. On likely examples from North Africa, see N. Tran, "Les cités et le monde du travail urbain en Afrique romaine," in C. Berrendonner, M. Cébeillac-Gervasoni, and L. Lamoine, eds., *Le quotidien municipal dans l'Occident romain* (Clermont-Ferrand: Presses Universitaires Blaise-Pascal, 2008), 339–343.

99. *SEG* 46, 1393.

100. *IK* 12, 444–445; *IK* 16, 2076–2082. See also van Nijf, *The Civic World*, 85.

101. On the *conventus civium Romanorum qui in Asia negotiantur*, see *IK* 12, 409 and *IK* 17/1, 3019.

102. *Trapezeitiké stoá: IK* 17/1 3005. On the role of the *conventus civium Romanorum qui in Asia negotiantur* in the construction of the city's main (Tetragonos) agora, see P. Scherrer, "Der *conventus civium Romanorum* und kaiserliche Freigelassene als Bauherren in Ephesos in augusteischer Zeit," in M. Meyer, ed., *Neue Zeiten, neue Sitten: zu Rezeption und Integration römischen und italischen Kulturguts in Kleinasien* (Vienna: Phoibos, 2007), 63–65. On the location of the *trapezeitiké stoá*, see P. Scherrer and E. Trinkl, *Die Tetragonos Agora in Ephesos: Grabungsergebnisse von archaischer bis in byzantinische Zeit. Ein Überblick. Befunde und Funde klassischer Zeit*, Forschungen in Ephesos 13, 2 (Vienna: Verlag der Österreichischen Akademie der Wissenschaften, 2006), 43.

103. So far, only the 190 *tabernae* of the Tetragonos-Agora have been studied in some detail: Scherrer and Trinkl, *Die Tetragonos Agora in Ephesos*, 42.

104. The well-preserved domestic decor of all housing units in Hanghaus 2 has led the excavators to believe that Hanghaus 2 was inhabited by well-to-do members of the upper classes. This is certainly the case with the two housing units facing the Kuretenstrasse, one of Ephesus's main urban arteries. The houses and apartments farther up the hill are, however, smaller in size and probably included rented apartments on the upper levels. The quality of their wall decoration, which is mirrored by stylistically very close samples from *taberna* H2/45, rather points to a cultural continuum in domestic decor than to high social class.

105. On the historiography of Roman *collegia*, see J. S. Perry, *The Roman Collegia: The Modern Evolution of an Ancient Concept* (Leiden: Brill, 2006). See 205–213 on modern research.

106. Acts 19:23–40.

107. Acts 19:24.

108. Acts 19:25.

109. Acts 19:29.

110. Acts 19:35–40.

111. For a list of inscriptions cf. C. Zimmermann, *Handwerkervereine im griechischen Osten des Imperium Romanum* (Mainz: Verlag des Römisch-Germanischen Zentralmuseums in Kommission bei Habelt, 2002), 137.

112. For an overview and critique of this research tradition, see D. Schinkel, "'Und sie wussten nicht warum sie zusammengekommen waren'—Gruppen und Gruppeninteressen in der Demetriosepisode (Apg 19, 23–40)," in A. Gutsfeld and D.-A. Koch, eds., *Vereine, Synagogen und Gemeinden im kaiserzeitlichen Kleinasien* (Tübingen: Mohr Siebeck, 2006), 97–98.

113. van Nijf, *The Civic World,* 5–23. For an excellent summary of current scholarship on this issue, see J. Liu, *Collegia Centonariorum: The Guilds of Textile Dealers in the Roman West* (Leiden: Brill, 2009), 4–11.

114. Perry, *The Roman Collegia,* 207–208, introduced friendly societies into the debate. The current trend to focus on the sociability of ancient *collegium* life is summarized by ibid., 205–213. However, the social aspects of medieval guild life have now become a focus of modern research, which makes them more comparable to ancient *collegia* than previously thought: van Nijf, *The Civic World,* 17–18.

115. See L. De Ligt, "Governmental Attitudes towards Markets and *Collegia,*" in E. Lo Cascio, ed., *Mercati permanenti e mercati periodici nel mondo Romano* (Bari: Edipuglia, 2000), 242–252, on government attitudes toward *collegia.* While not exactly friendly in the first two centuries C.E., De Ligt convincingly argues that there is no reason the Roman authorities "had an almost morbid fear" (237–238) of voluntary associations.

116. *P. Mich.* V 245, lines 9–24, trans. van Nijf, *The Civic World,* 13–14.

117. P. Venticinque, *Common Causes: Guilds, Craftsmen and Merchants in the Economy and Society of Roman and Late Roman Egypt* (PhD diss., University of Chicago, 2009).

118. On the high social status of the Ephesian *grammatèus* and his relations with the Roman authorities, see C. Schulte, *Die Grammateis von Ephesos. Schreibeeramt und Sozialstruktur in einer Provinzhauptstadt des römischen Kaiserreiches* (Stuttgart: Steiner, 1994), 52–75.

119. Zuiderhoek, "Political Sociology," 439–440.

120. Cicero, *pro Flacco* 18.

121. A. Lintott, *The Constitution of the Roman Republic* (Oxford: Clarendon, 1999), 78–83.

122. Tran, "Les cités," 333–336.

123. See Venticinque, *Common Causes.*

124. *P. Oxy.* 64, 3173; *P. Oxy.* 64, 3176; *P. Oxy.* 1, 84; *P. Got.* 7; *P. Oxy.* 65, 3265.

125. Petronius, *Satyrica* 44.

126. *CIL* 6, 266.

127. G. Clemente, "Il patronato nei collegia dell'impero romano," *Studi classici e orientali* 21 (1972): 142–229; R. Meiggs, *Roman Ostia,* 2nd ed. (Oxford: Clarendon Press, 1973), 313–314.

128. On the economic value of familiarity between patrons and freedmen, see P. Temin, "The Labor Market of the Early Roman Empire," *Journal of Interdisciplinary History* 34.4 (2004): 528.

129. S. D. Martin, *The Roman Jurists and the Organization of Private Building in the Late Republic and Early Empire* (Brussels: Latomus, 1989), 64–65.

130. M. Steinby, "I senatori e l'industria laterizia urbana," in *Epigrafia e ordine senatorio,* vol. 1 (Rome: Edizioni di Storia e Letteratura, 1982), 235.

131. A. J. B. Sirks, *Food for Rome: The Legal Structure of the Transportation and Processing of Supplies for the Imperial Distributions in Rome and Constantinople* (Amsterdam: J. C. Gieben, 1991), 193–239.

132. Asconius Pedanius, *In Orationem pro Cornelio* 75. On the Republican college, see J. H. Moore, "The Fabri Tignarii of Rome," *Harvard Studies in Classical Philology* 75 (1971): 202–205.

133. P. Kneißl, "Die fabri, fabri tignuarii, fabri subaediani, centonarii und dolabrarii als Feuerwehren in den Städten Italiens und der westlichen Provinzen," in R. Günther and S. Rebenich, eds., *E fontibus haurire. Beiträge zur römischen Geschichte und zu ihren Hilfswissenschaften (Festschrift H. Chantraine)* (Paderborn: Ferdinand Schöningh, 1994), 133–146, on the role of the *collegia fabrorum* and *centonariorum* in fire fighting. Kneißl (134–135) claims that in the second century C.E. these *collegia* ceased to function as trade-based associations and transformed into fire brigades. It is certainly correct that some *collegium* members did not practice the profession around which the *collegium* was originally founded (134). But inscriptions and papyri also clearly show that this was exceptional. Rome and Ostia had their own *vigiles,* which would have rendered the *fabri* and *centonarii* obsolete. Both *collegia* are attested to have existed simultaneously in Italian towns: Patterson, *Landscapes and Cities,* 257. On the issue see now also Liu, *Collegia Centonariorum,* 125–160, who convincingly argues that the *centonarii* did not play a major role in firefighting and were primarily concerned with wool working.

134. F. Kolb, *Rom: Die Geschichte der Stadt in der Antike* (Munich: C. H. Beck, 1995), 481.

135. Pliny, *Pangeyricus* 54, 3.

136. Two friezes of the Haterii tomb show the Colosseum and other public monuments. Since the Haterii were surely builders, the general assumption is that they helped in the construction: F. Sinn and K. S. Freyberger, *Vatikanische Museen. Museo gregoriano profano ex lateranense. Katalog der Skulpturen 2. Die Ausstattung des Hateriergrabes* (Mainz: v. Zabern, 1996), 34, 63–76, pl. 20, on the two friezes. Steinby, "I senatori," 235; and Kolb, *Rom,* 473, suggest that Q. Haterius Tychicus received these contracts through his patron. Kolb suggests that this was Q. Haterius Antoninus, the *consul ordinarius* of 53 C.E. According to Kolb, Q. Haterius Antoninus deliberately introduced his freedmen into the construction industry and got him government contracts so that he could sell more bricks from his brickworks in Narni. This is a possibility, but must remain speculative, as long as no brick stamps of the Haterii surface in the Colosseum.

137. Meiggs, *Roman Ostia,* 319–321.

138. Martin, *Roman Jurists,* 65–69.

139. Ibid., 67–68.

140. B. Bollmann, *Römische Vereinshäuser. Untersuchungen zu den Scholae der römischen Berufs-, Kult- und Augustalen-Kollegien in Italien* (Mainz: P. von Zabern, 1998), 287–288.

141. Ibid., 287.

142. This is an educated guess. If Cicero could expect about 10,000 sesterces in rent from a *taberna* in Puteoli (see above) and C. Caecilius Iucundus paid 1,600 sesterces per annum for a *fullonica* in Pompeii (see above), "tens of thousands" seems a reasonable guess for seven *tabernae* and at least three *cenacula* on the Ostian forum.

143. Bollmann, *Römische Vereinshäuser*, 340–348.

144. F. Zevi, "Miscellanea ostiense," *Atti della Accademia nazionale dei Lincei. Classe di scienze morali, storiche e filologiche. Rendiconti* 26 (1971): 474, 476.

145. As evidenced by *CIL* 6, 266. For the Egyptian evidence, see Venticinque, *Common Causes*.

146. Patterson, *Landscapes and Cities*, 255.

147. *RIB* 91: "collegium fabror(um) et qui in eo sunt" of Novimagus Reginorum (Chichester).

148. P. Zanker, "Veränderungen im öffentlichen Raum der italischen Städte der Kaiserzeit," in *L'Italie d'Auguste à Dioclétien: Actes du colloque international, Rome 25–28 mars 1992* (Rome: L'École Française de Rome, 1994), 273–276; Bollmann, *Römische Vereinshäuser*, 195–199; see also D. Steuernagel, *Kult und Alltag in römischen Hafenstädten. Soziale Prozesse in archäologischer Perspektive* (Stuttgart: Franz Steiner, 2004), 180.

149. Bollmann, *Römische Vereinshäuser*, 304–309.

150. G. Becatti, *Scavi di Ostia, vol. 4: Mosaici e pavimenti marmorei* (Rome: Libreria dello Stato, 1961), 64–85.

151. Vitruvius 5, 9, 1.

152. D. Steuernagel, *Kult und Alltag*, 199–201, sees these spaces in analogy to theater seats reserved for *collegia* and their "VIP-lounges" (200) in the *sottoscala* rooms of the amphitheater at Puteoli.

153. Bollmann, *Römische Vereinshäuser*, 298–300.

154. The classic epigraphic study on *collegia* by J.-P. Waltzing, *Étude historique sur les corporations professionnelles chez les Romains depuis les origines jusqu'à la chute de l'Empire d'Occident* (Bologna: Forni, 1968), fills four volumes.

155. On the *schola*, see Bollmann, *Römische Vereinshäuser*, 396–402; on the shops *(botteghe)*, see M. Fabbri and A. Trotta, *Una scuola-collegio di età augustea: L'insula II di Velia* (Rome: Bretschneider, 1989), 38–42. They were never connected to the rest of the *schola* and must have, consequently, been planned as rentals.

156. On street life, see now M. Beard, *The Fires of Vesuvius: Pompeii Lost and Found* (Cambridge, MA: Harvard University Press, 2008), 53–80.

157. For the debate in summary, see Zanker, "Veränderungen," 273–277.

158. B. C. Ewald, *Der Philosoph als Leitbild: Ikonographische Untersuchungen an römischen Sarkophagreliefs* (Mainz: v. Zabern, 1999), 216, pl. 101, 2.

159. Bollmann, *Römische Vereinshäuser,* 261–268. In 1539, the small but richly decorated *schola xantha* of the *scribae librarii et praecones* was discovered between the Arch of Septimius Severus and the Temple of Saturn. It was destroyed, but its inscriptions survive (*CIL* 6, 103 and 1068). The prominent position of this monument in the political and religious heart of Rome is remarkable. On the building, see Bollmann, *Römische Vereinshäuser,* 254–256.

160. On the letter by Marcus Aurelius (*IG* 2, 3176), see J. Krier, "Zum Brief des Marcus Aurelius Caesar an den dionysischen Kultverein vom Smyrna," *Chiron* 10 (1980): 449–456. On the *collegium,* see V. Hirschmann, "Macht durch Integration? Aspekte einer gesellschaftlichen Wechselwirkung zwischen," in Gutsfeld and Koch, eds., *Vereine, Synagogen und Gemeinden,* 41–59.

161. Bollmann, *Römische Vereinshäuser,* 323–327.

162. The identification is secure. It is based on a *fistula* found in situ under the house's original *atrium:* C. Bocherens and F. Zevi, "La schola du Trajan et la domus du consul Caius Fabius Agrippinus à Ostie," *Archeologia classica* 58 (2007): 257–258. The fragment of an inscription honoring C. Fabius Agrippinus was also found in the recent excavations of the *schola:* ibid., 257–261.

163. Ibid., 268–269.

4. In Search of Middle-Class Culture

1. Lucian, *De Luctu* 1.

2. On the relief, see K. Dunbabin, *The Roman Banquet* (Cambridge: Cambridge University Press, 2003), 1–2 fig. 1; on "drinking in the tomb," 103–140 and below.

3. *CIL* 6, 25531, trans. Dunbabin.

4. For a recent summary of this trend, see J. Elsner, *Roman Eyes: Visuality and Subjectivity in Art and Text* (Princeton, NJ: Princeton University Press, 2007), xi–xvii and 67–109, on "ecphrasis and the gaze." I borrow the term "superliterate" from N. Horsfall, *The Culture of the Roman Plebs* (London: Duckworth, 2003), 65–66, who rightly bemoans the dichotomous view of Roman cultural life, which distinguishes between a small minority of highly educated upper classes and a vast majority of "intellectually impoverished" lower classes, who may not have been downright illiterate but, on the whole, ignorant of even the most basic forms of cultural refinement.

5. Philostratus, *Imagines* I, 15, 1. See Z. Newby, "Absorption and Erudition in Philostratus' *Imagines*," in E. Bowie and J. Elsner, eds., *Philostratus* (Cambridge: Cambridge University Press, 2009), 326, on the necessity of schooling the boy to link an impressive image to the text on which it is based.

6. On "culture without education; education without school," see Horsfall, *The Culture of the Roman Plebs*, 48–63 and 66–68, for a cultural middle ground.

7. The opposite has been claimed by F. G. J. M. Müller, *The So-Called Peleus and Thetis Sarcophagus in the Villa Albani* (Amsterdam: Giebe, 1994), 147–156. Müller argues that the use of mythological exempla in Greek funerary orations of the Second Sophistic must have influenced how Roman audiences looked at their sarcophagi. There is no doubt that educated upper-class Romans were perfectly aware of "the new developments in the field of [Greek] rhetoric (147)." But there is no proof, that Roman upper classes took up the custom of consolatory funerary speeches. As a matter of fact, there is no proof for this, as Müller concedes himself (151). Indeed, there are no Greek-style consolatory speeches in the corpus of pagan Latin funerary oratory. In Latin, such speeches only became popular with Christian writers in the fourth century C.E., as shown by W. Kierdorf, *Laudatio Funebris. Interpretationen und Untersuchung zur Entwicklung der römischen Leichenrede* (Meisenheim am Glan: Verlag Anton Hain, 1980), 92–93. There are good reasons for this. As philhellene as Roman political elites may have been, in sticking with time-honored religious and political traditions at their funerals they flaunted their *romanitas*, which still mattered a great deal to the imperial aristocracy. See also below n. 151.

8. For a summary of current work on Roman necropoleis, see M. Carroll, *Spirits of the Dead: Roman Funerary Commemoration in Western Europe* (New York: Oxford University Press, 2006), 1–29. With Carroll, *Spirits of the Dead*, 2–3, I avoid the term "cemetery." The idea of a *coemeterium* as a sleeping place is closely tied up with Christian beliefs of resurrection. By contrast, the concept of a "city of the dead" is based on the idea that a tomb is the final resting place for the deceased.

9. On the importance of work and its representation in Ostian reliefs, see N. Kampen, *Image and Status: Roman Working Women in Ostia* (Berlin: Mann, 1981), 84. On representations of "sordid trades" in Cicero's terms, see H. Rose, "Vom Ruhm des Berufs. Darstellungen von Händlern und Handwerkern auf römischen Grabreliefs in Metz," in F. Hölscher and T. Hölscher, eds., *Römische Bilderwelten. Von der Wirklichkeit zum Bild und zurück. Kolloquium der Gerda Henkel Stiftung am Deutschen Archäologischen Institut Rom, 15.–17. März 2004* (Heidelberg: Verlag Archäologie und Geschichte, 2007), 164–166. See also M. George, "Social Identity and the Dignity of Work in Freedmen's Reliefs," in E. D'Ambra and G. P. R. Métraux, eds., *The Art of Citizens, Soldiers and Freedmen in the Roman World* (Oxford: Archeopress, 2006), 19–29. The last publication is

typical of the trend to assume that most of these reliefs were commissioned by freedmen. See also H. Mouritsen, "Freedmen and Decurions: Epitaphs and Social History in Imperial Italy," *Journal of Roman Studies* 95 (2005): 38–63. This was certainly so in several cases. But it is important to point out that freedmen are typically identified by a Greek *cognomen*. This strikes me as overoptimistic, as there were clearly Easterners and other *ingenui* with Greek *cognomina* working in the city of Rome. In the northwestern provinces, there is little indication that everyone commissioning a *Berufsdarstellung* on a tomb was a freedman or a first-generation *ingenuus*.

10. For an introduction into funerary rites and a basic typology of tombs, see J. M. C. Toynbee, *Death and Burial in the Roman World* (London: Thames and Hudson, 1971), 43–100.

11. The rare sarcophagi that fall into this category have been collected by R. Amedick, *Die antiken Sarkophagreliefs, 1, 4. Die Sarkophage mit Darstellungen aus dem Menschenleben* (Berlin: Mann/Deutsches Archäologisches Institut, 1991), 110–117.

12. Despite the tens of thousands of surviving epitaphs, gravestones, sarcophagi, and mausolea, the social and cultural analysis of Roman necropoleis is a relatively new trend in modern scholarship. Until recently, philologists, epigraphers, and archaeologists studied epitaphs and material remains separately. Archaeologists fragmented the evidence further by creating narrow categories of classification. Funerary art was grouped by its iconography, tombs by architectural type. As late as 1985, H. von Hesberg and P. Zanker criticized the "one-sided interest" of generations of scholarship in studying individual *membra disiecta* from Roman necropoles as "works of art." Their colloquium on *Gräberstraßen* was intended to change this: H. von Hesberg and Paul Zanker, *Römische Gräberstraßen: Selbstdarstellung, Status, Standard: Kolloquium in München vom 28. bis 30. Oktober 1985* (Munich: Verlag der Bayerischen Akademie der Wissenschaften, in Kommission bei der C.H. Beck'schen Verlagsbuchhandlung, 1987), 7. Since 1870, Roman sarcophagi have been collected in the *Antike Sarkophagreliefs* series, which still publishes sarcophagi primarily by the subject matter of their reliefs. All these publications have made an enormous amount of evidence available for further study. But putting the pieces together and writing a sociocultural history of Roman tombs is not an easy task. First of all, only very few signature pieces of Roman funerary art can be recontextualized. And even necropoleis that have been published to modern standards were mostly looted in antiquity—or by marble-hunting archaeologists since the Renaissance rediscovery of antiquity. Still, we know enough about the development of burial customs and necropoleis to contextualize individual inscriptions, altars, ash urns, and sarcophagi within Roman funerary culture at large. At this point, this can only be done in relatively

broad terms, but still in sufficient detail to place the world of middle-class tombs within the ever-changing landscape of Roman cemeteries.

13. On the ritual, see E. Flaig, *Ritualisierte Politik* (Göttingen: Vandenhoeck and Ruprecht, 2003), 51–68.

14. H. von Hesberg, *Römische Grabbauten* (Darmstadt: Wissenschaftliche Buchgesellschaft, 1992), 22–26.

15. On the archaeology of cremation, see M. Heinzelmann, *Die Nekropolen von Ostia: Untersuchungen zu den Gräberstrassen vor der Porta Romana und an der Via Laurentina* (Munich: Verlag Dr. Friedrich Pfeil, 2000), 49–50.

16. Ibid., 51–57; von Hesberg, *Römische Grabbauten*, 121–159.

17. On the pyramid of Cestius, see most recently R. Neudecker, "Die Pyramide des Cestius," in L. Giuliani, ed., *Meisterwerke der antiken Kunst* (Munich: Beck, 2005), 94–113. For its history and inscriptions, see R. T. Ridley, "The Praetor and the Pyramid: The Tomb of Gaius Cestius in History, Archaeology and Literature," *Bollettino di archeologia* 13–15 (1992): 1–29.

18. *CIL* 6, 1375. For a commentary, see Ridley, "The Praetor," 8–10.

19. For a discussion of this phenomenon, see L. H. Petersen, *The Freedman in Roman Art and Art History* (Cambridge: Cambridge University Press, 2006), 58–83.

20. Research on Roman "streets of tombs" was greatly stimulated by the 1985 colloquium Römische Gräberstraßen and the publication of its proceedings, von Hesberg and Zanker, *Römische Gräberstraßen*. For a summary in brief, see von Hesberg, *Römische Grabbauten*, 26–54.

21. For an overview of such middle-class tombs, see M. Koortbojian, "In commemorationem mortuorum: Text and Image along the 'Streets of Tombs,'" in J. Elsner, ed., *Art and Text in Roman Culture* (Cambridge: Cambridge University Press, 1996), 210–233.

22. Heinzelmann, *Die Nekropolen von Ostia*, 56–57.

23. On tomb typology, see ibid., 51–56.

24. N. Purcell, "Tomb and Suburbium," in von Hesberg and Zanker, *Römische Gräberstraßen*, 37–38. See also Heinzelmann, *Die Nekropolen von Ostia*, 46–47.

25. On Rome's mass society and the rise of burial clubs and collective tombs, see K. Hopkins, *Death and Renewal* (Cambridge: Cambridge University Press, 1983), 211–217. The role of burial clubs has been overstated, as pointed out by M. Heinzelmann, "Grabarchitektur Bestattunsbrauch und Sozialstruktur—Zur Rolle der familia," in M. Heinzelmann, J. Ortalli, P. Fasold, and M. Witteyer, eds., *Römischer Bestattungsbrauch und Beigabensitten in Rom, Norditalien und den Nordwestprovinzen von der späten Republik bis in die Kaiserzeit* (Wiesbaden: Dr. Ludwig Reichert, 2001), 184, 188. Yet 16 percent of all surviving *tituli* from Ostia show that the associated tombs were commissioned by unrelated individuals (Heinzelmann, "Grabarchitektur," 184 fn. 23).

26. A. Kolb and F. Fugmann, *Tod in Rom. Grabinschriften als Spiegel römischen Lebens* (Mainz: v. Zabern, 2008), 24–25.

27. On the conventionality of epitaphs, see Carroll, *Spirits of the Dead,* 126–136.

28. For a forceful version of this argument, see J. Clarke, *Art in the Lives of Ordinary Romans and Non-elite Viewers in Italy, 100 B.C.–A.D. 315* (Berkeley: University of California Press, 2003), 182–203.

29. The closest example is probably the tomb of Naevola Tyche in Pompeii: V. Kockel, *Die Grabbauten vor dem Herkulaner Tor in Pompeji* (Mainz: P. v. Zabern, 1983), 105–107.

30. Kockel, *Die Grabbauten,* 36–39; See also Petersen, *The Freedman in Roman Art,* 68–69.

31. On such aristocratic countercurrents against *philosophia,* see M. Trapp, "What Is *Philosophia* Anyway," in J. R. Morgan and M. Jones, eds., *Philosophical Presences in the Ancient Novel* (Groningen: Groningen University Library, 2007), 15–16. On the other hand, M. Trapp, *Philosophy in the Roman Empire: Ethics, Politics and Society* (Aldershot, UK: Ashgate, 2007), 253, argues that Trimalchio is not meant to imitate the aristocracy, as he does throughout his luxurious *cena,* but "is articulating for our scorn, the self-satisfied philistinism of the irredeemably low-minded *parvenu.*" This seems unlikely, as Trimalchio aspires to high-minded intellectual discourse elsewhere.

32. The literature on this monument is immense. For a recent and thorough discussion of the tomb, the scholarship surrounding it, and its social and cultural context, see Petersen, *The Freedman in Roman Art,* 84–120.

33. Ibid., 111–112.

34. *CIL* 6, 1958.

35. Petronius, *Satyrica* 78.

36. Self-ironic humor occasionally appears in Roman epitaphs (Carroll, *Spirits of the Dead,* 148–150, with a reference to Eurysaces. See also *CIL* 6, 8899, for a spicy take on the passerby motif). Tellingly, the *apparet* in Eurysaces's inscription has often been seen as a hint that he did serve as an *apparitor,* as some nonelite Romans would have proudly stated on their tombs. It is true that *apparet* could be translated as "he is an *apparitor.*" But one wonders why Eurysaces did not write *pistoris redemptoris apparitoris,* if he had wanted to make that point. For a discussion of the inscription and *apparet,* see Petersen, *The Freedman in Roman Art,* 253 fn. 13.

37. In modern Italy alone, scenes of baking and milling appear on at least fourteen tombs: G. Zimmer, *Römische Berufsdarstellungen* (Berlin: Mann, 1982), 20–25, 106–120. See now also A. Wilson and K. Schörle, "A Baker's Funerary Relief from Rome," *Papers of the British School at Rome* 77 (2009): 101–123.

38. Zimmer, *Römische Berufsdarstellungen*, 114–116 (cat. no. 25); Petersen, *The Freedman in Roman Art*, 227–230.

39. On the importance of craft and trade on Gallic and north Italian tombs, see Rose, "Vom Ruhm," 146–148; and M. Langner, "Szenen aus Handwerk und Handel auf gallo-römischen Grabmälern," *Jahrbuch des Deutschen Archäologischen Instituts* 116 (2001): 302–308, 348–353.

40. S. Joshel, *Work, Identity, and Legal Status at Rome* (Norman: University of Oklahoma Press, 1992), 76–91.

41. The connection between the tomb and the portrait is not secure but likely. On the issue see V. Kockel, *Porträtreliefs stadtrömischer Grabbauten: ein Beitrag zur Geschichte und zum Verständnis des spätrepublikanisch-frühkaiserzeitlichen Privatporträts* (Mainz: v. Zabern, 1993), 88–91 pl. 7a, 8a.

42. L. Giuliani, *Bildnis und Botschaft: hermeneutische Untersuchungen zur Bildniskunst der römischen Republik* (Frankfurt am Main: Suhrkamp, 1986), 190–199.

43. Ibid., 200–205.

44. P. Zanker, *Roman Art* (Los Angeles: Getty Publications, 2010), 116–117.

45. Kockel, *Porträtreliefs*, 62–67.

46. Ibid., 78.

47. Giuliani, *Bildnis und Botschaft*, 193–197.

48. F. Sinn, *Die Grabdenkmäler, Vatikanische Museen, Museo Gregoriano Profano ex Lateranense, Katalog der Skulpturen* 1 (Mainz: P. v. Zabern, 1996), 29–30 (cat. no. 8).

49. There is an unfortunate tendency to assume that every Roman citizen with a Greek *cognomen* was a freedman. This is clearly wrong (see below, for the example of Q. Lollius Alcamenes). In the case of C. Iulius Helius, there is no strong evidence for his servile origin. His tombstone was cut three generations after the death of Augustus, when C. Iulius was a common name for recently enfranchised foreigners and slaves. Helius may have been either a descendant or a freedman of one of these first-generation C. Iulii.

50. Zimmer, *Römische Berufsdarstellungen*, 137–138 (cat. no. 54).

51. Such portraits were displayed in tombs and in aristocratic houses. They are not to be confused with the ancestral death masks, of which no secure (aristocratic) examples survive.

52. See also Chapter 2 for the prominent position of the smithy in Prusa that caused Dio Chrysostomus so much trouble, and for the slander against the unsuccessful and consequently itinerant businessmen from the Praedia Iuliae Felicis.

53. Kampen, *Image and Status*, 85.

54. Zimmer, *Römische Berufsdarstellungen*, 155–156 (cat. no. 78).

55. Tacitus, *Annales*, 15, 34.

56. *CIL* 6, 41106. On the *titulus*, see G. Alföldy, "Bricht der Schweigsame sein Schweigen? Eine Grabinschrift aus Rom," *Mitteilungen des Deutschen Archäologischen Instituts, Römische Abteilung* 102 (1995): 251–268.

57. von Hesberg, *Römische Grabbauten*, 39–45; Heinzelmann, *Die Nekropolen von Ostia*, 63–72, 76–101. On the interior decor of these tombs, see F. Feraudi-Gruénais, *Ubi Diutius Habitandum Est. Die Innendekoration der kaiserzeitlichen Gräber Roms* (Wiesbaden: Ludwig Reichert, 2001).

58. von Hesberg, *Römische Grabbauten*, 37–39.

59. Ibid., 40–42; Heinzelmann, *Die Nekropolen von Ostia*, 69–70; Carroll, *Spirits of the Dead*, 71–74.

60. Heinzelmann, "Grabarchitektur," 188, even suggested that it was customary to pour wine over the ashes of the deceased. This would explain why Roman urns were not sealed.

61. On the monument, see H. Wrede "Klinenprobleme," *Archäologischer Anzeiger* (1981): 101–108; B. Ewald and P. Zanker, *Mit Mythen leben. Die Bilderwelt der römischen Sarkophage* (Munich: Hirmer, 2004), 158–159; M. Koortboijan, "Mimesis or Phantasia? Two Representational Modes in Roman Commemorative Art," *Classical Antiquity* 24 (2005): 285–305.

62. On this type of monument, see H. Wrede, "Stadtrömische Monumente, Urnen und Sarkophage des Klinentypus in den beiden ersten Jahrhunderten n.Chr," *Archäologischer Anzeiger* (1977): 395–431. On the wine sprinkling, see Heinzelmann, "Grabarchitektur," 188.

63. On this mode of representation and the subsequent shift toward more intimate images, see Ewald and Zanker, *Mit Mythen leben*, 179–185.

64. J. Bergemann, *Demos und Thanatos. Untersuchungen zum Wertsystem der Polis im Spiegel der attischen Grabreliefs des 4. Jahrhunderts v. Chr. und zur Funktion der gleichzeitigen Grabbauten* (Munich: Biering and Brinkmann, 1997), 129–130. On the lack of emotional representations, see 56–67.

65. On the phenomenon, see the monograph of H. Wrede, *Consecratio in Formam Deorum. Vergöttlichte Privatpersonen in der römischen Kaiserzeit* (Mainz: v. Zabern, 1981). See also E. D'Ambra, "The Calculus of Venus: Nude Portraits of Roman Matrons," in Natalie Boymel Kampen, ed., *Sexuality in Ancient Art: Near East, Egypt, Greece, and Italy* (Cambridge: Cambridge University Press, 1996), 219–232; and P. Zanker, "Eine römische Matrone als Omphale," *Mitteilungen des Deutschen Archaeologischen Instituts, Roemische Abteilung* 106 (1999): 119–131; and Ewald and Zanker, *Mit Mythen leben*, 193–201.

66. Wrede, *Consecratio*, 98–100; Ewald and Zanker, *Mit Mythen leben*, 196–197.

67. Statius, *Silvae*, 5, 1, 3.

68. Statius, *Silvae*, 5, 1, 225–238, trans. Loeb.

69. On the tomb, see H. Wrede, "Das Mausoleum der Claudia Semne und die bürgerliche Plastik der Kaiserzeit," *Mitteilungen des Deutschen Archaeologischen Instituts, Römische Abteilung* 78 (1971): 125–166. For a (hypothetical) reconstruction, see A. Claridge, "The Tomb of Claudia Semne and Excavations in Eighteenth-Century Rome," *Papers of the British School at Rome* 66 (1998): 215–244.

70. Claridge, "The Tomb of Claudia Semne," 243.

71. See Wrede, "Das Mausoleum der Claudia Semne," 127–129 pl. 77; on the tympanum. *CIL* 6, 15593.

72. Claridge, "The Tomb of Claudia Semne," 242 fig. 10a.

73. Wrede, "Das Mausoleum der Claudia Semne," 131 pl. 76, 3.

74. Wrede, *Consecratio*, 99.

75. Plautus, *Persa* 99–100.

76. Plautus, *Pseudolus* 323–330. On the connotations of these comparisons, see I. Gradel, *Emperor Worship and Roman Religion* (Oxford: Oxford University Press, 2002), 44–49.

77. For a summary of divine comparisons in epitaphs and other funerary contexts, see Wrede, *Consecratio*, 105–116.

78. Ewald and Zanker, *Mit Mythen leben*, 179–181, with a summary of recent research. Funerary inscriptions from Rome cannot be dated with the same accuracy as reliefs. But it is striking that in the epigraphic material, which mostly comes from *columbaria* and therefore dates from the late first and early second centuries, affectionate epithets like *carissimus/ma* and *dulcissimus/ma* dominate. Interestingly, these were mostly used for close family members. On the provenance and meaning of such epitaphs, see H. S. Nielsen, "Interpreting Epithets in Roman Epitaphs," in B. Rawson and P. Weaver, eds., *The Roman Family in Italy: Status, Sentiment, Space* (Canberra: Humanities Research Centre, 1997), 170, 204.

79. Wrede, "Das Mausoleum der Claudia Semne," 133–136 pl. 80–81.

80. *CIL* 6, 15595.

81. *CIL* 6, 15592.

82. D. E. E. Kleiner, *Roman Funerary Altars with Portraits* (Rome: Bretschneider, 1987), 162–165 (cat. no. 45) pl. 27, 3, and 28, 1–2.

83. On the parents' grief, see Kolb and Fugmann, *Tod in Rom*, 221.

84. On the project, see most recently J. Griesbach, *Villen und Gräber. Siedlungs- und Bestattungsplätze der römischen Kaiserzeit im Suburbium von Rom* (Rahden: VML Verlag Marie Leidorf, 2007), 28–30. See also von Hesberg, *Römische Grabbauten*, 6–8. On Cicero's grief, see now H. Baltussen, "A Grief Observed: Cicero on Remembering Tullia," *Mortality* 14 (2009): 355–369.

85. On the biting grief and the idea of the *fanum* as inspired by unnamed *auctores*, see Cicero, *ad Atticum*, 12, 18, 1. On the apotheosis, see Cicero, *ad Atticum*, 12, 38, 1; 40.

86. On the tomb and the columns procured by the Chian Apelles, see Cicero, *ad Atticum*, 12, 19.

87. On Atticus's concerns about Cicero's grief, see *ad Atticum*, 12, 13, 29, 44. Also his friend Servius Sulpicius, *ad familiares*, 4, 5, told Cicero to man up and get over his *dolor intestinus*.

88. On Cicero's fears about the property changing hands, see *ad Atticum*, 12, 19, 38.

89. On the monuments in honor of Annia Regilla, see M. Galli, *Die Lebenswelt eines Sophisten. Untersuchungen zu den Bauten und Stiftungen des Herodes Atticus* (Mainz: v. Zabern, 2002), 112–119, 121–134; S. B. Pomeroy, *The Murder of Regilla: A Case in Domestic Violence in Antiquity* (Cambridge, MA: Harvard University Press, 2007), 137–174.

90. Pomeroy, *The Murder of Regilla*, 137–138, notes that her final resting place cannot be determined with certainty.

91. For an edition, see U. von Wilamowitz-Moellendorff, "Marcellus von Side," in *Kleine Schriften*, vol. II (Berlin: Weidmannsche Verlagsbuchhandlung, 1942), 200–203. For an English translation, see Pomeroy, *The Murder of Regilla*, 170–174.

92. Line 43, trans. Pomeroy, *The Murder of Regilla*, 172.

93. Lines 19–21, ibid., 171.

94. Ibid., 121–123.

95. Ibid., 124–126.

96. Philostratus, *Lives of the Sophists*, 556.

97. On the inscription, see W. Ameling, *Herodes Atticus*, vol. II (Hildesheim: Georg Olms, 1983), 143–146 (cat. no. 140); on the monument, Galli, *Die Lebenswelt eines Sophisten*, 151–163.

98. On imperial women as goddesses, see A. Alexandridis, *Die Frauen des römischen Kaiserhauses: eine Untersuchung ihrer bildlichen Darstellung von Livia bis Iulia Domna* (Mainz: v. Zabern, 2004), 82–92, with a detailed discussion of previous literature.

99. Wrede, *Consecratio*, 160–164. As Alexandridis, *Die Frauen*, 83, points out, it is far from clear that nonelites copied the imperial cult. Indeed, it is entirely possible that the custom to honor the imperial family in the guise of gods went hand in hand with comparing one's deceased loved ones to deities and heroes. For the divine qualities of Roman emperors on nonelite public monuments, see E. Mayer, "Propaganda, Staged Applause or Local Politics? Public Monuments from Augustus to Septimius Severus," in B. Ewald and C. Norena, eds., *The Emperor and Rome* (Cambridge: Cambridge University Press, 2010), 111–134.

100. For a publication of the available archaeological evidence, see F. Sinn and K. S. Freyberger, *Die Ausstattung des Hateriergrabes,* Vatikanische Museen,

Museo Gregoriano Profano ex Lateranense, Katalog der Skulpturen, 2 (Mainz: v. Zabern, 1996).

101. Ibid., 11, 16, 118–119 (cat. no. 43) pl. 64, 1.

102. Ibid., 13–17.

103. Ibid., 40–42 (cat. no. 3) pl. 4, 6.

104. Ibid., 51–59 (cat. no. 9) pl. 11–16.

105. Ibid., 55–56 pl. 13, 2. See also Ewald and Zanker, *Mit Mythen leben,* 194.

106. Sinn and Freyberger, *Die Ausstattung des Hateriergrabes,* 43–45 (cat. no. 4) pl. 5, 7.

107. E. Leach, "Freedmen and Immortality in the Tomb of the Haterii," in D'Ambra and Métraux, *The Art of Citizens,* 7–8.

108. Sinn and Freyberger, *Die Ausstattung des Hateriergrabes,* 76–80 (cat. no. 9) pl. 25–27.

109. Interestingly, this Hateria is also shown Venuslike with her clinging undergarment slipping from her shoulder, even though she is sacrificing *capite velato.* It mattered that she was both pious and divinely beautiful.

110. Ibid., 81–83 (cat. no. 11) pl. 31.

111. *CIL* 6, 19148.

112. For a connection between Proserpina/Persephone and the cruel fates, see *AE* 1913, 0088, and *AE* 1987, 0178. The goddess frequently appears in other epitaphs. On a Hadrianic grave altar to a woman called Pedana, her surviving lover (or husband), Donatus, blames an ungrateful Venus, to whom he had made offerings, and "pale Persephone" for snatching away his loved one. On the monument, see G. B. Waywell, "A Roman Grave Altar Rediscovered," *American Journal of Archaeology* 86 (1982): 238–242.

113. Sinn and Freyberger, *Die Ausstattung des Hateriergrabes,* 54–55, pl. 14, 1.

114. Ibid., 59–63 (cat. no. 7) pl. 17–19.

115. On Greek myth, erudition, and *imitatio dominis,* see most recently P. Stewart, *The Social History of Roman Art* (Cambridge: Cambridge University Press, 2008), 74, in summary of the *communis opinio.* This argument goes back to Müller, *The So-Called Peleus and Thetis Sarcophagus,* 162. Müller linked the appearance of Greek myth in Roman funerary art, in particular on sarcophagi, to highly rhetorical and erudite speeches at the funerals of Greek and later Roman aristocrats (144–147). Only later, he supposes, did this form of showing off status and erudition trickle down the social scale. Müller's argument was very influential and is discussed in detail below in n. 151.

116. Sinn and Freyberger, *Die Ausstattung des Hateriergrabes,* 108–109 (cat. no. 31) pl. 56.

117. This also applied to infants and toddlers, despite high rates of child mortality. A characteristic example is *IG* 14, 2541: "My name was Julianus. Only was

I granted to live seven months. Much did my parents cry over me." For other particularly emotive epitaphs for toddlers and infants, see *CIL* 6, 34114b; *CIL* 8, 16572; *CIL* 14, 2482. These examples are not extreme outliers among funerary inscriptions. And it is worth pointing out that sarcophagus workshops provided bereaved parents with specifically designed sarcophagi for children. On this type of sarcophagus, see J. Huskinson, *Roman Children's Sarcophagi: Their Decoration and Its Social Significance* (Oxford: Clarendon Press, 1996). The statistical analysis of Roman epitaphs by Nielsen, "Interpreting Epithets," shows that emotional epithets like *dulicissmus/ma* and *carissimus/ma* were widely used to characterize a lost loved one.

118. Sinn and Freyberger, *Die Ausstattung des Hateriergrabes*, 41–51 (cat. no. 5) pl. 8–9, with an in-depth discussion of previous scholarship.

119. Ibid., 59–63 (cat. no. 7) pl. 17–19, 1.

120. Galli, *Die Lebenswelt eines Sophisten*, 112, on the connotations that came with the name.

121. Ibid., 123, on the inscription, 125–127, on the caryatids.

122. Zimmer, *Römische Berufsdarstellungen*, 159–160, cat. no. 82. The contractor in question proudly self-identified as the *redemptor prosceni*.

123. See Pomeroy, *The Murder of Regilla*, 163–168, in particular on the Greek of the inscriptions from the Triopion.

124. On this group of sarcophagi, see S. Rogge, *Die attischen Sarkophage. Achill und Hippolytos*, Die antiken Sarkophagreliefs IX 1,1 (Berlin: Mann, 1995), 20–25.

125. On the thematic spectrum of Attic sarcophagi, see G. Koch and H. Sichtermann, *Römische Sarkophage*, Handbuch der Archäologie (Munich: Beck, 1982), 376–378.

126. On the demonstratively conservative canon of female virtues in Roman senatorial inscriptions in the first four centuries C.E., see H. Niquet, *Monumenta virtutum titulique. Senatorische Selbstdarstellung im spätantiken Rom im Spiegel der epigraphischen Denkmäler* (Stuttgart: Steiner, 2000), 190–196.

127. Pomeroy, *The Murder of Regilla*, 171 (lines 30 and 33), 172 (line 36).

128. For a collection of senatorial inscriptions and sarcophagi, see F. Feraudi-Gruénais, "Für die Ewigkeit? Die Gestaltung von senatorischen Grablegen Roms und ihr Kontext," in W. Eck and M. Heil, eds., *Senatores populi Romani. Realität und mediale Präsentation einer Führungsschicht* (Stuttgart: Steiner, 2005), 137–168.

129. Every single inscribed sarcophagus decorated with status symbols like the public horse or scenes from political life like a *processus* belonged either to a senator or a knight (senators: C. Reinsberg, *Die Sarkophage mit Darstellungen aus dem Menschenleben. Vita Romana*. Die antiken Sarkophagreliefs, I, 3 (Berlin:

Mann/Deutsches Archäologisches Institut, 2006), cat. nos. 46 (*CIL* 11, 1595), 121 (*CIL* 6, 31953); knights: Reinsberg, *Vita Romana*, cat. nos. 9; 47 (*CIL* 14, 3919); 72; 83 (*CIL* 6, 37103); 141). This makes it very unlikely that non-elite Romans did cast themselves as member of the aristocracy on their tombs.

130. On these sarcophagi, see H. Wrede, *Senatorische Sarkophage Roms: der Beitrag des Senatorenstandes zur römischen Kunst der hohen und späten Kaiserzeit* (Mainz: P. v. Zabern, 2001), 31–50. See also S. Muth, "Drei statt vier. Zur Deutung der Feldherrnsarkophage," *Archäologischer Anzeiger* (2004): 263–273. The most famous of these sarcophagi comes from the Ludovisi collection and clearly belonged to a man of high status because also two of his portraits in the round survive. On his identity, see E. Künzl, *Der Traum vom Imperium. Der Ludovisisarkophag—Grabmal eines Feldherrn Roms* (Mainz and Regensburg: Verlag des Römisch-Germanischen Zentralmuseums and Schnell and Steiner, 2010), 67–72.

131. Wrede, *Senatorische Sarkophage Roms*, 25 pl. 6.

132. On the difficulties on identifying a *processus consularis*, see ibid., 71, with references.

133. Flaig, *Ritualisierte Politik*, 53–54.

134. For an in-depth discussion of these paintings, see still E. La Rocca, "Fabio o Fannio. L'affresco medio-repubblicano dell'Esquilino come riflesso dell'arte rappresentativa e come espressione di mobilità sociale," *Dialoghi di archeologia* 2 (1984): 31–53.

135. *CIL* 6, 31587.

136. On the tomb and its special place in Republican Rome, see F. Coarelli, *Il sepolcro degli Scipioni a Roma* (Roma: Palombi, 1988).

137. On this curious editing, see H. Flower, *The Art of Forgetting: Disgrace and Oblivion in Roman Political Culture* (Chapel Hill: University of North Carolina Press, 2006), 56 and 57, on the "upgrading" of the epitaph of Publius Scipio in the same tomb.

138. Flaig, *Ritualisierte Politik*, 55–68.

139. On the monument, see Ewald and Zanker, *Mit Mythen leben*, 50–51, fig. 35. Interestingly and importantly, Venus is absent from the Adonis scene. Also, the hero is not identified with the deceased by means of a portrait. Middle-class sarcophagi depicting the same theme typically stressed the love and tenderness between Venus and Adonis and the horror of the goddess over her lover's death. On the Ranuccini sarcophagus, Adonis's demise is nothing but a heroic death. On Adonis and other such sarcophagi, see below.

140. Cassius Dio 56, 36, 4. On these two (possibly equestrian) inscriptions within the larger context of *laudationes*, see N. Horsfall, "Some Problems in the 'Laudatio Turiae,'" *Bulletin of the Institute of Classical Studies* 30 (1983): 89–91. As

Horsfall points out, neither speech was probably a *laudatio pro rostris,* which points to a more intimate circle of mourners. This makes the lack of rhetorical flourish and mythological *exempla* all the more interesting.

141. Ovid, *Tristia* 2, 295–296.

142. On this methodological issue, see Wrede, *Senatorische Sarkophage.* See also B. Ewald, "Sarcophagi and Senators: The Social History of Roman Funerary Art and Its Limits," *Journal of Roman Archaeology* 16 (2003): 563–565.

143. The children's sarcophagus belonged to Maconiana Severiana, daughter of the *vir clarissimus* Sempronius Proculus. It was decorated with a scene depicting the discovery of Ariadne by Bacchus. As Maconiana died very young, the bereaved parents felt free to express their affection for the deceased and referred to her as *filia dulcissima;* F. Matz, *Die dionysischen Sarkophage,* Die Antiken Sarkophagreliefs IV, 3 (Berlin: Mann, 1969), 383–384, pl. 223, 2. Two of the three other bacchic sarcophagi were decorated with mythological creatures and cannot be linked to a mythological narrative like the discovery of Ariadne. The first belonged to the *consul suffectus* of 87 C.E., C. Bellicus Natalis Trebonianus (*CIL* II, 1430). It dates around 120 C.E. and was decorated with cupids holding garlands. Two vignettes above those garlands represented a lasciviously reclining Hermaphroditus with Pan stepping up to him and a satyr erecting a trophy; F. Matz, *Die dionysischen Sarkophage,* Die Antiken Sarkophagreliefs IV, 1 (Berlin: Mann, 1968), 124, pl. 1. The second sarcophagus belonged to the tribune of the people L. Iulius Larcius Sabinus (*CIL* II, 1431). It was decorated with two victories holding a *clipeus.* This shield was flanked by two centaurs drawing Bacchus's chariot; F. Matz, *Die dionysischen Sarkophage,* Die Antiken Sarkophagreliefs IV, 4 (Berlin: Mann, 1975), 455–456, pl. 282. The third Bacchic sarcophagus was decorated with the triumph of Bacchus and honored the son of a *praetor;* M. B. Comstock and C. C. Vermeule, *Sculpture in Stone: The Greek, Roman and Etruscan Collections of the Museum of Fine Arts, Boston* (Boston: Museum of Fine Arts, 1976), 153. Three more "Dionysiac" sarcophagi attributed to senators clearly did not belong to members of the order. Neither L. Damasius Germanus (Müller, *The So-Called Peleus and Thetis Sarcophagus,* 160) nor Metilia Torquata (Wrede, *Senatorische Sarkophage Roms,* 15 fn. 14. See also S. Fortunelli, "*Mundus muliebris* e ceto senatorio: alcune considerazioni su un sarcofago femminile con il mito di Achille a Sciro," in *Le perle e il filo: a Mario Torelli per i suoi settanta anni* [Venosa: Osanna, 2008], 117–134) can be identified as members of senatorial families. The third sarcophagus attributed to a senator (Wrede, *Senatorische Sarkophage Roms,* 15 fn. 15) was commissioned by the freedman Claudius Abascantus for one of his *alumni.* On the piece, see P. Herz, "Claudius Abascantus. Die Nomenklatur eines *libertus* und sein sozialer Aufstieg," *Zeitschrift für Papyrologie und Epigraphik* 76 (1989): 168. Of the Meleager sarcophagus of Titus Sulpicius Seranus only the lid

survives (G. Koch, *Meleager,* Die antiken Sarkophagreliefs, XII, Die mythologischen Sarkophage, 6 (Berlin: Deutsches Archäologisches Institut/Mann, 1982) cat. no. 103; *CIL* 6, 31769).

144. Of roughly 500 sarcophagus inscriptions from the city of Rome seventeen can be attributed to senators and twenty-two more to knights. As senatorial sarcophagi can also be identified by rank-specific attributes, they are very well represented among sculpted metropolitian Roman sarcophagi. On the numbers and their statistical relevance, see J. Dresken-Weiland, *Sarkophagbestattungen des 4.-6. Jahrhunderts im Westen des römischen Reiches.* Römische Quartalschrift für christliche Altertumskunde und Krichengeschichte Supplementband 53 (Rome and Freiburg and Vienna: Herder, 2003), 41–43.

145. R. Bielfeldt, "Orest im Medusengrab. Ein Versuch zum Betrachter," *Mitteilungen des Deutschen Archaeologischen Instituts, Roemische Abteilung* 110 (2003): 117–150; and Bielfeldt, *Orestes auf römischen Sarkophagen* (Berlin: Reimer, 2005), 306–328.

146. *CIL* 15, 1051.10, 2031.4. Bielfeldt, "Orest," 142.

147. On the tomb and its position and reconstruction, see Bielfeldt, "Orest," 137–140, fig. 8.

148. On the sarcophagi, see Bielfeldt, *Orestes auf römischen Sarkophagen,* 321–328.

149. Ibid., 318–319, fig. 91.

150. Ibid., 319–321, pl. 2.

151. On this issue, see most recently Stewart, *Social History,* 74–76, who summarizes this concept as the *communis opinio.* The argument, in its current form, goes back to Müller, *The So-Called Peleus and Thetis Sarcophagus,* 144–147. Müller believes that the appearance of mythological sarcophagi is connected with the mythological comparisons that Greek intellectuals made in funerary speeches for the rich and educated in Asia Minor and elsewhere in the East. This custom was, supposedly, taken up in the Latin-speaking West. Müller even suggested that the images on mythological sarcophagi were picked by Greek philosophical advisors, like the ones that some Roman aristocrats kept in their company (156). After all, comprehension of the mythological scenes on the sarcophagi called for the expertise of the *grammaticus,* at any rate (160 fn. 94). This argument was taken up and elaborated on by J. Elsner, *Imperial Rome and Christian Triumph: The Art of the Roman Empire AD 100–450* (Oxford: Oxford University Press, 1998), 145–154, and reiterated by Ewald and Zanker, *Mit Mythen leben,* 110–115. There are several problems with it. First, it makes sense to compare funerary speeches to sarcophagi. But it is deeply problematic to assume that a eulogy for a Greek aristocrat in Asia Minor was anything like a *laudatio funebris* for a Roman senator or knight (see above). Whereas Greek funerary speeches stressed the mythological lineage

of the deceased and compared him to the heroes from the great Greek past, Roman aristocratic funerary speeches stressed the actual deeds of the deceased and those of his great historical ancestors. This crucial difference seems to be reflected on the sarcophagi for the nobility in East and West. Attic sarcophagi represent great literary depictions of death and scenes of the glorious past, whereas Roman senatorial sarcophagi represent (highly formalized) achievements and political virtues. Also, the rather abstracting mythological comparisons in Greek funerary speeches were under the control of the speaker, who could make clear what exactly was being compared. This was not the case on metropolitan Roman sarcophagi.

152. All numbers quoted in the following are taken from P. Zanker, "Ikonographie und Mentalität. Zur Veränderung mythologischer Bildthemen auf den kaiserzeitlichen Sarkophagen aus der Stadt Rom," in R. Neudecker and P. Zanker, eds., *Lebenswelten. Bilder und Räume in der römischen Stadt der Kaiserzeit. Symposium am 24. und 25. Januar 2002 zum Abschluss des von der Gerda Henkel Stiftung geförderten Forschungsprogramms "Stadtkultur in der Kaiserzeit"* (Wiesbaden: Reichert, 2005): 243–251.

153. Bielfeldt, "Orest," 142.

154. Poets and mythographers in the second century C.E. were obsessed with genealogy. On this see phenomenon, see A. Cameron, *Greek Mythography in the Roman World* (Oxford: Oxford University Press, 2004), 279–280.

155. For this "abstracting" mode of interpretation, see Ewald and Zanker, *Mit Mythen leben*, 52–55.

156. On this episode and its interpretation in ancient literature, see S. Bartsch, *Actors in the Audience: Theatricality and Doublespeak from Nero to Hadrian* (Cambridge, MA: Harvard University Press, 1994), 38–42; and E. Champlin, *Nero* (Cambridge, MA: Belknap, 2003), 97–101.

157. On this see S. Bartsch, *Decoding the Ancient Novel: The Reader and the Role of Description in Heliodorus and Achilles Tatius* (Princeton, NJ: Princeton University Press, 1989), in particular 36–41.

158. For an overview, see now Zanker, "Ikonographie und Mentalität."

159. On such portraits, see most recently Z. Newby, "In the Guise of Gods and Heroes: Portrait Heads on Roman Mythological Sarcophagi," in J. Elsner and J. Huskinson, eds., *Life, Death and Representation: Some New Work on Roman Sarcophagi* (New York: de Gruyter, 2010), 189–227.

160. On this sarcophagus, see Ewald and Zanker, *Mit Mythen leben*, 285–288.

161. Zanker, "Ikonographie und Mentalität," 246.

162. Ewald and Zanker, *Mit Mythen leben*, 42–61.

163. Zanker, "Ikonographie und Mentalität," 244–245. See also Bielfeldt, *Orestes auf römischen Sarkophagen*, 321–328, on how such scenes can be understood within the context of the mourners visiting the tomb.

164. All numbers after Zanker, "Ikonographie und Mentalität," 245, fig. 1.

165. See Ewald and Zanker, *Mit Mythen leben*, 77–109, for sarcophagi on cruel death and the role of onlookers.

166. On the emotional drama on such sarcophagi, see M. Koortbojian, *Myth, Meaning and Memory on Roman Sarcophagi* (Berkeley: University of California Press, 1995), 39–40.

167. Ewald and Zanker, *Mit Mythen leben*, 102–108; Koortbojian, *Myth, Meaning and Memory*, 63–113.

168. Ewald and Zanker, *Mit Mythen leben*, 103.

169. On the mythographic knowledge of nonelite vis-à-vis highly educated Romans, see Cameron, *Greek Mythography*, 228–233; on handbooks, 237–249.

170. *CIL* 6, 37965. On the epitaph, see N. Horsfall, "CIL VI 37965 = CLE 1988 (Epitaph of Allia Potestas). A Commentary," *Zeitschrift für Papyrologie und Epigraphik* 61 (1985): 251–272. See also Zanker, "Eine römische Matrone als Omphale," 126–127, on the poem's importance for understanding nudity in funerary art.

171. Horsfall, "CIL VI 37965," 253–254.

172. *CIL* 6, 37965, lines 10–15 deal with her domestic virtues on chastity(!). The quote is taken from lines 17–22 (trans. Horsfall).

173. Horsfall, "CIL VI 37965," 263.

174. R. Webb, *Demons and Dancers: Performance in Late Antiquity* (Cambridge, MA: Harvard University Press, 2008), 50–51.

175. *CIL* 6, 37965, lines 22–23, 28–34 (trans. Horsfall, "CIL VI 37965," 256). On the ménage à trois, see ibid., 265–267.

176. Ibid., 268.

177. Ovid, *Tristia* 1, 3, 25; Horsfall, "CIL VI 37965," 268.

178. *CIL* 6, 37965, line 35.

179. *CIL* 6, 37965, lines 40–41.

180. *CIL* 6, 37965, lines 44–45.

181. On the sarcophagus and its context, see E. D'Ambra, "A Myth for a Smith: A Meleager Sarcophagus from a Tomb in Ostia," *American Journal of Archaeology* 92 (1988): 85–99.

182. On the necropolis, see I. Baldassare, "La necropolis dell'Isola Sacra (Porto)," in von Hesberg and Zanker, *Römische Gräberstrassen*, 125–138; and Petersen, *The Freedman in Roman Art*, 185–203.

183. On the building, see D'Ambra, "A Myth for a Smith," 87–89.

184. Zimmer, *Römische Berufsdarstellungen*, 183–185 (cat. nos. 117–119).

185. D'Ambra, "A Myth for a Smith," 92.

186. Ibid., 93–95. For an analysis of the scene and further comparisons, see Koch, *Meleager*, 48–50.

187. Koch, *Meleager*, 7–18.

188. D'Ambra, "A Myth for a Smith," 90. See also Koch, *Meleager,* 97 (cat. no. 35).

189. D'Ambra, "A Myth for a Smith," 96, argues that Verrius Euhelpistus picked this particular type of Meleager sarcophagus because it "provided a story in which the hero's weapon was a spear with a sharp point, and other sharp spears and tools were prominently displayed in the reliefs of the sarcophagus and its lid. By illustrating the utility of razor-sharp blades and points, this representation of the myth of Meleager is appropriate to commemorate Verrius" as "the tomb reliefs indicate the smith's pride in making a variety of precision instruments requiring finely ground cutting edges." In her opinion "sharp objects" are the "common denominator" between the reliefs on the exterior of the tomb and the sarcophagus on the inside. As argued above, such—highly idiosyncratic— responses to standardized iconography are indeed likely, but in this case beyond proof.

190. Lucian, *Saltatio,* 50.

191. Koch, *Meleager,* cat. nos. 67, 131, 147, 178.

192. Ibid., 95–96 (cat. no. 30) pl. 44–51; cat. no. 103.

193. *CIL* 3, 14496.

194. See already Ewald and Zanker, *Mit Mythen leben,* 250. On a fluted sarcophagus in Wilton House (Koch, *Meleager,* cat. no. 147), Atalante and Meleager appear in the central relief panel as a loving couple. Atalante is tenderly holding on to Meleager, who is offering a sacrifice with the dead boar lying at his feet. The heads of the two heroes are left in the rough. They were intended to be carved as portraits of the deceased.

195. Ewald and Zanker, *Mit Mythen leben,* 298–301.

196. Newby, "In the Guise of Gods," 224.

197. All numbers after Zanker, "Ikonographie und Mentalität," 245 fig. 1.

198. On this group vis-à-vis Hippolytos's sarcophagi made in Athens, see B. Ewald, "Myth and Narrative in the Second Sophistic—a Comparative Approach: Notes on an Attic Hippolytus Sarcophagus in Agrigento," in Elsner and Huskinson, *Life, Death and Representation,* 275–280.

199. Ibid., 275, 279.

200. Ewald and Zanker, *Mit Mythen leben,* 370–372.

201. A similar shift toward a less dramatic and more dignified representation is found on the well-known Adonis sarcophagus in the Museo Gregorio Profano, which was made for a couple. See ibid., 211–212.

202. Ibid., 285–288. See also D. Grassinger, *Achill, Adonis, Aeneas, Aktaion, Alkestis, Amazonen,* Die antiken Sarkophagreliefs, XII, Die mythologischen Sarkophage, 1 (Berlin: Deutsches Archäologisches Institut/Mann, 1999), 250–251 (cat. no. 127) pl. 118–119.

203. Grassinger, *Achill, Adonis,* cat. nos. 119, 125, 127, 131, 140.

204. B. Ewald, "Rollenbilder und Geschlechterverhältnis in der römischen Grabkunst. Archäologische Anmerkungen zur Geschichte der Sexualität," in N. Sojc, ed., *Neue Fragen, neue Antworten. Antike Kunst als Thema der Gender Studies* (Berlin: Lit, 2005), 59–72.

205. On the sarcophagus see Ewald and Zanker, *Mit Mythen leben,* 378–381.

206. On these two types, see now K. Lorenz, *Bilder machen Räume. Mythenbilder in pompeianischen Häusern* (Berlin: Walter de Gruyter, 2008), 83–124.

207. Galli, *Die Lebenswelt eines Sophisten,* 158–160.

208. On the composition of mythological scenes on sarcophagi, see Koch and Sichtermann, *Römische Sarkophage,* 250–252.

209. Ewald and Zanker, *Mit Mythen leben,* 248–249.

210. M. Beard, *The Fires of Vesuvius: Pompei Lost and Found* (Cambridge, MA: Harvard University Press, 2008), 146.

5. Decor and Lifestyle

1. The fundamental study on this issue remains A. Wallace-Hadrill, *Houses and Society in Pompeii and Herculaneum* (Princeton, NJ: Princeton University Press, 1994). See also R. A. Tybout, "Roman Wall Painting and Social Significance," *Journal of Roman Archaeology* 14 (2001): 42–43. For a more recent discussion of the ancient literature on Roman houses, see E. Leach, *The Social Life of Painting in Ancient Rome and on the Bay of Naples* (Cambridge: Cambridge University Press, 2004), 1–54. For a critical appraisal of this approach, see P. Allison, "Using the Material and Written Sources: Turn of the Millenium Approaches to Roman Domestic Space," *American Journal of Archaeology* 105 (2001): 181–204.

2. Wallace-Hadrill, *Houses and Society,* 51–61. For a discussion of Wallace-Hadrill's approach, see J.-A. Dickmann, *Domus Frequentata. Anspruchsvolles Wohnen im pompejanischen Stadthaus,* Studien zur antiken Stadt 4,1 (Munich: Bayerische Akademie der Wissenschaften, 1999), 43–48. On "the political house," see now also S. Hales, *The Roman House and Social Indentity* (Cambridge: Cambridge University Press, 2003), 40–46.

3. Wallace-Hadrill, *Houses and Society,* 165–174; A. Wallace-Hadrill, *Rome's Cultural Revolution* (Cambridge: Cambridge University Press, 2008), 165–174; P. Zanker, "Die Villa als Vorbild des späten pompejanischen Wohngeschmacks," *Jahrbuch des Deutschen Archäologischen Instituts* 94 (1979): 460–523; P. Zanker, *Pompeii: Public and Private Life* (Cambridge, MA: Harvard University Press, 1998), 135–203.

4. The main reception room of the Casa del Sacerdote Amando (room b) and one of the *cubicula* in the villa at Boscotrecase (room 19) are decorated with

the same motifs: the rescue of Andromeda by Perseus (P. v. Blanckenhagen, *The Augustan Villa at Boscotrecase* [Mainz: v. Zabern, 1990], 33–35, pl. 43 [Boscotrecase] and 57 [Casa del Sacerdote Amando]) and the nymph Galatea riding on a *ketos* to the island of Polyphemus (ibid., 28–43, pl. 42 [Boscotrecase] and 58 [Casa del Sacerdote Amando]). Despite some alterations, the paintings in Boscotrecase and Pompeii clearly depend on the same prototype, as ibid., 38, demonstrated. The combination of the two motifs is also attested in three other Pompeian houses (VII 15, 2; IX 2, 18; V 1, 18; ibid., 37). This is interesting because these houses belonged to owners of widely diverging means. The Casa del Sacerdote Amando is clearly not an elite house (see Wallace-Hadrill, *Houses and Society*, 169). Conversely, the villa at Boscotrecase must have belonged to a man of means. M. Rostovtzeff, *The Social and Economic History of the Roman Empire* (Oxford: Clarendon, 1926), 496–497, fn. 31, believed that the villa belonged to the Julio-Claudians and more specifically to Julia and later her son Agrippa Postumus. This identification is beyond proof. Instead, Leach, *Social Life of Painting*, 150, argues that the villa belonged to the imperial freedman Ti. Claudius Eutychius. His name appears on two bronze stamps, which were found in the servants' quarters, supposedly still lying in a cupboard; M. Della Corte, "VIII. Pompei. Scavi eseguiti da privati nel territorio di Pompei (secondo rapporto)," *Notizie degli scavi di antichità* ser. 5, 26 (1922): 460. Leach's suggestion is possible but by no means secure. Only stamped water pipes *(fistulae)* or, in rare cases, inscriptions within a house can establish the identity of its owner. On the interpretation of the images of Polyphemus and Galatea in combination with those of Perseus and Andromeda, see most recently M. Squire, *Image and Text in Graeco-Roman Antiquity* (Cambridge: Cambridge University Press, 2009), 337–338, and below.

5. Wallace-Hadrill, *Houses and Society*, 173–174, argues that formerly aristocratic modes of decoration were subject to "banalization" when they trickled down the social scale. This banalization does not, however, mean that the paintings in themselves were banal but that they were banal in their new social setting. In an aristocratic *domus*, decor could be employed meaningfully to express the status of the *dominus*, which was, in Wallace-Hadrill's model, not the case lower down the social scale.

6. This applies, in particular, to the so-called first and second styles of Campanian wall painting. On this model of interpretation, see Wallace-Hadrill, *Houses and Society*, 23–37; and more recently Leach, *Social Life of Painting*, 85–92; and A. Grüner, *Venus Ordinis. Der Wandel von Malerei und Literatur im Zeitalter der römischen Bürgerkriege* (Paderborn: Schönigh, 2004), 143–163.

7. See P. Stewart, *The Social History of Roman Art* (Cambridge: Cambridge University Press, 2008), 41–53, on how the "works of art" in a Roman house

"inform the social 'personae' of their owners." Based on a discussion of modern scholarship, Stewart goes on to claim that "suitable artistic ornaments do not only *reflect* the cultivation and sophistication of their owner; they also *make* the man" (43). On such self-fashioning lower down the social scale and the methodological problems of identifying a "freedman taste" as opposed to the taste of the educated, see H. Petersen, *The Freedman in Roman Art and Art History* (Cambridge: Cambridge University Press, 2006), 123–183. An extreme case of this approach is E. Swift, *Style and Function in Roman Decoration* (Burlington, VA: Ashgate, 2009), 101–103, who claims with Gell that all art has a "specific social function." In this sense a complex geometrical floor pattern is designed to "induce a feeling of incomprehension and even powerlessness of the viewer . . . [that] is in stark contrast to the power of the owner, which power relation is reproduced and constituted in social exchange which takes place in the viewing of the floor" (101–102).

8. On this aspirational model, see Stewart, *Social History,* 53–62, with a careful discussion of current literature. See also Swift, *Style and Function*: "Figurative motifs offer the possibility of inclusion: if you can interpret the scene, you can belong, becoming a member of an exclusive, elite culture" (102).

9. On the issue of prototypes and copies see now C. Hallet, "Emulation versus Replication: Redefining Roman Copying," *Journal of Roman Archaeology* 18 (2005): 419–435. On surviving plaster casts for the copying of statues, see C. Landwehr, *Die antiken Gipsabgüsse aus Baiae* (Berlin: Mann, 1985). On pattern books and workshop organization, see A. Schmidt-Colinet, " 'Musterbücher' statt 'Meisterforschung.' Zum Verständnis antiker Werkstattstrukturen und Produktionsprozesse," *Journal of Roman Archaeology* 22 (2009): 787–792. On the concept of the pattern book in art history, see J. Elsner, "P. Artemid.: The Images," in K. Brodersen and J. Elsner, eds., *Images and Texts on the "Artemidorus Papyrus." Working papers on P. Artemid. (St. John's College Oxford, 2008)* (Stuttgart: Steiner, 2009), 43–46. On detectable pattern books for textiles and mosaics, see A. Stauffer, *Antike Musterblätter. Wirkkartons aus dem spätantiken und frühbyzantinischen Ägypten* (Wiesbaden: Reichert, 2008); and P. Bruneau, "Les mosaïstes antiques avaient-ils des cahiers de modèles?" *Revue archéologique* (1984): 241–271. On the newly discovered Artemidorus Papyrus as a possible pattern book, see S. Settis, "Il contributo del papiro alla storia dell'arte antica," in C. Gallazi, B. Kramer, and S. Settis, eds., *Il Papiro di Artemidoro* (Milan: LED, 2008), 612–614; and M. Donderer, "Antike Musterbücher und (k)ein Ende. Ein neuer Papyrus und die Aussage der Mosaiken," *Musiva* 2–3 (2005–2006): 81–113. The overwhelming evidence for pattern books in other media and the high standardization of motifs in Campanian wall painting make it seem very likely that decorators in Pompeii and elsewhere also relied on them. See now R. Clarke, "Model-Book,

Outline Book, Figure Book: New Observations on the Creation of Near-Exact Copies in Romano-Campanian Painting," in I. Bragantini, ed., *Atti del X Congresso internazionale dell'AIPMA (Association internationale pour la peinture murale antique). Napoli, 17–21 settembre 2007* (Naples: Università degli Studi di Napoli "L'Orientale," 2010), 203–214.

10. The classic study of this phenomenon in statuary is still P. Zanker, *Klassizistische Statuen: Studien zur Veränderung des Kunstgeschmacks in der römischen Kaiserzeit* (Mainz: v. Zabern, 1974). On painting, see Clarke, "Model-Book."

11. A common trend in scholarship has been to reinterpret Roman "copies" as "emulations" of Greek art. The most recent publications following this trend are E. Gazda, ed., *The Ancient Art of Emulation: Studies in Artistic Originality and Tradition from the Present to Classical Antiquity* (Ann Arbor: University of Michigan Press, 2002); and E. Perry, *The Aesthetics of Emulation in the Visual Arts of Ancient Rome* (Cambridge: Cambridge University Press, 2005).

12. Hallet, "Emulation versus Replication," 431–433.

13. G. Rodenwalt, "Eine spätantike Kunstströmung in Rom," *Mitteilungen des deutschen archäologischen Instituts, Römische Abteilung* 36–37 (1921–1922): 58–110.

14. R. Bianchi Bandinelli, *Rome, the Center of Power: 500 B.C. to A.D. 200* (New York: George Braziller, 1970), 51–71.

15. Wallace-Hadrill, *Houses and Society,* 37, argues that the styles of wall painting in Campania were, in the late Republic, "patently generated by and for the Roman aristocracy, and express eloquently their public self-image." This, Wallace-Hadrill argues, remained so under the Empire, even though the styles of this period trickled down the social scale with the rising prosperity of the empire at large. J. Elsner, *Roman Eyes: Visuality and Subjectivity in Art and Text* (Princeton, NJ: Princeton University Press, 2007), 153, circumvents the issue of Wallace-Hadrill's "trickle-down effect" by claiming that all Pompeian wall painting was commissioned by "the wealthy elite—though not . . . of the most elevated aristocracy." Drawing on and summarizing much recent work on art viewing in antiquity, Squire, *Image and Text,* 242, argues that viewing was socially divisive: educated elites were able to "gaze" intelligently, while commoners were not. This idea is developed on the basis of Lucian's *Hall* and is used to illustrate the concept of "iconotexts," which implies that images only developed their full potential when viewed by the erudite, who knew their Theocritus and their Homer (300–356). This excludes a very large part of Pompeian landlords, who had their homes decorated with mythological wall painting. In sum, middle-class domestic decor is mostly viewed and studied as a surrogate for the visual culture of hypereducated elites, which is now mostly lost.

16. Wallace-Hadrill, *Rome's Cultural Revolution,* 313–355.

17. On houses see Wallace-Hadrill, *Houses and Society,* 151–155. On *tabernae* and apartments, see F. Pirson, *Mietwohnungen in Pompeji und Herkulaneum: Untersuchungen zur Architektur, zum Wohnen und zur Sozial- und Wirtschaftsgeschichte der Vesuvstädte* (Munich: Pfeil, 1999), 91–95 and 121–122. For a statistical analysis of Pompeian wall painting, see now J. Hodske, *Mythologische Bildthemen in den Häusern Pompejis. Die Bedeutung der zentralen Mythenbilder für die Bewohner Pompejis* (Ruhpolding: Rutzen, 2007), 59–68 fig. 10–11.

18. Most recently, Hales, *Roman House,* 11–39, constructs an "ideal home" on the basis of Roman aristocratic literature. To her "the Roman *domus* becomes the medium through which the Roman family communicated with the wider community and expressed and justified their space in society" (18). This is done through aristocratic rituals like the morning *salutatio* (18–19). Hales contrasts this "ideal home" with the "reality" of Pompeii (98–101). But this "reality" only changes the picture insomuch as "real" houses must accommodate the "practical needs of housing the family" in addition to its "idealistic role . . . as signifier of the family's public presence and Roman identity" (101). This a priori reasoning makes it seem as if all *atrium* houses in Pompeii belonged to families of public stature. But this is unlikely, as we shall see. See also Wallace-Hadrill, *Houses and Society,* 38–61. F. Kleiner, *A History of Roman Art* (Belmont, CA: Thompson Wadsworth, 2007), 34 fig. 3–5, illustrates the "typical Roman house of the second and first centuries BCE" with an idealized computer animation before turning to actual houses. Also, the Philadelphia Museum of Art uses an idealized model to explain Roman domestic decor.

19. Wallace-Hadrill, *Houses and Society,* 37.

20. Zanker, *Pompeii,* 200.

21. See *ILS* 6089, lines 26–29, on 1,500 *tegulae* as a requirement for membership in the *ordo* of republican Tarentum. The overly optimistic attributions of individual houses to Pompeian politicians go back to M. Della Corte, *Case ed abitanti di Pompei,* 3rd ed. (Naples: Faustino Fiorentino, 1965). For a critique of Della Corte's method, see H. Mouritsen, *Elections, Magistrates, and Municipal Elite: Studies in Pompeian Epigraphy,* Analecta Romana Instituti Danici Supplementum 15 (Rome: L'Erma di Bretschneider, 1988), 13–19. Indeed, almost no house in Pompeii can be linked to a specific person with any certainty. Yet Della Corte's attributions are still used, for instance by Leach, *Social Life of Painting,* 211–233, in her treatment of houses that are, traditionally, ascribed to politicians. This is not to say that all of these identifications are necessarily wrong. But because of the high degree of uncertainty, it is problematic to draw scholarly conclusions about the decor of these houses on the basis of the putative political ambitions of their owners. Again, the remarkable feature of standardized Roman art

is that individual images can be charged with a whole variety of subjective interpretations.

22. Hodske, *Mythologische Bildthemen,* 61–62, could show that only shops and the very smallest houses in Pompeii were significantly less often decorated with wall painting. Conversely, 40 percent of all houses with a ground area of more than 100 square meters had some wall painting. Houses of 200 square meters and up were painted at a rate of almost 90 percent. As for the quality and choice of mythological painting, Hodske does not see any significant differences between large and small houses, except that some of the painting in large houses is sometimes less carefully executed than in smaller ones.

23. See Wallace-Hadrill, *Houses and Society,* 155–164, on the role of domestic decor in elite houses during the late Republic and 164–174 for its diffusion among the lower classes, tellingly under the heading "from luxus to kitsch." Wallace-Hadrill, *Houses and Society,* 158, argues that wall painting and other decor dominate in *atrium* houses, which he sees as conducive to "social life." But clearly the presence of an *atrium* alone does not necessarily imply the kind of social life we would expect in an elite house. Interestingly, the vast majority of high-quality domestic decor is not found in easily accessible rooms like the *atrium* or the large reception rooms (so-called *tablina*) opening up to them. Hodske, *Mythologische Bildthemen,* 69, could show that *atria,* which, in large houses, could be entered without an invitation, or *tablina,* which are often identified as salons for the morning *salutatio,* were only rarely decorated with mythological wall painting. But according to Wallace-Hadrill, *Houses and Society,* 159, this was exactly the type of "fine decoration" that characterized houses of greater social importance. Instead, over a quarter of all mythological wall painting is found in small rooms that could be locked (so-called *cubicula*) and another quarter in relatively intimate reception rooms that are typically associated with dining. Obviously, Pompeians reserved the most elaborate and meaningful decoration in their houses for rooms that afforded at least some privacy and were, as a result, used for sleeping, intercourse, confidential conversations, or dining with friends. Wallace-Hadrill, *Houses and Society,* explains this with a shift of the "locus of political power: no longer won out in the open, in forum and senate, power is generated through informal contacts, at drinking parties, in the corridors and bedrooms of the palace" (29). But Pompeii was not Rome. The local decurions and knights continued to compete in elections, which is why we should find a continuation of what Wallace-Hadrill sees as the hallmark of Republican decor: well-decorated *atria* and *triclinia.* (On the terminology and literarily attested uses of rooms in Roman domestic architecture, see now Leach, *Social Life of Painting,* 18–54, with an extensive discussion of previous scholarship.)

24. As mentioned above, the rooms that were probably most "lived in" were also the best decorated. The idea of domestic decor as imagery to be "lived with" has been explored in recent years, most importantly by S. Muth, *Erleben von Raum, Leben im Raum. Zur Funktion mythologischer Mosaikbilder in der römisch-kaiserzeitlichen Wohnarchitektur* (Heidelberg: Verlag Archäologie und Geschichte, 1998). For a study of Pompeian wall painting under this aspect, see now K. Lorenz, *Bilder machen Räume. Mythenbilder in pompeianischen Häusern* (Berlin: Walter de Gruyter, 2008), in particular 447–454.

25. Pirson, *Mietwohnungen*, 94–95.

26. Elsner, *Roman Eyes*, 153.

27. K. Stemmer, *Casa dell'Ara massima: (VI 16,15–17)*, Häuser in Pompeji 6 (Munich: Hirmer, 1992), 55.

28. Ibid., 58.

29. On the finds and the occupation of the owner and/or occupant, see ibid., 58–59.

30. Ibid., 31–33, pl. 78, 188–204.

31. Ibid., 18–20, pl. 78, 80–93. On *scaenae frontes* as a decor element, see Leach, *Social Life of Painting*, 93–122, with a thorough discussion of previous scholarship.

32. Stemmer, *Casa dell'Ara massima*, 49–50, pl. 84. It is interesting that the painting no longer represents Egypt as clearly as typologically similar images in the temple of Isis (ibid., 50). Obviously, specific references were not what the decorator and the owner of the house had in mind. This is all the more remarkable because a few Egyptianizing items were found in the Casa dell'Ara Massima. The most prominent piece is a bronze table support in the form of a sphinx, which stood in the *atrium*. On Egyptiaca and Nilotic scenes in Pompeii and the Roman world at large, see M. J. Versluys, *Aegyptiaca Romana: Nilotic Scenes and the Roman Views of Egypt* (Leiden: Brill, 2002).

33. Stemmer, *Casa dell'Ara massima*, 51, 56.

34. On Narcissus in literature, see S. Bartsch, *The Mirror of the Self: Sexuality, Self-Knowledge, and the Gaze in the Early Roman Empire* (Chicago: University of Chicago Press, 2006), 84–103; and R. Taylor, *The Moral Mirror of Roman Art* (New York: Cambridge University Press, 2008), 56–64. For an interpretation of Narcissus paintings along literary and Lacanian lines, see Elsner, *Roman Eyes*, 152–176.

35. On similar arrangements, see Stemmer, *Casa dell'Ara massima*, 56; and L. Balensiefen, *Die Bedeutung des Spiegelbildes als ikonographisches Motiv in der antiken Kunst* (Tübingen: Wasmuth, 1990), 146. See also Elsner, *Roman Eyes*, 158–160. Elsner, 167–168, does notice that the Narcissi on Pompeian walls are not always looking at their own reflection. But he interprets this as a "triangulation of

viewing" along the lines of Lacan's "sardine story" and, more importantly, Philostratus's *ekphrasis* of a Narcissus painting in the *Imagines*. Elsner assumes a highly literate and intellectual approach to painting, in particular an interest in the "gaze" and "voyeurism," either Victorian or psychoanalytic in orientation. He argues that Pompeian painters deliberately referenced these concepts when Narcissus is looking directly at the viewer. But this is rarely the case among "modified" Narcissi. Most of them are looking upward and are, therefore, engaged with neither their own reflection nor with a viewer. In light of the common and straightforward changes to standardized images in Campanian wall painting (see below), it is, at least, beyond proof that wall painting in the houses of mostly middle-class Pompeian businessmen served as an invitation to engage in the kind of narcissistic self-reflection that was encouraged on psychoanalysts' couches in the 1970s. After all, psychoanalysis as a method and an intellectual movement is specific to its own historical moment. On the methodological difficulties raised by Elsner's approach, see now B. Kellum's review of *Roman Eyes, Art Bulletin* 91 (2009): 107–110.

36. On this compositional principle, see in summary Lorenz, *Bilder machen Räume,* 302–307. On pendants in Roman art, see the seminal article by E. Bartmann, "Sculptural Collecting and Display in the Private Realm," in E. Gazda, ed., *Roman Art in the Private Sphere* (Ann Arbor: University of Michigan Press, 1991), 71–88.

37. Wallace-Hadrill, *Houses and Society,* 25.

38. Ibid., 25–37.

39. Ibid., 18–20. On *decor* in Roman architecture and decor, see also Muth, *Erleben von Raum,* 54–59; and Perry, *Aesthetics of Emulation,* 50–77.

40. Leach, *Social Life of Painting,* 47–49. See also Lorenz, *Bilder machen Räume,* 384–390.

41. Vitruvius 6, 5, 2. Wallace-Hadrill, *Houses and Society,* 19.

42. Cicero, *ad Atticum* 1, 6.

43. Cicero, *de oratore* 1, 13–26. Wallace-Hadrill, *Rome's Cultural Revolution,* 172.

44. P. Zanker, *Pompeji. Stadtbild und Wohngeschmack* (Mainz, P. v. Zabern, 1983), 200.

45. Ibid., 197.

46. Stemmer, *Casa dell'Ara massima,* 23–26, pl. 120–153.

47. On the model of gardens and *pinacothecae,* see Leach, *Social Life of Painting,* 123–155.

48. Zanker, *Pompeii,* 190 and 192.

49. Wallace-Hadrill, *Houses and Society,* 29–30, summing up the standard narrative.

50. Zanker, *Pompeii,* 137–138.

51. For an excellent summary of the evidence and recent scholarship, see Leach, *Social Life of Painting*, 132–155.

52. On Vitruvius's intellectual project, see Wallace-Hadrill, *Rome's Cultural Revolution*, 144–153.

53. Vitruvius 7, 5, 1: *imago fit eius, quod est seu potest esse.*

54. Vitruvius 7, 5, 2.

55. Vitruvius 7, 5, 3.

56. Vitruvius 7, 5, 5–6.

57. Vitruvius 7, 5, 6.

58. Grüner, *Venus Ordinis*, 233–251.

59. Vitruvius 7, 5, 7.

60. On placing statues, see P. Stewart, *Statues in Roman Society: Representation and Response* (Oxford: Oxford University Press, 2003), 136–140.

61. Vitruvius 7, 5, 7. On *ratio* in Vitruvius, see Grüner, *Venus Ordinis*, 236–239.

62. Vitruvius 7, 5, 1–2, trans. J. Gwilt.

63. For a brief introduction to the development of the four styles, see now the survey article by V.-M. Strocka, "Domestic Decoration: Painting and the 'Four Styles,'" in J. J. Dobbins and P. Foss, eds., *The World of Pompeii* (Andover, MA: Routledge, 2007), 302–322.

64. On mimesis and the first style, see now Grüner, *Venus Ordinis*, 46–55 and 56–60. For the marbled paper see H. Mielsch, *Römische Wandmalerei* (Stuttgart: Theiss, 2001), 25 fig. 11.

65. On the house and its decor, see most recently Grüner, *Venus Ordinis*, 61–63, with a discussion of previous scholarship.

66. The seminal article on this issue is K. Fittschen, "Zur Herkunft und Enstehung des 2. Stils—Probleme und Argumente," in P. Zanker, ed., *Hellenismus in Mittelitalien. Kolloquium in Göttingen vom 5. bis 9. Juni 1974* (Göttingen: Vandenhoeck und Ruprecht, 1976), 537–559. On the Thalamegos see 546–547. For a critique of this approach see Wallace-Hadrill, *Houses and Society*, 27–28.

67. Suetonius, *Divus Augustus* 72, 4. K. Galinsky, *Augustan Culture: An Interpretive Introduction* (Princeton, NJ: Princeton University Press, 1996), 189–191, believed he had identified the *technophyion* in the so-called House of Augustus on the Palatine Hill. This identification is far from certain. On this issue and the *technophyion* in general, see now E. Gowers, "Augustus and 'Syracuse,'" *Journal of Roman Studies* 100 (2010): 69–87 (70–71 fn. 6 on the identification of the room with a discussion of previous scholarship).

68. Wallace-Hadrill, *Houses and Society*, 20–21, and *Rome's Cultural Revolution*, 171–175. See also B. Bergmann, "Greek Masterpieces and Roman Recreative Fictions," *Harvard Studies in Classical Philology* 87 (1995): 80–81.

69. For a collection, translation, and commentary on the letters see R. Neudecker, *Die Skulpturenausstattung römischer Villen in Italien* (Mainz: P. von Zabern, 1988), 11–14; and M. Marvin, "Copying the Roman Sculpture: The Replica Series," in E. D'Ambra, *Roman Art in Context: An Anthology* (Englewood Cliffs, NJ: Prentice Hall, 1993), 180–184.

70. Neudecker, *Die Skulpturenausstattung*, 16–18, summarizes Cicero's attitude toward art and connoisseurship.

71. Cicero, *ad Atticum* 1, 5, 7.

72. Cicero, *ad Atticum* 1, 6, 2.

73. Cicero, *ad Atticum* 1, 8, 2.

74. Cicero, *ad Atticum* 1, 8, 2, trans. after Loeb.

75. Cicero, *ad Atticum* 1, 9, 2.

76. Cicero, *ad Atticum* 1, 9, 2, trans. after Loeb.

77. Neudecker, *Die Skulpturenausstattung*, 18; Marvin, "Copying," 165–167.

78. Marvin, "Copying," 166.

79. On the Villa dei Papiri and its sculptures, see now C. C. Mattusch, *The Villa dei Papiri at Herculaneum: Life and Afterlife of a Sculpture Collection* (Los Angeles: J. Paul Getty Museum, 2005). For the most recent, stunning finds, see M. P. Guidobaldi, "La Villa dei Papiri di Ercolano. Una sintesi della conoscenza alla luce delle recenti indagini archeologiche," *Cronache ercolanesi. Bollettino del Centro internazionale per lo studio dei papiri ercolanesi. Indice 1971–2010* (2010): 17–32. On the garden *gymnasium,* see Neudecker, *Die Skulpturenausstattung*, 106–114.

80. Neudecker, *Die Skulpturenausstattung*, 107.

81. Ibid., 153, suppl. 1, nos. 54–57.

82. Ibid., 154 cat. no. 62.

83. Ibid.

84. Ibid., 151 cat. no. 31, 33, 34.

85. Cicero, *Brutus,* 24.

86. Of course, there were exceptions, for instance the imperial grotto at Sperlonga with its monumental marble dioramas of Odysseus fighting Scylla and defeating Polyphemus (see below). But such virtuoso showpieces were beyond the reach of anyone but the emperor and the very richest senators, whose lives were indeed a perpetual performance or *mimus vitae* as Augustus put it. Suetonius, *Divus Augustus* 99; Leach, *Social Life of Painting,* 114. On the grotto in Sperlonga, see now Squire, *Image and Text,* 202–238, with a strong emphasis on the Faustinus epigram and other literature-inspired responses to the ensemble.

87. Bartmann, "Sculptural Collecting."

88. Neudecker, *Die Skulpturenausstattung*, 107–108 cat. nos. 64–65.

89. Ibid., 106 cat. nos. 35–39.

90. Ibid., 108 cat. nos. 67–68.

91. As Neudecker (ibid., 108) points out, almost all pieces were made in Campania. This represents an important difference from Cicero's time, when he had to import the sculptural decor of his villas unseen from Greece.

92. See already ibid., 112.

93. Cicero, *Ad Quint. fr.* 3, 1, 6.

94. Petronius, *Satyrica* 52 (silver cups) and 89–90 (Eumolpus). On the silver cups see below; on Eumolpus and *ekphrasis* see Elsner, *Roman Eyes,* 181–199.

95. Statius, *Silvae* 2, 2, 63–73. For an archaeological commentary on the poem, see B. Bergmann, "Painted Perspectives of a Villa Visit: Landscape and Status as Metaphor," in Gazda, *Roman Art,* 51–70, who stresses the topicality of the poem. See now also Stewart, *Social History,* 42–43.

96. Statius, *Silvae* 83–97. For a commentary, see Bergmann, "Painted Perspectives," 62–64.

97. Statius, *Silvae* 4, 6. On the poem and the Herakles Epitrapezios in Statius, see most recently C. McNelis, "'Ut Sculptura Poesis': Statius, Martial, and the Hercules ‚Epitrapezios' of Novius Vindex," *American Journal of Philology* 129, 2 (2008): 257–267.

98. Martial 9, 44. For a very heavy-handed interpretation of Martial's humor, see McNelis, "'Ut Sculptura Poesis,'" 268–273. On Petronius, *Satyrica* 52, see below.

99. Cicero, *ad Atticum* 1, 16, 15.

100. On this episode, see Neudeucker, *Die Skulpturenausstattung,* 15–16; and Beard, *Fires of Vesuvius,* 134.

101. On the Amaltheum, see Neudecker, *Die Skulpturenausstattung,* 9–11, with a discussion of the relevant sources (Cicero, *Ad Atticum* 1, 13, 1; 1, 16, 15, 18; 2, 7, 5; *De legibus* 2, 7). See also B. Bergmann, "Meanwhile, Back in Italy . . . : Creating Landscapes of Allusion," in S. E. Alcock, J. F. Cherry, and J. Elsner, eds., *Pausanias: Travel and Memory in Roman Greece* (Oxford: Oxford University Press, 2001), 155, who imagines that Cicero and his friends "dressed and spoke in Greek while wandering through Plato's academy or the Vale of Tempe or while lingering at a cave where Zeus had been suckled by the goat/nymph, Amalthea." For a less evocative Amaltheum, see G. Sauron, "Un amaltheum dans la villa d'Oplontis-Torre Annunziata?" *Rivista di studi pompeiani* 18 (2008): 41 (sources), 42 (imaginary reconstructions). Sauron, "Un amaltheum," 41, argues on the basis of Cornelius Nepos, *Atticus* 18, 5–6, that the portrait of Cicero was part of a gallery of leading Roman citizens. This is likely but beyond proof.

102. Sauron, "Un amaltheum," 42, follows previous scholarship in the assumption that the Amaltheion must have contained a grotto with a statue of the muse. Amaltheia and the Corybantes appear on so-called Campana reliefs (ibid.,

44), but a grottolike ensemble is pure fantasy. Even the famous grotto *triclinium* at Sperlonga was not built around just one mythological theme, as M. Beard and J. Henderson, *Classical Art: From Greece to Rome* (Oxford: Oxford University Press, 2001), 80–82, have pointed out.

103. The most influential advocate of such visual programs (or *Bildprogramme*) was K. Schefold, *Pompejanische Malerei, Sinn und Ideengeschichte* (Basel: K. Schwalbe, 1952). See also R. Brilliant, *Visual Narratives: Storytelling in Etruscan and Roman Art* (Ithaca, NY: Cornell University Press, 1984). The most influential and intelligent critique of this concept was formulated by B. Bergmann, "The Roman House as Memory Theatre," *Art Bulletin* 76 (1994): 223–256. Bergmann argued that mythological images were arranged not by an overarching theme but by formal criteria. For an "educated viewer" the various mythological scenes could, further, "prompt open-ended analogies" (254) between the stories "by unlocking a variety of associations and inviting a sequence of reasoned conclusions" (255). On the combination of images, see more recently Lorenz, *Bilder machen Räume*, 261–328.

104. On these paintings, see Leach, *Social Life of Painting*, 196–197 (Casa dei Dioscuri); and P. Kastenmeier, "Priap zum Grusse. Der Hauseingang der Casa dei Vettii in Pompeji," *Mitteilungen des Deutschen Archäologischen Instituts. Römische Abteilung* 108 (2001): 301–311.

105. Petronius, *Satyrica* 29.

106. Lorenz, *Bilder machen Räume*, 262.

107. Achilles Tatius, *Leucippe and Cleitophon* 3, 6, trans. after T. Whitmarsh, *Achilles Tatius: Leucippe and Cleitophon* (Oxford: Oxford University Press, 2001), 48.

108. Complex genealogies were an obsession of Roman poets. On this issue, see A. Cameron, *Greek Mythography in the Roman World* (Oxford: Oxford University Press, 2004), 279–280.

109. See most recently Lorenz, *Bilder machen Räume*, 287 fig. 136 a–c. See also Elsner, *Roman Eyes*, 100–103.

110. On this juxtaposition, see most recently Squire, *Image and Text*, 337–338, who believes that viewers were invited to compare the pictures for analogies. For this model of interpretation, see Bergmann, "The Roman House."

111. On sex and erotic scenes in such cubicula, see most recently Lorenz, *Bilder machen Räume*, 384–390.

112. On the frieze and its interpretation, see now F. De Angelis, "Playful Workers: The Cupid Frieze in the Casa dei Vettii," in E. Poehler, M. Flohr, and K. Cole, eds., *Pompeii: Art, Industry and Infrastructure* (Oxford: Oxbow Books, 2011).

113. On this much-discussed ensemble, see now B. Bergmann, "A Painted Garland: Weaving Words and Images in the House of the Epigrams in Pompeii,"

in Z. Newby and R. Leader-Newby, eds., *Art and Inscriptions in the Ancient World* (Cambridge: Cambridge University Press, 2007), 60–101.

114. Ibid., 90–91.

115. On the poems, see ibid., 100–101.

116. On so-called still lives, see Squire, *Image and Text,* 357–428. Squire intellectualizes them. Instead of assuming that such images referenced the food that was probably enjoyed in large rooms, he associates them with high-pitched philosophical debates. Because fake food is used in philosophical examples and similes, still lives must, in his mind, be placed within "ancient discourses of make-believe, simulation and illusion" (406). This, supposedly, even applies to small craftsmen's houses like the Casa dell'Ara Massima (384). By this token, every motif in Pompeian wall painting would have referenced an intellectual "debate," as long as it is mentioned in literature. Squire believes this approach to be an improvement over the current state of the scholarship (360–372). But instead it is a step back into the early twentieth century, when ancient art was explained by and through literary references. For instance, Squire's overinterpretation of the "still-lives" in the Casa dell'Ara Massima is, methodologically, not all that different from August Mau's overly learned reconstruction of the house's graffiti; A. Mau, "Metrisches aus Pompeji," *Mitteilungen des Deutschen Archaeologischen Instituts, Roemische Abteilung* 23 (1908): 263–264. Mau reconstructed a fragmentary distich as "si quis non vidi(t) Venerem quam pin[xit Apelles], Pupa(m) mea(m) aspiciat; talis [illa nitet?]" But there is no indication that the poet wrote *pin[xit]*, which is the only reason Mau could throw Apelles into the mix. Instead, the graffiti almost certainly breaks off with the letters *n* and *a* and not *p, i,* and *n.* Mau clearly wanted to believe that Pompeians cared about the Greek painters whose work their pictures may have borrowed. Conversely, Squire wants to believe that Pompeians looked at their wall painting with literature in mind, because they were, supposedly, conceived as "iconotexts." But at least when it comes to the Casa dell'Ara Massima, the only secure ancient response to the elegantly painted walls of the house is the graffito of a gladiator in the particularly well-decorated *triclinium* G (Stemmer, *Casa dell'Ara massima,* 30).

117. Beard, *Fires of Vesuvius,* 146.

118. Most recent discussion by Lorenz, *Bilder machen Räume,* 428–429.

119. "Cernite Thebiades modo tales sed Bromios regia menas." On the epigram and the painting, see E. Leach, "The Punishment of Dirce: A Newly Discovered Painting in the Casa di Giulio Polibio and Its Significance within the Visual Tradition," *Mitteilungen des Deutschen Archaeologischen Instituts, Roemische Abteilung* 93 (1986): 177.

120. On the graffito and its context, see K. Milnor, "Literary Literacy in Roman Pompeii: The Case of Virgil's *Aeneid,*" in W. Johnson and H. Parker, eds.,

Ancient Literacies: The Culture of Reading in Greece and Rome (Oxford: Oxford University Press, 2009), 299–300. The house takes its archaeological nickname after a *rogator* in an election *programma,* which was painted to the left of the main entrance. The *cognomen* of Fabius (Ululitremulus = he who trembles before screech owls) has been taken as a hint to his profession, as fullers were associated with screech owls. This is also corroborated by the painted owl in the *fullonica* VI 8, 20.21.2. As Ululitremulus's *programma* was endorsed by fullers, his odd *cognomen* could indeed be seen as a hint that he was associated with the trade. But it is beyond proof that IX 13, 5 was either the house or the *fullonica* of Ululitremulus.

121. M. Langner, *Antike Graffitizeichnungen. Motive, Gestaltung und Bedeutung* (Wiesbaden: Reichert, 2001), 100–108.

122. Ibid., 106–107.

123. On Roman poetry on Pompeian walls, see Beard, *Fires of Vesuvius,* 182–185. On the "dialogic nature" of Pompeian graffiti, see now also R. R. Benefiel, "Ancient Graffiti in Pompeii," *American Journal of Archaeology* 114 (2010): 65–69.

124. Programmatically, Squire, *Image and Text,* 147.

125. For a passionate and necessary defense of Mau's system as a chronological tool, see Tybout, "Roman Wall Painting."

126. On the Heroides and wall painting, see Elsner, *Roman Eyes,* 75–77.

127. For a collection of roughly two dozen such "cycles," see K. Schefold, *Vergessenes Pompeji* (Bern: Franke, 1962), 186–188.

128. On this room, see most recently, A. Coralini, "Una 'stanza di Ercole' a Pompei," in I. Colpo, I. Favaretto, and F. Ghedini, eds., *Iconografia 2001. Studi sull'immagine: atti del Convegno, Padova, 30 maggio–1 giugno 2001* (Rome: Quasar, 2002), 331–343.

129. The most influential discussion of the house remains Zanker, *Pompeii,* 145–156.

130. Ibid., 145.

131. On the sculpture from the so-called House of Octavius Quartio, see now F. Tronchin, "The Sculpture of the Casa di Octavius Quartio at Pompeii," in Poehler et al., *Pompeii.*

132. For a detailed discussion of the frieze, see J. R. Clarke, *The Houses of Roman Italy: 100 B.C.–A.D. 250* (Berkeley: University of California Press, 1991), 201–207; and M. De Vos, "II, 2, 2: Casa di D. Octavius Quartio," in I. Baldassare et al., eds., *Pompei Pitture e Mosaici* 3 (Rome: Istituto della Enciclopedia Italiana, 1991), 82–98.

133. On images of Hercules and Hesione, see Lorenz, *Bilder machen Räume,* 135–137 and 222–223.

134. Petronius, *Satyrica* 59.

135. A recent discussion is V. Platt, "Viewing, Desiring, Believing: Confronting the Divine in a Pompeian House," *Art History* 25 (2002): 87–112. Platt chooses

a literary mode of viewing, which requires a good knowledge of Ovid in particular.

136. Elsner, *Roman Eyes,* 160.

137. On this image. see I. Baldassare, "Piramo e Thisbe: dal mito all'immagine," in *L'Art Décoratif a Rome. À la Fin de la République et au Début du Principat* (Paris: Bocard, 1981), 337–347.

138. Ibid., 348–349, fig. 1–3.

139. Ovid, *Met.* 55–166.

140. See already Baldassare, "Piramo e Thisbe," 342.

141. Squire, *Text and Image,* 219, even declares that "learned discussions of myths and philology were the bread and butter of the *cena* and *convivium.*" This may have been so in some circles. But it was certainly not commonplace, just as the conversation at Plato's *symposion* did not mimic what most Athenian men talked about at their drinking parties.

142. Lucian, *Saltatio* 80.

143. Pyramis and Thisbe are common (slave) names. It stands to reason that with the names also a basic knowledge of the story circulated.

144. Lorenz, *Bilder machen Räume,* 394–396.

145. Neudecker, *Die Skulpturenausstattung,* 112.

146. Tronchin, "The Sculpture of the Casa di Octavius Quartio."

147. Baldassare et al., *Pompei Pitture e Mosaici* 3, 101, fig. 89. On Orpheus in the Casa di Orfeo (VI 14, 20), see F. N. Narciso, "VI 14, 20. Casa di Vesonius Primus o di Orfeo," in I. Baldassare et al., eds., *Pompei Pitture e Mosaici* 5 (Rome: Istituto della Enciclopedia Italiana, 1994), 284–287; and Zanker, *Pompeii,* 187.

148. Baldassare et al., *Pompei Pitture e Mosaici* 3, 106, fig. 96–97. On such hunts as a reflection of *venationes* in Pompeii's amphitheatre, see Leach, *Social Life of Painting,* 130–132.

149. Baldassare et al., *Pompei Pitture e Mosaici* 3, 106–108, fig. 98.

150. Most recently Platt, "Viewing, Desiring, Believing," 89, notes that the images differ from Ovid's *Metamorphoses* but still believes them to be dependent on the poem. In her treatment of the ensemble, she assumes a good knowledge of Ovid's version, most importantly in the case of "Pyramis and Thisbe," who die because of what "each character has seen" (96). Ovid, *Metamorphoses* 3, 341–510 (Narcissus), 4, 55–161 (Pyramis and Thisbe), 10, 143–146 (Orpheus among animals).

151. There is no text prior to *Metamorphoses* 3, 358–399, that brings the two together. On paintings of Narcissus and Echo, see Elsner, *Roman Eyes,* 170–174.

152. On the possibility that Roman poets took their imagery from paintings, just as they learned their mythology from handbooks, see Cameron, *Greek Mythography,* 253–254. Indeed, poets refer to paintings, mostly for sexually charged comparisons. Under this attractive hypothesis, a poem would be one of the many possible responses to standardized painting. An actual instance of this

is the so-called House of Propertius in Assisi. On the similarity between land-scape and mythological wall painting in Campania, see also B. Bergmann, "Rhythms of Recognition: Mythological Encounters in Roman Landscape Paint-ing," in De Angelis and Muth, *Im Spiegel des Mythos,* 102–103. Bergmann sees this as a "common mode of analogical thinking" (103). On this issue see below.

153. See Allison, "Using the Material and the Written Sources."

154. On this material, see most recently M. Squire, "Texts on the Tables: The Tabulae Iliacae in Their Hellenistic Literary Context," *Journal of Hellenic Studies* 130 (2010): 67–96.

155. There is little doubt that the chronological framework of Mau's four styles is correct (see Tybout, "Roman Wall Painting"). On the development of figural scenes, see in summary Lorenz, *Bilder machen Räume,* 37–41, 312–317.

156. On such landscapes, see Bergmann, "Rhythms of Recognition."

157. Lorenz, *Bilder machen Räume,* 312–317.

158. On such ensembles, see Zanker, *Pompeii,* 163–168.

159. A rare exception would be the Menander from the otherwise Dionysos-themed Casa degli Amorini Dorati. But the identification with the poet is again wishful thinking: F. Seiler, *Casa degli Amorini dorati: (VI 16,7.38)* (Munich: Hirmer Verlag, 1992), 125–126. On the Dionysiac and idyllic character of Pom-peii's sculptural decor, see E. Dwyer, *Pompeian Domestic Sculpture: A Study of Five Pompeian Houses and Their Content* (Rome: Bretschneider, 1982), 136–137.

160. Petronius, *Satyrica* 29.

161. On the houses, see I. Bragantini, "Casa del Criptoportico e Casa del Sacello Iliaco," in I. Baldassare, ed., *Pompei Pitture e Mosaici* 1 (Rome: Istituto della Enciclopedia Italiana, 1990), 193–329.

162. Langner, *Antike Graffitizeichnungen,* 106–107, and above.

163. Philostratus, *Imagines,* pr. 4. Over the last ten years, the *Imagines* by Philostratus has become a key text to understand ancient responses to art and the relationship between image and text. For an insightful summary on the current debate and an erudite mode of viewing, see Z. Newby, "Absorption and Erudi-tion in Philostratus' *Imagines,*" in E. Bowie and J. Elsner, eds., *Philostratus* (Cam-bridge: Cambridge University Press, 2009), 322–342.

164. Squire, *Image and Text,* 242. See also Newby, "Absorption and Erudi-tion," 326–327.

6. Conclusions

1. I. Calvino, *Invisible Cities* (New York: Harcourt, 1974), 86.

2. On the ignorance of the *idiotai,* see Lucian, *de Domo,* 2. On the need for mediated viewing, see Philostratus, *Imagines,* pr. 1, 5 and 1, 1, 1.

3. Petronius, *Satyrica* 29, 48, 59, 52.

4. See most recently P. Stewart, *The Social History of Roman Art* (Cambridge: Cambridge University Press, 2008), 62.

5. On the house, see M. Squire, *Image and Text in Graeco-Roman Antiquity* (Cambridge: Cambridge University Press, 2009), 249–293.

6. Ibid., 265.

7. Ibid., 267.

8. Ibid. on the date of the inscriptions, 277–278 on discrepancies.

9. Plutarch, *Brutus* 23. On these and similar episodes, see Bergmann, "The Roman House as Memory Theatre," *Art Bulletin* 76 (1994): 248–249. J. Elsner, *Roman Eyes: Visuality and Subjectivity in Art and Text* (Princeton, NJ: Princeton University Press, 2007), 184, accuses Encolpius of "bathetic subjectivism" and writes his experience off as a failure "to find a way of viewing the images" (181). But Encolpius's perspective is what is frequently reported in ancient literature. It was one likely response to standardized images that required no specific response.

10. Cicero, *Orator ad Brutum*, 110. As a descendant of the Brutus who chased out the Tarquin kings, Caesar's assassin Marcus Iunius, Brutus put up the statue of Demosthenes, who had defended the liberty of the Greeks against the Macedonian kings. R. Neudecker, *Die Skulpturenaustattung römischer Villen in Italien* (Mainz: v. Zabern, 1988), 26, suggests that the piece stood among statues of Brutus's ancestors. This is possible, but it is important to remember that Demosthenes was one of the most copied statues of Attic orators in Italy's *villegatura*. What was a political statement for the Iunii Bruti was probably just a commitment to Greek oratory by others.

Index